# MONET

at Vétheuil
and on the Norman Coast
1878–1883

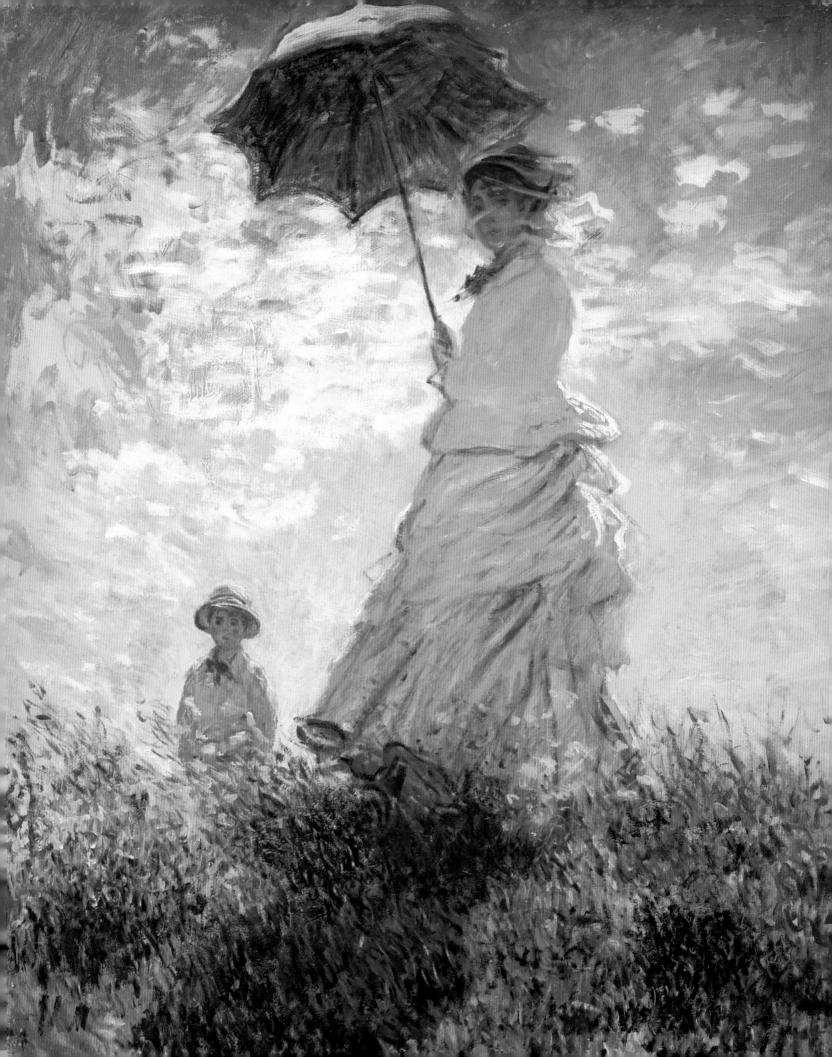

# MONET

## at Vétheuil
## and on the Norman Coast
## 1878–1883

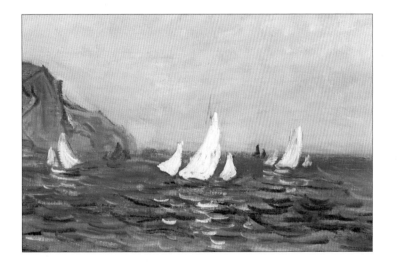

DAVID JOEL

ANTIQUE COLLECTORS' CLUB

ISBN 1 85149 4235

British Library Cataloguing-in-Publication Data
A catalogue record for this book is available from the British Library

**Frontispiece: W381 La Promenade, la femme à l'ombrelle – The Walk, Camille with a Parasol and Jean Monet**
100cm x 81cm. 1875. (Collection of Mr and Mrs Paul Mellon) Photograph © 2002 Board of Trustees, National Gallery of Art, Washington

Origination by Antique Collectors' Club Ltd., Woodbridge, England
Printed and bound in The Czech Republic

To Jean-Marie Toulgouat,
architect, Impressionist painter of nature
and great-grandson of Alice Hoschedé Monet
and to his wife, Claire Joyes Toulgouat,
eminent Monet and Impressionist historian

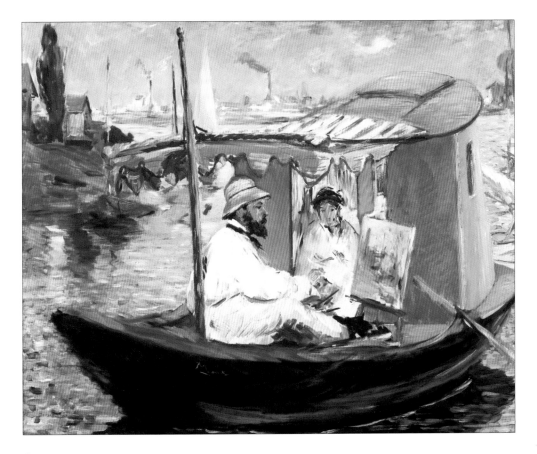

**Édouard Manet (1832–1883)**
**Claude Monet and his wife Camille on the Floating Studio (bateau atelier), 1874.**
82.5cm x 100.5cm    (Neue Pinakothek, Munich) Photo: Joachim Blauel – Artothek

All the Monet paintings illustrated in my book are identified by the numbers given to them in the *Monet Catalogue Raisonné* compiled by Daniel Wildenstein (published by Taschen). The use of these numbers is now widespread as a means of reference and identification and I have included them to assist the reader. As works by Monet continue to be discovered, I understand these will be introduced, and numbered, in revisions of the *Catalogue Raisonné* produced by the Wildenstein Institute.

*David Joel*

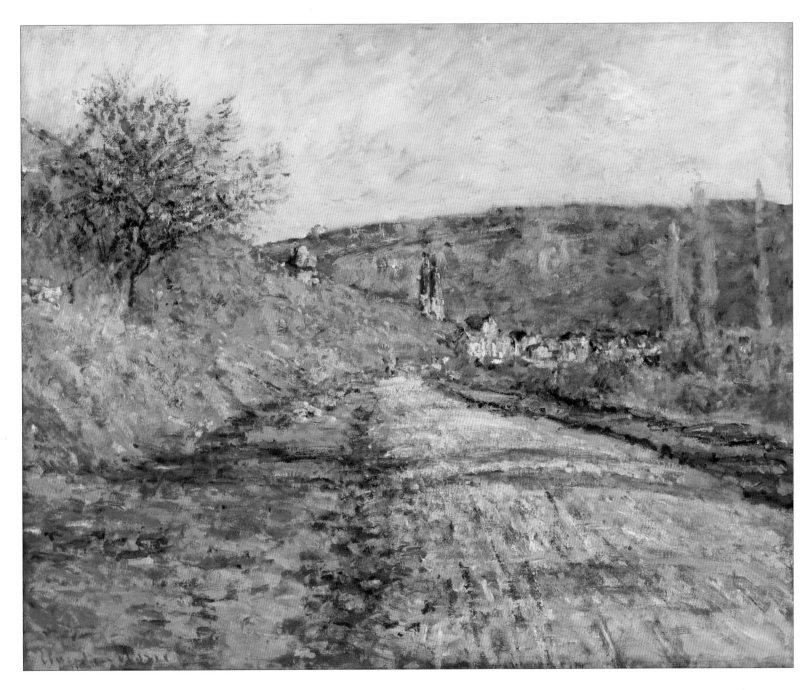

**W581 La Route de Vétheuil – The Road to Vétheuil**
58.5cm x 72.5cm. 1880.   (The Phillips Collection, Washington D.C.)

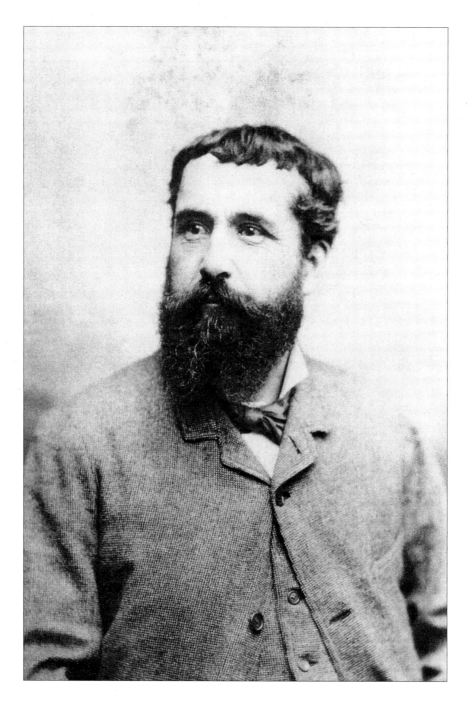

Portrait of Claude Monet in 1877 (aged 37).   (Collection: Toulgouat)

# CONTENTS

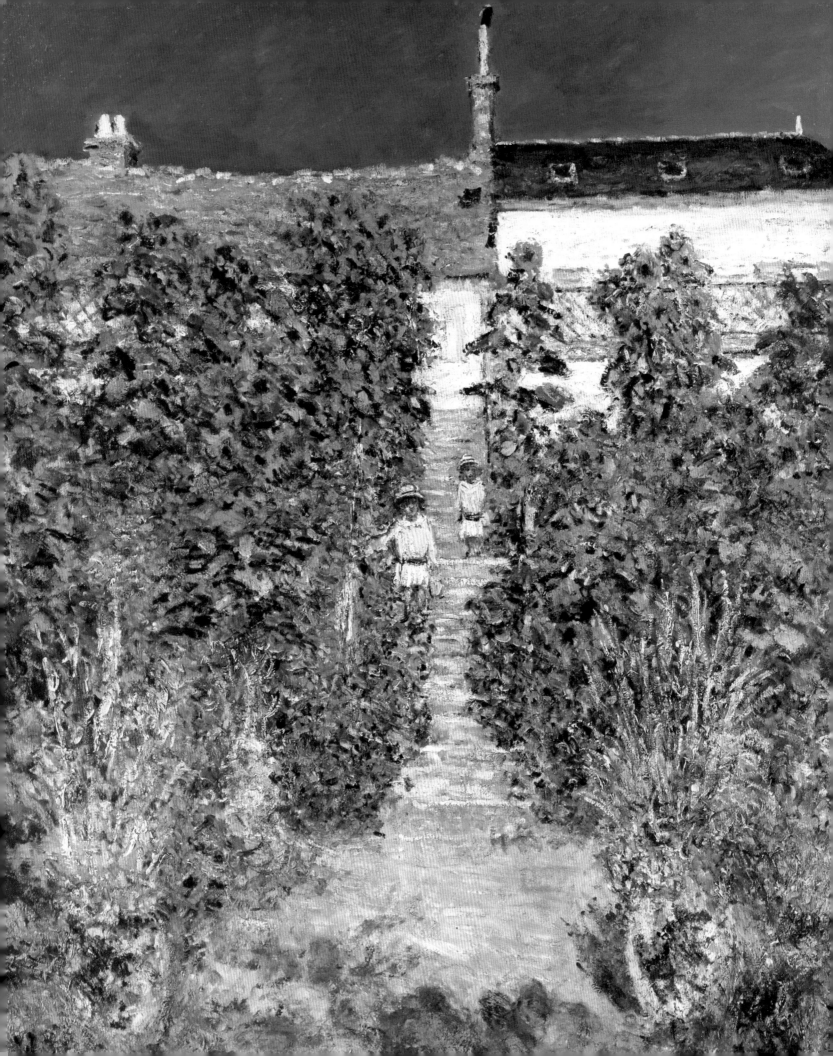

# ACKNOWLEDGEMENTS

My thanks for the assistance of all the following Monet scholars and enthusiasts: Professor Ronald Pickvance, the University of Glasgow; Professor John House, the Courtauld Institute; Professor Richard Thomson, University of Edinburgh; Professor Paul Hayes Tucker, University of Massachusetts, Boston; Michael Clarke, Director General, National Galleries of Scotland, and his secretary, Sheila Scott; Catherine Gimpel of Gimpel Fils (London); Genevieve Lacambre, Musée d'Orsay; John Leighton, Musée Van Gogh (Amsterdam); Claudette Lindsay, Musée Monet, Giverny; Charles Stuckey, Art Institute of Chicago; Dominique Halpin, Mayoress of Vétheuil (2202); Mme Caroline Durand-Ruel Godfroy; Mary Anne Stevens, The Royal Academy; Marianne Delafond, Musée Marmottan; Virginia Spate, University of Melbourne.

Thanks also to Ian and Patricia Anderson, with whom I stayed so many times whilst 'ashore' at Vétheuil. Ian also carried out research for this book in Paris. George J.D. Bruce and the late Ian Gibson, three painters in a motor cruiser. The late Edward Jones of Urchfont. The late Dr and Mrs Peyto Slatter for good company and the loan of *Lady Audacious*; for Jenifer, Suzy and Emma Joel for crewing the ship. Mike Parsons for photo montage, Janey Joel for indexing all the transparencies and for her public relations work for me. Nicholas Herrtage for supervision. Jude Welton and Dorling Kindersley for help with illustrations. The late Daniel Wildenstein for answering all my questions but one. Rodolph Walter and Michèle Paret for their research on my behalf. Philip Piguet for his book on Venice and shared photographs with Toulgouat. Fritz Curzon for research on Sir Clifford Curzon's Monets. Sotheby's for assistance with New York transparencies via Charles Moffett and Melissa Doumitt. In London to Melanie Clore, Michael Strauss, Lucy Tegg and Eva Avloniti. Christie's to Jussie Pyllekannen and Meli Meostopoulos. Charlotte Lorimer at The Bridgeman Art Library. Stella Calvert-Smith at Christie's Images. Vicky Isley and Clare Mitchell at Southampton City Art Gallery. Gaby Proctor for broadcasting advice. Simon Matthews for helping with Monet paintings sold by Arthur Tooth & Sons. Eddy Schavemaker of Noortman Gallery (Maastricht). To my publisher, Diana Steel; editor, Diana McMillan; designer, Sandra Pond; map designer, Steve Farrow; Mark Eastment for his enthusiasm and Susan Ryall and Sarah Smy for publicity.

**W684 Le Jardin de l'artiste à Vétheuil — The Artist's Garden at Vétheuil**
100cm x 80cm. 1881.    (Christie's Images Ltd.)

Jean-Pierre Hoschedé and Michel Monet on the steps.

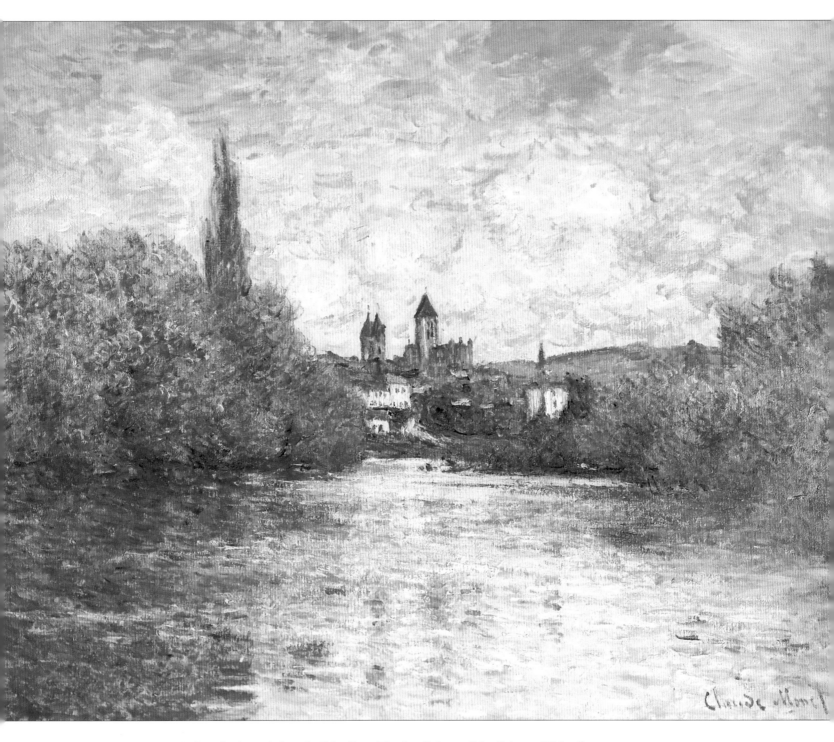

**W601 L'entrée du petit bras à Vétheuil – The Small Arm of the Seine at Vétheuil**
68.5cm x 90cm. 1880.   (Christie's Images)

Opposite: Monet's house, seen in 2001, is below 'Les Tourelles' and to the right is the tower of Notre Dame de Vétheuil.

# INTRODUCTION

Like so many other painters, I greatly admired Claude Monet's paintings and wished I could paint like him, studying his works and his technique whenever I had the opportunity. But I was misled by him into believing that his paintings were usually completed in one sitting. Some of his sketches were, and some of his paintings are sketch-like, but that is not the whole truth. As we now know, he worked for days on some paintings, and even then returned to them time and time again before allowing them to be exhibited or sold. His London and Venetian pictures are good examples of this. But earlier pictures, painted at Vétheuil and on the Norman coast, were more immediate. Many of them are shown in this book, though doubtless even some of these were finished at a later date.

Around 1978 I had the use of a motor cruiser which was ideal for the French rivers and canals, and as a *bateau atelier*. It had three cabins, a saloon-cum-dining room, kitchen, fridge, and shower. She was based at Lymington, near my house, and belonged to the late Dr. Slatter, Orthopaedic Physician and a most expert photographer. The deal was, if I took the *Lady Audacious* across the Channel to Le Havre and up the Seine for him, then I could have the boat for myself and my friends when he was not using it. So for many years we holidayed on the Seine between Paris and

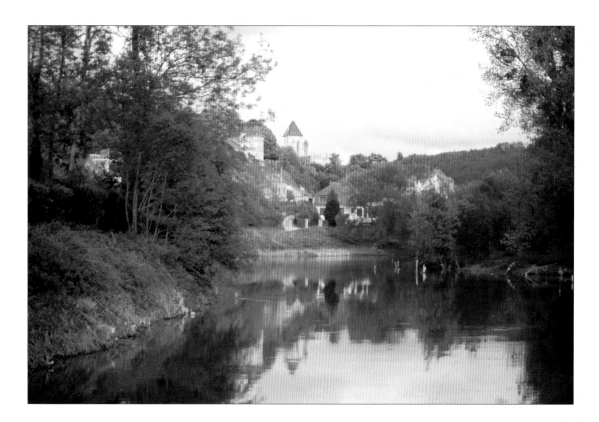

the sea. Bad weather in the Channel often delayed the crossings.

On our first return journey from Paris, we passed Vétheuil during a rainstorm. I was so impressed with the Monet view of the church on the hill, that on my next visit I decided to base the boat there, in order to explore the many Monet sites between Vernon and Vétheuil. We moored at the then derelict jetty in the Bras de la Seine, below Monet's house, and we painted there for two weeks. We included visits to Jeufosse, Port Villez, the Epte river, Bennecourt, la Roche-Guyon, Chantemesle, Lavacourt, Île de St Martin la Garenne and of course Giverny and Vernon.

We gained an extensive knowledge of the area and photographed and painted at many Monet sites. Most of his motifs are still there, but noticeably the tree and bush foliage has grown far higher than in his lifetime. l have recorded this too in the Creuse Valley, where timber is no longer cut for fuel for domestic use, and the herds of goats and other bovines which used to eat the young trees and shoots are no longer about. But little has altered the views between Vétheuil and Lavacourt on the other bank of the Seine, particularly the river scenes.

In the course of my many visits I met Madame Alice Monet's great-grandson, the painter Jean-Marie Toulgouat and his wife Claire Joyes, the eminent Impressionist historian. Around 1994 Claire suggested that I should write about my extensive knowledge of the Vétheuil and Varengeville Monet sites. I agreed to do this if the Toulgouats helped me with the family Hoschedé/Monet matters. They have given me great support, and allowed me the use of the family archives which include their personal photographs.

When John Leighton of the National Gallery, London heard about my proposed book he mentioned it to Michael Clarke, Director of the National Gallery of Scotland, who was keen to make an exhibition of Monet's work at Vétheuil. Edinburgh houses the second of the two earliest paintings Monet made of 'L'Église de Vétheuil'. It is an interesting picture on which to base the National Gallery of Scotland's exhibition, which will show a further fifty-four of Monet's paintings. This book illustrates one hundred and thirty paintings, drawings and pastels from the same period. It also includes Monet's forays from Poissy to the Normandy coast between Fécamp and Dieppe, and before his move to Giverny. Additionally, I have included many photographs taken as recently as 2002. These show the Monet sites and will help those who wish to follow his trail.

I have also done my best to adumbrate the story of the sad death of Camille, his first muse, model and wife, and, four years later, his commitment to Alice Hoschedé and their subsequent marriage. I have also dispelled rumours that some American writers have invented concerning the Alice/Monet relationship.

Lastly, I attack other popular ideas put forward by New World writers concerning the Normandy coast paintings. It is absurd to suggest that Monet painted for the tourist trade, or linked his paintings there to tourism. He was there mostly in the winter months in any case, when the Atlantic gales are not conducive to tourism of any sort. Étretat was, and is, a tiny resort. It has a sand and pebble beach where the small fishing boats, called Étretat caiques, were hauled up the beach by capstans. Contrary to what one writer has said, the capstans were worked by everyone available (all hands to the pumps), men, women and children. One writer even refers to these fishing boats as 'flocks of yachts'. What nonsense. Étretat is not a port; these are fishing boats, and very decorative. That same writer also suggested that Monet moved two trees in one of his four paintings of Sainte-Marguerite-sur-Mer, 'L'Église de Varengeville'. He did not. All Monet did was move his easel. To state that Monet moved objects to suit his composition is totally wrong. He painted what he saw, and not to understand that is not to understand Monet. It is necessary to state this now, before any more false ideas are put about. Monet of all painters was deadly accurate.

I have dedicated this book with grateful thanks to Claire Joyes and Jean-Marie Toulgouat, who provided me with the inspiration and background to write about this important period in the long and productive life of Claude Monet.

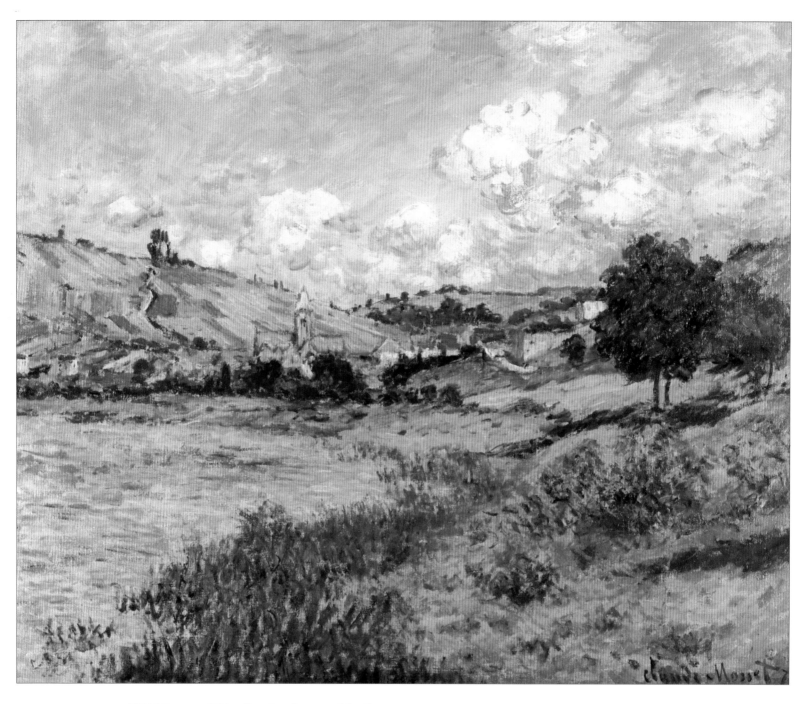

**W526 Paysage, Vétheuil  – Landscape, Vétheuil**
60cm x 73cm. 1879.    (Musée d'Orsay, Paris)

This is the view Monet would have seen as he travelled in the coach from Mantes to Vétheuil on the south approach road via the village of St. Martin La Garenne. Today, trees occlude the best part of this view but it can still be glimpsed through them. At the river bank the view is still the same.

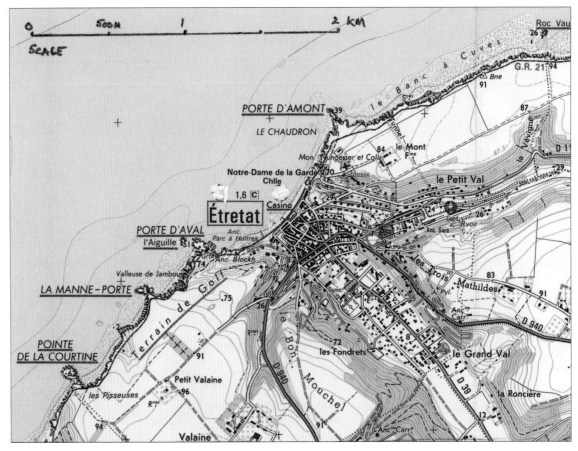

Étretat, 1980, showing the features painted by Monet.

Varengeville, 1998, showing Monet's painting points and hotel at Pourville.

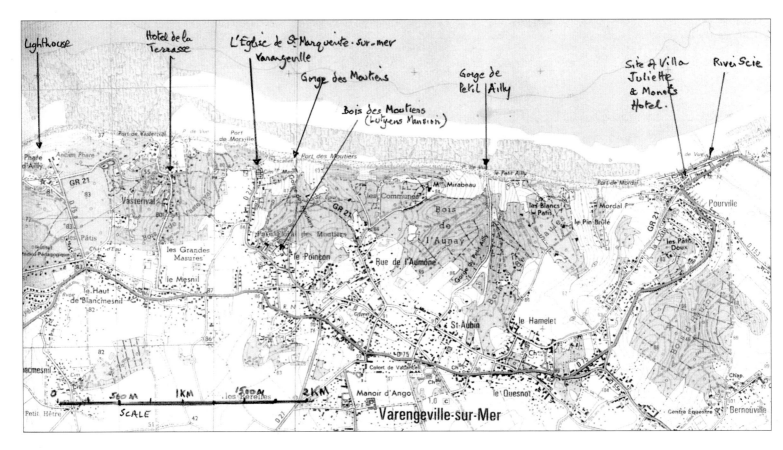

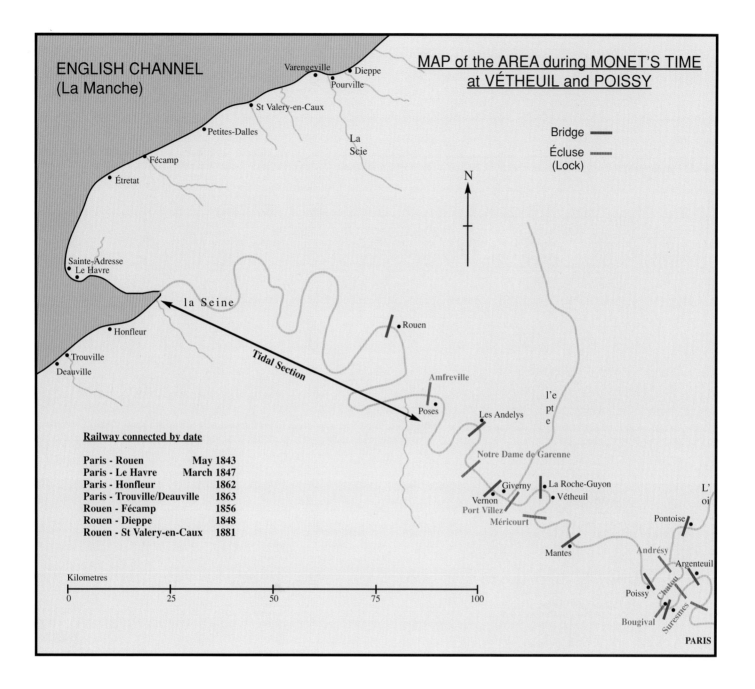

ENGLISH CHANNEL
(La Manche)

MAP of the AREA during MONET'S TIME
at VÉTHEUIL and POISSY

Varengeville
Dieppe
Pourville

St Valery-en-Caux

Petites-Dalles

La
Scie

Fécamp

Étretat

N

Bridge ─────
Écluse ━━━━━
(Lock)

Sainte-Adresse
Le Havre

la Seine

Rouen

Honfleur

Tidal Section

Trouville
Deauville

Amfreville

Poses

Les Andelys

l'e
pt
e

Railway connected by date

| Paris - Rouen | May 1843 |
| Paris - Le Havre | March 1847 |
| Paris - Honfleur | 1862 |
| Paris - Trouville/Deauville | 1863 |
| Rouen - Fécamp | 1856 |
| Rouen - Dieppe | 1848 |
| Rouen - St Valery-en-Caux | 1881 |

Notre Dame de Garenne

Giverny
La Roche-Guyon
Vernon
Vétheuil
Port Villez
Méricourt

L'
oi

Pontoise

Mantes

Andrésy

Argenteuil

Kilometres

0        25        50        75        100

Poissy
Chatou
Suresnes

Bougival

PARIS

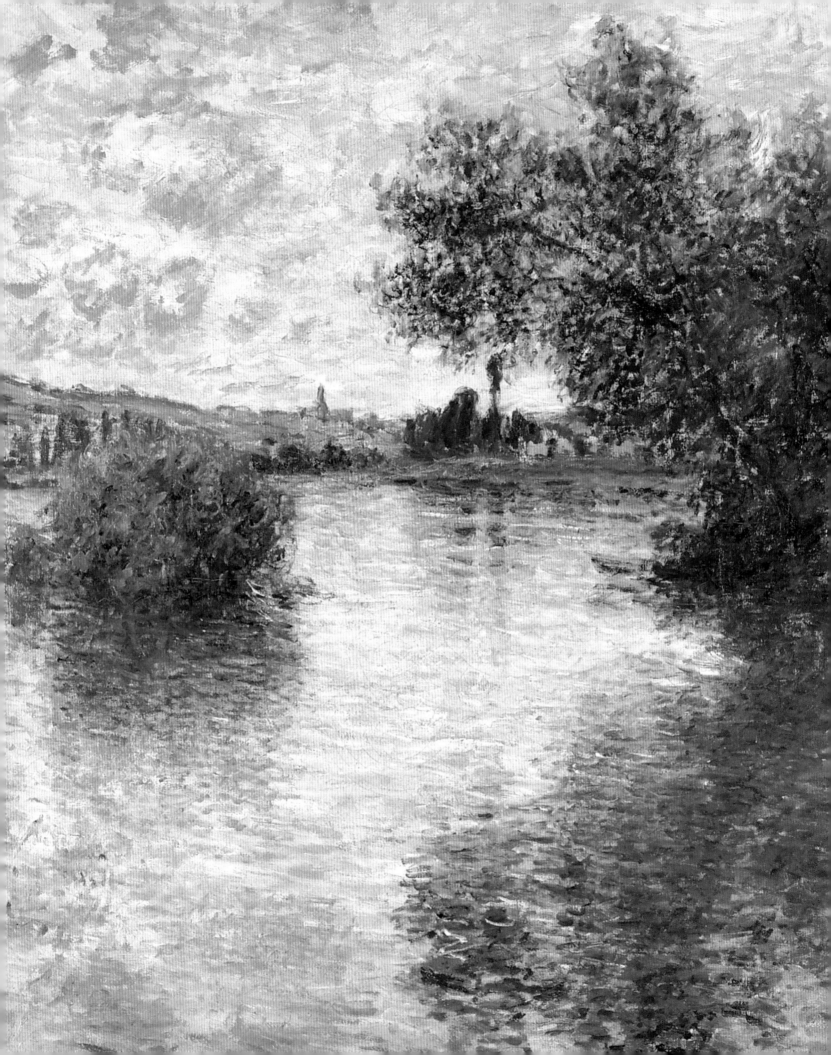

# 19TH CENTURY FRANCE AND THE SEINE

The valley of the Seine between Paris and Le Havre has been shaped by the great river into no less than ten great loops as it has forged its way against cliffs and rock, on its journey to the sea. Seven of these loops occur before it reaches Rouen and in the fourth, the tightest bend of all, formed by the white chalk cliffs that surround the Anglo-Norman fortress at La Roche-Guyon, lies Vétheuil. The Seine at Argenteuil and Bougival and its tributaries at Pontoise and Marly were all important sites for the Impressionist painters, but Claude Monet ventured further down river towards his native Le Havre and it was at Vétheuil that he lived and painted from 1878 to 1881; a key period in his long life. In this mostly medieval village the families Monet and Hoschedé shared their many early vicissitudes.

While concentrating on this short period, some mention must be made of Monet's move to Vétheuil from Argenteuil, where he had lived from 1872 to 1877, of his subsequent move to the 'hated' Poissy in 1881, and finally, of his settling in Giverny in 1883 where he lived for the rest of his life.

But before describing life at Vétheuil, it may be useful to highlight some problems in France at this time, with particular reference to the canalization of the River Seine, which played such a prominent part in the works of the Impressionist group of painters and the landscapes they presented to the startled French public of the day.

France was late to enter the Industrial Revolution for many reasons, not least the exhaustion which followed Napoleon Bonaparte's final defeat at Waterloo and the constitutional problems thereafter. France lacked iron and steel, and the cautious programme she followed was a full thirty years behind England where the Industrial Revolution had started much earlier. This had important effects on communications and on river traffic: communications were by road or by river, using tidal stream, with horse and manpower to tow against the force of the currents. In contrast Belgium, Holland and Germany were well ahead with both rail and canal communications.

The first railway in England was in use from Stockton to Darlington in 1825. By 1843 London was linked by rail as far as York, Birmingham, Southampton, Bristol, Dover, Lancaster and Brighton. It was now possible to get about all over England, as far as the borders of the wild countries of Wales and Scotland. In 1842 France had one railway from Paris to Le Pecq – St. Germain; only twenty-five kilometres of track.

**W537 La Seine à Vétheuil – The Seine at Vétheuil**
81cm x 60cm. 1879.    © Musées de la Ville de Rouen  Photo: Catherine Lancien/Carole Loisel

There were many small islands in this section of the Seine which became navigational hazards as traffic increased. They have been dredged away, one by one, until only the major islands remain. The church tower in the background is that of St Martin la Garenne on the road to Mantes.

In England, the first iron steam paddle boat was made in 1822 and the *Aaron Manby*, as she was called, created a record by paddling up the Seine from Le Havre to Paris in that year. It was not for another twenty years that steam ships were in use on the Seine.

The Seine was a fully tidal river until the first lock (*écluse*) was built at Bougival in 1830. Until then the spring and equinoctial high tides produced a fearsome tidal bore or *mascaret*, which travelled up the lower Seine, particularly at Caudebec where it could run at twelve knots with a wave as high as four metres. It was a long, hard haul to bring a barge from Rouen to Paris using the efforts of tide and horse or manpower, towing along the *chemin de halage* which each village was forced to maintain by law along the banks of the Seine. Eight locks and many weirs were planned for the canalization of the Seine but the work was not finally completed until 1870. This was to become the basic system for navigation on the Seine and for its tributary, the Oise. Since then the locks have been modified and enlarged three times, finishing with new large locks as late as 1970. In addition, and particularly between Vétheuil and Lavacourt, much dredging was completed and many small islands removed; in the case of Vétheuil, the spoil was used to enlarge the promenade extensively below the village. This was where Monet kept his *bateau atelier*, the *Norvégienne*, and his two mahogany skiffs. The anchorage is still the same today but there is now a grassy park of six hectares, used as a picnic site and annually as a large fairground, beside and below the gardens of the village.

The hydraulics of this river system, as with any other, are difficult to get right, particularly if there is a great deal of surface water to take away after heavy and continuous rainfall, as sometimes happens. This can explain the regular *inondations* and *déluges* which occurred, not to mention the *débâcles*, the break-up of extensive icing of the river in very cold winters. These events were well recorded by Monet, Sisley and Pissarro at their various river sites.

As with other cities in the middle of the nineteenth century, sanitation and the removal of garbage was primitive. Paris was no exception. Everything was thrown into or discharged into the Seine. The river in consequence was very smelly all the time, and appalling in hot weather. Fresh water was drawn from the Seine above Paris, but as the city grew larger a lot of the spoil moved with the tide, from time to time above the city. There were serious outbursts of cholera in consequence in the years before the water systems were improved, and a particularly bad epidemic in Montmartre in 1865.

Even at the outset of Napoleon III and Baron Haussmann's reorganisation of the roads and buildings of old Paris it was not realised just how serious this problem was. At first Haussmann organised that the sewerage be piped and spread over the vineyards at Argenteuil. This appalling solution offended even the most Gallic noses, ruining the vineyards and after a short interlude had to be stopped, whilst the modern sewerage system was created by Haussmann as Préfect and First Citizen of the City of Paris. His enormous efforts are well described by J.M. and Brian Chapman in their *Life and Times of Baron Haussmann* – 'Paris in the Second Empire'.

Paris was expanding rapidly in the mid-nineteenth century. Because of some of the problems already mentioned, it was becoming popular for successful Parisians to move out into the newly-built suburbs. Once the railway had arrived it became very easy to travel from a home in the country, and commute home again in the evening. The first railway in France ran from Gare Saint-Lazare (as it was to become) in Paris to Le Pecq, crossing the Seine at Châtou, and this was completed in May 1842. Soon after its completion there was a disaster on the line, with forty-five lives lost. This was a great setback to public confidence in the railway system. However, between 1852 and 1857, 15,000 kilometres of track were laid in France and this rose to 18,000 kilometres by 1870. By then there were good services throughout Western Europe, and as far as the Monet

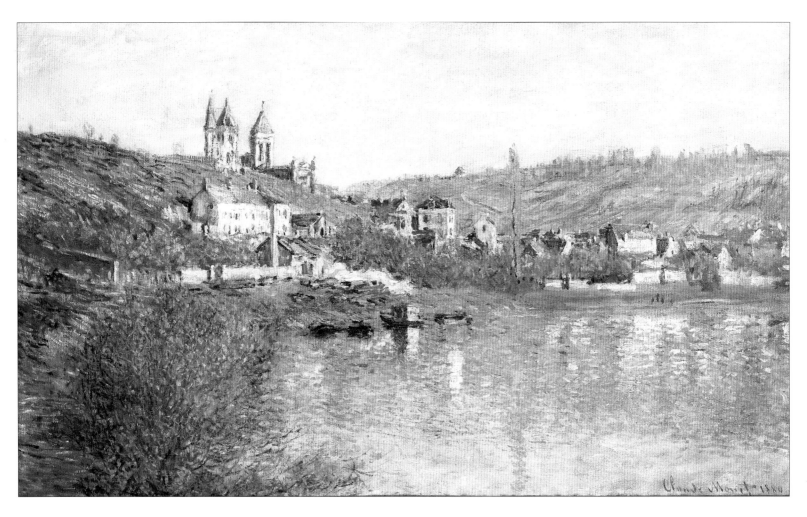

**W591 Les Coteaux de Vétheuil – The Hills at Vétheuil**
61cm x 99cm. 1880.   (Sotheby's New York)

Monet's house is directly below the twin towers of 'Les Tourelles'. The garden runs down to the riverbank where his three boats are moored, including the *bateau atelier*, which is clearly visible.

family was concerned, an excellent service both to Argenteuil and on to Mantes, Rouen and Le Havre. Later on a small railway also ran along the north Normandy coast. Châtou, of course, and Bougival, were to be made famous by the Impressionists. It was the railway line that carried the painters there, and it was the canalization of the Seine which maintained the subject for them. For the first time the river remained at a near constant level which was useful for yachting at Argenteuil, and for an unvarying setting for the painters of the Seine, Oise and the Loing. In a way then, the Industrial Revolution was part of Impressionism, and supported it.

Then suddenly, on 19th July 1870, all this development was shattered. Under Napoleon III France declared war on Prussia and a very nasty short war resulted. A great deal of damage was done to the structure of France, much of it self-inflicted, in order, unsuccessfully as it turned out, to stop the onward advance of the enemy. After the capitulation at Sedan, on 4th September 1870, a French Republic was proclaimed but the war went on.

Monet fled to England, to be joined there later by Camille, by now his wife, and their son Jean, aged three. He knew that if he remained in France, as an ex-soldier who had served in the French Army in Algeria, he would be called up, and he certainly was not in sympathy with that. Others

also headed for London, including Boudin, Daubigny and Pissarro, who was able to introduce Monet to the French art dealer, Durand-Ruel, whilst in London. Only six paintings by Monet are known from this period. This was his introduction to England and despite lack of money and the circumstances of his visit, he found it, to use his words, 'a charming country'. He had his thirtieth birthday in London.

Meanwhile, in Paris, the Germany army had occupied the suburbs but spared the city. On 28th January 1871 an armistice was concluded with the German Empire. As a result, a Commune was established to govern Paris.

The French Revolution of 1785-93 had been a terrible period for France, but it was their way of freeing the majority of the French from serfdom to King and Nobility, for France was entirely an agrarian society at that time. The Revolution was brutal and in the unspeakable 'terror' at least 300,000 people were arrested, with a majority killed mostly by the knife and gun, and a minority suffering the guillotine (including the King, Louis XVI, his Queen, Marie Antoinette and its inventor). Lafayette, the dangerous revolutionary, narrowly escaped it, which was a pity so far as the British were concerned! From then on there was turmoil throughout the Napoleonic period and instability with, in succession, the regency of Louis XVII, Louis XVIII (1815-1824), Charles X (1824-1830), Louis Philippe (1830-1848), to be followed by Louis Napoleon (Napoleon III) (1848-1870), as the first President of the Republic. There were frequent minor revolutions, with the barricade going up and down in Paris, and the usual brutalities occurred.

To an Englishman these frequent upsets seem incredible, and they were, and still can be very violent. It is in the nature of the Gauls. Luckily England has been stable since Cromwell and the

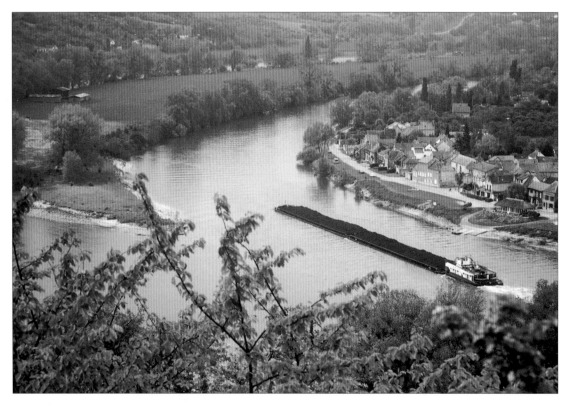

Barges on the Seine off Lavacourt bound upstream with coal for power stations nearer to Paris. This pusher tug is pushing two giant barges, each carrying 1000 tons of cargo. This is a daily occurrence that is carried out most skilfully.

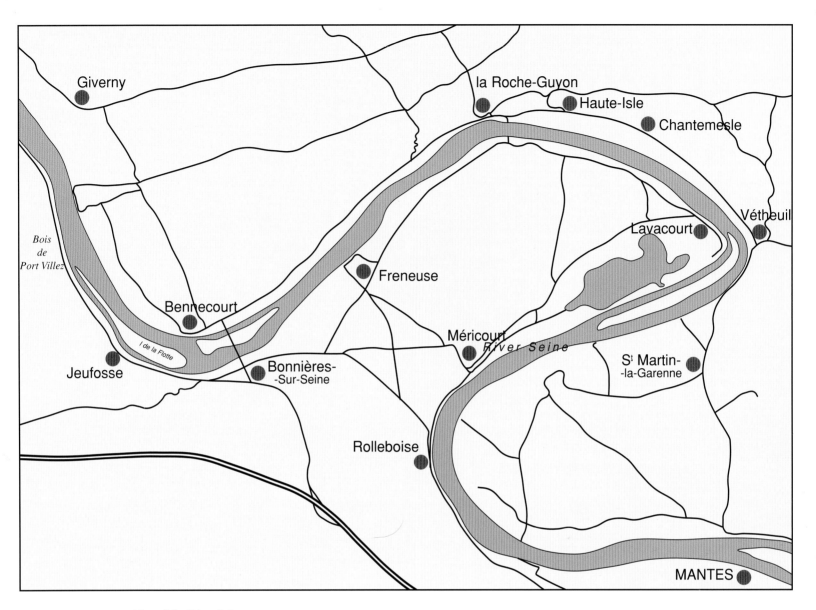

Map of the River Seine

Restoration of King Charles II, and so was often able to host those who fled from France. Our revolution had been settled on the battlefields in the 1650s.

In contrast to the French Revolution eighty years before the Commune of 1870, where the majority of Frenchmen had nothing comparable to complain about, only 10,000 were shot, mainly in Paris and without trial. It was just as nasty as in years gone by, but to fewer people. Monet was wise to avoid it.

Monet could not return to Paris at this stage and so he decided to take Camille and Jean with him to Holland, arriving in late spring. He was enchanted with the Low Countries. He stayed mainly in Zaandam where a wonderful series of twenty-four paintings resulted, before he thought it safe to return to Paris in the autumn of 1871.

Monet's father, Claude Adolphe Monet, joined his brother-in-law, Jacques Lecadre, in his ships' chandlers business in Le Havre. He died during the war aged sixty-nine and left his son a small inheritance. This, together with Camille's dowry, enabled them to take a house in the small town of Argenteuil on the right bank of the Seine, ten kilometres from the centre of Paris. Monet also had

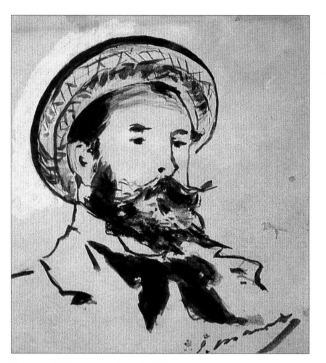

**Edouard Manet – Claude Monet in 1880**
14cm x 12.5cm. Brush and black ink drawing.   (Private collection)

a studio and apartment near the Gare Saint-Lazare. The railway and road bridges across the Seine at Argenteuil had been destroyed by the French in the war, but were repaired again by 1872 and so, once again, Monet was able to commute to Paris and to Le Havre, where he had spent his youth.

By 1870 eight locks and *barrières* had been built below Paris and the canalization of the Seine was completed very much as it is today. It has been modified twice since then, increasing the size of the locks to accommodate the very large modern barges but, as mentioned before, the hydraulics were not quite adequate and from time to time there were floods and *inondations*. With the benefits of the steam paddlers and later screw tugs, traffic was enormously increased on the rivers because the depth of water was constantly maintained. There were several excellent stretches of deep water, Argenteuil being the main one, where the sport of yacht racing could be enjoyed near the heart of a great city. The current runs down the Seine from Paris, nowadays averaging a knot in summer, but faster in the spring and winter; so when Monet rowed down to Rouen with the family he had a good current with him from Argenteuil. Coming back would have been much harder work. No doubt he would take a tow from a steam-driven tug. In the latter part of the nineteenth century the barges were a lot smaller than today's barge of 400 tons, 38 metres in length, drawing four metres when fully laden. Sometimes six of these barges are linked together and pushed from astern by a pusher tug. Thus enormous consignments, usually of coal or ballast for building and road-making, using six barges three pairs abreast means a cargo of 2,400 tons. The whole tow, banded together, will be 114 metres in length, as big, if not bigger, than some ocean-going liners.

Today there is one lock less, for the islands and the barrage at Port Villez have been dredged away to make another fine large sailing area much used by the Yacht Club at Vernon. Monet was to paint this part of the Seine many times, both from his *bateau atelier* and from the shore.

Argenteuil was in the countryside in 1870 but when Monet left on 15th January 1878 it had become a busy industrial town, which was no longer to his liking. He had recorded all the views that appealed to him, around 175 paintings within the Argenteuil area, and he needed refreshment and change. In addition, the proximity of the factories and of Paris was unhealthy for him and his

young family, and Camille was expecting a second child. He was also living too well for his income and many debts had piled up. It was time to move on and find, if possible, some cheaper accommodation further down river. To cut and run!

On 17th March 1878 a second son, Michel, was born to Camille at Monet's new address of 26 Rue d'Edimbourg, Paris 8th Arrondissement. But alas, Camille was not to recover from this and had but eighteen months to live, for she had developed a uterine problem and died of cancer on 5th September 1879.

**W529 La Seine à Vétheuil – The Seine at Vétheuil**
54cm x 73cm. 1879.     (Christie's Images Ltd.)

A barge moves up the Seine and Monet, from his boat, records the dappled light on the water below Vétheuil with the hills of Chantemesle to the right and the chalk cliffs beyond.

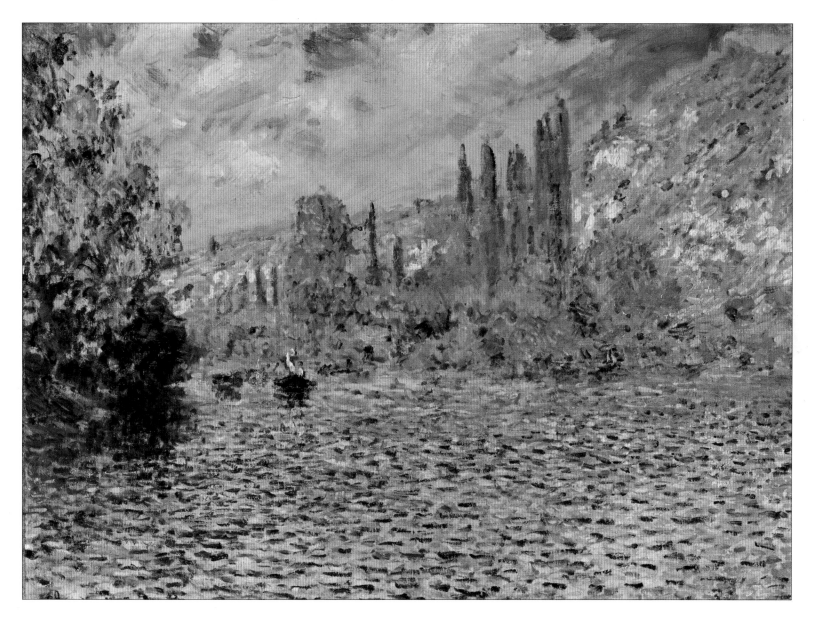

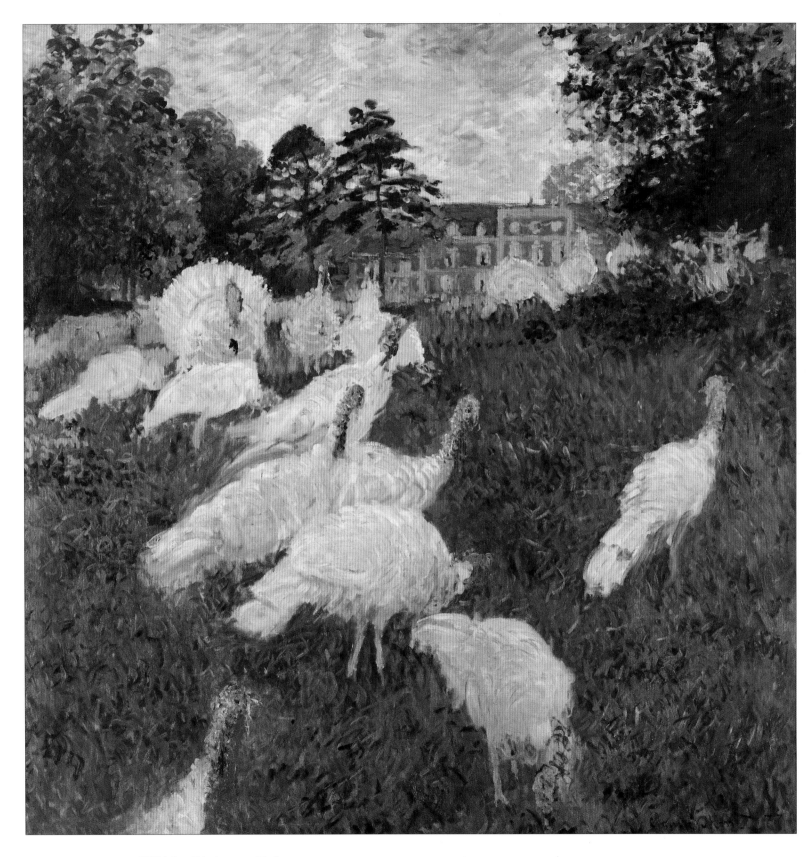

**W416 Les Dindons – Turkeys**

172cm x 175cm. 1877.   (Musée d'Orsay)

The Château de Rottembourg with turkeys free-ranging in the parkland.

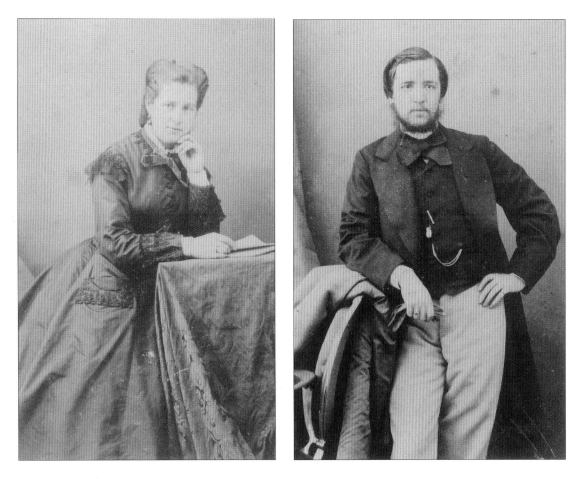

Ernest Hoschedé, aged 27 and his wife Alice, aged 21, 1865.    (Collection: Toulgouat)

CHAPTER 2

# ERNEST HOSCHEDÉ AND HIS FAMILY

**M**onet had by now met, liked and made decorative paintings for Ernest Hoschedé, a merchant with a fine apartment in Paris, where he worked during the week. He also lived in the Château de Rottembourg at Montgeron.

Historians are beginning, at last, to realise the importance of Ernest Hoschedé and his interest in Impressionist art and sculpture. He was born in 1837 and was three years older than the leading Impressionist, Claude Monet, whom he first met in 1875. Hoschedé took over his father's successful Parisian textile business in 1867, when he was aged thirty. His uncle, François Nicolas Herbet, who had been his father's partner, collected paintings of the Barbizon School and clearly Ernest was deeply interested in them, and was to become even more involved in modern art, particularly with the Impressionists. When François died in 1877, he left his entire collection of paintings to Ernest.

Ernest had married Alice Raingo, who was only nineteen, in 1863. She was from a wealthy

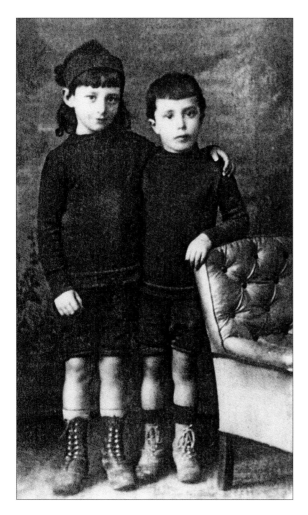

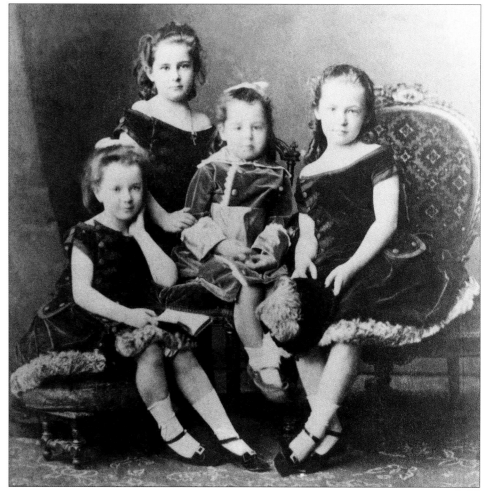

The two youngest children: Jean-Pierre Hoschedé and Michel Monet, 1883.   (Collection: Toulgouat)

The four Hoschedé girls c.1876/77. Marthe, Suzanne, Blanche and Germaine.   (Collection: Toulgouat)

Belgian family, but had taken French nationality on marriage. She brought with her an annual income of 15,000 francs and capital of 100,000 francs, which was a very large sum at that time. When her father died in 1870, she inherited a fortune of 1.5 million francs and the Château de Rottembourg at Montgeron, twenty kilometres south-east of Paris. By 1873 Ernest and Alice had five children: Marthe born in 1864, Blanche in 1865, Suzanne in 1868, Jacques in 1869 and Germaine in 1873. A substantial family, and one more yet to be born.

In 1870 came the Franco-Prussian War and siege of Paris, during which Ernest enlisted in the Garde Nationale, and was even engraved in his uniform by Bracquemond. Could this have been a conceit or a well-founded tribute by a painter of the day?

After the horrible Commune had ended, Ernest behaved like a latterday Medici, with his château, family, fortune, textile business and grand apartment in Paris, at 64 Rue de Lisbonne. Alice was dressed by the couturier, Worth. But he became carried away, did not harbour his capital sufficiently, and unknowingly was slipping into bankruptcy.

On occasions he would charter a train to bring his guests to the station beside the château at Montgeron, where he entertained in a grand manner, taking a great interest in painters of the day, particularly in the Impressionists, whom he was to champion. By 1877 he owned at least sixteen Monets, thirteen Sisleys, nine Pissarros and two Renoirs, amongst his very large collection, which

he was forced to sell, on 5th and 6th June 1878. This had been of enormous financial benefit to the struggling Impressionists. Hoschedé was a generous man and only Pissarro complained about the prices paid. He even owned Monet's *Impression Soleil Levant* at one time. It was from the title of this painting that the critics derisively gave this small group of painters the name Impressionist.

Manet and Sisley had both been guests at Montgeron and in the summer of 1876 Monet went to stay there for several months, on and off. Camille may well have visited too. Monet worked in the little fisherman's cottage called La Lethumière. He worked on decorations for the château, having been advanced sufficient money by Hoschedé for the necessary paints, canvas and materials. Monet finished his work there early in 1877, but that is not to say that he stayed there all the time.

Some French and American writers have tried to suggest that he had an affair with Alice in this period, but this is not likely. Professor Paul Tucker dismisses this possibility in his masterly *Claude Monet Life and Art*. Alice's diaries, which have been consulted thanks to the generosity of Jean Marie Toulgouat, and his wife, the historian Claire Joyes, suggest that Alice was a woman of deep religious conviction. Certainly none of Monet's early letters to her, after Camille's death, suggest such a relationship.

The major pictures painted by Monet at Montgeron were four large decorations – *Les Dindons* (see page 26), *Coin de Jardin* and *L'Etang*, both 1.72m x 1.93m and now in the Hermitage at St. Petersburg (formerly Leningrad), and *La Chasse*, 1.73m x 1.740m, which was in the Musée de la Chasse in Paris and is now in a private collection. These were four fine commissions by Ernest

Ernest Hoschedé with his daughter Marthe in 1876, by Edouard Manet.
86cm x 130cm.   (Museo Nacional de Bellas Artes, Buenos Aires)

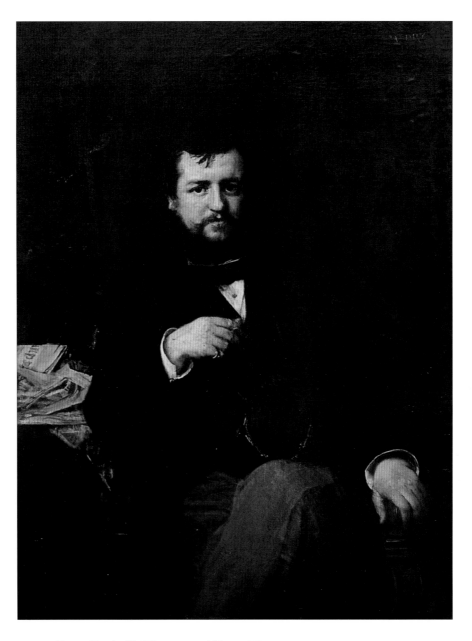

Ernest Hoschedé. Oil on canvas 100cm x 75cm.    (Collection: Toulgouat)
by Léon Bonnat (1834-1923). Member of the Institute from 1881.

Hoschedé, whose example had a profound effect on collectors, and greatly benefited the artists at this time.

Mention must also be made of *L'Arrivée à Montgeron*, (opposite), a small painting, now in the USA, of the train arriving at the halt for the château. Already train-travel was Monet's method of transport. He recorded it faithfully. This painting was a prelude to the great Gare Saint-Lazare paintings, which followed in the next year.

Ernest Hoschedé was spending too much, entertaining too extravagantly, and was not paying sufficient attention to his business when his co-partner died. At the same time came a recession in textile sales and suddenly he could not find enough money. He went bankrupt. His collection, his wife's château, the business, all had to be sold and there was still not enough money to satisfy his

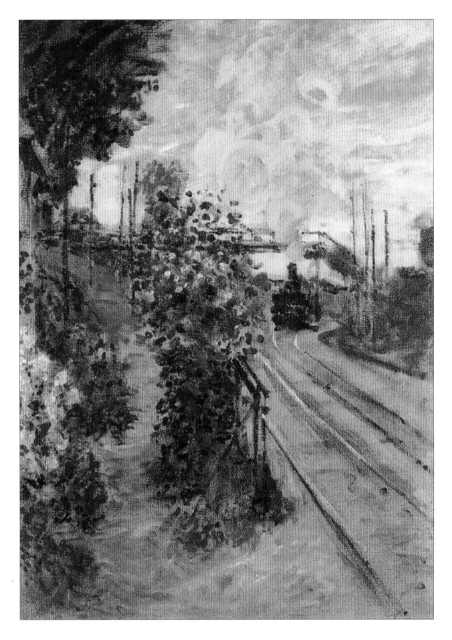

**W421 L'Arrivée à Montgeron – Arriving at Montgeron**
81cm x 60cm. 1876.   (Private collection, USA)

creditors. This situation started in June 1877 and went on beyond 1879. Ernest fled to Belgium, which had no extradition treaty with France, to escape the French legal system. He did not return for some time to face his creditors.

From great luxury, the Hoschedés now found that they had very little they could call their own. Alice, who was used to a life of luxury, with many servants and fine gardens, went with her five children to stay with her sister in Biarritz. On the way the train had to be stopped, and she gave birth, on 20th August 1877, to her sixth and last child, Jean-Pierre Hoschedé.

The Hoschedé world was broken forever. Monet was to be the saviour of the two families, for they were to unite. Alice was to nurse Camille through her distressing fatal illness, and later on was to bring up the combined families of eight children – an enormous undertaking.

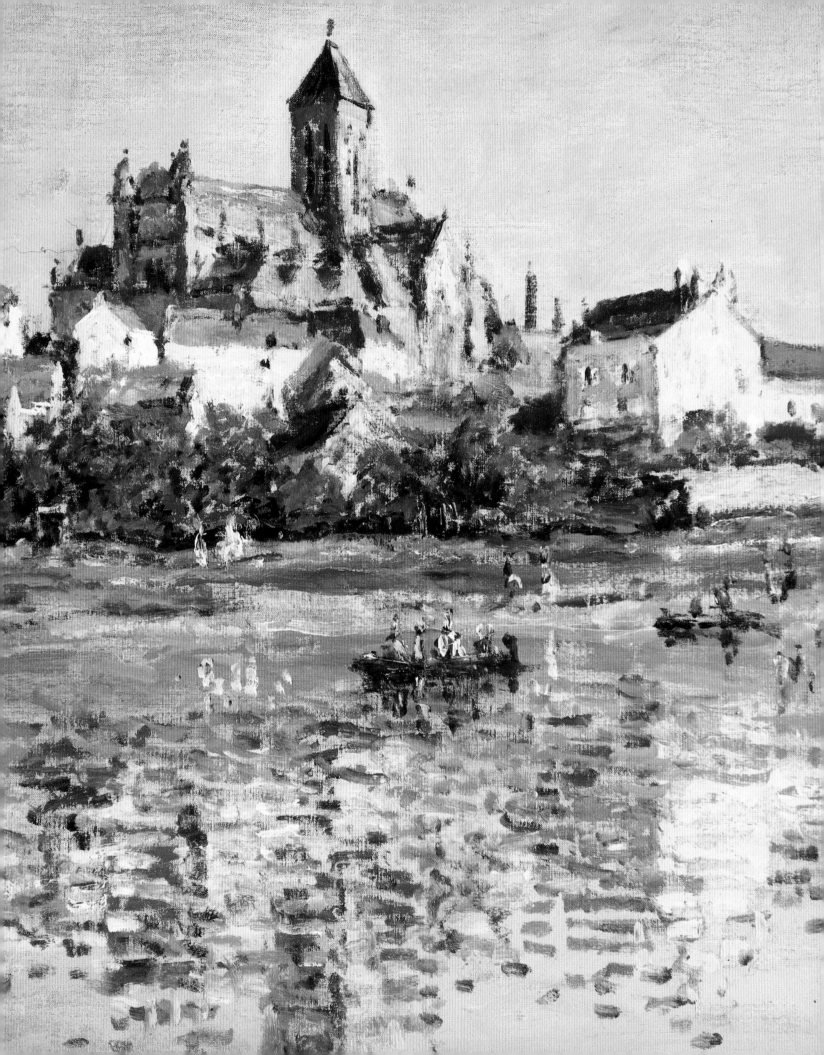

# THE FAMILIES ARRIVE IN VÉTHEUIL

In August 1878 Monet left Paris for a stay in the country and presumably went by train to Mantes. We do not know how, but he discovered a 'delightful place' (*un endroit ravissant* as he wrote to Murer). It was Vétheuil, a medieval village with a great church on a hill above it, overlooking the river Seine, with the village of Lavacourt on the opposite bank. It was in the *région* Île-de-France, an *arrondissement* of Mantes at that time.

Vétheuil is eleven kilometres from the railway at Mantes and the only means of transport, other than by river, was in a public coach run by Père Papavoine. This twice daily service, which linked with the trains to Paris, was frequently used by the Monet and Hoschedé families. Mantes La Jolie, a grand old town of Île-de-France, is only forty-five kilometres from Paris as the crow flies. However the railway ran beside the river, and made several crossings over it, resulting in a journey of sixty kilometres to the Gare Saint-Lazare. In 1878 this journey took seven hours by rail, clanking over four river bridges and calling at over a dozen stations en route. Today it takes about forty minutes. Thus the total journey time from Vétheuil to Paris was an all-day affair.

Vétheuil was a large village with over six hundred inhabitants, including a doctor, and had a post office and the usual village shops – baker, butcher, greengrocer, *charcuterie*, hotel and *tabac*.

Monet first stayed for a few days at the Hotel Cheval Blanc, run by the widow Auger. He then took a short tenancy on a house on the road to Mantes (yet to be identified). There the two families – four adults, Ernest and Alice Hoschedé, Claude and Camille Monet and eight children were installed. Alice also brought a nurse and a cook with her. It was a large household. The children were on holiday in August 1878 and below they are arranged by age:

| | | | |
|---|---|---|---|
| Marthe Hoschedé | 14 | Jacques Hoschedé | 9 |
| Blanche Hoschedé | 12 | Germaine Hoschedé | 5 |
| Jean Monet | 11 | Jean-Pierre Hoschedé | 1 |
| Suzanne Hoschedé | 10 | Michel Monet | 5 months |

Monet was aged thirty-eight, Camille thirty-one, Ernest Hoschedé forty and Alice thirty-four, all united under one roof, albeit in a small house.

The first house they took on the Route de Mantes proved too small and Monet found another, larger and more comfortable cottage, which the two families moved into in December 1878. This house, part of the estate of a much larger house on the hill above called 'Les Tourelles', belonged to Mme. Eve Elliott, the French-born widow of an Englishman, Thomas Elliott, who had been an industrialist in Nottingham. Today, this cottage remains much as it must have been in 1878. It is

**W531 L'Eglise de Vétheuil – The Church at Vétheuil (detail)**
51cm x 61cm. 1880.    (Southampton City Art Gallery)

**W552 Vue de Vétheuil, l'hiver – View of Vétheuil in Winter**
60cm x 81cm. 1879.   (Private collection)
**Pierre-Auguste Renoir (1841-1919)**
Barges on the Seine between St Germain and St Cloud, c.1869.
(Musée d'Orsay, Paris/Giraudon/Bridgeman Art Library)

now the home of the retired gardener of 'Les Tourelles'.

When Monet lived there the road to La Roche-Guyon was a cart track running outside the front door. The traffic was infrequent. On the other side of the road were steps leading down into the garden and orchard, as seen in W682-W685 (pages 134-135), and thence to a *bras de la Seine* where the *bateau atelier* was moored. Today the house has no garden in front. Another house has been built there. The cart track has become a modern road but is still not very busy. The village remains almost unaltered and has a feeling of timelessness. Later it will be described in detail but, for the moment, the Monet/Hoschedé families were resident in Vétheuil.

Originally 'Les Tourelles' had two tall turrets, five storeys high, but it has now been modernised and reduced in height. Even so, from some angles, particularly from the west (La Roche-Guyon) it is possible to confuse the one remaining but cut-down tower with the church steeple behind it. Recently it belonged to the American artist Joan Mitchell who died in 1992 aged sixty-six. She was a well known abstract impressionist much in sympathy with Monet's later style.

The Valley of the Seine has its own peculiar light and its own micro-climate. It is misty, more often than not, in the mornings. On quiet days the cliffs form great updraughts which are very favourable for today's gliders. These climb and soar upward after being towed into the air from the aerodrome above Vétheuil, and then ride the thermals. Down below, on the inland lakes behind the village of Lavacourt, directly opposite Vétheuil, mini-hulled yachts and sailboards can be seen racing. At all times barges move up and down the Seine, their muffled engines humming in the distance.

From 'Les Tourelles' and the hills above the village of Vétheuil, you can watch and hear this endless traffic. The barges heading for Paris go to the right of the Île Saint-Martin, and those going from Paris to Rouen take the opposite side, so they are separated. In front of Vétheuil the islands that can be seen in Monet's paintings have been dredged away, but the scene is much the same. Renoir painted 'Barges on the Seine' (above) in 1869, which could be Vétheuil. So far as we know Monet never painted this subject, for his only barge painting is the magnificent W501 (page 38) – a landscape-shaped painting, which he painted at river level. Significantly the barges in this painting are being towed up river, to the right of the Île Saint-Martin, by a steam paddle tug. The steam-driven tug was late to be developed, late anyway by English standards.

It is strange that Monet did not use the remarkable view from the heights of the garden at 'Les Tourelles', more especially since he painted Vétheuil church from all directions, including W672 which would have complemented the view from the lane outside Mme. Elliott's house. Perhaps

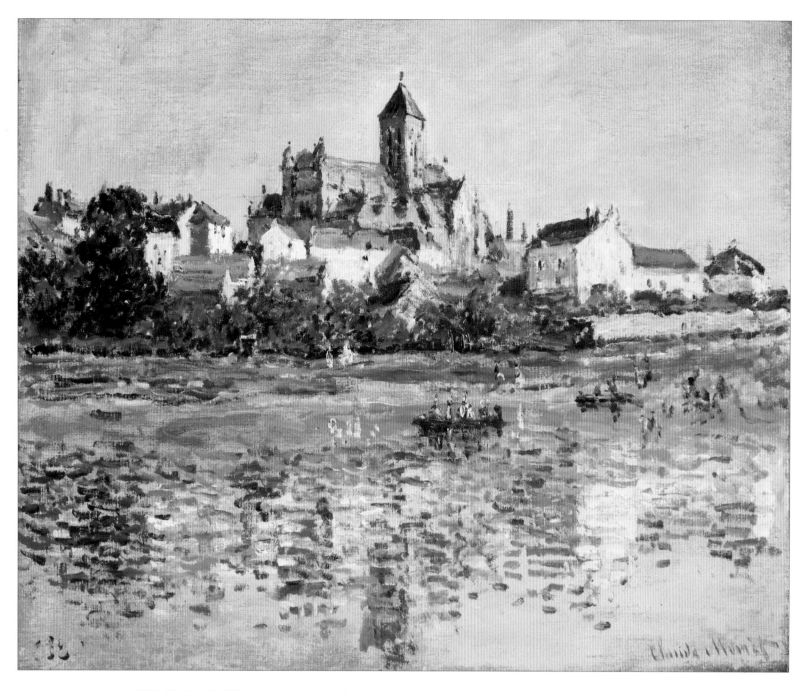

**W531 L'Eglise de Vétheuil – The Church at Vétheuil**
51cm x 61cm. 1880.    (Southampton City Art Gallery)

The church of Notre Dame de Vétheuil towers over the beautiful village in the late morning sunshine. There is no wind to disturb the reflections observed by the painter from his position on top of the riverbank at Lavacourt. He probably rowed across hours earlier. See detail, page 32.

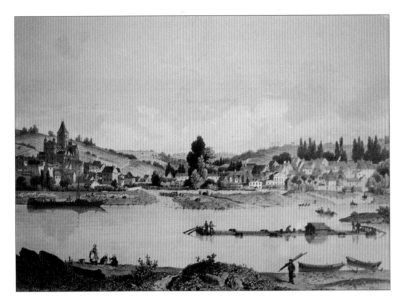

A. Maugendre, Vétheuil, seen from Lavacourt in 1853. Coloured lithograph.
(Mairie de Vétheuil)

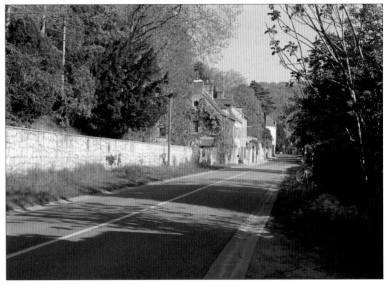

The road entering Vétheuil. Monet's house is is the third on the left, overlooking the Seine. Photographed in 2002.

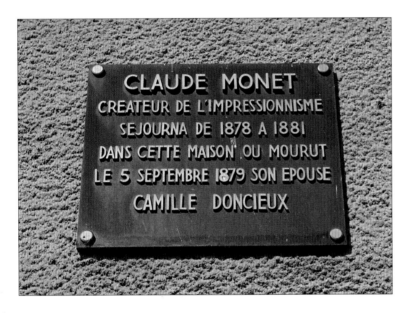

Plaque commemorating Claude and Camille Monet on the front of their house in Vétheuil, now in rue Claude Monet.

Monet's house at Vétheuil, 2002.

he did not wish, or was not on good enough terms, to utilise her views; or perhaps he thought that as a tenant of hers he could not use her territory to his advantage.

The towers of 'Les Tourelles' do add some confusion to the pictures that he made of Vétheuil. This is because, when seen from the road to Chantemesle, they appear to be as tall as the steeple of L'Eglise de Notre Dame. Furthermore there were two of them, so the viewer may be forgiven for thinking in W502 (page 39) that the tower above Monet's house is that of the church. It is not, it is one of the twin towers of 'Les Tourelles', seen more clearly in W508 or W510 (page 66). The church is about two hundred metres from the towers, as you can see in the view from Lavacourt, W536 (page 72), but in the 'Vue de Vétheuil, l'hiver', W552 (page 34), they seem to be part of the same building.

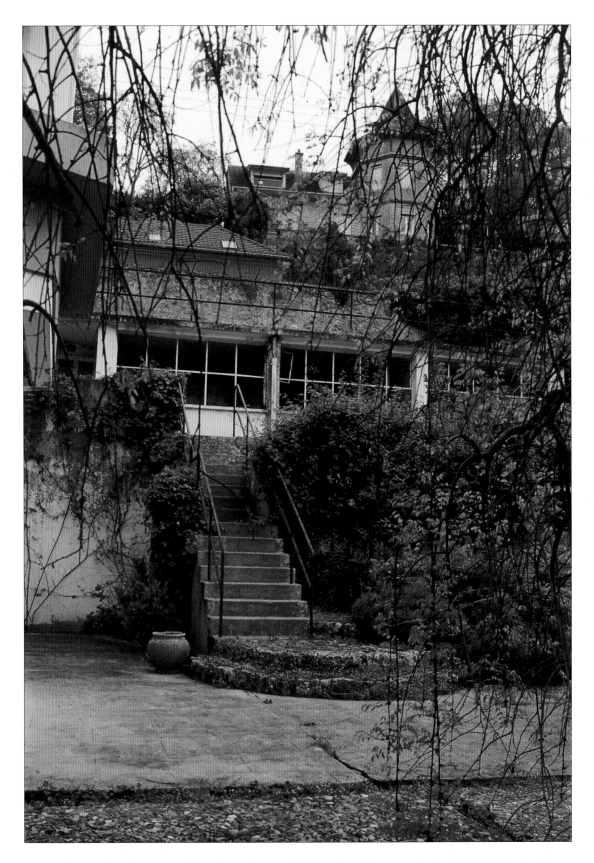

Monet's house and garden steps in 2002. This is where, in 1881, he painted the great paintings (W682–685) of sunflowers (pages 134–135) and the children. His house is partly obscured by the stone wall and 'Les Tourelles' is seen above it and to the right. Photograph taken in the garden of the late Dr Tabernet, 13 rue Claude Monet.

Monet, as always, is deadly accurate, and not to recognise this is not to understand his work. He did not invent any of his compositions and adhered strictly to the scene before him.

In W590 (page 41) there is a similar separation, but then in W591 (page 21) which tower is which? And in that painting also are the *bateau atelier* and the *Norvégienne*, on the right and two skiffs to the left; Monet's little fleet, moored to buoys in the Seine with lines to the shore. All four boats had been brought down the Seine from Argenteuil, for there was no other way to move them except through the locks of Bougival, Andresy, Meulan and Mericourt. Quite an adventurous journey, and now they were within a very short distance of Giverny and the Île-aux-Orties, where they would be taken in 1883, and remain.

There was a bridge across the Seine from Mantes to Limay. This ancient bridge, part of which can be seen today, was built in the year 1340 and often became the subject of a painting. It was replaced by a modern structure in 1952, but its remains, an eight-arched span, are preserved. It was painted by Corot but though Monet must have seen it often, he did not stop to record it.

The next bridge across the Seine was at La Roche-Guyon and Monet must have used it. It was renewed after collapsing in the 1930s but unfortunately was destroyed in the last war and has not been replaced. In March 1944, Grand Marshal Rommel made Château de La Roche-Guyon his headquarters at the time of the Normandy invasion. From there he controlled all the German forces in Normandy, and fortunately the Allies did not realise this. Had they done so, no doubt the great Château would have been destroyed by bombing, and the loveliest village in Île de France would have been brutalised. This is a strange twist, but to the advantage of posterity.

It so happened that Rommel's staff car was attacked on 17th July 1944 by British aircraft on the Route N179 as he was on his way from Trouville before returning to La Roche. His driver was killed

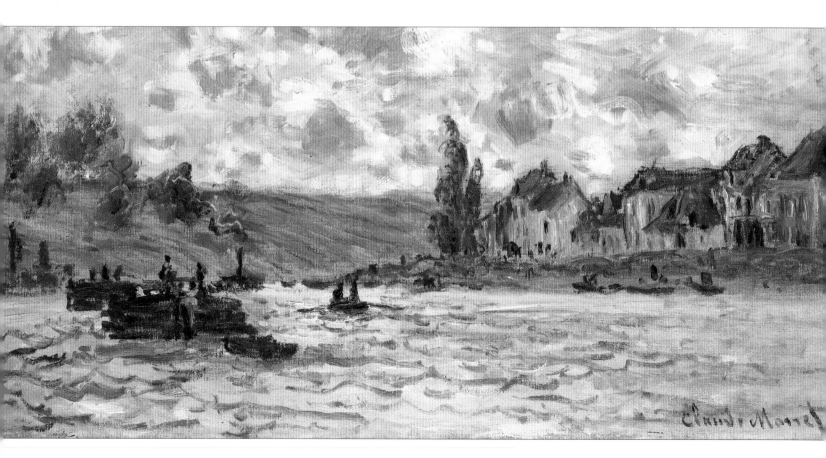

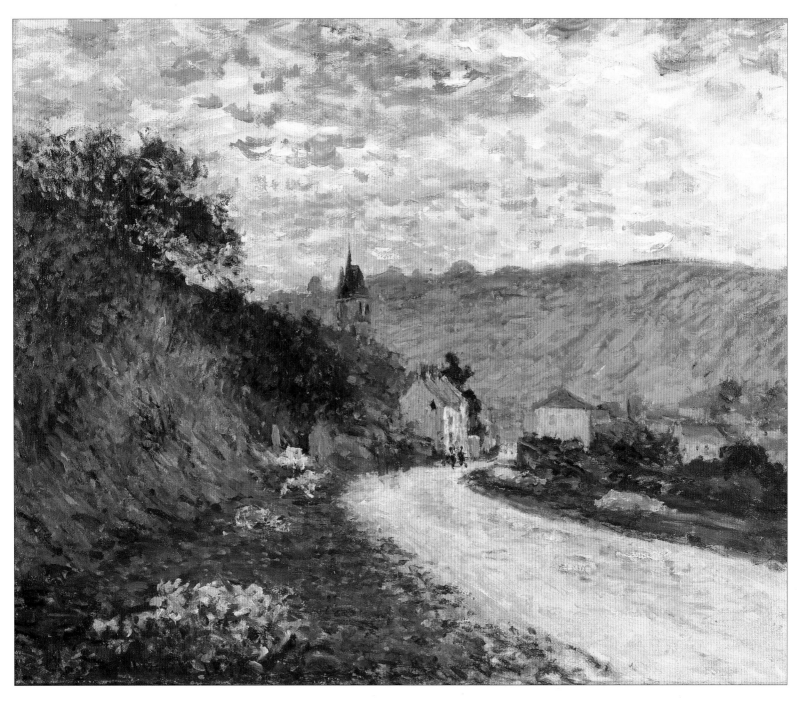

**W502 La Route à Vetheuil – The Road coming into Vétheuil.**
49.5cm x 61cm. 1878.    (Photograph courtesy of Sotheby's Inc. © 2002)

The entrance to the village on the road from La Roche-Guyon. Monet's house is on the left and 'Les Tourelles', where his landlady lived, is above and to the left.

**W501 Le Village de Lavacourt – The Village of Lavacourt**
35.5cm x 73cm.    (Christie's Images Ltd.)

Painted on the Seine (perhaps from the *bateau atelier*) looking upstream towards Paris. A steam tug tows a line of barges, the last with a rowing boat astern. There are three ferry boats at Lavacourt on the beach and another rowing down towards the painter. A good wind from the west disperses the smoke and ruffles the water. *Plein air* painting in a rocking boat is difficult. Obviously signed later!

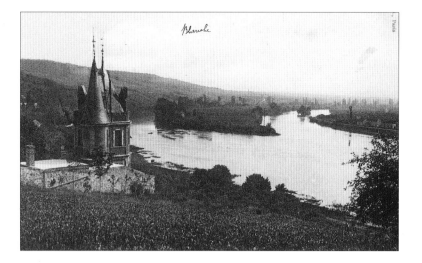

The view from 'Les Tourelles' in 1900 of the Seine, looking upstream across to Lavacourt. In the centre is Île Saint-Martin la Garenne, which divides the river. Traffic bound for Paris goes to the right of the island, that from Paris comes down on the left. The island seen in the right channel has been dredged away.   (Collection: Toulgouat)

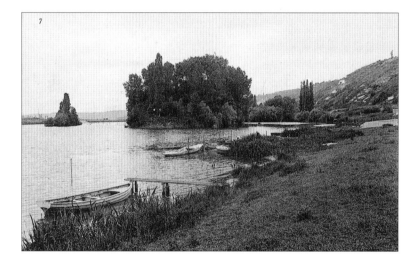

Vétheuil (Seine et Oise) Iles de Moisson. About 1900.
This is the area below and outside Monet's garden. The Bras de la Seine is on the right, where he kept his boats. To the left is the Seine, in the middle of which is an island with stakes holding a fishing net. The island has been dredged away.
(Collection: Toulgouat)

and he was seriously wounded and taken to hospital at Bernay and a few days later was transferred to Le Vesinet near St. Germain. In La Roche, two Resistance leaders were executed by the Germans, just outside the Town Hall in 1944, prior to the liberation of the area by the British Army.

The bridge has yet to be rebuilt, but the buttresses are still there, in a key position by the Hotel Saint Georges. It is a quiet place with fine views up and down the Seine. With that bridge, Lavacourt, the Forêt de Moisson and the huge lakes where the gravel has been removed, would be more accessible: but equally without the bridge the tourists stay away. It remains an unspoiled area of rural France, a reminder of her agricultural heritage, so much of which is by-passed today by the Route Nationale N13, by those seeking the hot sun and crowded beaches of the French Riviera, over six hundred miles to the south.

Monet knew every useful scene to be found from the shores of the Forêt de Moisson, mainly views from Lavacourt and Moisson itself. He could cross on the ferry, which ran a regular service from Vétheuil

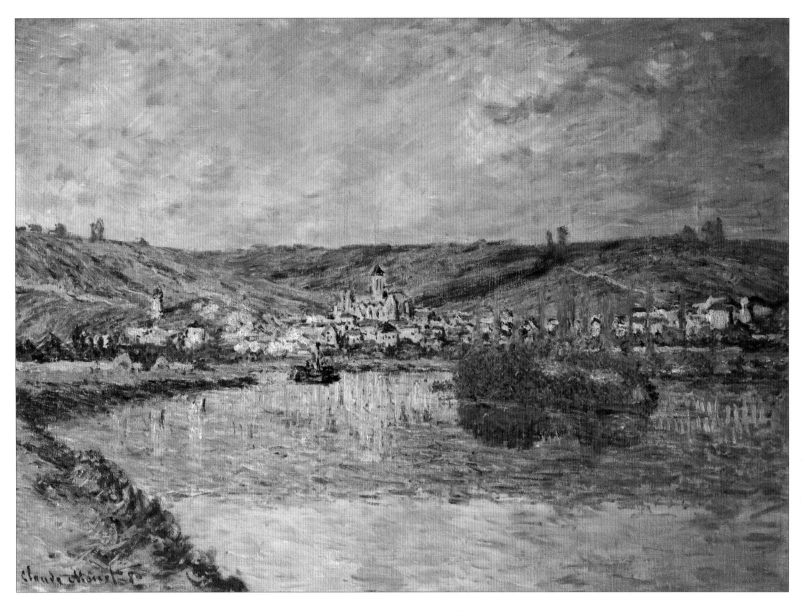

**W590 Fin d'après–midi, Vétheuil – Late Afternoon at Vétheuil**
72cm x 99cm. 1880.  (Christie's Images Ltd.)

to Lavacourt, or use the bridge at La Roche-Guyon, or take his *bateau atelier*. The boat was most useful when he wanted to anchor in the river or visit the islands. The current of the Seine always runs at least at one knot, and in winter and spring quite a bit faster. At times of flood it might have run at four knots, with even stronger currents in restricted shallow waterways. A wise man would not row a boat against a strong current, unless he had to. He would probably have waited for a 'steam powered' tow. It would have been possible to sail, for there was plenty of fair wind in the winter and spring, but mostly calms in the summer. It seems that Monet did not use sails. Even today it is rare to see a boat sailing on the Vétheuil stretch of the river, though many motor up and down to Paris. Some are yachts with their masts unstepped and horizontally stowed on deck, because of the problem of passing beneath bridges. It is possible to take a yacht all the way to the Mediterranean using the French rivers and canals, thus avoiding the long journey down the Bay of Biscay, and into the Mediterranean via the Straits of Gibraltar.

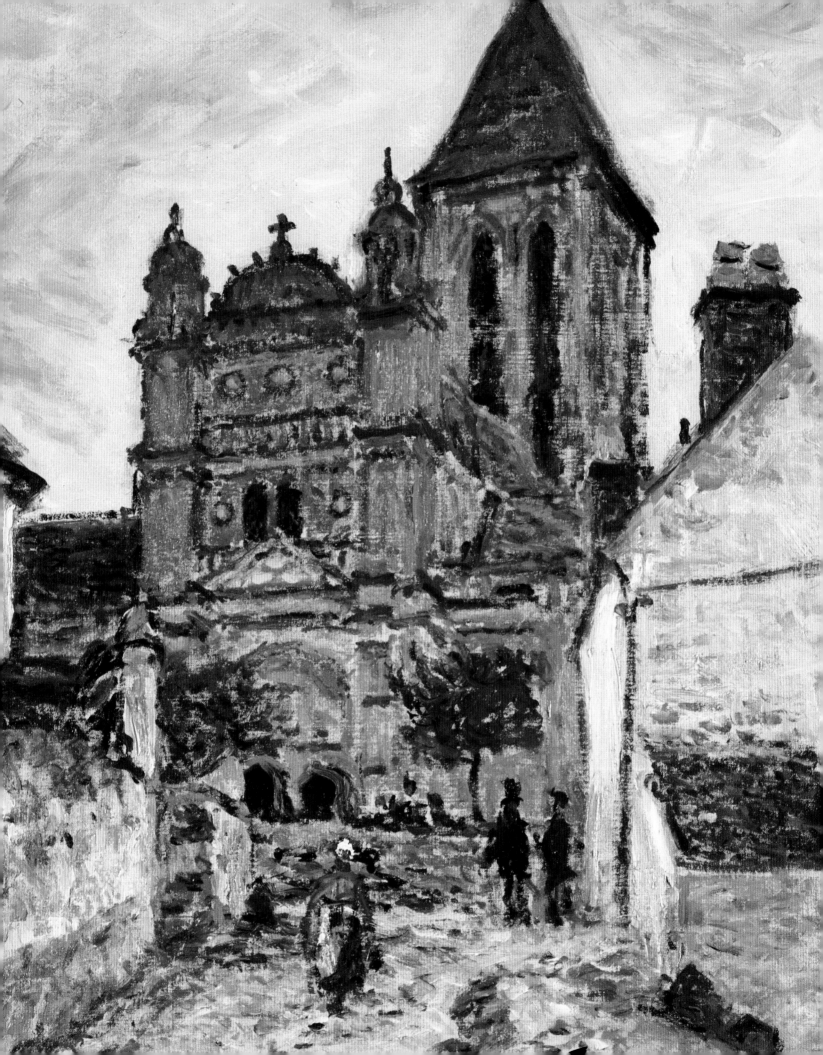

# THE VILLAGE OF VÉTHEUIL AND THE CHURCH OF NOTRE DAME DE VÉTHEUIL

The valley of the Seine between Paris and Le Havre was shaped by the great river and on the fourth bend on the way down lies Vétheuil, at the top of the loop between the city of Mantes and the town of Vernon.

Above the next great bend, caused by the cliffs at Les Andelys, towers the Château Gaillard. This great castle was built in 1196 by Richard the Lionheart, King of England and Normandy, and of the Crusades. Strangely Monet has not painted a picture either from, or of, this superb fortress even though he must have passed it in his boat. In the seventh bend of the Seine is the city of Rouen, where the English burned Joan of Arc at the stake in 1431. That this province was Norman was of great importance to Monet and his immediate family. Rouen today has a magnificent Musée des Beaux-Arts with many Impressionist paintings, including ten by Claude Monet, mostly the gifts of his family.

The river bends from the north-west to the north-east as it passes the modern lock at Rolleboise, and the hills begin to rise on the right bank by the village of Saint Martin-la-Garenne, where their height reaches 150 metres, to descend again where runs the stream of the Vallée du Roi. The houses of the village of Vétheuil are on both sides of this valley. Towering above them on the north side, on its own hill, is the great *église*, Notre Dame de Vétheuil, which dates back to the tenth century. The main construction is twelfth century but the final form and finish was in the sixteenth century. It was badly damaged by a shell which burst inside the church during the Liberation of 1944, when sadly the stained glass of the Renaissance was destroyed.

Camille Monet, Alice Hoschedé and the older children worshipped in the church, which Claude Monet was to include in no less than sixty of his paintings, now dispersed all over the world.

At Alice's request, Michel was baptised there on 18th November 1881. It is certain too that Monet visited the interior on the sad day of Camille's funeral. The cemetery where she is buried is about a hundred metres to the left, along the steep road which leads to the hills above 'Les Tourelles'. This burial ground is below but beside the land of Mme. Elliott's house. Camille's tomb is in the corner, which overlooks the Seine, with the view to the village of Saint Martin-la-Garenne and to Mantes beyond.

There was, in all probability, an early church on this site in the tenth century when Gui de la Roche gave the land to the Abbaye de Fécamp. Fécamp is on the Normandy coast about forty miles to the north-west of Rouen. The four giant pillars of today's church tower were in place soon after the twelfth century, but the present clock tower was not finished until the Renaissance. However the clock, still to be seen, dates in part from the thirteenth century and is extremely rare.

The church itself is enormous for a small village, and its construction must have put a great strain on the resources of the Renaissance villagers. In Monet's two paintings of 'L'Église de Vétheuil',

**W474 L'Eglise de Vétheuil  –  The Church at Vétheuil (detail)**
65cm x 55cm. 1878.   (The National Gallery of Scotland, Edinburgh)

we are looking up the approach road at the west elevation, a Renaissance façade surrounding two great decorated oak doors, each with six panels. The main entrance door is on the south side, facing the centre of the village. If you are coming from the Mairie, you have to climb a giant staircase of fifty steps before you reach that door.

The nave is over forty metres in length, high-vaulted with ten pillars supporting a very elegant roof eighteen metres above. There are five separate chapels on the north side, and four chapels and the entrance lobby to the south. There is space for seating six hundred people in the nave itself, thus it can easily accommodate everyone in the village in relative comfort. Surprisingly, all the roofs are tiled with small brick tiles. The whole of the inside is of stone, including the inner roof and perpendicular vaulting, simple and very beautiful.

The choir is magnificent, with Romanesque pillars and arches. Outside it is held together with twelve elaborate buttresses reaching out into the surrounding road. This narrow road, which goes round the north and east sides of the church, gives access to many small houses and two shops which front on to it.

The roof of the nave has galleries at three different levels, surrounding it, and is complicated to draw accurately from any angle. The giant tower which dominates the scene is equally complicated with its openwork. It has two tall arched openings on each of its four sides. These contain slanting slate-tiled baffles which hide the bells. The roof of the bell/clock tower is slate-tiled too, longer than it is wide, allowing two crosses on the apex of the ridge. The roof of the choir is higher than that of the nave, whilst the north-south roofs are lower than both. These are all red tiled.

Within the church itself is an excellently descriptive booklet in French, prepared with assistance from the Foundation Wildenstein. Suffice to say that there are very many treasures within this wonderful building and any visitor will be amply rewarded for time spent there.

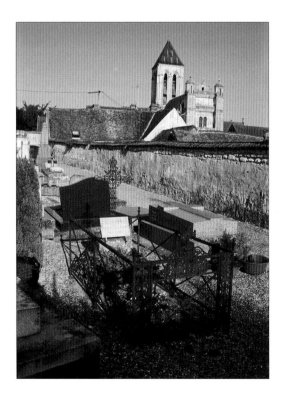

Camille's grave, photographed in 2002.

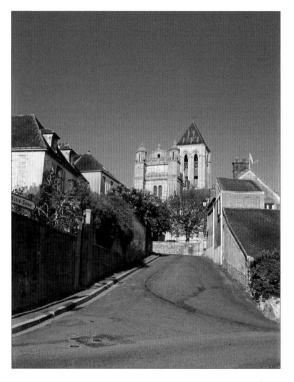

The road leading up to the west end of the church.

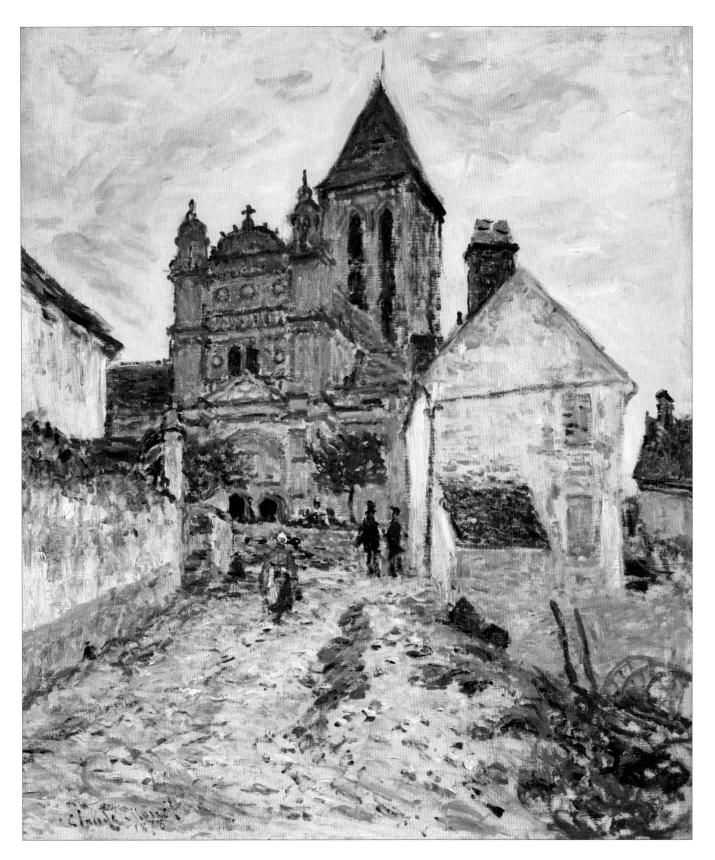

**W474 L'Eglise de Vétheuil – The Church at Vétheuil**
65cm x 55cm. 1878.   (The National Gallery of Scotland, Edinburgh)

Notre Dame de Vétheuil, the west entrance, which is within 100 metres of Monet's house. See detail, page 42.

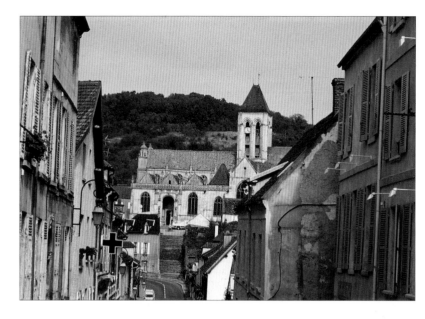

View from the south of the steps up to the church, from the Mairie, in 2002.

The gazebo in 2002, in the garden of Mme Violette Street. The present owner says it was a pigeon house (*pigeonnier*).

The church, Notre Dame de Vétheuil, has, amongst its many statues, an exquisite example from the fourteenth century, of Notre Dame de Grace de Vétheuil which is in the chapel beside the choir on the south side.

Because the tower is 'open plan' it has always been home to a large colony of jackdaws (*Corvus Monedula*, Linnaeus). They have been living in the tower since the twelfth century, and can be seen sunning themselves on the roof and giving aerobatic displays at all times. They can also been seen in some of Monet's paintings and any photograph of that church is bound to include them. The Cathedral of Reims — Saint Remi à Reims — is also an 'Église Romane'. The poem *The Jackdaw of Reims* (*Ingoldsby Legends* by Reverend R.H. Barham, 1788-1845) is clearly pertinent here.

There is a substantial square courtyard belonging to the church at the west entrance, a meeting ground. It can be seen in two Monet paintings, W474 (page 45) and W475. The three lime trees in the paintings are still there today, but substantially larger.

Monet made two more paintings of the church dominating the scene, W505 (opposite) and W506. Most of the houses, and there are some fine ones on the river side of the church, have large but narrow gardens with steps down to a level of about five metres above the Seine. All these gardens have orchards nearest to the river and one, the garden of Mme. Street, has a small round-tiled summerhouse or gazebo. It is there in Monet's painting, W505, in the snow and can still be seen today (above). The second of these pictures is from a point further to the east, probably about five gardens to the right. In both paintings it looks unpleasantly cold. These pictures are now to be found in the Louvre. Monet painted at least ten snow scenes during that winter (1878/79). No-one should doubt his hardiness — he would paint in all weathers but we are told that he had small hot-water bottles in his pockets so that he could keep his hands warm.

These then were the only close-up views of Notre Dame de Vétheuil, but there are at least another forty views painted in this period in which the great church figures. Much later, in 1901, he travelled by car from Giverny and painted a further fifteen, making fifty-five! These last can be considered as a series,

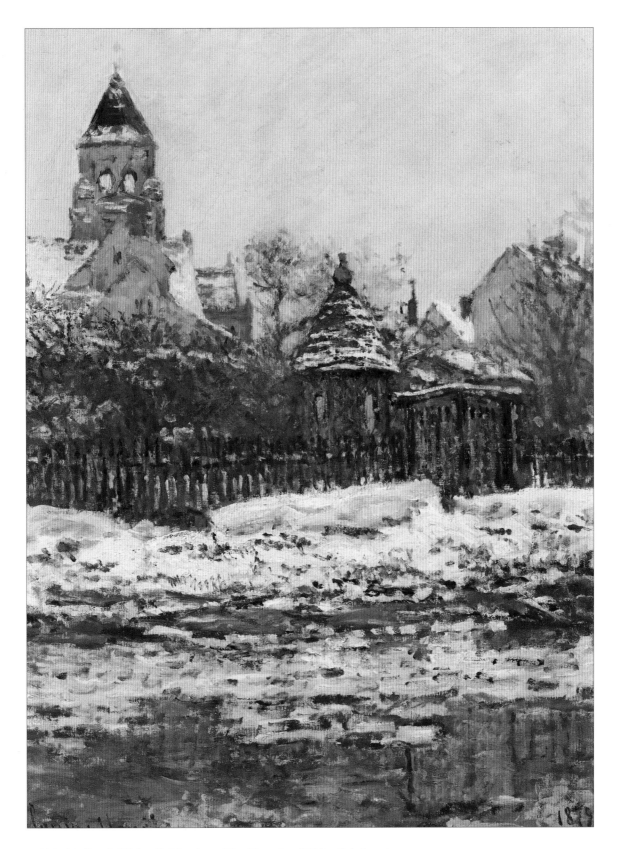

**W505 L'Eglise de Vétheuil (hiver) – The Church at Vétheuil (winter)**
65cm x 50cm. 1879.    (Musée d'Orsay, Paris) Photo RMN – H. Lewandowski

Monet painted this winter scene either from his landing stage or, more likely, from the *bateau atelier* moored in the river. There is a gazebo close to the river bank which is shown opposite.

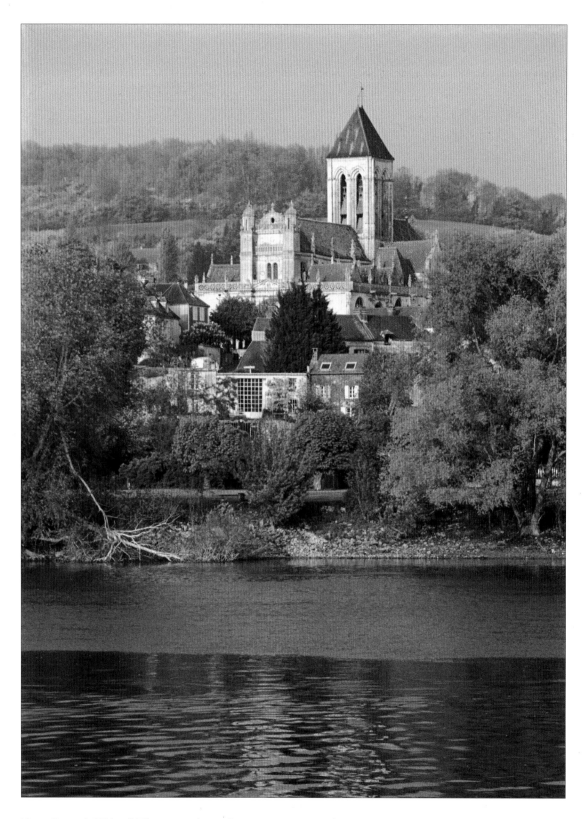

Notre Dame de Vétheuil. The west end seen from Lavacourt across the Seine.

**Opposite: W533 Vétheuil**
60cm x 81cm. 1879.    (National Gallery of Victoria, Melbourne, Australia) Felton Bequest, 1937

Vétheuil seen from Lavacourt in the early afternoon. It is nearly calm and reflections begin to stretch right across the Seine on this fine summer's day.

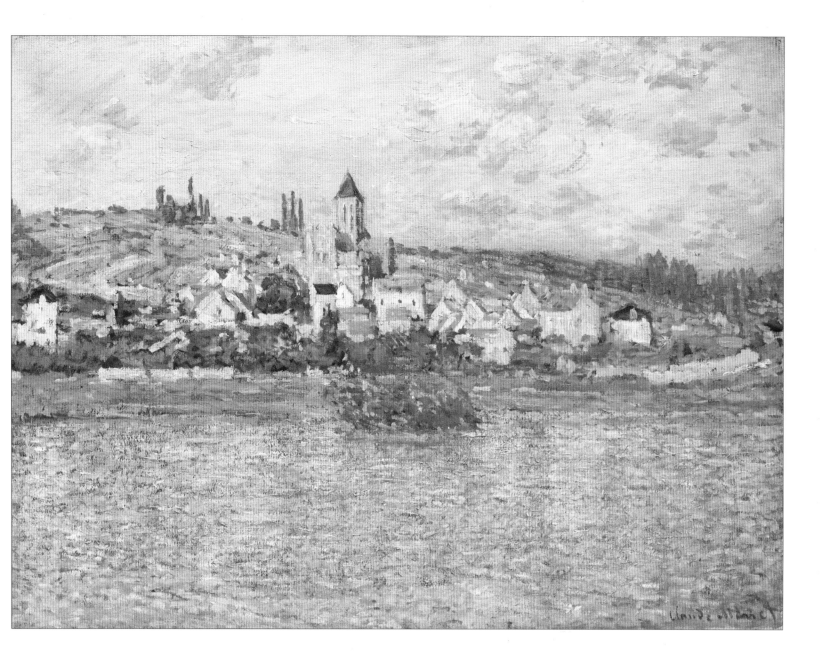

each scene slightly different to the next, but there is no doubt of the remarkable domination of the scene by the church. Today the view is more or less the same, a painter's paradise. There are some newer houses which do not obtrude, in fact it is hard to see them against the backdrop of the ancient village.

A fine chestnut walk between typically French pollarded trees now runs along the bottom of the gardens, making a very attractive backdrop to this area of land. These chestnut trees are to the left of the central pathway from the river to the church, whilst to the right the walk is between pollarded lime trees. In the autumn, when the leaves turn colour, the chestnut walk in particular glows red with autumn tints.

One other change, which is not so apparent, is in the number and size of the trees today. No longer are houses dependent on open fires, most have some form of central heating; in Vétheuil from gas or oil. In consequence trees are not cut down for fires, and only substantial trees are cut for timber and building. Further, fewer animals are grazed – a flock of goats would have kept down all those young shoots. Thus there are many more trees everywhere and the countryside looks much greener than it was a hundred years ago. This is also apparent in the scenes that Monet painted in the Creuze Valley, relatively barren in his day, but today woodlands cover so much of

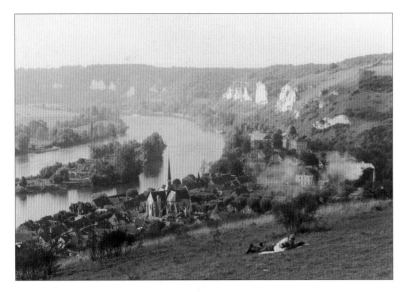

Les Andelys and the Seine from château Gaillard, built by King Richard the Lionheart, 1196.

Early morning mist, Rouen, up river from the city.

the rocky landscape that I fear his views there are lost in consequence.

The poplars are no longer stripped of their lower branches by animals as they grow, but many of the trees harbour great clusters of mistletoe, a parasitic plant, which spoil the purity of their shape. Nor are the large poplars which Monet painted on the River Epte to be seen, these are now cut down for industrial purposes, long before they reach such giant sizes.

The church is very near to Monet's second house, where the white chalk cliffs start again. They run all the way past La Roche-Guyon, and on, round to the south-west, and the village of Tripleval. Their height there varies from 150 metres below the aerodrome, which lies between Vétheuil and La Roche-Guyon and a hundred metres from then on. The cliffs become hills once more and drop down to Giverny which is only thirteen kilometres from Vétheuil. Giverny, unknown to Monet at this time, was to become his permanent home less than five years later, in April 1883. Thus it is fair to say that Monet spent over half his life in that very local area, never far from the river Seine.

Fishing is the most popular sport on the river, mainly done from small landing stages, usually at the bottom of gardens, or some point of the river accessible from a road or track. Fishermen abound at all times of the day and the riverbanks are quite crowded on Bank and national holidays. These are freshwater fish – bream, carp, chub, eels, gudgeon, pike, roach and tench. Punts, flat-bottomed square-ended boats, invariably painted dark green, are often used; their design is quite unchanging. A fine painting, W749 (page 142), one of the four painted by Monet at Poissy, shows two boats, each with a fisherman. W748 shows five boats with six fishermen, and another on the riverbank (Sotheby 26th June 1990).

On sunny days, as the sun rises higher and the land gets warmer the morning mists are dispelled, and the breeze created is funnelled up by the white cliffs forming a circular wind system, often rising to ten thousand feet. This system can bring all sorts of summer cloud formations unique to this area of Normandy, which may or may not vanish by sunset. Thus the skies are constantly changing and fine sunsets and effects are created. They differ by the hour. Meanwhile there is little road traffic to break the countryside sounds and birdsong. The cliffs also act as an amphitheatre, harbouring and magnifying sound and creating echoes, which can be delightful. Today the sounds of distant passing barges serve as a reminder that the Seine is busy, carrying great cargoes from the

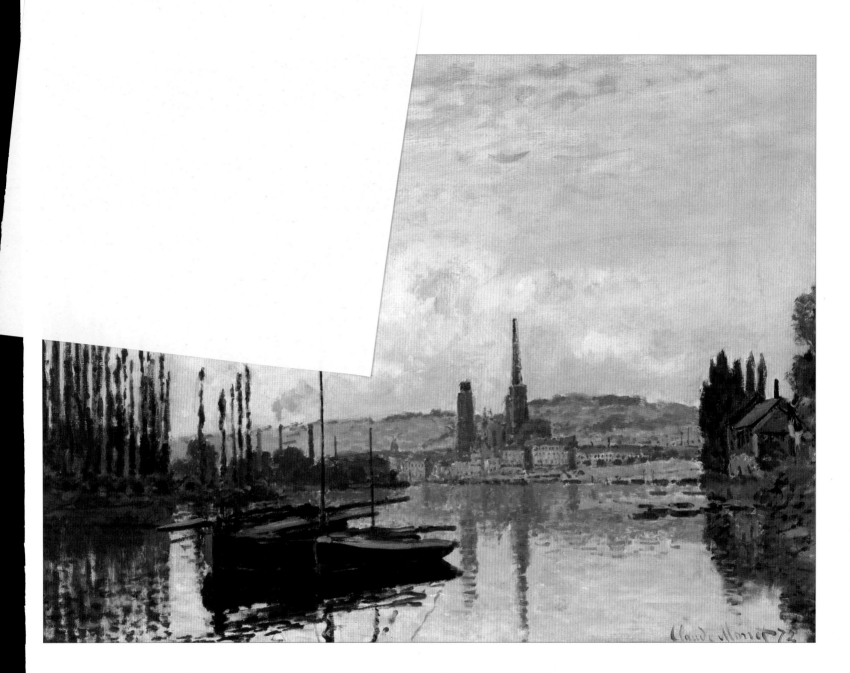

**W217 Vue de Rouen – View of Rouen**
54cm x 73cm. 1872.
(Photograph courtesy of Sotheby's Inc. © 2002))

Sketch of Rouen.
Monet made this sketch a year after he had made the oil painting above. The sketch was for an important review by Alfred de Lostalot of Monet's first one man exhibition at Durand-Ruel's gallery in 1883 published in *Gazette des Beaux-Arts* Vol. 1 p.342-348. Twenty years later Monet made his great Rouen Cathedral series of 30 paintings. Rouen is the capital city of Normandy.

sea to Paris and beyond. The locks, of course, are almost completely silent, unless you are within one in a boat, when it can be noisy and quite hectic caught in the wash of a barge, or too near the inlet sluice. The smell is of watery life, a clean, clear smell of water, the life-blood of the land.

The surrounding lands in the valley are extremely fertile – the trees grow quickly, and are very large, as can be seen in Monet's poplar series. Those French poplars must be eighty or ninety feet tall. The crops, which are grown behind the river, are wheat, barley, oats and a great deal of maize or sweetcorn, as well as large fields of rape seed, which would not have been grown in Monet's day. All manner of fruit trees are cultivated: apples, pears, plums, cherries, and many types of vegetables, particularly artichokes and asparagus. Cattle a-plenty, and farmyard fowl, including a lot of guinea fowl and quail. And flowers for the table, whilst wild flowers abound in all the meadows, including buttercups and a proliferation of poppies.

The market towns of Mantes and Vernon have twice-weekly markets, and Vétheuil has, within its village square, a flower and vegetable market right outside the Mairie. There the French tricolour is always in evidence. It is not taken down at night. Around the small square are the Poste, Tabac, Boulangerie, Charcuterie, several small restaurants, a small supermarket and two antique shops.

Every French house seems to have a dog that barks, usually savage enough to bite you, and very often chained up in the master's absence, whilst the old ladies walk their well-pampered poodles, large and small, beside the river. At Monet's house in Vétheuil there was no dog, but within the garden there was a *lapinière* (a rabbit house) and a *poulailler* (chicken shed), both to produce food for the kitchen as required.

The house itself is semi-detached; it is the end house of a row of three. On the ground floor it had a salon and dining room, with a kitchen extension behind the house. The first floor had three rooms, of which two had fireplaces, and a *lieu à l'anglaise* – presumably a bathroom and lavatory – a comfort rarely found in towns at this time. There was a second stairway to the attic above, which was very large and had three skylights in the roof. It appears that the owner, the late Mr. Elliott, had brought English ideas with him. It would have been quite a large house by the village standard, with a frontage of twelve metres and ten metres deep. To the rear, cut into the cliffs, is a cave four metres wide and eight metres deep. This made a large, cool storage area and probably had another toilet room. It is possible that there were sleeping quarters there, but only for use in the summer, because it was damp.

The view to the Mairie from the church. A gardener is hoeing up the weeds by the memorial.     (Collection: Toulgouat)

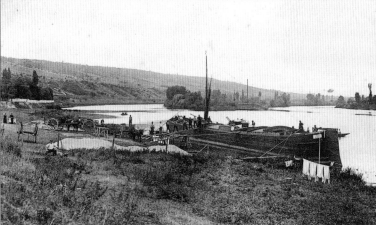

The crew of twelve men unload the cargo of sand and ballast from a barge at Vétheuil.     (Collection: Toulgouat)

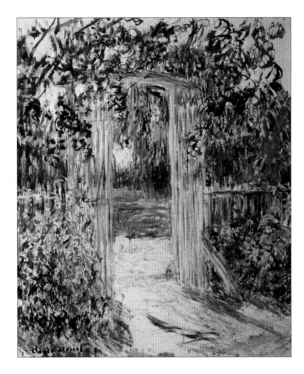

**W691 La Porte du jardin – Garden Gate**
73cm x 60cm. 1881. (Private collection)

**W680 Alice Hoschedé au jardin –
Alice Hoschedé in the Garden**
81cm x 65cm. 1881.

(Photograph courtesy of Sotheby's Inc. © 2002)

To the right of the house, which is set close against the chalk cliffs, is a long garden about fifteen metres deep and running along the road for about thirty-five metres. It is entered by large wrought-iron gates, which today are always closed. Within this part of the garden is another large storage area with two outbuildings.

Immediately across the road was the main garden, enclosed on three sides by a substantial wall, and this led almost to the river. As can be seen in W685, 'Le Jardin de Monet à Vétheuil', of which there are four versions, there are two distinct flights of steps, the upper one of twelve stone steps and the lower with fourteen. On either side are handrails. In this painting Michel Monet is at the foot of the steps, Jean-Pierre Hoschedé halfway down and, a little above him, one of the girls is descending, perhaps twelve year-old Germaine. Michel has his toy wheelbarrow and Monet's blue delft vases line the lower walk. Sunflowers abound. The three skylights in the house are open and it is a fine summer morning, as shown by the shadows. Today the left-hand skylight has been replaced by a dormer window, and a house has been built to the left of the steps. Now the garden belongs to that new house on the left, below the tarmac road.

The far end of the garden can be seen in W691 (above) with its paling fence, gate and arch leading to the river and to the *bateau atelier*. In W680 (above), Alice Hoschedé is reading at a table in the lower garden under the apple trees, enjoying the quiet seclusion and the shade.

Monet was a keen gardener, but of course this had not been possible in Paris. In Argenteuil, he had been the gardener; Renoir's painting of him gardening there records this. By the time he came to Vétheuil his gardening ideas were well established. So far as we know, and dread the thought, he never undertook the cooking, but he did grow vegetables for the table, and flowers for decoration and for his painting.

The garden at Vétheuil shows his interest in both flowers and, more importantly, vegetables, for he had a large family to support. There was no question of buying produce ready-packed from supermarkets: you grew your own vegetables in those days whether you were in England, America

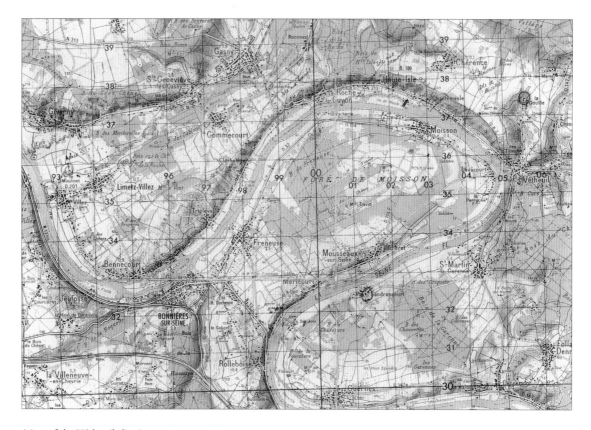

Map of the Vétheuil district.    (Courtesy: Military Survey)

or France. For those living in Paris only second best was available; produce that had travelled through the dusty countryside to a Parisian market, perhaps in hot weather, losing its first freshness.

Sanitation and sanitary systems were very slowly developed in Paris and in the countryside. Here in Vétheuil, Monet's house was fitted with the latest English system as early as 1875. It is small wonder that disease was accordingly reduced. Today all modern housing in Vétheuil is well equipped, but there are still old-fashioned systems to be found in older houses and restaurants. Luckily Monet, who had great respect for the English systems, copied them in his subsequent home at Giverny. About Poissy we do not know, but the children suffered a great deal of illness there. French sanitation was appalling until well after the Second World War.

Alice must have been an extraordinarily good mother and foster mother, for quite apart from constantly nursing Camille, she was looking after eight children, of whom five were ten years old or younger and two of these were babies.

In no way could Monet have coped with Camille's illness on his own, so it was fortunate that Alice was there to take over the two Monet boys and help Camille in her desperate, long, and fatal illness. Monet, too, was extremely attentive to Camille, but he had to work hard in the countryside on his painting, as a priority, in order to make money.

Alice, we know from her diaries, was a deeply religious person. So also was Camille. They were Catholics of course. What Monet believed at this time is not known, but certainly at his death he would have been described as an agnostic. Nevertheless, his first painting at Vétheuil was of the church, W474 (page 45), and the road leading to it, which was a stone's throw from his front door. In fact he painted two similar versions of the church – the other, W473, is in the United States. W474 is a vertical painting showing the church from a better angle, with most of the great bell tower visible, whilst W473 is a horizontal one and consequently larger.

54

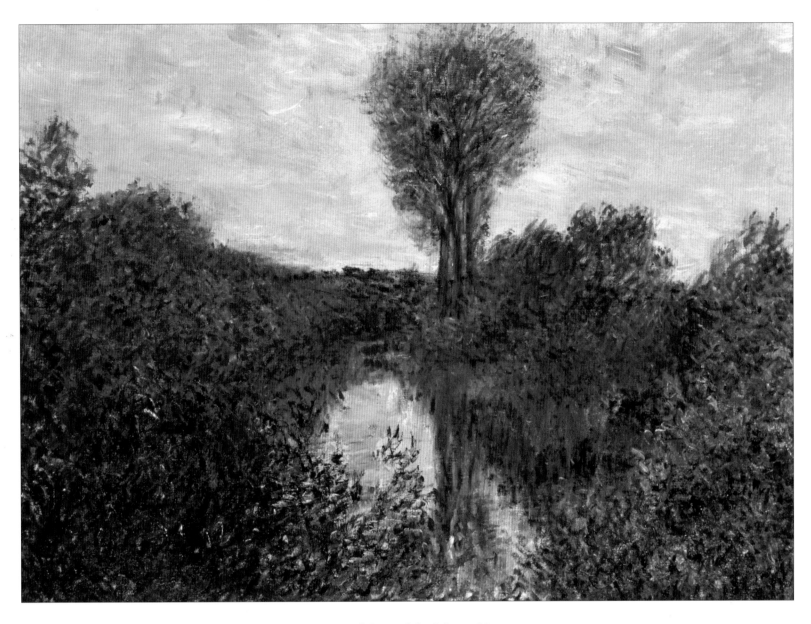

**W479 Le Petit Bras de Mousseaux – Small Arm of the Seine at Mousseaux**
60cm x 81cm. 1878.    (Christie's Images Ltd.)

It is unlikely that these paintings were done together. W473 must have been later, for the house on the right of the street has shutters on the window, and a terrace, which are not in the Edinburgh painting. So it is suggested that they must have been painted at least six months apart, the minimum time taken to make the changes, and that W474 came first. It also includes an overturned pony cart. Today the church remains almost exactly the same, triumphing above the village, though there is now a good tarmac road up to and around to the left of the church, with new houses and walls added on either side. Little has changed in 120 years! And that is wonderful, for who wants to change the country villages or the enchantment of rural France.

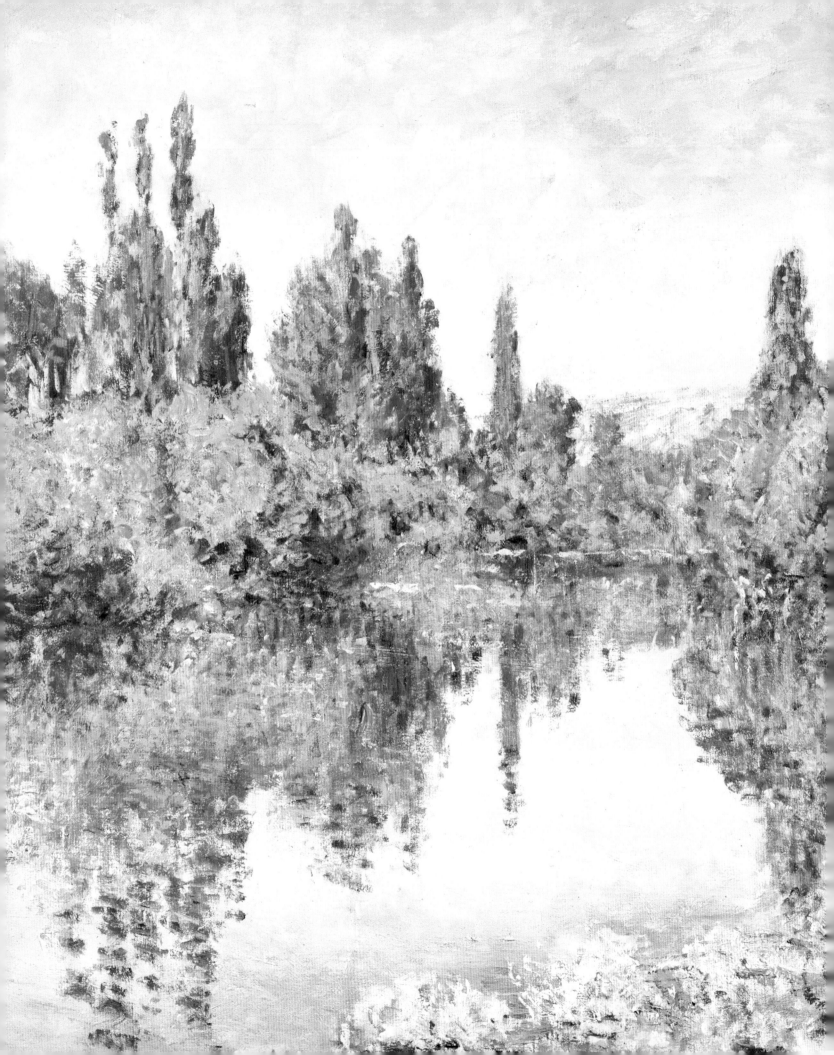

CHAPTER 5

# THE VILLAGE OF LAVACOURT AND PAINTINGS OF 1878

The Seine is very wide at Vétheuil, three hundred metres across. Opposite is the village of Lavacourt, which is on the inner north apex of the river and on a flat landscape that runs back to the hills behind Mantes and Vernon. In that great bulge are many gravel areas which have been worked out and made into a huge lake. This is now a holiday and camping area surrounded by farms.

Lavacourt itself is a ribbon of old houses along the riverbank, which has a *chemin de halage* – a towpath for pulling barges, between the houses and the river. This is now a road in front of the old houses. On either side, hidden in their gardens, are more modern houses which do not intrude.

Lavacourt looks very attractive from Vétheuil and of course Vétheuil looks quite magnificent from Lavacourt. In Monet's day there was a regular ferry service of rowing boats, but he also had his *bateau atelier* moored at the bottom of his garden, which gave the painter and the two families complete independence, in his case for painting, and for the families, for picnics on both the far shore and on the many islands.

Monet's first two paintings of Lavacourt were made from one of the small islands slightly downstream from Vétheuil, both from the same position: the first on a fine, sunny, clear day and the other with an early morning mist. They are landscape shape and apart from showing many of the houses of this village they also show the church tower of Saint Martin-la-Garenne, past which ran Père Papavoine's coach twice daily to Mantes in fair weather.

Today there is no ferry across the river at this point. It is necessary to drive either sixteen kilometres west to Bennecourt, or twenty-four kilometres to Mantes in the east in order to cross by their bridges. One day perhaps the bridge will be rebuilt at La Roche-Guyon and that will halve the journey.

Later in the autumn, Monet was to paint a further five pictures from similar positions, including one showing a steam paddle tug towing a line of barges towards Mantes. This painting, W501 (page 38), is long and narrow, much the shape of his Dutch pictures of 1871, very loosely worked and it includes the rowing ferry boat and others on the Lavacourt shore. It is undated, but signed Claude Monet.

Along with these views Monet also started to work ashore at Lavacourt, making seven paintings of houses in the village showing the foreshore, and then, when the snow fell, he made a further five, of which W511 is in The National Gallery, London (page 62).

Using the dating and sequence in Wildenstein's *Catalogue Raisonné*, we can see that in addition to the foregoing, the painter made sixteen paintings of the Seine or of the *bras de la Seine*, W479 to W487. They are of the waterways between the islands and the shore. There were several

**W481a Le Matin dans les îles, environs de Vétheuil  –  Morning on the Islets, near Vétheuil (detail)**
54cm x 65cm. 1878.   (Photograph courtesy of Sotheby's Inc. © 2002)

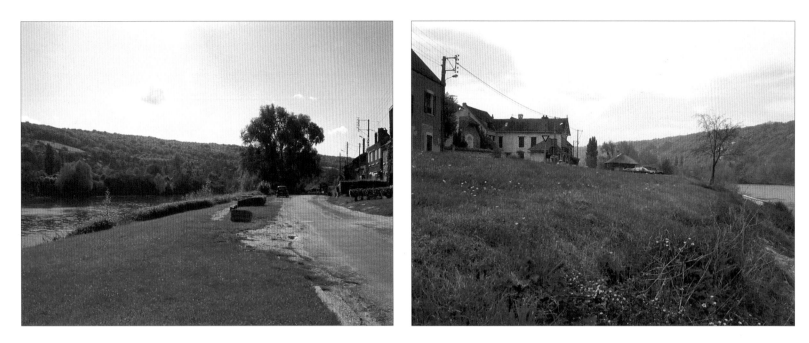

The riverbank at Lavacourt today showing the *chemin de halage* – now a road.

Lavacourt houses on the riverbank in 2002.

**W490 Pommiers, Vétheuil – Apple Trees, Vétheuil**
55cm x 66cm. 1878.  (Private collection)

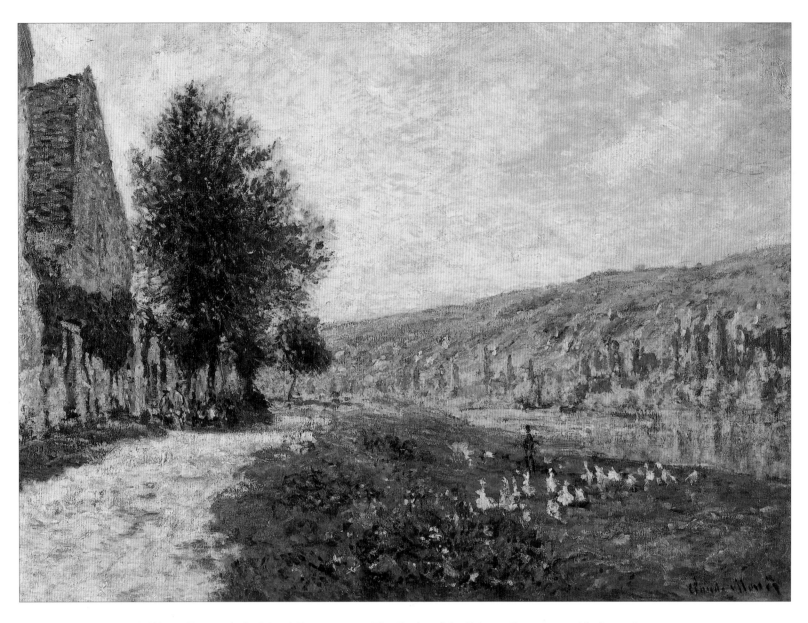

**W498 Les Berges de la Seine à Lavacourt** − **The Banks of the Seine at Lavacourt, with domestic geese**
60cm x 80cm. 1878.   (Christie's 21 June 93)

advantages to painting out of the main river flow. First of all it was quieter and calmer, with less current and wind, and secondly it was shallow and much easier to anchor or tie up to a tree or on the shore. All these paintings were made downstream of Monet's house, where there was less current and it was much easier to row home in calm water.

From the land he made four fine studies of apple orchards, W488 to W491 (pages 58, 64). These were within two kilometres of his house, usually on the slopes of a hill; with the apple trees reaching upwards to the hills behind.

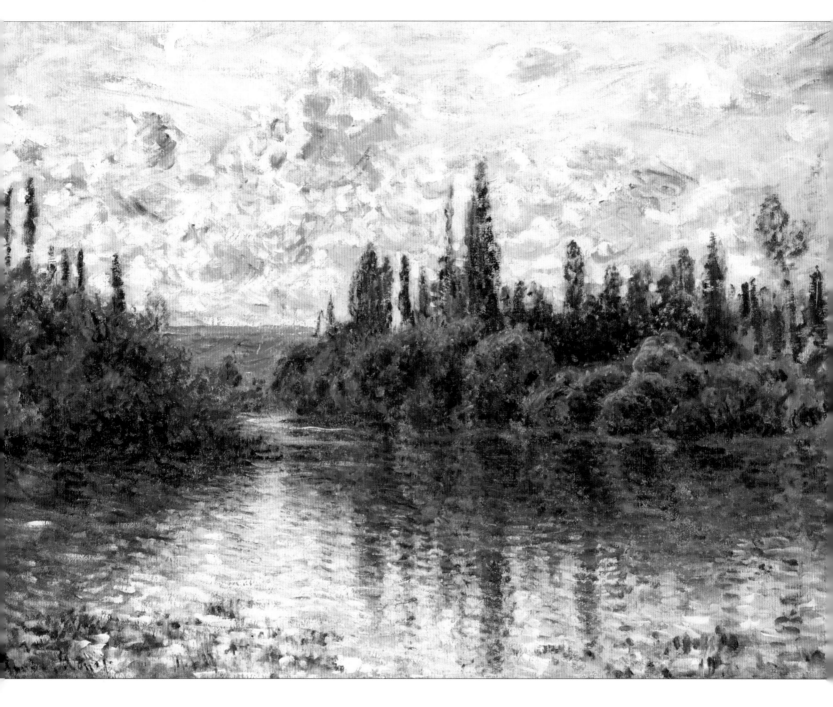

**W482 Bras de la Seine près de Vétheuil –
Arm of the Seine near Vétheuil**
60cm x 80cm. 1878.   (Sotheby's)

A backwater behind the Seine and between les îles de Moisson and the shore, where it was usually calm and with less current. It is also very quiet.

Bras de la Seine below Monet's house in 2002.

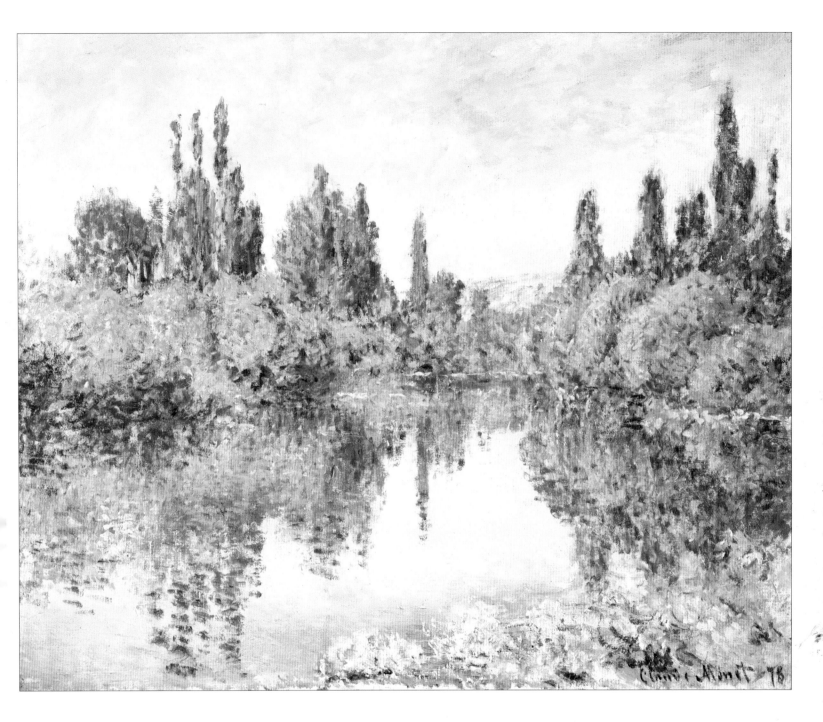

**W481a Le Matin dans les îles, environs de Vétheuil – Morning on the Islets, near Vétheuil**
54cm x 65cm. 1878.   (Photograph courtesy of Sotheby's, Inc. © 2002)

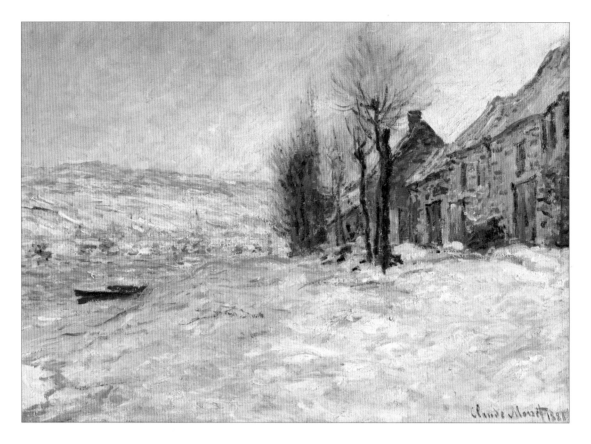

**W511 Lavacourt, soleil et neige – Lavacourt, Sun and Snow**
59.5cm x 81cm. 1881.    (National Gallery, London. Gift of Sir Hugh Lane in 1917)

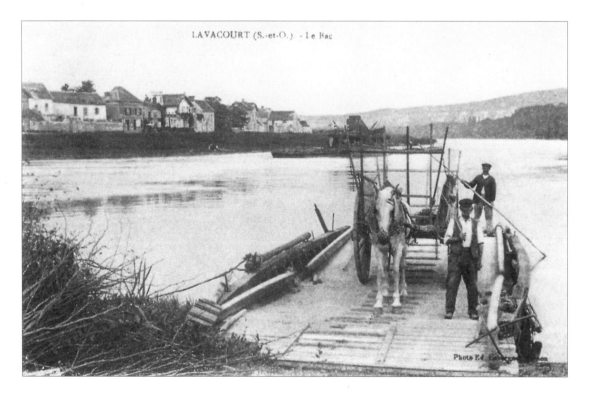

This is the farmer's flat-bottomed ferry taking him across the short stretch of water between Vétheuil and his farm on Île de Saint-Martin la Garenne.    (Collection: Toulgouat)

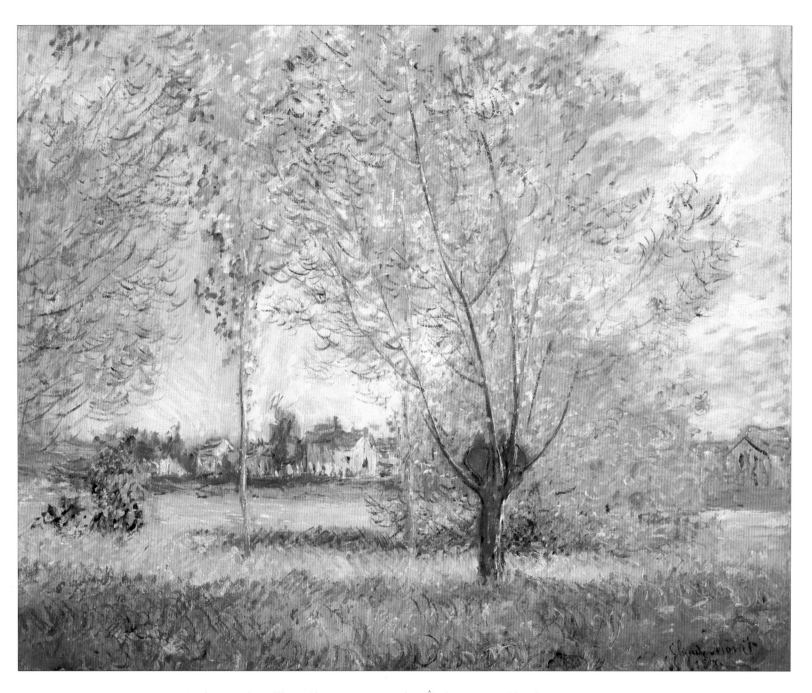

**W611 Les Saules – The Willows** (showing Lavacourt from Île de Moisson, Vétheuil)
66cm x 81.5cm. 1880.   (In the Collection of the Corcoran Gallery of Art, Edward C. and Mary Walker Collection)

As 1878 drew to a close, he painted the two youngest children, Jean-Pierre Hoschedé, W503, and Michel Monet, who was still a baby, W504 (page 65). These paintings remained in the family until Michel's death in 1966, when the former went to the United States, and the latter to the Musée Marmottan.

The Marmottan has a superb collection of Monet's works, given by Michel in his legacy of 1966. No other museum can equal this collection, many of them intimate works, which Claude Monet had kept for himself. Michel's legacy to the Marmottan was joined up with the legacy of Madame Donop

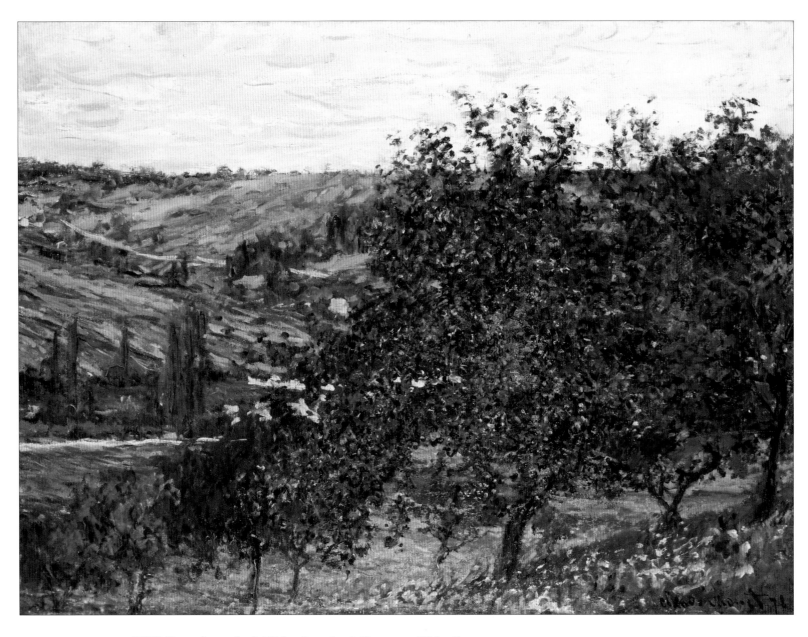

**W488 Pommiers près de Vétheuil  –  Apple Trees near Vétheuil**
62cm x 82.5cm. 1878.    (Christie's Images Ltd.)

Painted in the valley of Vienne-en-Arthies. The hamlet of Millonnets can be seen through the foliage. It is about 1½km east of Vétheuil.

de Monchy, daughter of Dr Georges de Bellio, one of Monet's earliest collectors who bought no less than thirty-eight of his paintings. He was also one of his medical advisers over a long period.

In 1878 Monet also made four paintings showing the road to Vétheuil as it passed his house, which was below his landlady's mansion, 'Les Tourelles' or 'Chalet du Belvedere' as it was sometimes called. The house had twin towers joined together in those days which appear much taller than the single tower of today. The first of these paintings is made at a distance of about 250 metres, on a sunny day. It shows two distant figures in the road before Monet's house (page 67).

The next three paintings, W508 to W510, were done in the winter of 1878/79, in the snow, and the painter is much closer to his subject in two of them. The last one shows seven figures in the street but in none is there any traffic.

Monet's final work of 1878 is a large painting of Vétheuil itself, from the shore of Lavacourt, W507 (page 67), now in the Frick Collection in New York. It shows ice floes in the Seine. The church as usual dominates the snow-clad scene, whilst on the river the four-oared ferry could have six or even eight passengers. Another smaller boat to the right has a complement of four, while there are people on the Vétheuil shore. It looks very cold!

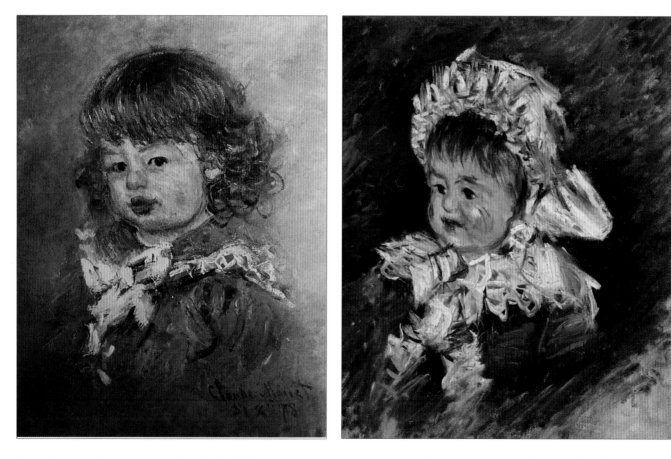

**W503 Portrait de Jean-Pierre Hoschedé, dit 'Bébé Jean' –
Jean-Pierre Hoschedé, also called Bébé Jean**
41cm x 33cm. 1878.

The sixth and last child of Ernest and Alice Hoschedé.

**W504 Portrait de Michel Monet bébé  –  Michel Monet as a
Baby**
46cm x 37cm.    (Musée Marmottan, Paris/Bridgeman Art Library)

The second son of Claude and Camille Monet.

Above: **W510 La Route à Vétheuil, l'hiver — The Road in Vétheuil, Winter**
52.5cm x 71.5cm. 1879.    (Göteborg Konstmuseum, Gothenburg, Sweden)

Left. The west end of the church in the snow, 2002.    (Photo: Anne Owen)

Opposite above: **W509 Entrée du village de Vétheuil, l'hiver —
Entering the Village of Vétheuil in Winter**
60cm x 81cm. 1879.    (Museum of Fine Arts, Boston) Gift of Julia C. Prendergast in memory of her
brother, James Maurice Prendergast, 21.7

The same scene as in W581 (page 7) and W502 (page 39), but in the depth of winter,
with two figures in the road and two more beyond Monet's house.

Opposite below, and detail: **W507 Vétheuil l'hiver — Vétheuil in Winter**
69cm x 90cm. 1879.    (Copyright the Frick Collection, New York)

The river is partly frozen but the ferry boats are still working across to Lavacourt,
where Monet has his easel.

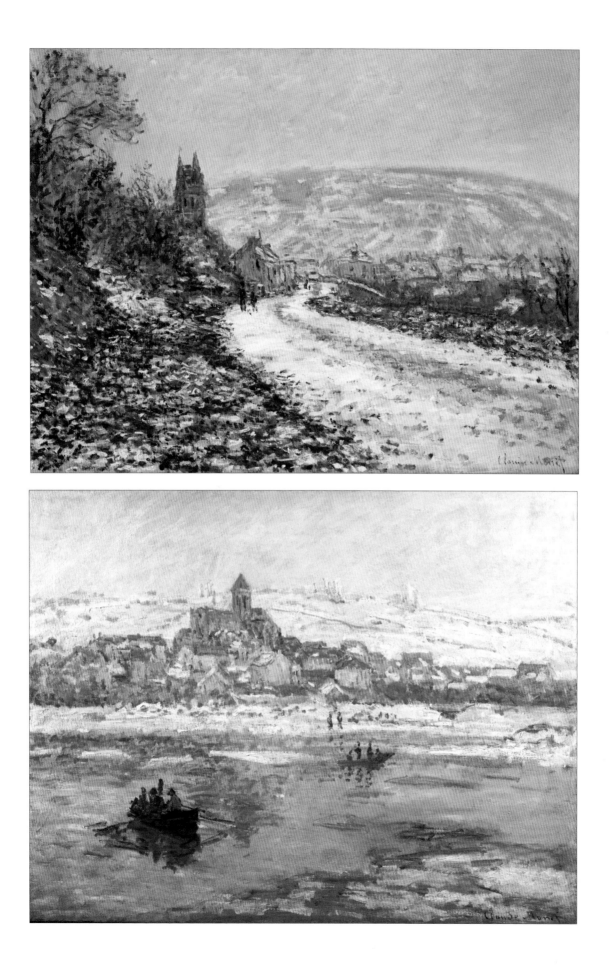

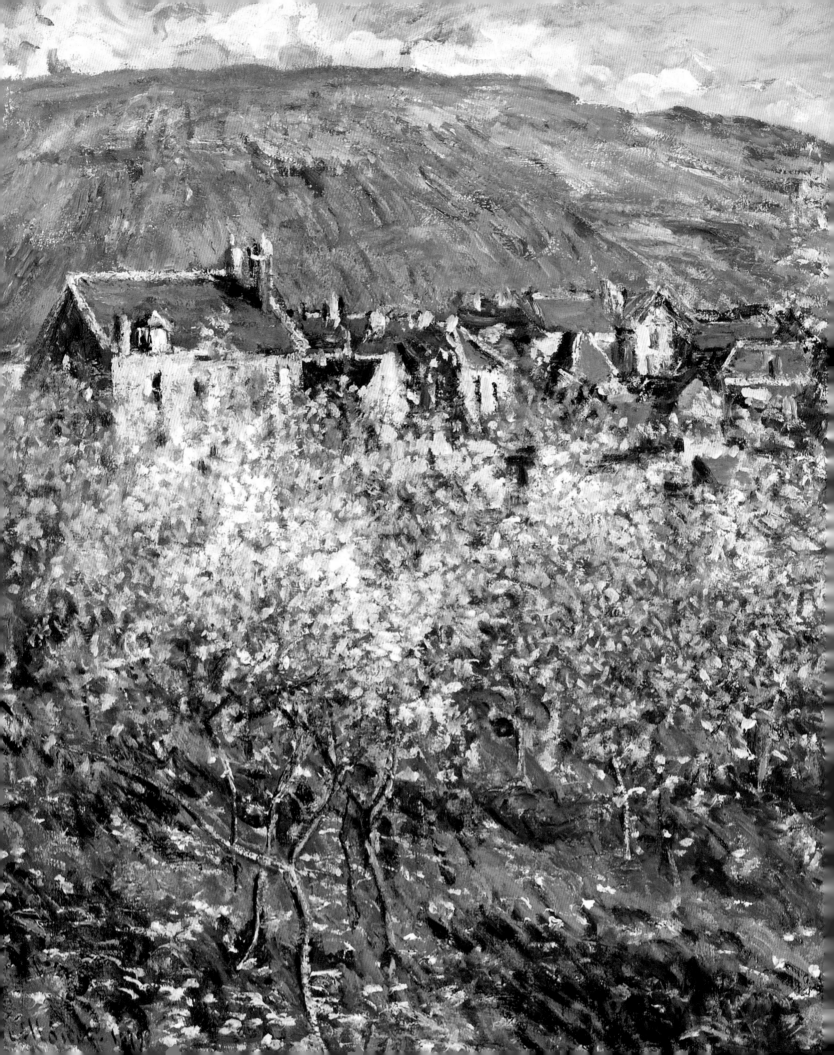

# THE PAINTINGS OF 1879

The winter of 1878/79 had been cold, and financially disastrous for both Hoschedé and Monet. Jean Monet was now nearing twelve, but Michel was only one year old on 17th March. Camille showed no signs of recovery and was in fact terminally ill, getting weaker daily. That Alice, alone, was able to maintain the families is remarkable, for her own baby, Jean-Pierre, was only eighteen months old. They were poor, at times without money, and without serious medical attention. The eldest Hoschedé girls, Marthe, now fifteen, and Blanche, thirteen, must have been of enormous help to the combined families. Ernest Hoschedé had a minor job in Paris and a small allowance from his mother. Monet fought a great battle to keep the situation solvent. He wrote copious letters, many of which survive, imploring people to buy his pictures, even to naming their own prices: he begged and borrowed money from every collector, every artist friend he knew. Dr de Bellio, the rich Romanian doctor and homoeopath, did his best, visiting and giving advice. He bought paintings regularly, which must have been of great assistance, but did not pay much for them.

In spite of Camille's illness and lack of funds, Monet never gave up hope, but he did get very close to giving up as a painter. When spring arrived he began painting around Vétheuil, never very far from home. He painted a series of fruit trees in blossom, W519 to W524, with either the roofs of Vétheuil or the hills behind them. Three were of plum trees (page 71), two of apple trees and one of two pear trees on the plain. There was also a large painting of Vétheuil in the morning mist, W518 (page 73), seen from Lavacourt. This painting he sold to the leading baritone singer Faure, who found it 'too white for him', so Monet refunded the price, and promptly sold him another. Monet kept that painting, refusing to part with it, and when Michel died in 1966, it was left by him to the Académie des Beaux-Arts in Paris and is now in the Musée Marmottan, Paris, with the rest of his bequest.

Next came a thatched cottage painting which would appear to be on the land below Monet's house, about a thousand metres towards Chantemesle where a large mansion, now a hotel, has been built beside a *bras* of the Seine.

Then came two more paintings from the *bateau atelier* in the *bras de la Seine*, both exquisite Impressionist works of similar subjects. W529 (see Chapter 1, page 25) is of dappled light across the water with poplar trees and hills behind. The other, W530, is of poplar trees with vertical and perfect reflections in a calm scene.

When the Monet and Hoschedé families first shared a home in Vétheuil, Ernest Hoschedé contributed most of the rent, and expenses, but he did have a much bigger family. He often

**W520 (detail) Les pruniers en fleurs à Vétheuil – Plum Trees in Blossom at Vétheuil**
64.3cm x 81cm. 1879.　(Szépmüvészeti Muzeum, Budapest)

attended to what remained of his business affairs in Paris, where he also took a job in a publishing house. Claude Monet was content to paint the views of Vétheuil and its surrounds, but thought that his comparative poverty was causing a drag on the other family. He therefore wrote a very kind and well composed letter to Hoschedé on 14th May 1879:

'I don't know if the weather in Paris is the same as here, though it is quite likely that it is, so you can imagine how dispirited I am. My heart is heavy and I have to share the burden of my disappointments with you. For almost two months now I have been struggling away with no result. You may have some reason to doubt this, perhaps, but it is a fact. I didn't waste an hour and would have reproached myself for taking even one day off to go and see our exhibition, for fear of nothing more than one good working session, an hour's sunshine. No one but myself knows the anxiety I go through and the trouble I give myself to finish paintings which do not satisfy me and seem to please so very few others. I am utterly discouraged and can no longer see or hope for a way ahead. I have just been jolted into this realisation; I have to come to terms with the fact that I cannot hope to earn enough with my paintings to live in Vétheuil. That is the sad fact of the matter. Moreover, I can't imagine that we are very good company for Madame Hoschedé and yourself, with me becoming increasingly bitter and my wife ill most of the time. We must be and we are, I am sure, a hindrance to all your plans, and I regret now that we once again started living in arrears. I am only too aware of the wall that has grown up around me and of the impossibility of coping with our share of expenses if we continue to live together; if we left it any later, we would be unable to extricate ourselves. It is far better that we should face up to things as they are. Personally speaking, we will not be any better off as a result, but at least we will be living the life laid out for us.

I am heartbroken to have to talk to you in this way, please believe me. I am utterly without hope, and see everything at its blackest and worst, and I don't think I am wrong in saying that our departure will be a relief to everyone in the house. I actually believe that it would be doing you a service in a place where, in the eyes of tradesmen and servants, we look like your dependants. That is what bothers me, and as it will become a reality I would ask you to settle our accounts, it is wiser I think, much as I might have believed in an idyll of work and happiness.

You must believe how much it pains me to upset you like this.

Yours Claude Monet'

We have no reply from Ernest Hoschedé to this letter, and despite Monet's offer to move away, both families continued to live together at Vétheuil. Ernest Hoschedé wrote to his mother on 16th May 1879 'the health of Madame Monet preoccupies us most at the moment, for I do not believe that she has more than a few days to live and her agony is slow and very sad.' We believe that the only doctor to help was Dr Tichy at La Roche-Guyon. Whatever was going on at home, Monet continued to produce some astonishing sunlit pictures at this critical time. He was painting to make money to buy medicines and assistance for Camille.

He started with long-distance views of Vétheuil. The first two, W526 (see Introduction, page 15) and W527, were painted at the water's edge, just outside the village by the road to Saint Martin-la-Garenne. Surprisingly, it is almost treeless and most of the village is visible. In the calm water the reflections are eye-catching. As already mentioned, the view today is much restricted by trees

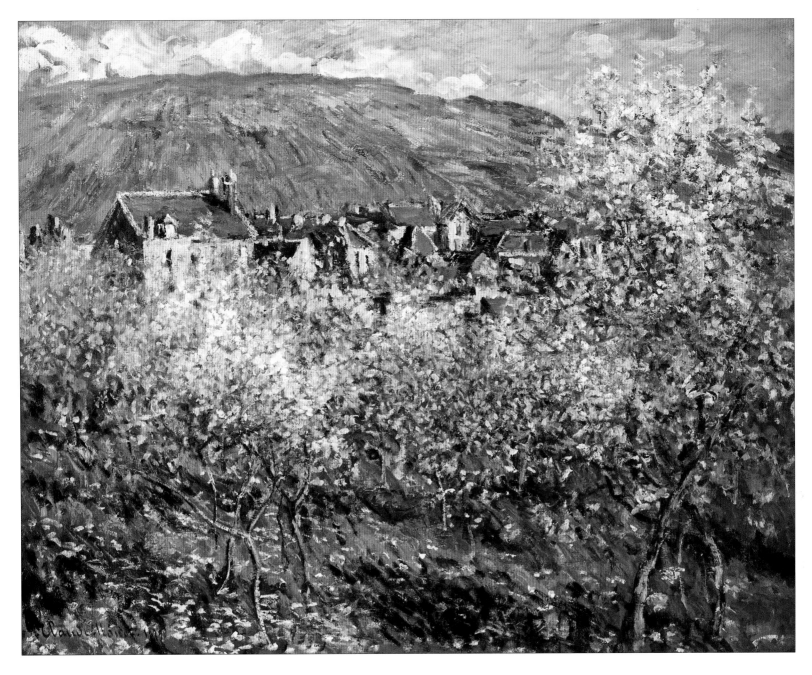

**W520 Les pruniers en fleurs à Vétheuil  –  Plum Trees in Blossom at Vétheuil**

64.3cm x 81cm. 1879.   (Szépmüvészeti Muzeum, Budapest)

Monet painted this quite near to his house, with part of the village behind the plum trees and to the southeast, the hills of Chênay in the background. See detail, page 68.

and undergrowth and the river banks have a considerable drop into the water, whereas in the painting it would be easy to paddle one's feet in the stream.

The four great views of Vétheuil from Lavacourt are spread around the world: in Southampton, England, W531 (see page 35); in the Musée du Louvre, Paris, W532; National Gallery of Victoria, Melbourne, Australia, W533 (see page 49); and The Art Gallery of Toronto, Canada, W534. Two more scenes, of the îles de Moisson, are W535, in the Joslyn Art Museum, Omaha, Nebraska, USA, and W536 (see below), 'Champ de coquelicots près de Vétheuil', was sold to Emil Georg Bührle in 1941, during the most violent period of the Second World War. In the foreground, amongst the poppies, with the Seine between them and the Île de Moisson, are four children, including the two youngest. Two older children look out across the water to Vétheuil. Obviously, this is a family picnic day with at least six of the combined family supporting the artist.

Monet was well aware that his pictures would be despatched around the world and was not too keen when Durand-Ruel took so many away to the United States. He was worried that France would not be able to keep a representative selection of his works. They were seeping away from his Parisian dealers to the United States from 1874 onwards. In 1885 Durand-Ruel held a major exhibition in New York entitled 'The Impressionists in Paris', which upset Monet sufficiently for him to write to the dealer on 28th July 1885, saying that he did not like the pictures going '...to

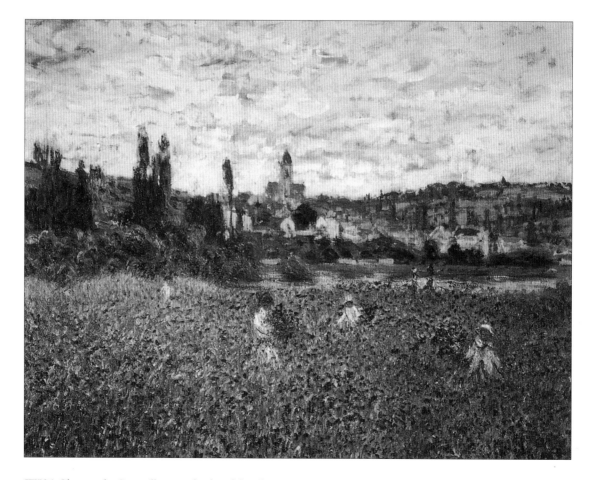

**W536 Champ de Coquelicots près de Vétheuil  –  Poppy Field near Vétheuil**
70cm x 90cm.    (E.G. Bührle Foundation Collection, Zürich)

**W518 Vétheuil dans le brouillard – Vétheuil in the Fog**
60cm x 71cm.1879.    (Musée Marmottan, Paris/Bridgeman Art Library)

The church, swathed in fog, gradually emerges as the sun comes out. Monet waited on the Lavacourt bank, probably before sunrise, for this to happen. A masterly Impressionist work, once rejected, which was kept by Monet and later by his son Michel.

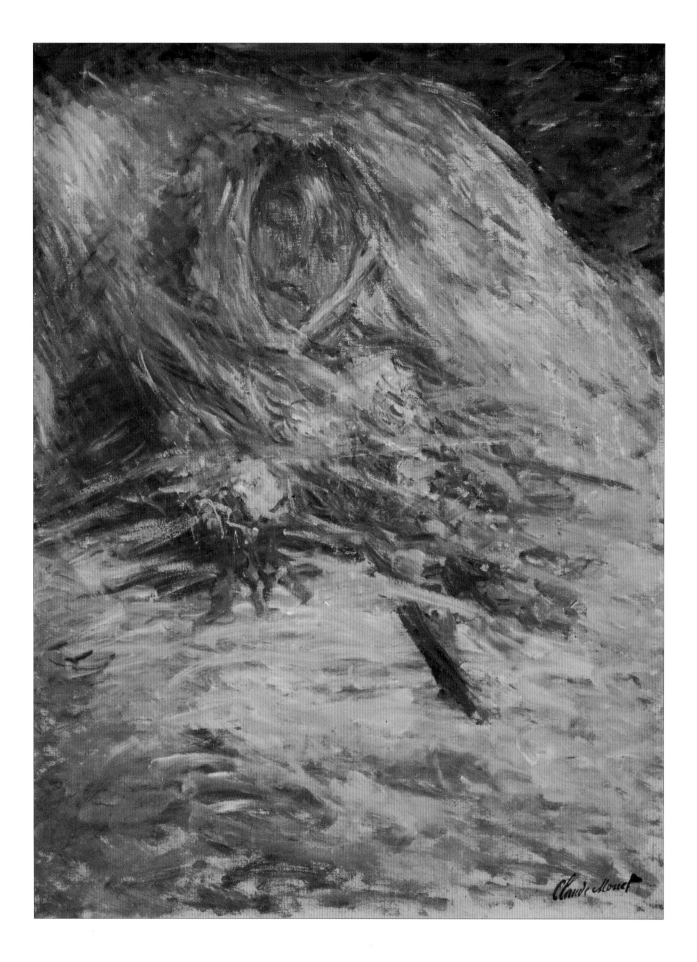

the land of the Yankees. I would prefer to reserve a choice for Paris because it is there, and only there, that a little taste still exists.' By that time only nineteen of his pictures had been shown in London, and none had sold!

The greatest of these paintings could be W531 (see page 35). It shows the church and the calm river with brick stroke reflections: the peak of Impressionism. It was sold originally to stay in France, but Wildenstein in Bond Street, London, sold it to a Mr Balfour in 1936 for £1700. I have a copy of the receipt before me, signed by Monsieur F.C. Van Duzer!

Next he painted five views of Lavacourt from the *bateau atelier*, moored amongst the islands near his house. Three are in the United States, one in Switzerland and the first, W537 (see page 18), originally sold to Dr de Bellio, is now in the Musée des Beaux-Arts in Rouen, where there is a large collection of Impressionist paintings, including eleven by Claude Monet.

Camille's health was growing steadily worse and on 17th August 1879, Monet wrote to Dr de Bellio, revealing the desperate situation:

'... For a long time I had been hoping for better days ahead, but alas, I believe the time has come for me to abandon all hope. My poor wife is in increasing pain and I cannot imagine that she could be any weaker than she is now. Not only does she not have the strength to stand up or walk one step, but she cannot hold down the slightest bit of nourishment, although she has an appetite. One has to be at her bedside continually attending to her smallest wish, in the hope of relieving her suffering, and the saddest thing is that we cannot always satisfy these immediate needs for lack of money. For a month now I have not been able to paint because I lack the colours; but that is not important. Right now it is the sight of my wife's life in jeopardy that terrifies me, and it is unbearable to see her suffering so much and not to be able to provide relief... But I would ask another favour of you, dear M. de Bellio, which is to help us out from your own pocket. We have no resources whatsoever. I have a few canvases in the rue Vintimille; take them for whatever price you like: but please respond to my call for help and send us what you can. 200 francs or 300 francs now would save us from hardship and anxiety; with 100 francs more I could procure the canvas and paints I need to work. Do what you can, in short; I told our landlady to let you in so look at my paintings and buy them for whatever you like.
Awaiting your reply, I send you my best wishes.

Yours Claude Monet'

Eighteen days later, on 5th September 1879, Camille died after a long drawn-out and painful struggle. She was only thirty-two years old. On that day Monet wrote another letter to de Bellio, saying:

**W543 Camille Monet sur son lit de mort  –  Camille Monet on her Deathbead**
90cm x 68cm. 1879.    (Musée d'Orsay, Paris/Bridgeman Art Library)

Monet never parted with this painting. The studio stamp signature was added after his death. Michel kept this picture of his mother until persuaded to pass it to Katia Granoff, who then gave it to the Louvre in 1963. Michel died three years later, aged 88.

'… My poor wife gave up the struggle this morning at half past ten after the most ghastly suffering. I am in a state of distress, finding myself alone with my poor children.

I am writing to ask another favour of you; could you please retrieve from the 'Mont de Piété' the locket for which I am sending you the ticket. It is the only keepsake that my wife had managed to hold on to and I would like to be able to place it around her neck before she goes.

Could you do me this favour and send it tomorrow, on receipt of my letter, to the main office in the rue de Blancs-Manteaux before 2 o'clock? You could send it by post; in this way I would get it before she is placed in her bier.

I hope to have word from you tomorrow in response to my previous letter. Your very unhappy and very pitiable friend,

Claude Monet'

Camille's funeral service took place in the church of Notre Dame de Vétheuil, and her committal was to the graveyard which is separated from the great church, about forty metres up the hill, before the gardens of 'Les Tourelles'. Her grave is in the corner nearest to Lavacourt and has a spectacular view across the Seine. It is a simple grave with an elaborate and finely worked metal cross. The whole is surrounded by metal rails and black-painted filigree work. Monet paid for a concession for a temporary period of fifteen years for the grave, from 25th January 1882 and then forgot about its renewal. So also did Michel Monet and interest was revived in the tomb in 1962 when it was positively identified and cleared. Now it is a shrine to 'La Femme à la robe verte', whom Monet painted in 1866. It was this painting which brought about his initial fame in the Salon that year.

Camille is remembered as a charming, gay and witty girl, of whom all the Impressionists were fond. She had realised from the beginning that Monet's art came first. In 1920, Monet told Clemenceau that Camille had been and still was very dear to him, and that was over forty years after her death. There is little doubt that he fell in love with her, probably on first sight. She was tall and slender, with an excellent model's figure which he found enchanting, for she wore all sorts of exotic clothes and hats for him, as can be seen in so many of his paintings. In their fourteen years of living together, there were periods of great happiness and many successes, to be followed later by long periods when they were very poor indeed, and undernourished. This must have been difficult for a young mother, whose first child was born when she was twenty, followed by another son when she was thirty and in dire poverty. After her tragic death finances were to slowly improve for Monet and his family. Alice Hoschedé was well aware of Monet's love for Camille and their children, of this there can be no doubt.

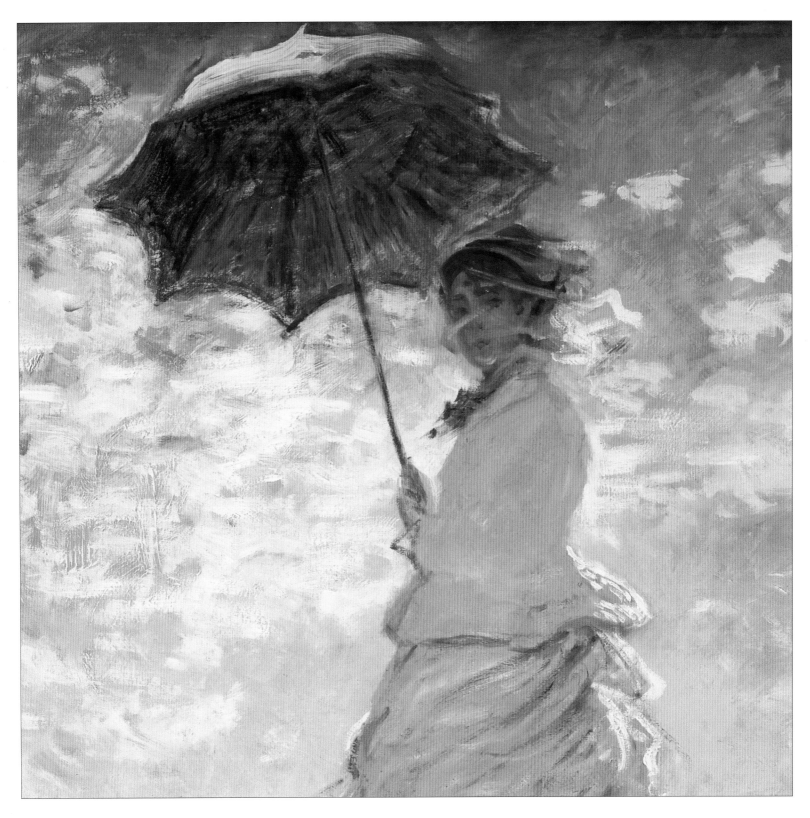

**W381 (detail) La Femme à l'ombrelle** (see page 2)
Camille Monet, painted by her husband in 1875.

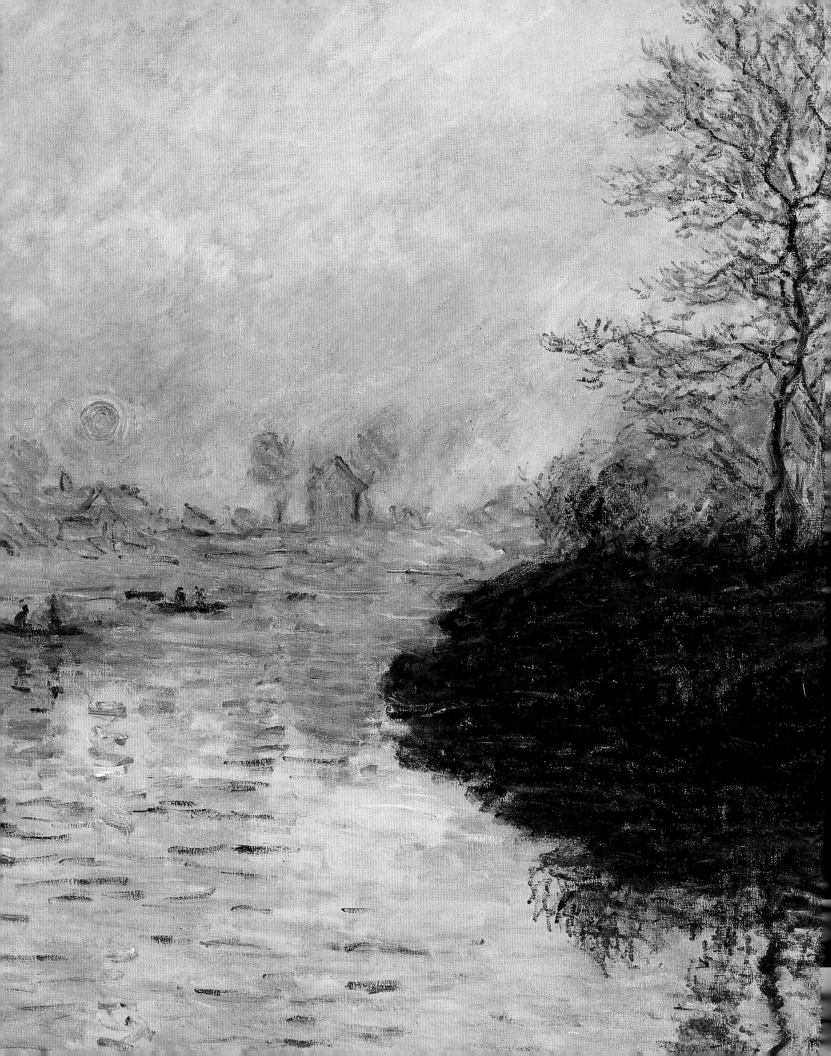

# CAMILLE AND CLAUDE MONET'S RELATIONSHIP AND MEDICAL MATTERS

Monet was a young man when he first met his charming, lively, pretty Camille, around the time he was painting at Fontainebleau in 1865. She was born on 15th January 1847 and thus was eighteen when he first met her. He was twenty-five. He painted a charming portrait of her in 1866, the first of over fifty-six pictures in which she is the model or is included. By contrast, Alice Hoschedé only figures in two of his paintings. Different periods, different pictures and different people but Camille really was essential for the early part of his life as a painter.

Camille-Léonie Doncieux was born in Lyons, the first child of Charles-Claude and Léonie-Françoise Doncieux, both citizens of Lyons. In 1864 the family moved to Paris and a second daughter, Genevieve-Françoise, was born on 12th February 1867. The development of the Sorbonne caused them to move from old Paris and when Monet met Camille they were living at 17 Boulevard des Batignolles.

Monet at that time was renting a studio, at 800 francs per annum, on the third floor of 1 Place Pigalle; at the corner of Rue Duperre, which is not more than 1000 metres from Boulevard des Batignolles, where Camille lived. They probably met somewhere in this vicinity. Monet, seven years her senior, was yet to establish himself as an artist, though he had been painting seriously for the four years since he had been forced to give up his Military Service in Algeria. He now considered himself to be a man-about-town.

Camille became his model and then his mistress and on 8th August 1867 bore him a son, Jean, who was born at his father's studio, now at 8 Saint Louis aux Batignolles, where Camille was attended by a medical student, Ernest Cabadé. Monet made a portrait of him later that year. Dr. Cabadé, as he was to become, eventually owned a further three of Monet's works. They kept in touch for some time after the doctor had gone to work in Montignac de Lauzun (Lot and Garonne), and then Valance d'Argen (Tarn and Garonne). Monet and Camille were extremely poor during this period, for Monet was dependent on a small allowance given by his father. That would have been stopped had the latter known of Camille and Jean. But the details of this part of his life are not for a book about the short stay at Vétheuil. It is only to give an informative account of their relationship as it developed.

Monet married Camille in a civil ceremony on 26th June 1870, just before the outbreak of the Franco-Prussian War. He fled to London soon after, for fear of being called up as a soldier, for he had no heart in the war and was technically a Reservist. The war broke out on 19th July. Monet's great friend, the painter Frédéric Bazille, joined up and was killed on 18th November at Beaume-

**W576 (detail) Soleil couchant sur la Seine, effet d'hiver  –  Sunset on the Seine, Winter**
100cm x 152cm. 1880.   (©Photothèque des Musées de la Ville de Paris/P. Pierrain)

la-Rolande. This was a great blow to Monet, for quite apart from their friendship Bazille was well-to-do, and helped him financially at frequent intervals.

Camille and Jean joined Monet later in London and together they went to Holland in May 1871 for about four months. After this it was safe for them to return to Paris for the winter. Monet had been abroad then for over fifteen months. They then moved to Argenteuil, where they stayed from 1872 to 1878.

Whilst in London, where Monet lived for most of the time at 1 Bath Place, Kensington (now 183-185 Kensington High Street), he was to meet Daubigny, an old friend. The latter made a most significant introduction of Monet to Durand-Ruel, who for a short time had a gallery at 168 New Bond Street. It was here that Monet first exhibited a painting in London. According to Wildenstein this was 'L'Entrée du port de Trouville' (opposite). But Monet's paintings were far too far advanced for the stodgy English collectors to risk a purchase.

Monet was very happy with his little family. He confided to Bazille that when he first saw his first-born, he realised that he loved the child as his own immediately, even if at that time he was not married to baby Jean's mother.

There are good reasons to believe that around 1876 Camille conceived again, but this time an abortion was decided upon. No more details are given of this except by Wildenstein, who writes that 'the doctor treating her in Argenteuil called in a colleague in consultation since Camille was seriously ill; it was so serious that there was talk of an operation'. Monet believed it was caused by some ulceration of the walls of the womb. One is drawn to the conclusion that Camille was the victim of some attempt at abortion. In fact the ulceration of the matrice meant that the young woman had been really damaged. There were also fears of other causes such as tuberculosis or cancer for example. It seems that the surgery projected was avoided, perhaps following the moderate counsel of Dr. de Bellio; a fully qualified doctor who was a firm believer in homoeopathy.

There are two key letters written by Monet covering this period, one to Manet and the other to de Bellio. Unfortunately neither is dated. The first letter asks for assistance from Manet, who never failed to respond. The second, to de Bellio, a collector and a patron, was to say that Monet would call on him the next day, to explain his wife's illness and their predicament. No doubt this happened and the good doctor gave him both advice and financial assistance. De Bellio was critical to Monet's survival as an artist. He was extremely useful also to several other Impressionists in their struggle to survive.

Apparently no operation took place and the supposition must be that nature and perhaps time and a herbal remedy carried Camille through this hazardous illness.

There is little doubt that Dr Charles Auguste Porak (1845-1921) would have been consulted about Camille's illness. He was a brilliant doctor and surgeon, admitted to the Académie de Médecine in 1874, and at the forefront of research at the École de la Maternité de la Piété in Paris, where he was the *accoucheur* (specialist doctor in charge of childbirth) and deputy *Chef de Service* and later on was to become the Professor. An early gynaecologist and paediatrician, he was also an expert on venereal disease and its treatment. So far he has not been mentioned in art history and it is from London that the initial research has been made. He qualified in the Faculté de Médecine in 1866 and in 1878 he gained the rare silver medal for his Doctoral Thesis on *L'ictere des nouveaux-nés*. That same year he wrote a definitive paper on diseases of the womb. As a leading paediatrician, there is no doubt that later on Alice also sought his advice on the health of the eight children, particularly during the Poissy period when one or more of them were ailing constantly. We know this because Monet gave Dr. Porak an oil painting when the family was staying at Villa Saint Louis in Poissy around 1882 or 1883.

Porak had an international reputation from before this time, and his works were available at Cambridge University and also the main specialist schools of surgery and medicine in London from 1873 onwards; he was at the forefront of medical discovery and innovation at that time.

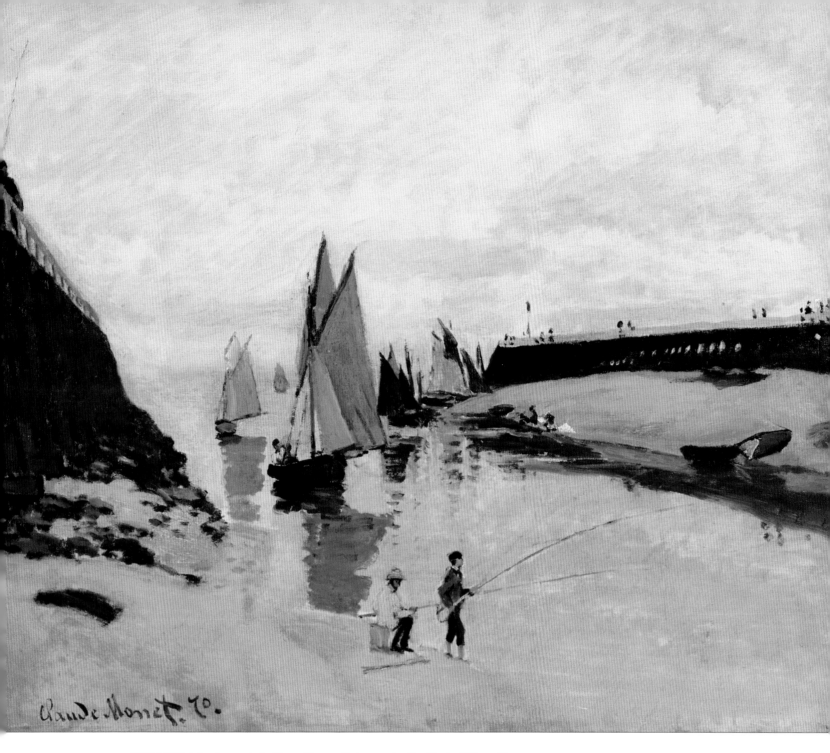

**W154 L'Entrée du port de Trouville  –  Entrance to the Port of Trouville**
54cm x 65.7cm. 1870.    (Szépmüveszti Muzeum, Budapest)

This was the first of Monet's paintings to be shown in London at the 168 New Bond Street gallery of Durand-Ruel. It did not sell. Prior to this Monet had submitted two canvases to the Royal Academy's 1870 exhibition. Both were rejected.

It seems then that Camille in part recovered, for the next medical incident was to be another pregnancy which started in June 1877. Perhaps that was too early for her to have recovered completely from the earlier aborted pregnancy, if that is what it was.

In January 1878 Monet wrote to his friend Murer, the collector well known to all the Impressionists. Murer, a famous *patissier* (pastry cook), owned a restaurant at 95 Boulevard Voltaire where they gathered. He also became a writer and a painter. When he died in 1906 his magnificent collection of 109 Impressionist paintings was sold, including ten by Claude Monet. In his letter Monet informs Murer that Camille and Jean have been ill for ten days. On 15th January the painter wrote to Dr. de Bellio asking for money to pay his creditors but he also says 'you know the condition of my wife – please make enough effort to help…' Then on 9th February he wrote to Dr. Gachet telling him of the impending birth, and asking for any financial help he could give. Monet was desperate for money. It was a miserable time for him; there was a recession and he was forced to sell paintings for very small sums, sometimes fifty francs or even less. The canvas, paint and stretchers would have cost a significant portion of this.

Michel was born in the studio flat at 26 Rue d'Edimbourg on 17th March 1878 at eleven o'clock in the morning. We are not certain which doctor attended, but we do know that Edouard Manet and the composer Emmanuel Chabrier witnessed to his birth at the Mairie of the 8th Arrondissement in Paris.

Monet then got on with his painting at the Île de la Grande-Jatte. He had many debts, and there is no doubt that he lived too extravagantly. Though from time to time he had been supported by sudden windfalls, Camille's inheritance from her father for instance, or his own from the estate of his father and his aunt, quite obviously he spent more than his income. When troubles came he fell into debt and his creditors pursued him.

The graph of Monet's income shows that from 1872 for the next eight years it was averaging a little over ten thousand francs a year and that in 1873 it soared to over double this as a result of

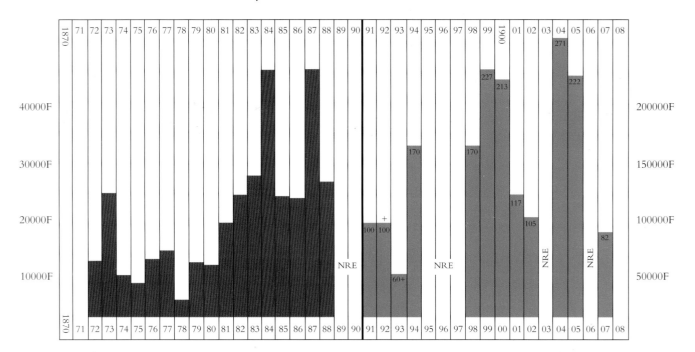

Graph of Monet's Income (1873-1907) (NRE: No records exist).

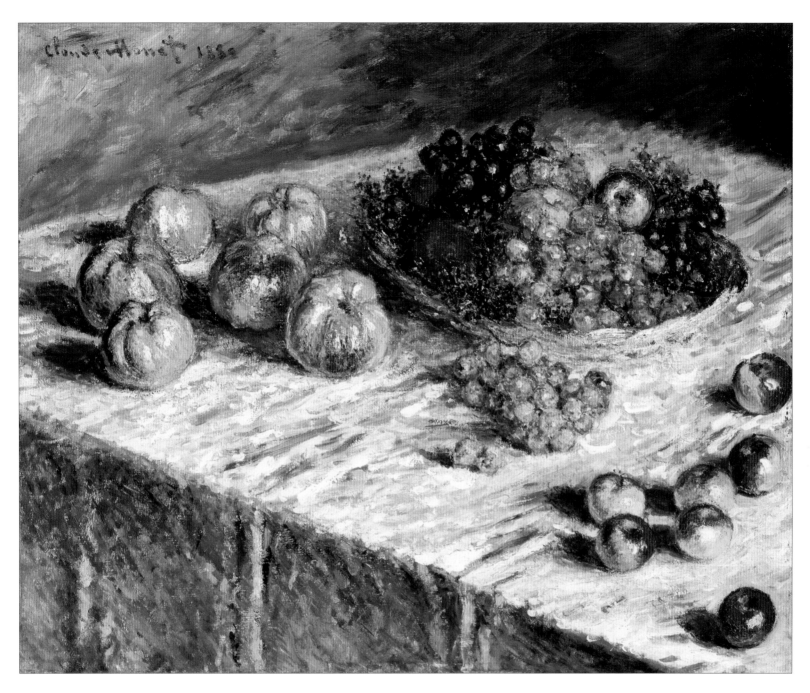

**W546 Nature morte: pommes et raisin – Still Life: Apples and Grapes**

66.2cm x 82.3cm. 1880.

After Camille's funeral in 1879 Monet slowly started work again with a series of eight still life paintings.

purchases by Durand-Ruel. The latter then had trouble with his bankers from which he did not recover for a decade. This was very bad news for all the Impressionists: a principal building-block of their success could no longer purchase their paintings.

In 1873 Monet, being a firm optimist, thought that success would be permanent, and like most artists, who are notorious for not saving for a rainy day, he spent his income on raising his standards of living with servants, good food and fine wines. This proved disastrous. The other expenses of

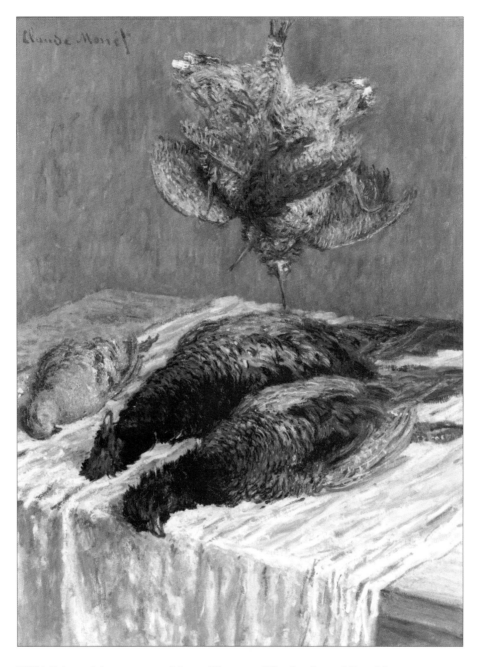

**W551 Faisans, bécasses et perdrix  –  Pheasants, Woodcocks and Partridge**
89cm x 68cm. 1879.   (Photograph courtesy of Sotheby's, Inc. © 2002)

Some writers have suggested that Monet's sorrow made him paint pairs of birds, not noticing that these are all cock birds!

canvas, stretchers, brushes, paint and media also got completely out of hand. He conveniently forgot about paying his running accounts with his suppliers, was not punctual in either paying his rents or his gardener, his wife's maid or the nurse. He was always spending money before he actually made the necessary sales and in consequence he fell heavily into debt.

In the critical year of 1878, with Hoschedé bankrupt and Camille mortally ill, Monet's sales were reduced to four thousand francs and his debts were huge. Of course his sales had slumped, for France was suffering what we call a recession, and as previously mentioned Durand-Ruel was in

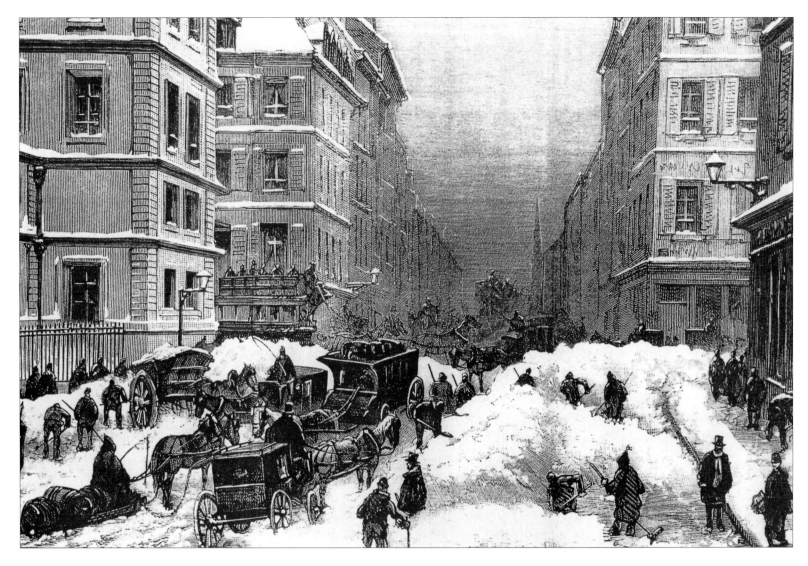

Paris in the snow. Winter of 1879-80. Wood engraving. Meelon Tilly. *La Nature,* 1880.

trouble too. In that desperate year and in the following one in which his wife died, Monet strove to make more sales. No one could have tried harder; he begged and borrowed from everyone he knew. The graph shows his earnings but does not show his debts – here are some of them :

October 1875: Camille transfers rights for her two thousand franc inheritance to art supply dealer Charpentier to settle Monet's bill.

April 1876: Monet raises 1500 francs from Berthe Morisot and her husband Eugène Manet in exchange for fifteen paintings. Caillebotte buys several paintings and advances money for more.

January 1877: Caillebotte pays 700 francs a year for Monet's studio rent at 17 Rue de Moncey.

June 1877: Dr de Bellio buys ten Monets for 1000 francs.

July 1877: Art supply dealer Voisinot receives sixteen Monets to settle his account, returning but forty francs to the painter.

December 1877: Monet sells five paintings to Eugène Murer for 125 francs.

1878: Manet lends 1,200 francs to Monet. Manet and Murer buy 1000 francs worth of paintings from Monet, buying through nominees so that he did not know of their involvement.

April 1879: Caillebotte sends 2900 francs to Monet.

April 1881: The Hoschedé/Monet household owed the grocer Madame Lefèvre 3000 francs, the innkeeper Madame Auger 800 francs, Madame Ozanne, shopkeeper, several hundred francs and to Madame Ansault-Chauvel 968 francs for six terms of rent. But more of this was owed by Hoschedé than by Monet.

There are over 15000 francs in the sums mentioned above. In fact he was not able to fully clear his debts until 1890, and after that he became a very rich man indeed. Sadly, this was all too late for his devoted Camille.

With regard to wages in France at this time, Professor Paul Tucker says that 12000 francs per annum would be a good income for a doctor. 2000 francs was the working wage per year, which works out at forty francs per week for ordinary working folk. Monet painted on large canvases costing at least fifteen francs for size 80cm x 100cm. The price of those from Le Franc and Company in 1863 was twelve francs. Then we have to add all the other equipment to see just how much a painter's art supplies would cost.

Camille was dead. What was Monet to do? Alice Hoschedé had nursed her through her long,

**W555 Le Givre – Frost**
61cm x 100cm. 1880     (Musée d'Orsay, Paris) ©Photo RMN – H. Lewandowski

Painted during the great freeze of December 1879 looking downstream (*en aval*) from Vétheuil.

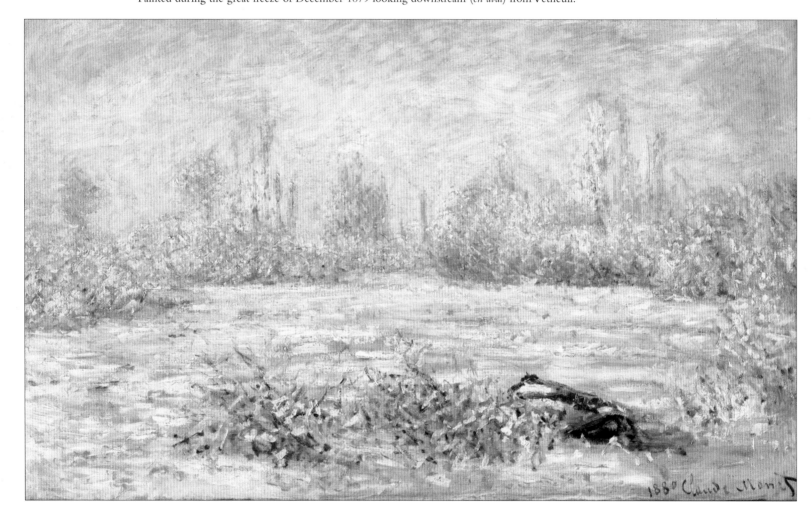

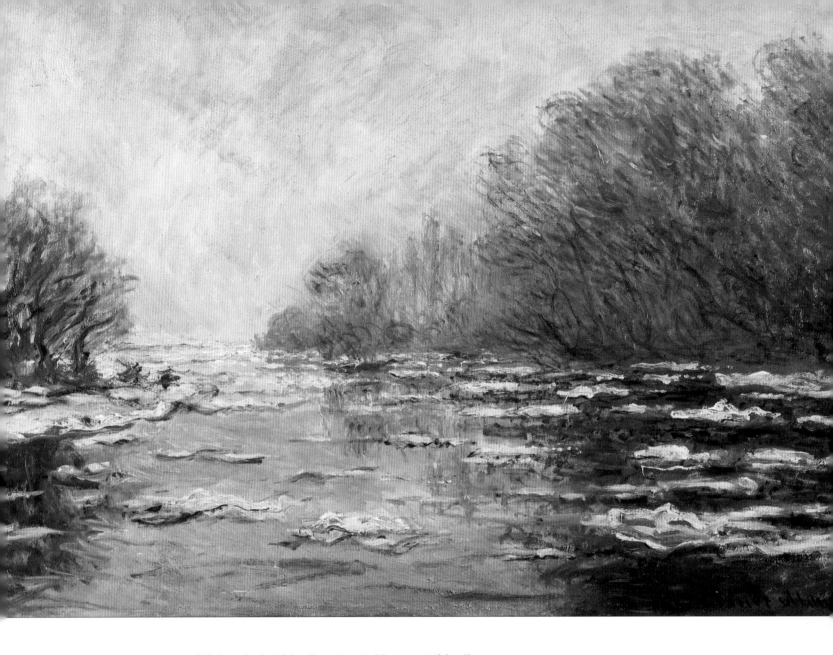

**W572 La Débâcle près de Vétheuil – Ice Melting near Vétheuil**
65cm x 91.5cm.    (Musée du Louvre) ©Photo RMN – R.G. Ojeda

The break-up of ice on the Seine started on 5th January 1880. This is one of fourteen paintings showing the Seine and the îles de Moisson, looking downstream.

painful and tragic illness, as well as looking after his two children, who were by now interlinked with her own large brood. Monet was now a widower. Alice was married to Ernest, whose visits from Paris were to become less frequent. Monet could earn money, but Ernest had to be supported by his mother, he did however continue to pay his share of the outgoings at Vétheuil.

Monet's only income depended on his ability to make pictures, but as already shown he was heavily in debt with his colourmen and he needed money to buy canvases and paint. At this time he had simplified his palette to include but eight colours, including flake white of which he used great quantities, and such requirements were a large ongoing expense.

It is difficult to give a true sequence to the paintings that followed, but assuming that Wildenstein

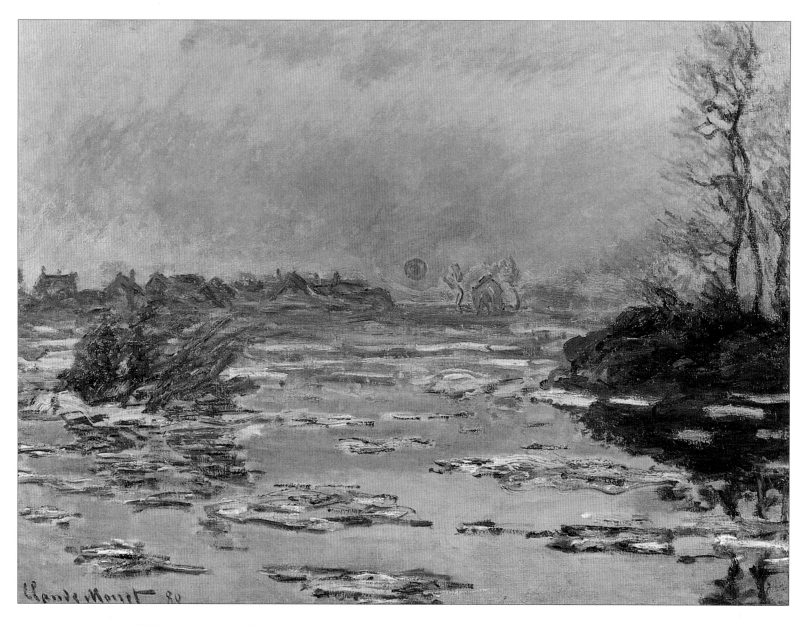

**W574 Coucher de soleil sur la Seine, l'hiver – Sunset on the Seine in Winter**
60cm x 80cm. 1880.    (Private collection, Japan)

Showing Lavacourt seen from the bottom of Monet's garden with Île Musard to the right.

is correct, Monet now started to paint still life. The first five were of fruit and flowers, the next three of game. More brilliant paintings of these subjects could not have been made – pheasants, lapwing, snipe and partridges. There was no diminution of painterly power here.

Then came a cruel, hard winter. He painted a large series of cold weather scenes. Some people have said these are a sign of Monet's depression; American scholars have written that Monet responded to the scenes and showed how miserable he was. That man was far too strong for this. He had suffered

**W575 (detail) Coucher de soleil à Lavacourt – Sunset at Lavacourt (study for W576)**
53cm x 80cm.1880.    (Christie's New York)

This is very freely painted, probably with freezing hands in the heavy frost.

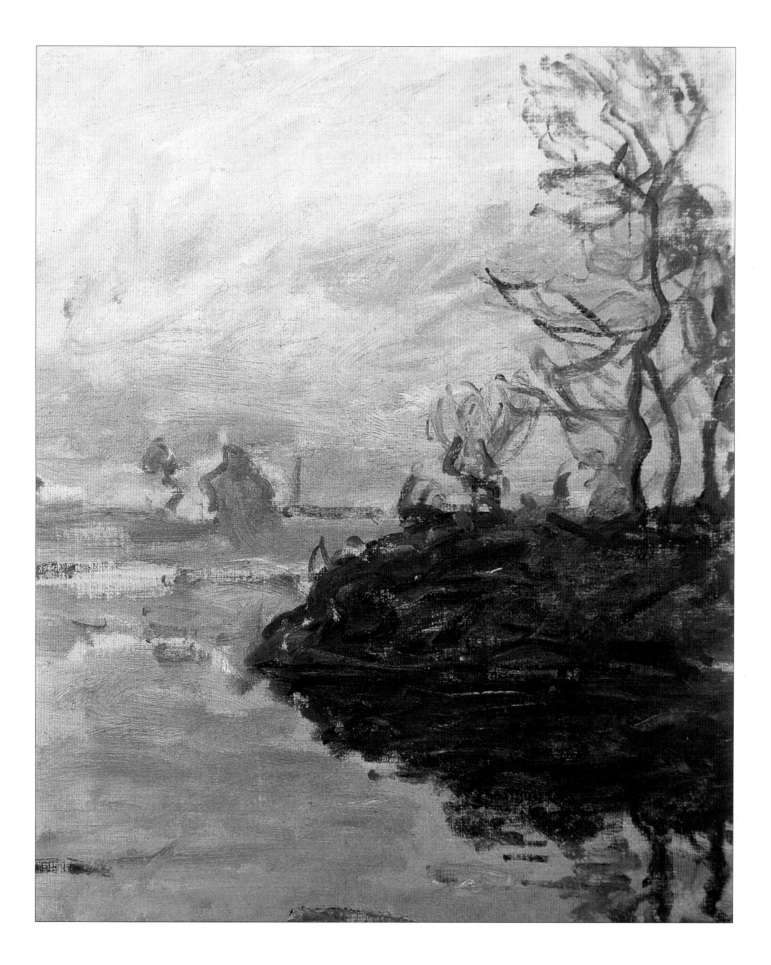

through the long period of his wife's dying, now the weather was rotten, cold, damp, wet and the river iced over. He painted what he saw with enormous strength, in spite of the preceding sad events.

It was indeed a cold winter but remarkable to behold. Obviously the canalization of the Seine was not working as intended. The heavy rains had been held up by the new locks and barrages, and the waters were unable to escape to the sea. The weirs were inadequate and the water could not get by, so in the following year they had to be modified and widened to accommodate such flood conditions.

Before the river was canalized the whole weight of water would have roared down the Seine to Rouen and the sea, taking the debris with it. Now, since the water was unable to escape, it rapidly froze when the cold weather came. The whole surface of the Seine iced over, just like the Hudson River in New York State, it was trapped and Monet had a quite unique opportunity to record it in one of the widest stretches on the Seine.

Despite the cold, Monet made a wonderful series of paintings, starting with the frosts and ending with a thick sheet of ice over the entire river. Then he recorded the upward pressure which forced the breakup of the ice. This made strange noises and caused alarm, for it started at night. When the river began to flow again, it carried the ice with it over the lower layer of water which, hidden from view, had never ceased to flow.

The remarkable series known as the *débâcle* paintings came from Monet's observations of this extraordinarily severe weather. There were heavy snowfalls over two months, and very low temperatures. The thaw which followed caused the great floods of the winter of 1879-80 throughout northern Europe. Nowhere was it more spectacular than in Paris, which is only thirty-five miles up river from Vétheuil. Of course, once the thaw began all that water, with rubbish and incorporated flotsam and jetsam, had to pass down river to exit into the sea at Le Havre. Whilst on its way it blocked the locks and weirs, causing havoc all the way to the sea for, apart from the normal debris, the water carried very many uprooted and broken tree trunks. The Bay of Le Havre must have looked like the mouth of the Amazon river in flood! And it was a hazard to all mariners. Ice floes, large areas of ice from frozen rivers, are most dangerous to small ships, particularly when packed high by the currents, just as happens in the Arctic regions. An ice floe can easily pierce a thin steel or wooden hull if struck at a sharp angle.

There was plenty of evidence of the effect of this very cold weather on the city and citizens of Paris. The newspapers of December and January 1880, particularly *Le Monde Illustré* and *L'Illustration*, carried graphic pictures of these events (see page 85).

At first it was a novel experience to find the Seine frozen over in the city: you could walk across the river everywhere. Revels were held on the ice and ice houses built where warm drinks could be purchased. The city authorities, trying to clear the streets of ice and snow, threw it over the bridges, making enormous heaps which almost filled the archways. This was a foolish mistake and when the thaw began there was concern for the safety of many bridges, particularly the incomplete Pont des Invalides, which predictably collapsed on 3rd January 1880. Other bridges were damaged from Pont d'Austerlitz to Pont Neuf. Similar problems occurred upstream of Paris and beyond the Seine junction with the Marne, causing worse damage than on previous occasions when the Seine froze over in the winters of 1830-31 and 1870-71.

During the *débâcle* the coldest day was recorded at -26 degrees centigrade on 10th December 1879. Snow began at the end of November and continued to fall heavily for over a month, blocking roads and stopping trains. Food and fuel ran short. Thousands of workers were employed disposing of snow into the rivers, exacerbating the floods following the thaw. There were serious health concerns, for the garbage was mixed together with snow.

Meanwhile, as the freeze began, Monet was painting but in financial difficulties. He managed to borrow fifty francs from the Postmistress at Vétheuil on 28th December. It is hard to imagine a postmistress doing

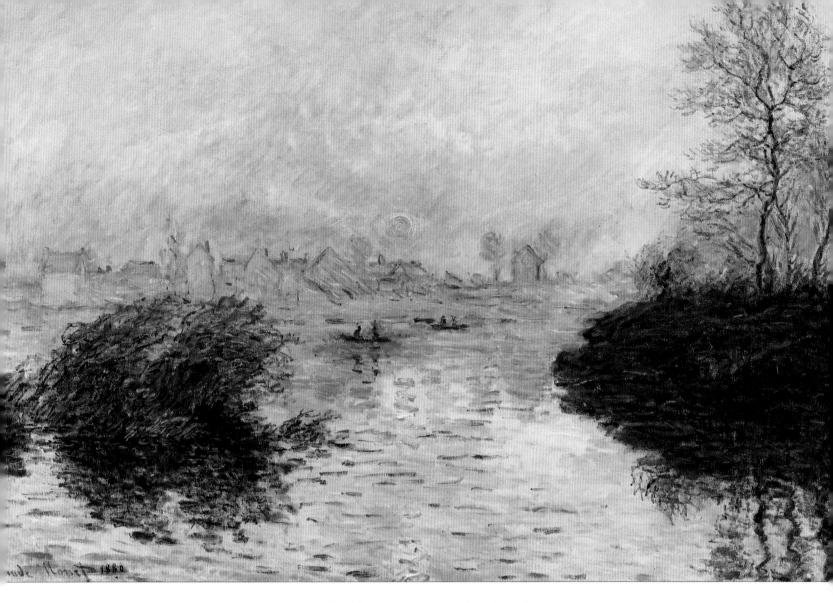

**W576 Soleil couchant sur la Seine, effet d'hiver  –  Sunset on the Seine, Winter**
100cm x 152cm. 1880.    (©Photothèque des Musées de la Ville de Paris/P. Pierrain)

Painted from the bank below Monet's house, looking down, with the tip of the Île Musard on the right and Lavacourt on the other side of the Seine. Two rowing boats are in line with the sinking sun and the reflection, and the thaw is well underway. See detail, page 78.

this today. She was either a great friend to the family or realised the importance of Monet's artistic record of the *débâcle*. Monet must have used Père Papavoine's coach and the train from Mantes to Paris, and have returned the same way, for he was back home in time for the great thaw, the *dégel*, which started at Vétheuil on 4th January, when the mass of debris came down the Seine from Paris. In those few days he had sold the first two of the *débâcle* paintings to Georges Petit and Théodore Duret respectively, for 225 francs each. This was a relief for the two families at Vétheuil and to the Postmistress, no doubt.

Monet's *glaçon* paintings showed the break-up of the ice, with small ice floes floating down the Seine. Perhaps a foretaste of the waterlily paintings, the first of which was painted seventeen years later, in 1897. Later came the *inondations*, the floods caused by too much water which had to overflow the riverbanks to escape downstream.

The stay in Vétheuil was a critical period in the lives of the two families and, as it turned out, they were to be joined together permanently, though this certainly was not apparent to them at this time.

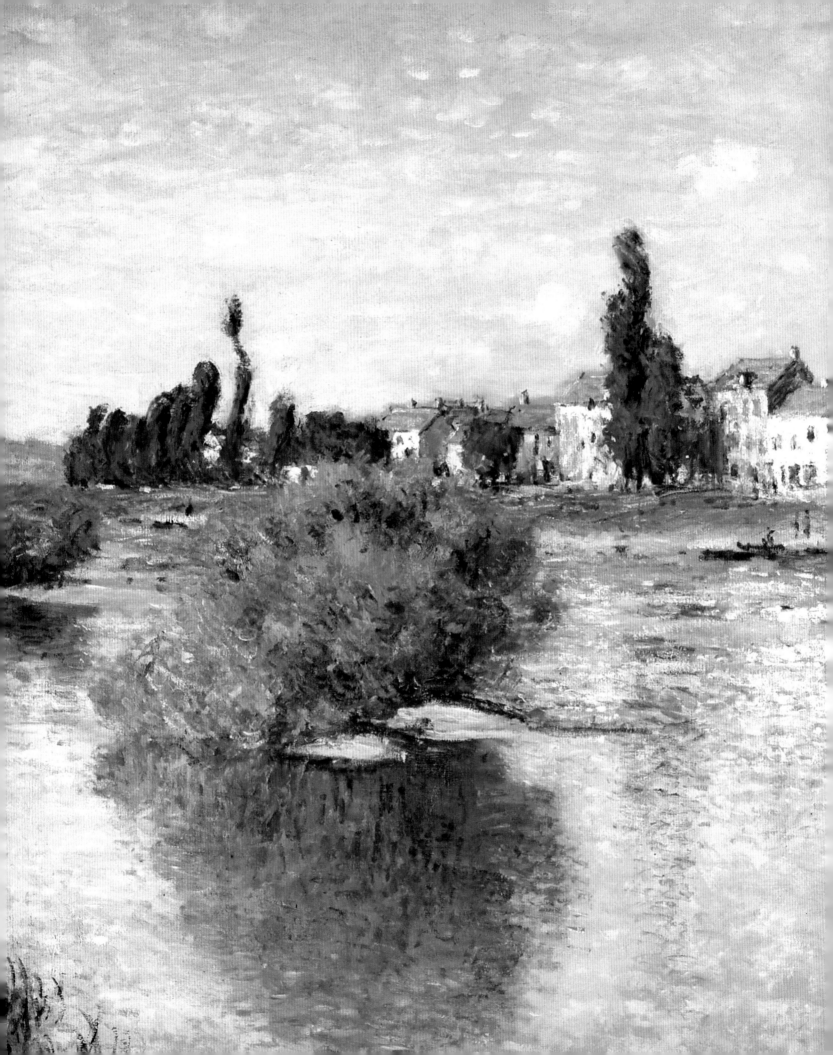

# THE PAINTINGS OF 1880

When the ice began to move and break up, this was accurately recorded by Monet. Wildenstein gave a date of 5th January 1880 for this. A few days later Alice Hoschedé wrote to her husband Ernest and described the awesome sight of the ice breaking up '…at 5 in the morning I was woken up by a frightful noise like the rumbling of thunder … on top of this noise came cries from Lavacourt; very quickly I was at the windows and despite considerable obscurity saw white masses hurling about. This time it was the *débâcle*, the real thing.'

In December 1879, Monet had made five paintings of the river in the severe frost. The first was a scene painted on the ice between the islands downstream of his house, W552 (page 34). It shows the bitterly cold conditions of the river, with the church and 'Les Tourelles' towering above it. With difficulty, Monet's house can be identified. Two figures are on the ice near the mooring, with perhaps clear water beyond. The water in the small channels of the *bras de la Seine* would be first to freeze, as there is less current running through it.

The other four paintings show boats, apparently trapped in the ice with no people to be seen. It was far too cold to go outside but despite this, Monet painted at his easel, staying near to his house so supplies of hot water could be brought out to him (W555 page 86).

Next he painted a frozen scene of the sun going down amongst the rooftops of Lavacourt, W557, now in the Musée des Beaux-Arts in Le Havre, a remarkably atmospheric painting, followed by a very similar scene.

To record the *débâcle* he crossed by boat to Lavacourt, pushing the ice floes aside to get there, and painted a desperately cold scene, W559, of Vétheuil with snow on every roof and on the hills.

The next pictures are both from the same viewpoint, by the bank, beside his house, looking upstream and showing Lavacourt on the right. In the first, W560 (page 110), the force of the *débâcle* is very evident, with great blocks of river ice piled high against the trees on the Île Musard. The picture is now in Lisbon with the Gulbenkian Foundation. In the second painting, now in the Musée des Beaux-Arts, Lille, there are two figures rowing a boat.

By this time Monet had a system worked out. He dressed to maintain body warmth and kept his hands warm by keeping small hot bottles in his pockets. He was thus able to produce sixteen great paintings of the *débâcle*, followed by the after-effects as the water level fell, W562-573. Eight of these paintings are of the *bras* between the banks of the Seine and the îles de Moisson, most of them around one metre wide. W568, now in the Shelburne Museum in Vermont, is a metre high and one and a half metres long, and was painted in March 1880. They all show glacier-green water and ice-floes. On the horizon are poplars and willows with their red winter stems, some with a few green shoots breaking through.

**W578 Lavacourt (detail)**
100cm x 150cm. 1880.    (Dallas Museum of Art, Munger Fund)

To the right the rowed ferry crossing from Vétheuil can be seen.

The last four are of sunsets by Lavacourt and it is apparent that the water level has fallen by as much as two metres, for the end of the îles de Moisson can now be seen, whilst boats are reappearing on the water, W574-576 (pages 88-91). W577 was given to Alice, and on her death it passed to Germaine Hoschedé, by then Mme. Salerou, her youngest daughter.

With the arrival of spring, Monet started to make expeditions further afield and towards La Roche-Guyon. We should not forget that his only means of getting around the district was on foot, or by boat, each requiring a lot of physical effort, for there was all the paraphernalia of a painter to carry with him, plus food and water. The motor car had not yet been invented, and it was not until 1901 that Monet was able to buy one. Until that time he was dependent on rail and boat; and of course Père Papavoine's horse carriage, to take him to the railway station at Mantes. In this sense Vétheuil was unique for Monet, for it had no direct rail service, as there had been in Argenteuil and Paris, and was to be in Poissy. The railway actually ran along beside his garden at Giverny, but that was three years away.

W578 (opposite) is a fine view of Lavacourt, looking towards St. Martin with the ferry boat alongside, seen from just outside his garden gate.

The next painting, W579 (page 96), shows some of the children walking through the birch trees on one of the îles de Moisson, with 'Les Tourelles' and the church in the background. It is a very satisfactory composition, and the only painting to be made from that viewpoint. Maybe the owner of that island did not appreciate Monet and his family wandering around there.

Lavacourt in the morning sun, 5th April 2001. The small islands seen in W578 (opposite) have long since been dredged away.

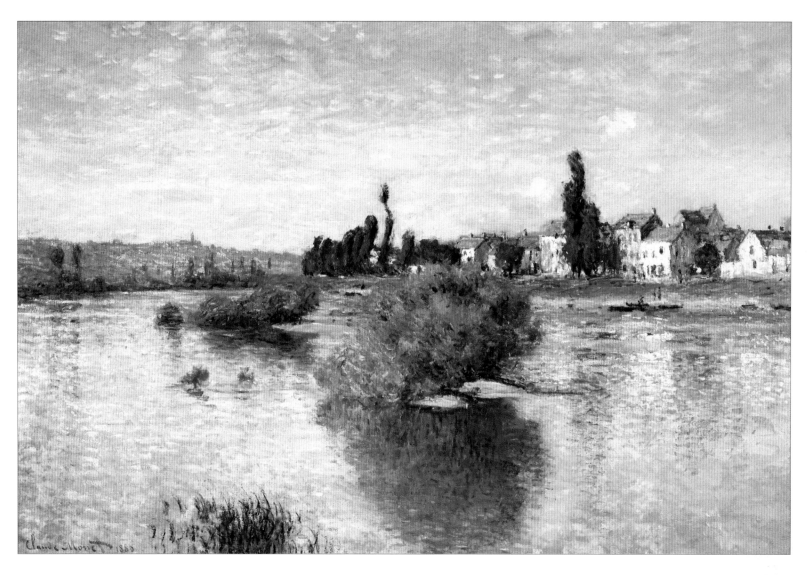

**W578 Lavacourt**
100cm x 150cm. 1880.    (Dallas Museum of Art, Munger Fund)

The view from the riverbank below Monet's garden on a calm March morning. See detail, page 92.

Monet then painted a landscape, W580 (page 97), on the Ile Saint-Martin, a larger, fully cultivated island, over three kilometres long and a farm in its own right, with barns, storage and tractors today. Monet would have used his boat to get there and land on one of the sandy beaches. This too is a very pleasing composition, painted early in the year, before the crops have grown, showing all the hills behind Vétheuil, and the church tower in the centre. Monet was to return often to this island and must have been friendly with the farmer.

For the following paintings he walked out of his front door and took the road to La Roche-Guyon; going a little further each day like an explorer. The first day's work, W581 (page 7), looks back down the road towards Vétheuil, which is about a mile away, concealed behind the hill. The unmade road takes up a disproportionate part of the foreground, and there are few trees: today it is heavily wooded.

For the next painting, W582, he has passed through the tiny hamlet of Haute-Îsle, turned the corner to the south-west and there ahead of him is a long straight road leading to Chantemesle.

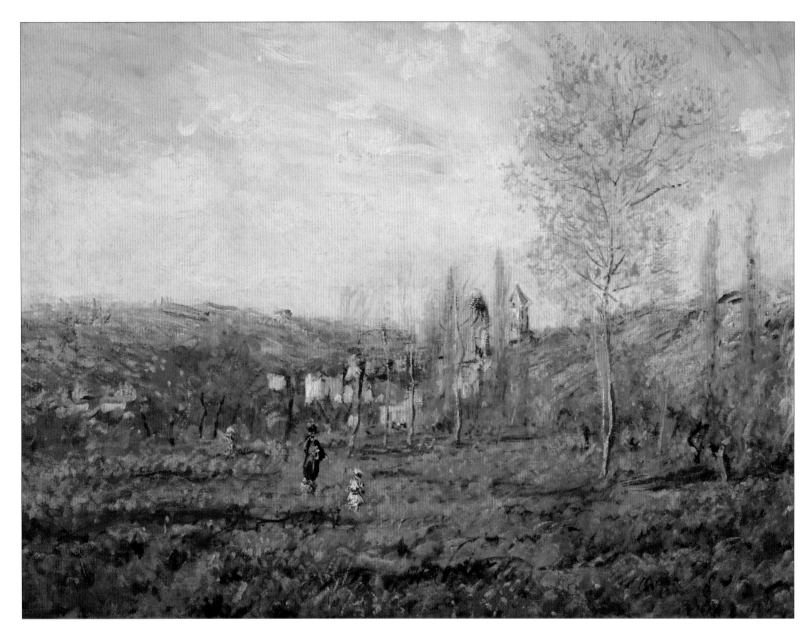

**W579 Printemps à Vétheuil  –  Springtime in Vétheuil**
60.5cm x 80.5cm. 1880.    (Museum Boijmans Van Beuningen, Rotterdam)

Painted from a meadow on the Île de Moisson. The tower of 'Les Tourelles' is to the left of the church of Notre Dame de Vétheuil.

The road occupies the right foreground and to the left are apple orchards, whilst right across the painting, the chalk cliffs march away into the distance (see photograph, page 100). The cliffs are over fifty metres above the road here. This picture is now in the National Museum of Western Art, Tokyo.

The next painting, W583, shows the same cliffs, this time looking like white circular towers along the skyline. The road occupies the centre and at the end of it are the houses of Chantemesle. It is possible to climb up the cliffs and at the top is a narrow footpath all the way along, giving fine views of the valley of the Seine.

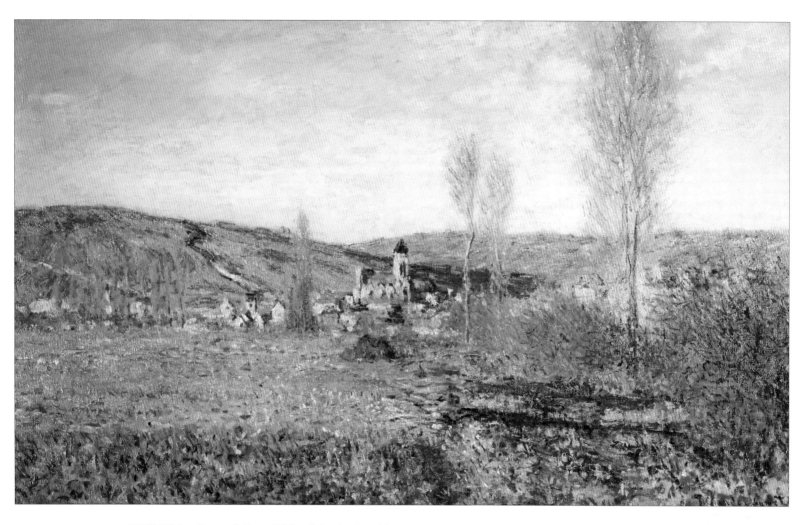

**W580 Vétheuil au soleil – Vétheuil in the Sunshine**
60cm x 100cm. 1880.   (Christie's New York)

Sunshine in the early spring. Monet has rowed over to the Île Saint-Martin de Garenne, which is still fully farmed. 'Les Tourelles' can just be seen to the left of the painting, with Monet's house below, and to the left, behind the row of poplars.

W584 shows the penultimate bend in the road to La Roche-Guyon, with young poplar trees to the left and the cliffs to the right as the road sweeps around the bend. This activity must have been tiring, for the next painting, W585, is of apple trees by a stream, that in the foreground is curving out of the river bank.

Another long walk for the next two paintings, W586 and W587, past the previously mentioned villages to the outskirts of the large village of La Roche-Guyon with its great Norman keep above the vast Château, which is cut into the cliffs. Both pictures have distant views of the Seine beyond, and the village, which can be seen through the screen of fruit trees.

Now finally, in W588 (page 99), we see the village of Chantemesle as the road enters it and passes the house of the English painter, Charles Conder (1868-1909). The cliffs, towering into the sky, dominate the ancient houses. This scene is two and a half kilometres from Monet's home.

The last painting in this series, which is almost a guide to La Roche, is of the nearest hamlet to home, namely Haute-Îsle, W589, where a few old houses have been built beside a Mairie. Set back

from them is an ancient Christian church hollowed out of the chalk cliffs and still in use today. The painting shows the line of cliffs, about fifty metres high, which curve to follow the river, all the way to Bennecourt, where Monet had painted Camille sitting on the riverbank in the spring of 1867, twelve years earlier. The road occupies the right-hand foreground, with apple orchards on the left, whilst the cliffs run right across the centre of the painting and into the distance. This picture was last seen in London in 1954.

That ends the peregrinations to the west for the time being, for Monet now turns the other way to make some of his most important paintings of the period.

'Les Coteaux de Vétheuil' W591 (page 21), is the clearest painting of Monet's house and garden, with the *bateau atelier* moored with other boats. It shows also the twin towers of 'Les Tourelles' beside the church tower, but even taller. In fact, the towers of 'Les Tourelles' are much lower than the clocktower and a long way from it, but this view is from much lower down and at an angle which puts the two buildings nearly into juxtaposition. Today, 'Les Tourelles' has only one tower and appears to have been reduced in height. The view has now been spoilt to some extent by an abundance of trees.

W590, 'Fin d'après-midi, Vétheuil' (page 41), is catalogued as a view from the riverbank upstream of Lavacourt, but in reality it is painted from the east bank of the Île Saint-Martin. 'Les Tourelles' is to the left of the picture, the church dead centre, and between the two is a steam paddle-tug puffing white smoke over the top of Monet's house. On the shore of the island on which Monet stands can be seen, in the distance, two hayricks and the farm buildings of Île Saint-Martin. In the

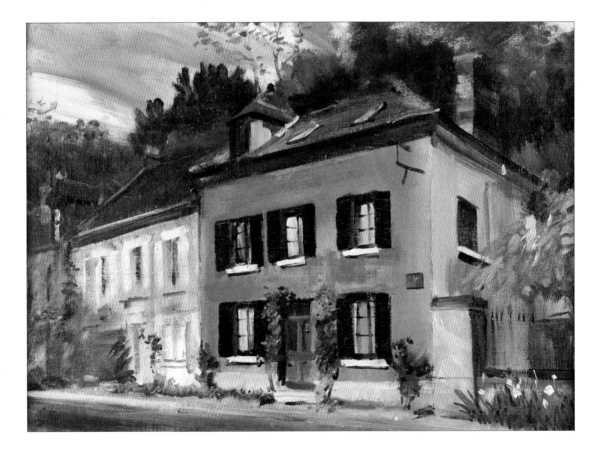

**George J.D. Bruce, RP.  –  Monet's House at Vétheuil**
Oil on canvas, 12in x 16in (30.5cm x 40.6cm).

**W588 Le Hameau de Chantemesle au pied du rocher – Chantemesle Hamlet at the Foot of the Rock**
60cm x 80cm. 1880.   (Christie's Images Ltd.)

Chantemesle is the first hamlet en route to La Roche-Guyon from Vétheuil. It is where the English painter, Charles Conder, and the English writer, poet and mountaineer, Robin Fedden lived.

right foreground, quite close to the painter, is a small island which has long since been dredged away, for it would have seriously impeded barge traffic going down river to Vernon. The painting is dominantly warm, red and pink, contrasting with blue reflections for the sky and blue-tiled roofs of the village of Vétheuil, whilst the hills and farmland are yellow-green.

The next five paintings were made on the Île Saint-Martin. The first, W592 (page 111), was painted in a cornfield not far from the northern tip of the island. A pathway leads back to where Monet has landed, running between the cornfield, which is full of poppies, and poplar trees at the edge of the field, on the end of the island. The Seine cannot be seen but it is between the island

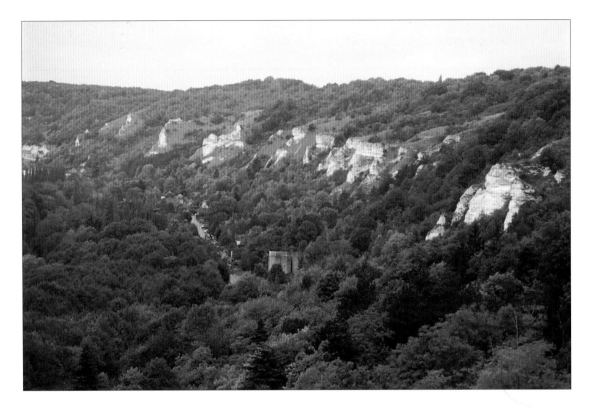

View of the road to Chantemesle, from the hills above Monet's house. The chalk cliffs run down the north bank of the Seine as far as Le Havre. Photographed in 1998.

and Vétheuil in the distance, with the great church and tower overlooking the scene, and the hills behind. This remarkable painting, 80cm x 60cm, can be seen in the Metropolitan Museum of Art in New York.

W593 is precisely the same composition but the artist is closer to Vétheuil, and the poplar on the right is now out of the picture, which is a little smaller at 73cm x 60cm.

W594 (opposite) is equally remarkable; the same basic subject but a landscape shape, painted extremely vigorously and almost like a sketch, with huge brushstrokes. Monet did not part with it until 1918.

The final two paintings of the scene are in landscape format, made at a later date, with the corn grown. Both are somewhat sketch-like and not in the same category as the first three.

Plaques to commemorate two English residents of Chantemesle.

**W594 Paysage à Vétheuil  –  Landscape at Vétheuil**
61cm x 79cm. 1880.    (Glasgow Museums: Art Gallery & Museum, Kelvingrove)

This quite remarkable picture was painted with great energy and rapidity using large paintbrushes, giving a sketch-like effect.

The next two paintings are known throughout the world. W597 'Au bord de la Seine, près de Vétheuil' (National Gallery of Art, Washington D.C.) and its sister, W598, 'L'Île aux fleurs' (page 110), are of the same view but from slightly different angles, as shown by the numbers and groupings of the poplars. The first is painted upstream of Vétheuil, and looking down across the Seine to the plain of Lavacourt, with the hills of Chantemesle on the right and in the background. The second painting is probably 100 metres down the same river bank. The foreground of both is rural France – banks of wild flowers right across the canvas, the river behind, and beyond, the far bank with willows and about eighteen poplar trees, with their marvellous Impressionist reflections in the current of the

Seine, flowing down to Rouen to the right.

Monet was in his element. Summer, scenery, flowers, trees and the great river tamed for the time being. He painted two more scenes down the river as if to take a break and then produced sixteen more river scenes, at least nine of which are in the world's great galleries today. Only two remain in France, both in private collections. In W601 (page 12) we are looking upstream from a *bras de la Seine*, a backwater, at the church. We are amongst the islands which are there today, where if you are careful you can moor a boat. The water is deep at this point and you are sheltered from the passing traffic. The white house between 'Les Tourelles' and the clocktower is Monet's house with a track running down to the river, where usually his *bateau atelier* was moored. Undoubtedly he was painting from the anchored boat, which is not at its mooring place in the picture. The current, about one knot, is running down the painting, holding the boat at a steady angle.

The next two paintings, W603 and W604, were painted from the hills of Chênay, looking down into Vétheuil, a view that has changed today, for the hills are now heavily wooded.

'Vétheuil en été', W605, a great masterpiece of Impressionism, is a large landscape painting, 60cm x 100cm, of the village of Vétheuil and on the left, l'île Musard. There are four boats in the painting and it is probable that Monet was in his boat, because we seem closer to the island than we would be if we were on shore at Lavacourt. It is a hot afternoon bathed in brightly speckled sunlight. The weather is calm, with lazy clouds reflected in the shimmering water. Like all of Monet's pictures over this period it is signed 'Claude Monet' and dated, 1880. There are five pictures in this sequence of great summer compositions, all with boats in the foreground. In W607 and W608 (opposite), there are two ladies, one with a parasol, and the paintings are done from shore and slightly downstream. In W609, two ladies are setting out a picnic, one carrying a parasol. Clearly members of the family were in attendance. W610 shows a different view, from the south, and the village is blanketed by some large willow trees on an island. This painting belonged to the American painter Theodore Butler and his wife Suzanne (née Hoschedé) when it was first painted. It must have been a gift from the artist, perhaps a wedding present.

Monet enjoyed the mobility that his boat gave him, and painted the next three scenes on the îles de Moisson, accompanied by members of his family. All depict the houses of Lavacourt seen across the river, through a light screen of pollarded willow trees. The first of the three is W611 (page 63). W613 (page 111) has the distinction of featuring the first portrait of Alice Hoschedé sitting on the grass on the right with a full dress and wearing a floral hat.

Monet finishes the summer with two paintings, simple compositions, with the Seine running to the right across the pictures, and the riverbank with houses at Lavacourt and poplar trees behind. W615. W616 is of a stream or brook near Vétheuil, the Rû de la Vallée du Roi near a village called Vienne-en-Arthies.

Monet then completed four portraits, in three cases no doubt to help with his expenses. The fourth, entitled 'Portrait de jeunesse', W619 (page 107), is of Blanche Hoschedé, aged fourteen or fifteen. She was Alice's second daughter, and in 1897 married Monet's elder son, Jean. Much later she ran Monet's household at Giverny. A painter in her own right, she was to paint with, and look after Monet, in his old age. She left this painting to the French State on her death in 1948 and it belongs now to the Musée des Beaux-Arts in Rouen.

In September 1880, one year after becoming a widower, Monet took the train to Rouen for a brief stay with his brother, Léon. He then returned to Léon's holiday villa at Les Petites-Dalles where they had stayed together before, again using the train to the Normandy coast. Here Monet painted at least four paintings, probably all from the same viewpoint, which was the launching slipway for small boats, built over the beach into the sea. It was protected by groynes, wooden breakwaters, on either side, and made a good viewpoint in rough weather, where the sea could not

**W608 Vétheuil**

60cm x 100cm. 1880.   (Christie's. 25 June 2002)

View from the riverbank to the west of the village of Lavacourt. Vétheuil is partly masked by the trees on the Île Musard.

disturb him. Here he painted one view to the south-west and another to the north-east (W621, page 105, and W622), both showing the superb sheer of the cliffs. These were followed by two seascapes, W623 and W624: the painter looks straight out to sea at the waves rolling in towards him.

Each of these paintings is remarkable by any previous standard. Two days' work by the seaside and finished at home, perhaps. Who knows? By studying the wind and the seas, it can be seen that W623 and W622 have similar skies, while W621 and W624 have the same weather effects of overcast sky and north-west 'on-shore' wind, which does suggest that Monet painted two pictures a day for two successive days.

Monet had previously painted in the estuary of the Seine, and made various marine pieces, but this is the first time that he combined high cliffs and high winds. And he records high drama. He has made so many paintings of rivers, mainly calms, but here we see the effect of strong gales on an unfriendly shore and it is obvious that he was able to enjoy such splendid scenes and the business of recording them on canvas. These are major studies. Painting *en plein air* in a gale is very difficult. Quite apart from protection from the weather, there is an enormous problem of keeping the canvas and easel fastened down. It is difficult to find shelter on an exposed beach, saltwater spray and wind-blown sand cut into the face, and drift on to the canvas. These four paintings were Monet's baptism to northern beaches and many more were to follow.

A gale is blowing in W621, which shows five figures on the main slipway, there for launching and hauling out small boats. The figure farthest from the sea appears to have the support of two sticks, one in either hand. Two others are standing looking to the south-west, whilst two are seated. What can they be doing on that slippery green slope in a gale? Perhaps a fishing boat is missing? Maybe they are waiting for the boat to return with its catch and are sitting on the empty baskets ready to fill them with fish. The painting was bought from Monet by Durand-Ruel in February 1881, and he sold it to Denman Ross of Cambridge, Massachusetts, in 1894.

This remarkable Impressionist painting appears to be very roughly painted, yet it is superb. Monet has practically hewn the paint out of the tube and roughly pulled it down the canvas to make the cliffs. He has returned, again and again, to add more texture and yet in places there is no paint at all – as in the horizontal logs which form the upper part of the breakwater. The brushstrokes are circular where the waves break and the small boulders at the top of the beach are just indicated, as it were, with dark curved covers. The figures themselves are just indications, perhaps six brushstrokes per figure, sometimes less. The very roughness of the painting captures the feeling of that blustery September afternoon.

The second painting of the cliffs to the north-east, W622, has a calmer sea, with blue skies and puffy cumulus clouds. The sea is washing over the small seaweed-covered rocks in the foreground, whilst further away beneath the cliffs, which look just the same today, is a line of large rocks reaching out to sea as far as the cliffs are high, probably as much as fifty metres. The cliffs are painted equally forcefully and they are sheer vertically. Monet has strengthened the cliff edge as it curves through three sinuous bends down to a much lower level and there is a welcoming green sward leading back at the clifftop.

W623 and W624 look seawards, to the north-west. The first is of rock in the middle distance and a row of five harmless rollers coming in. It is a delightful sunny day with a puffy, cumulus sky, the sea at its most attractive, invigorating but harmless. The second shows much rougher, overcast conditions. Pure sky, with sea boiling in towards the beach.

A magnificent series of nine still life paintings follows these, and three portraits.

If Monet had to choose, he seemed to prefer to spend his days painting landscapes, outdoors for the composition and if the weather was bad he would complete them in his studio. In Vétheuil, of course, where space was limited, this would almost certainly have meant painting in a busy room, or in one of the chalk caves behind the house, or possibly in the attic. At Vétheuil he did paint a significant number of still lifes and also portraits. More, in fact, per year than he had ever done before. He had only painted five still lifes and ten portraits in his eight years in Argenteuil and during his three years at Vétheuil he painted no less than nineteen still lifes and twelve portraits. It is difficult to ascertain why he chose to make so many studio subjects in a house with no studio at all. Maybe easy sales had something to do with it, for these paintings sold immediately.

Perhaps if we start looking beyond Vétheuil a pattern of work can be found. In his stay at the 'hated Poissy' he only made three paintings at or near that place. In his year and a half there, almost all the pictures were painted in other places, a long way away.

For the painter, as far as the years after leaving Vétheuil until 1884 were concerned, he made eleven still lifes and four portraits, not counting a self-portrait and one of Jean Monet. By this time both families were contentedly living as one, even if the two fathers were away. So it can be seen that the stay at Vétheuil was unique in the production of these very special pictures.

Later, between 1882 and 1885, Durand-Ruel commissioned thirty-six still life canvases to ornament the six doors of the grand salon at his apartment at 35 rue de Rome, in Paris. It took the painter all of three years to complete this task and at the end of it there were six extra paintings which were sold elsewhere.

We return now to the Vétheuil still lifes. The first series of six was completed in the autumn after

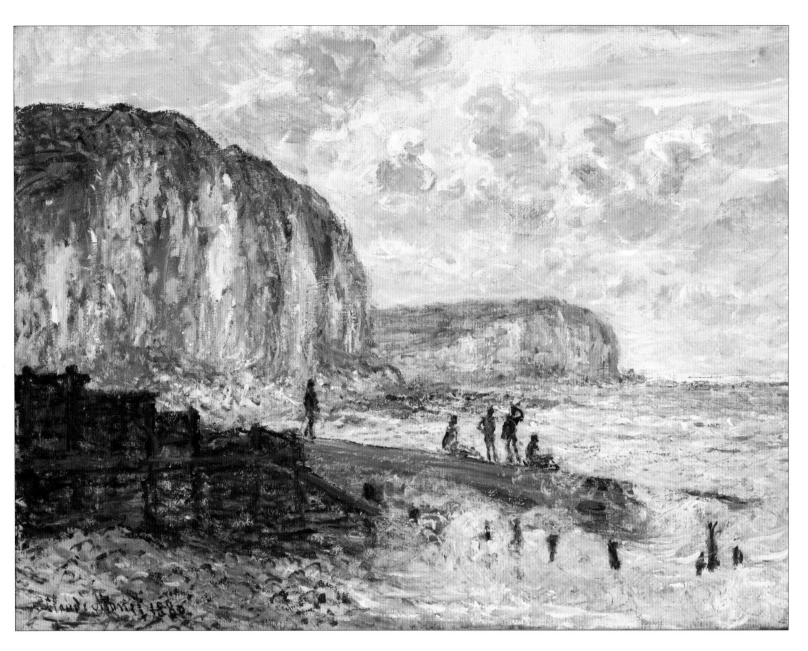

**W621 Les Falaises des Petites-Dalles – The Cliffs of Les Petites-Dalles**
59cm x 75cm. 1880.     (Museum of Fine Arts, Boston)  Denman Waldo Ross Collection, 06.116

Painted in September, 1880, when Monet visited his brother Léon's holiday home.

Camille had died. They are mentioned in a letter by Marthe Hoschedé to her father dated 20th November 1879 in which she writes: 'M. Monet works hard at his nature mortes which are very pretty: yesterday as the sun came, he made an arrangement of fruits on the table which he painted. He has made a little vase of blue porcelain with capucines indoors, and the picture is charming.' The still lifes of pheasants and green plovers (lapwing), W549, W550 (page 110) and W551 (page 84) were painted about 5th December, for Alice wrote to Ernest: 'Mons Coqueret came past and wished to take Mons Monet to La Roche but he would not give up painting his game.'

'Nature morte au melon d'Espagne', W544, is in the Kimbell Art Museum, Fort Worth, Texas.

**W626 Bouquet de mauves  –  Bouquet of Mallows**
100cm x 81cm. 1880.    (The Courtauld Institute Gallery, Somerset House, London)

'Corbeille de fruits', W545, is in the Metropolitan Museum, New York. 'Nature Morte: pommes et raisin', W546 (page 83) is in Chicago, whilst 'Faisans et vanneaux' is in the Institute of Art, Minneapolis. Thus, out of the eight still lifes for 1879, four are in major galleries and four remain in private collections, three in the USA, while only one remains in France. Monet had every reason to fear that too many of his paintings would be sold to America.

The three paintings of game are quite unequalled in their colouring and execution in Impressionist art, and just as beautiful as any of the much earlier and equally sought-after Dutch still lifes of the seventeenth century.

**W619 Portrait de jeunesse de Blanche Hoschedé – Blanche Hoschedé as a Young Girl**
46cm x 38cm. 1880.　(©Musées de la Ville de Rouen) Photographie Catherine Lancien/Carole Loisel

Blanche was about fifteen years old when Monet painted this lovely portrait. She was later to marry his eldest son, Jean, in 1897. She often painted alongside Monet and was later to teach Jean-Marie Toulgouat, her great-nephew and Alice's great-grandson, to paint in Monet's style, using the same bright colours.

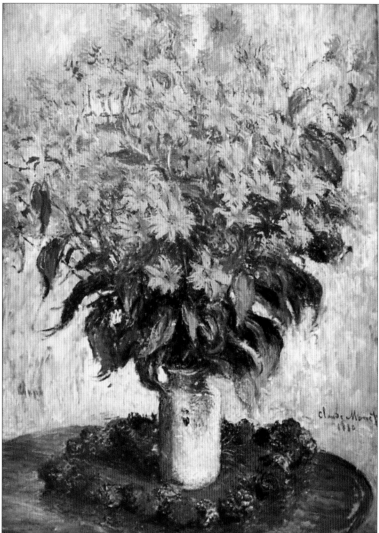

**W628 Bouquet de soleils – Bouquet of Sunflowers**
101cm x 81.5cm. 1880.   (The Metropolitan Museum of Art, New York)

Bequeathed in 1929 by Mrs. H.O. Havemeyer, whose husband
bought it from Durand-Ruel in 1899.

**W629 Fleurs de topinambours – Jerusalem Artichoke Flowers**
100cm x 73cm. 1880.   (National Gallery of Art, Washington D.C.)

The second series of still lifes includes seven flower paintings and two of fruits on a table, all painted indoors in sunlight. Wildenstein says that they were all painted in 1880, and there is no reason to doubt this, even though one is dated 1881 and another 1882. Monet probably dated them when they were sold. The flower paintings are some of the most beautiful ever made. They are all large paintings by today's standards, painted for large houses.

'Dahlias', W625, are in a decorated white vase, with four fallen blooms on a mahogany table. W626, 'Bouquet de Mauves' (page 106), are in a blue-glazed stubby vase on a white tablecloth, with a semi-circle of fallen pollen. This is a large flower painting by any standard, with a remarkable light across it.

'Asters', W627, are in the same vase as the dahlias, on the same table, but with no fallen blooms. There is a mass of over 160 flowerheads in this painting. The design and execution are faultless and

it must have been painted very rapidly indeed. Astonishing bravura and complete mastery is the only way to describe it.

'Bouquet de Soleils', W628 (opposite), are in a straight-sided white vase. One has to be careful with sunflowers in France. The type painted by Van Gogh has the name *Tournesol*: very large flowers that turn with the sun as the day goes by. The smaller variety here is called *Soleil* in France and *Helianthus Chrysanthemum* in England. The table is covered with a red, decorated cloth and the contrast between this and the yellow of the flowers gives the painting great depth.

'Fleurs de topinambours' W629 (opposite), are another type of sunflower with many more leaves than the *Soleils*, and smaller. The same mahogany table has a small square vermilion centrepiece with alternating red and green bobbles around the edges. It is a more delicate painting, as are the flowers, which are lighter yellow than the *Soleils*, with brighter green, smaller leaves.

W630, 'Le Pannier de pommes' was bought from Monet by Delius, the great composer, and has remained in France. A simple rush basket of French apples, with five that have spilled over on to the narrow table.

'Poires et raisin', W631 (below), is much more complicated, but on the same table covered with a cloth. Eight pears, bunches of black and green grapes and two rogue tomatoes in the foreground, are all set out on wispy green leaves. This painting also belonged to Delius.

W634, 'Chrysanthèmes', was bought from Monet by Durand-Ruel in 1882, after signing, and went straight to America. It was gifted to the Metropolitan Museum in New York by Mrs H.O. Havemeyer in 1929.

The last flower painting of this period (W635) has the title 'Chrysanthèmes rouges'. It belonged to Monet's great friend and early benefactor, the painter Gustave Caillebotte of Paris, who left it to the French State as part of his huge bequest of Impressionist paintings on his death in 1894.

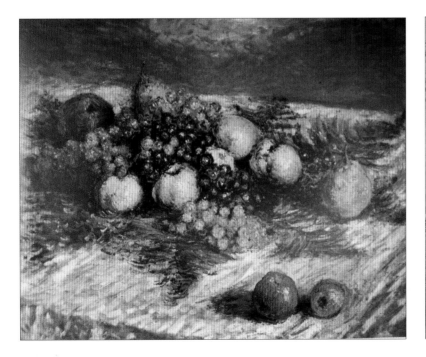

**W631 Poires et raisin – Pears and Grapes**
65cm x 81cm. 1880.    (Hamburger Kunsthalle, Hamburg)

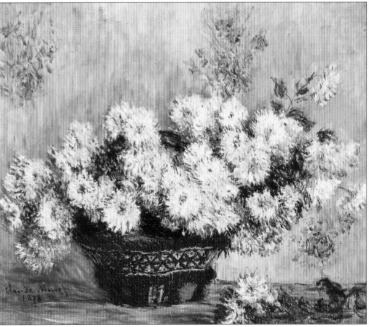

**W492A Chrysanthèmes**
53.5cm x 61cm. 1878.    (Private collection)

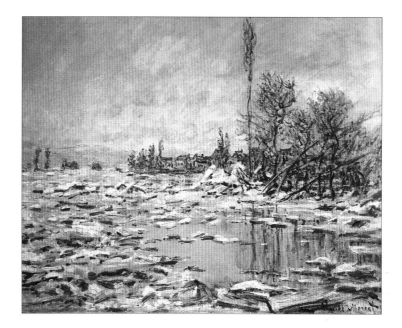

**W560 Le Débâcle, temps gris – Breakup of Ice – Grey Weather**
68cm x 90cm. 1880. (Museu Calouste Gulbenkian, Lisbon)

Such was the opinion in France on Impressionism that it was refused entry to the Louvre in 1896 and in consequence remains in a private French collection. So for the present, the French nation has not even one of these magnificent still life paintings of the Vétheuil period.

All of these paintings were sold quickly and, together with the commissioned portraits, provided much-needed funds for the joint household, which still remained heavily in debt. Monet was

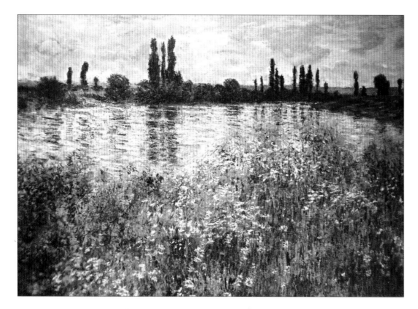

**W598 L'Île aux fleurs – The Island of Flowers**
65cm x 81cm. 1880. (The Metropolitan Museum of Art, New York)

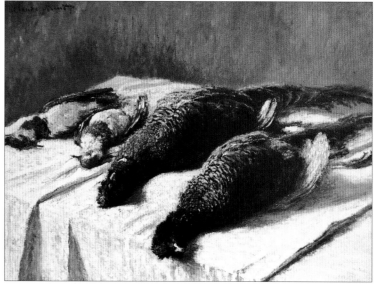

**W550 Faisans et vanneaux – Two Cock Pheasants and Lapwings**
68cm x 90cm. 1879. (The Minneapolis Institute of Arts, Minnesota)

**W592 Sentier dans les coquelicots, Île Saint-Martin –
Lane in the Poppy Field, Île Saint-Martin**
80cm x 60cm. 1880.   (The Metropolitan Museum of Art, New York)

**W613 Femme assise sous les saules  –  Woman sitting under the Willows**
81cm x 60cm. 1880.    (National Gallery of Art, Washington D.C.)

Presumed by Wildenstein to be Alice Hoschedé.

always a spendthrift and lived well. Now with sufficient funds, he was about to start his travels and planned visits to Fécamp, Grainval and Les Petites-Dalles, all on the Normandy coast.

At the end of the year Monet painted the portraits of his two sons, and painted them for himself. Jean was now thirteen and Michel nearly three years old. Both paintings remained at Giverny until the death of Michel in 1966, when all the remaining pictures, and the house itself, were left by him to l'Académie des Beaux-Arts de Paris. This enormous gift to the French State left the remaining members of the Hoschedé family without any benefaction and, to their great credit, no fuss was made about it. The bequest included some 400 of Monet's paintings and his own private collection of other Impressionist paintings, numbering over forty. The Académie des Beaux-Arts instructed one of its members, Daniel Wildenstein, to catalogue the gift and collect the paintings on their behalf. The majority of the paintings, including these two portraits, are now to be found in the Musée Marmottan, Paris. Significantly there was a violent robbery there on 27th October 1985 and the portrait of Jean Monet was amongst the

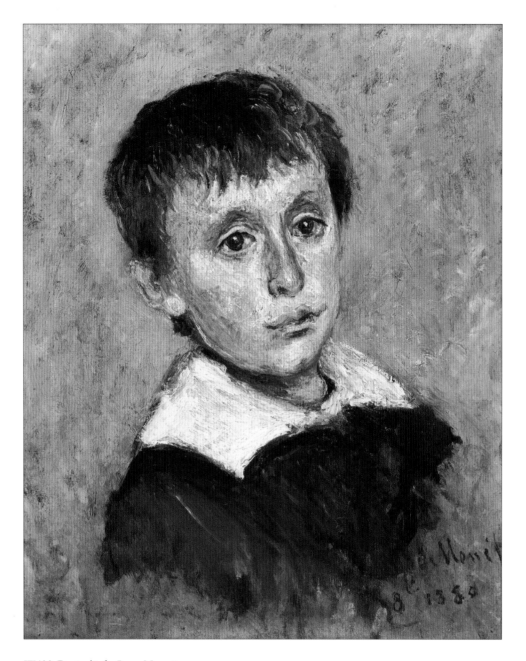

**W632 Portrait de Jean Monet**
46cm x 37cm. 1880.
(Musée Marmottan, Paris/Bridgeman Art Library)

A serious-looking boy, aged thirteen.

paintings stolen. They were recovered with only minor damage in December 1990 in Corsica.

Jean Monet's portrait (above) shows a wide-eyed, slightly startled, little boy of serious disposition. Painted against a light background, he is wearing a dark blue shirt with a large white square collar. Michel also look serious in his portrait (opposite) under his black knitted woolly hat. He wears a vermilion tunic with a white fringe collar which dominates the picture. Together they are a lovely reminder of those little boys, and it is small wonder that Monet, and later Michel, kept these paintings all their lives.

Monet completed another two commissions, in January 1881, of members of the Coqueret

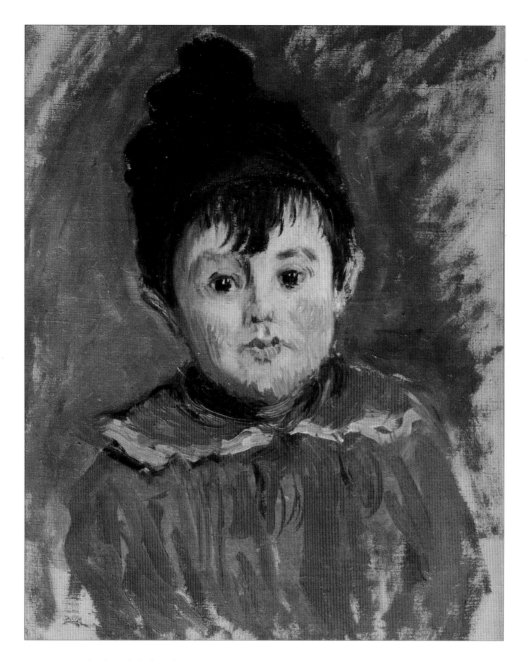

**W633 Portrait de Michel en bonnet à pompom –
Michel Monet wearing a Bobble Hat**
46cm x 38cm. 1880.
(Musée Marmottan, Paris/Bridgeman Art Library)

Michel is about three years old in this slightly apprehensive portrait.

family of Vétheuil. One is of the son, Paul, but the other is not identified. According to Wildenstein the latter painting was found again by Monet in 1920, but was so badly damaged that he destroyed it. M. Coqueret was an instrument maker, who made compasses in his small factory at Millonnets, a village one kilometre north-west of and above Vétheuil. He and his friend M. Serveau, a merchant of Mantes, commissioned six paintings by Monet, which must have been very helpful to the painter. Coqueret is frequently mentioned in Alice's letters to her husband. The painting of Paul Coqueret is now in a private collection in the USA.

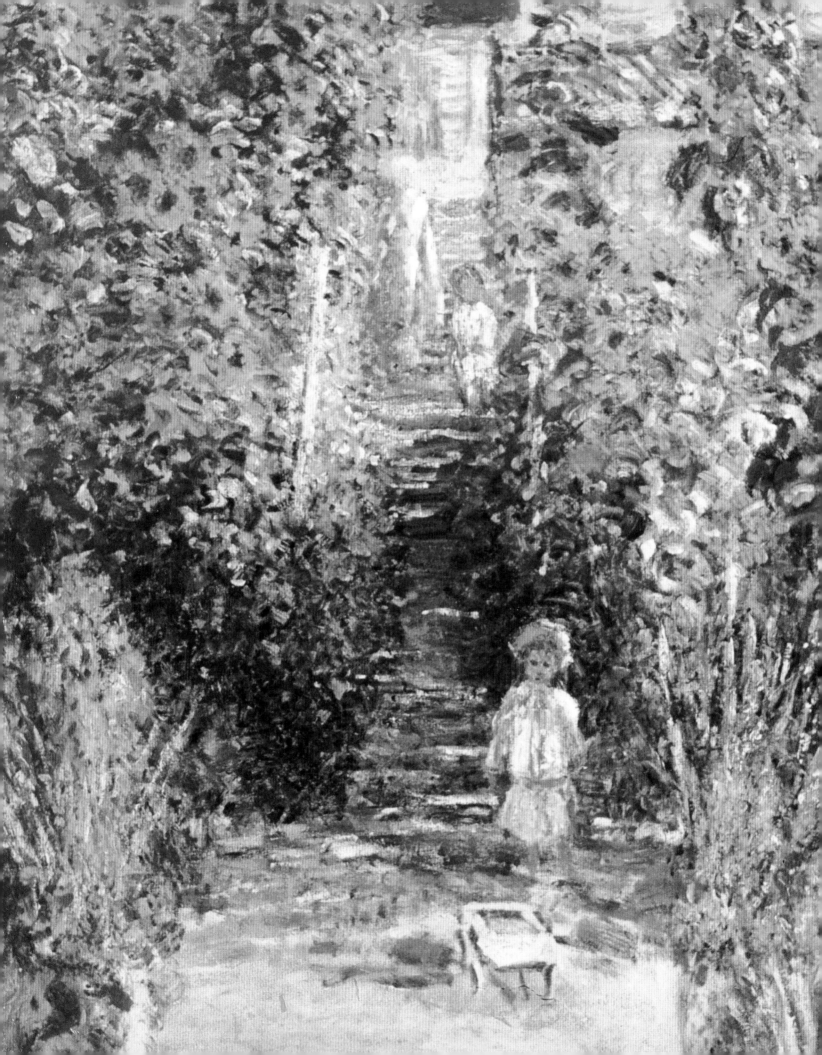

CHAPTER 9

# The Paintings of 1881

There was an *inondation*, a river flood, in the early part of 1881, which absorbed Monet's energies for the first two months of that year. It would appear that the Seine had still not been fully tamed, and that more work had to be done to allow a faster flow of waters through the various barrages to Rouen, and thence to the open sea. Once the engineers had started to improve the canalisation of the Seine from Rouen to Paris there were bound to be floods and freezing weather *débâcles*, after the river had frozen over. It would have been exceptional had the engineers been successful in controlling the Seine at their first attempt. And so it was to prove. The weirs, where the excess water could escape, had to be enlarged and made longer, and bottlenecks in the river itself had to be removed. The best way of achieving the latter was by dredging and where suitable by widening. In addition, the removal of numerous islands was necessary, for they restricted navigation in any event, particularly around Vétheuil and at Port Villez in this section of the Seine. Charts of 1870 show islands which are no longer there today, and at Port Villez a great widening and deepening of the river took place. (See map, page 54.)

Meanwhile, Monet had a flood to deal with, and his boats to make safe, with better and stronger moorings at the bottom of his garden. Monet's house was quite safe from the river flood, for it was at least ten metres above the river, but in his next six paintings one can clearly see the problems for houses beside the river, especially if the water was rough and waves were whisked up by the gales.

In 'La Seine en crue' (in flood), W638, the water level looks to be about three metres higher than normal for the winter. We are looking up river but to the south-west and on the right is the Île de Bouche. Ahead are the turrets of 'Les Tourelles' and just to the right, the church's great clock tower. Monet's house is visible below the turrets. At this point the *bras de la Seine* should be about ten metres across, but Monet shows it at four times its normal width. The Seine is over the top of the island on the right going across to Lavacourt. Monet must have been painting from his *bateau atelier*, sheltered from the wind and rain, at anchor.

The two following scenes, W639 (see page 117) and W640, were painted from the *grande* île de Moisson, now called Île de Bouche. The water level has clearly fallen and Monet has almost certainly put his boat aground, or has actually landed on a piece of slightly higher ground, and fixed his easel into it. Because of the slightly different view, for he is further away and a little further north, the church clock tower is now to the left of 'Les Tourelles'. Spring is more advanced in the second

**W685 Le Jardin de Monet à Vétheuil  –  Monet's Garden at Vétheuil (detail)**
150cm x 120cm. 1881.    (Ailsa Mellon Bruce Collection).  Photo © 2002 Board of Trustees, National Gallery of Art, Washington, DC

The ghostly figure is probably Germaine Hoschedé, just below is Michel Monet with Jean-Pierre Hoschedé at the foot of the steps.

of these pictures, the water lower, and calm, with wonderful reflections. It is a very watery painting.

The next painting in this series, W641, is of Lavacourt village. There is so much water about that it could be a village in Holland seen through the willow trees. The Seine and the flood have taken over completely, and the water is almost, but not quite, lapping at the front doors of Lavacourt. The river must have risen about five or six metres above its normal level to do this. There is no sign of any boat or ferry. It is all water and sky with the horizon one-third of the way up the picture.

In W642, 'L'Inondation', Monet took his boat over to Lavacourt, to see what was going on across the river and he would have been astonished, for the whole plain behind the village is under water, as far as the hills in the background. In the left foreground a copse of nine trees seems to be under three metres of water, for the lower branches are only just above the surface. Monet must have been in his boat with ample refreshment. It is windy and the water rough, clearly not a day for water sports!

The final painting, W643, 'Le Château de La Roche-Guyon' (page 119), six kilometres from Vétheuil, is puzzling, for the Seine is a wide river before the château and Donjon de La Roche-Guyon, and it would seem more likely that the screen of trees, right across the centre of the painting, is hiding the river behind it, and what we are seeing is flooded fields. Either way, the great castle dominates the hills and the village, as it has done since Norman times, with its group of fine buildings including the château below. All of this is reflected in the calm of the flooded meadow or river beyond. It was in this château that Field Marshal Rommel had his headquarters during the allied invasion of Normandy. The bridge across the Seine, which the retreating French army destroyed in 1940, has yet to be replaced, but the supporting pillars can still be detected on the river banks. You can take a boat alongside a stone quay on the north side of the river, but beware of obstructions, the mooring place needs a good clean out.

The magnificent château was the seat of the Ducs de Rochefoucauld for over four hundred years, and has only recently been sold to the French state. No doubt a new use will be found for it, but meanwhile it continues to dominate one of France's most attractive villages.

Now, for the second time since his arrival at Vétheuil, the painter moves back to the cliffs beyond his old home at Le Havre and Sainte-Adresse, and to his old playgrounds of Fécamp, Grainval and Les Petites-Dalles, a short train journey from Rouen, and even shorter from Le Havre. With twenty-two canvases and all his painter's equipment the train was vital for Monet's journeys away from home.

Monet arrived at Fécamp on 9th March 1881 and stayed, as he had before, on the Grand Quay at the home of M. le Marrois. He had intended to stay for two weeks only, but this was extended to a month, and of that he spent the weekends with his brother, Léon, at his villa at Petites-Dalles, which is fifteen kilometres to the north-east. The assumption is that Monet went to Rouen and on to Fécamp by rail. Les Petites-Dalles was then reached either by local coach or on foot. Communication was by post or telegram.

Fécamp has a proper harbour at the mouth of the Valmont River. It is quite different from Étretat which only has a pebble beach, where small fishing boats are hauled out of the water and up the beach by capstans and manpower. All the north-facing beaches and ports are very exposed to the prevailing south-westerly winds, particularly when the wind veers round to the north, as it so often does in the winter months.

The harbour at Fécamp is very well sheltered. Like other Channel ports the twice-daily tides can reach a height of nine metres at springs and five metres at neaps, giving a wide range of water levels. So it is not surprising to find that Monet's first paintings are of fishing boats, which have been beached for the necessary springtime maintenance work. They are substantial boats, two-masted, with squared topyards, bowsprit, jibs, main and mizzen sails. Monet also painted these elegant deep-sea fishing boats in many of his later pictures.

In W644 (page 121) and W645, 'Bateaux échoués à Fécamp', he paints the same fishing boat. In

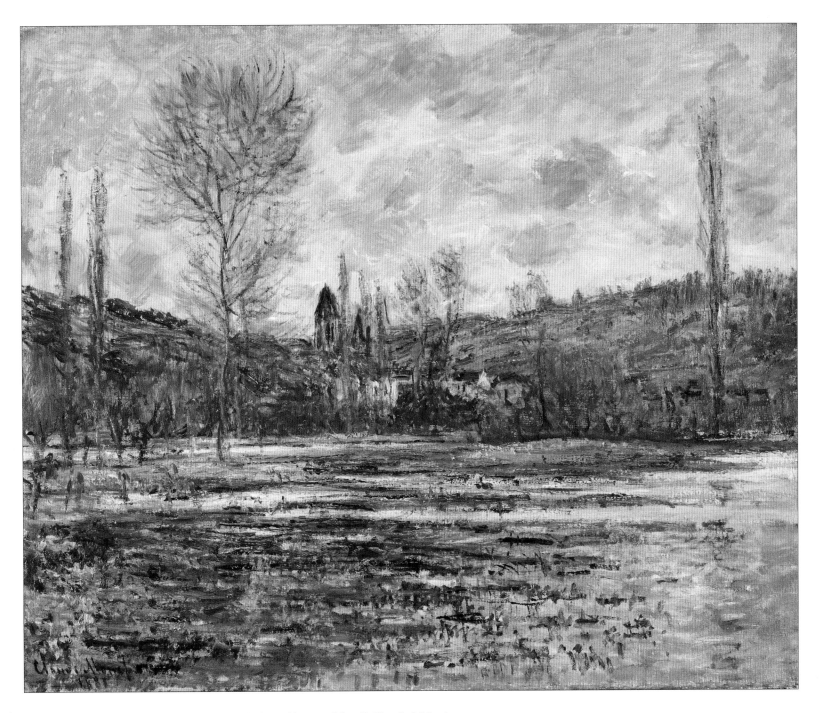

**W639 Vétheuil, prairie inondée – Vétheuil, Flooded Meadow**
60cm x 73.5cm. 1881. (Christie's Images Ltd.)

The floods have submerged the Île de Moisson and the river now stretches from Monet's garden to the fronts of the houses at Lavacourt, and then across the plain. From this viewpoint the turrets of Les Tourelles are to the right of the Church tower.

the first painting she is stern-on and in the second, bows toward. A perfect subject for him, with his love of boats, their hull lines, masts and rigging and you can be sure that he painted them accurately.

The tide is out in both paintings and the boat lies at an angle on the hard sandy bottom, at the side of the outer harbour. She is resting on her port bilge in the first picture, W644, with men working on her starboard side, which towers above them.

In W645, the vessel has been refloated on a subsequent tide and turned, to rest this time on the other bilge, whilst the men work on her port side. It is early spring so they have probably scraped barnacles and weed off the lower hull, and caulked and repainted the bottom of the boat between successive tides. This quick hull refit was recorded by Monet, in detail, with the houses on the main quay in the background. The port anchor is lowered in the first study and the starboard in the second, making a nice feature against the black hull. A much smaller fishing boat, with the bows visible on the right of the painting, has the letter 'F' on her bow showing she was registered at Fécamp.

In W646 Monet turned his attention to the stone breakwater, and Fécamp lighthouse at the harbour entrance. It is a blustery day, probably high tide, with a good sea running, judging by the size of the waves beating on the steeply shelving shore. There are two fishing boats in the distance to the south-west, and the cliffs of Fécamp and Grainval run from left to right across the horizon to Pointe du Chicard, just beyond the fishing village of Yport. Beyond that is the open sea of the English Channel.

The painter would have been in a perilous position at the top of the beach, almost trapped between the raging sea and the rocks and cliffs behind him. Monet loved that sort of situation and no doubt anchored his easel with rope tied to a rock. He needed to, for his substantial canvas measured 54cm x 73cm. There must be some sand in the paint! Monet kept this painting, which was not sold until 1962, by Michel.

Having painted the harbour scenes and then the entrance, Monet took to the cliffs and painted

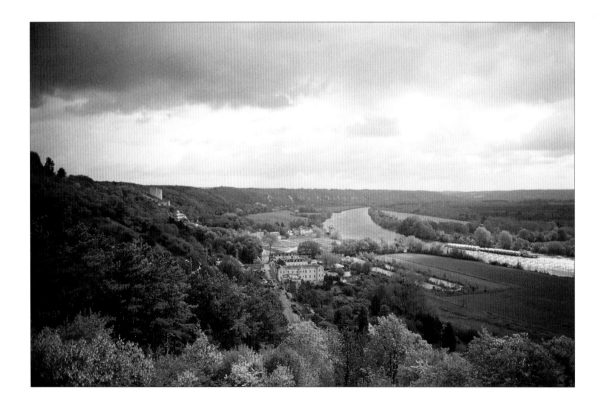

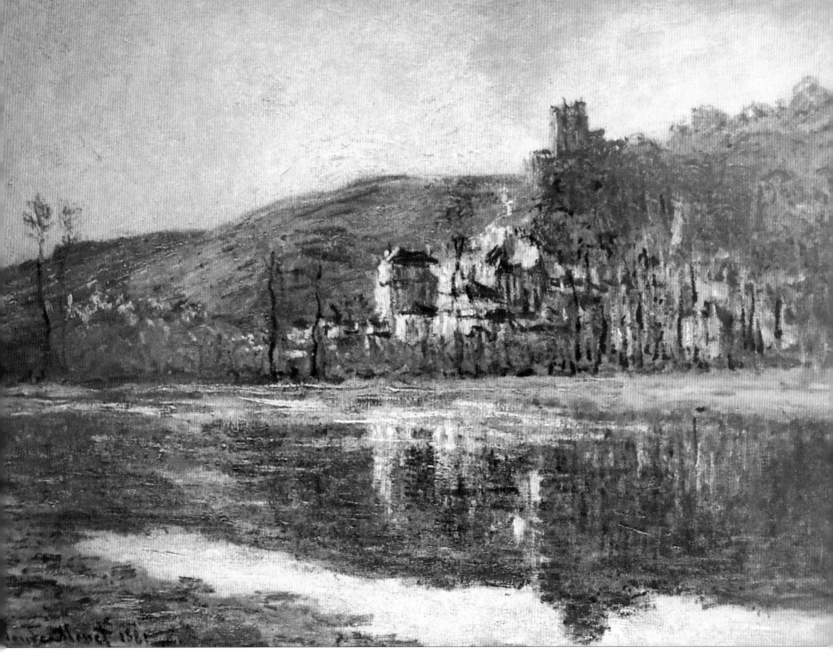

**W643 Le Château de La Roche-Guyon**
60cm x 80cm. 1881.   (Private collection, USA)

The Donjon sits high on the hill above the chateau, which is set into the chalk cliffs and surrounded by the pretty village.

Opposite. The Donjon, left, overlooking the village and the newly reconstructed gardens of the Château by the river, with barge traffic moving eastward up the Seine towards Vétheuil. Photographed in April, 2002.

119

four pictures above Fécamp and a further five below, from the beach, W647-W655. He then moved further along the cliffs to the area seaward of the village of Grainval, and from this vantage point on the cliff, and looking to the north-west, he painted the cliffs of Fécamp in the distance in four paintings. Then he painted a view to seaward.

Next are three magnificent seascapes (pages 125, 138), followed by two cliff scenes (page 138), painted from the beach whilst staying with Léon at Les Petites-Dalles. The sea scenes are so similar to those painted at Petites-Dalles in September 1880, that they must have been painted from the same spot. Of the two below-cliff scenes, one is to the south-west, showing the slipway and breakwaters, with three people on the slip. The other is to the north-east, with rocks in the foreground and the magnificent cliffs beyond.

Monet had good reason to be pleased with this intensive work plan. He had made twenty-two fine pictures in a short visit of under a month, including travelling time. A remarkable achievement by any standard.

He returned to Vétheuil towards 10th April and the whole family celebrated Marthe's seventeenth birthday eight days later. Significantly Ernest Hoschedé did not attend, which was hurtful to his family, and particularly to Marthe, his first born, who was close to her father.

Monet went to Paris on 29th April, with a large number of paintings, of which Durand-Ruel bought twenty-two the following day for three hundred francs each. They included eighteen views from Fécamp and Les Petites-Dalles. From Paris he returned exhausted, but he realised that his future was assured. His enormous efforts were beginning to pay off and he was becoming well known.

Monet was painting again by mid-May 1881, with a relaxed start in his own garden across the road from his house. Looking back from the orchard, he painted W666 (page 126), the lowest section of the steps leading down from the road in bright sunlight, with just the right-hand end of the top of his house to be seen, behind a screen of leaves and branches. This painting is the preparatory lead-in to his great series of four paintings known as 'Le Jardin de Monet à Vétheuil', in which he painted his blue and white Delft vases, and included some of the children. Those four paintings were painted two months later with the *tournesols*, giant sunflowers in bloom.

Having thought about the possibilities of this composition, the painter decided to make an excursion along the chalk cliffs above his house and towards Chantemesle. He probably took the elder children with him for a picnic. It is a walk above the top of the cliffs and just below the tree line, quite safe on the path, despite the height. Monet made three small sketches, *pochades* (see pages 127, 130 and 131). Perhaps the canvases fitted into the lid of a paint box, which he could perch on his knee. All three viewpoints are easily found today, for the rock formations are unique. Monet gave these sketches to Blanche Hoschedé, who would almost certainly have been with him, aged nearly sixteen. She became a successful landscape painter and sixteen years later, as his stepdaughter, she was also to become his daughter-in-law when she married Jean Monet. That was to add just another complexity to the relationships within the Monet/Hoschedé families.

The first of these sketches, 'Les Coteaux près de Vétheuil', W669 (page 127), is made from the path at the top of the cliffs above Chantemesle, and below the aerodrome de Mantes-Charence. It looks back into the village of Vétheuil and has been painted very rapidly and with great strength. Every brush-mark is shaped to the stone or cliff, road or tree; and since it is a very small painting he used quite small brushes. W671 (page 131) looks the other way, with the keep of the castle of

**W644 Bateau échoué — Boat lying at Low Tide at Fécamp**
80cm x 60cm. March/April 1881.    (Christie's Images Ltd.)

This fine fishing barque is receiving her bottom scrub at low tide and the starboard side is being painted.

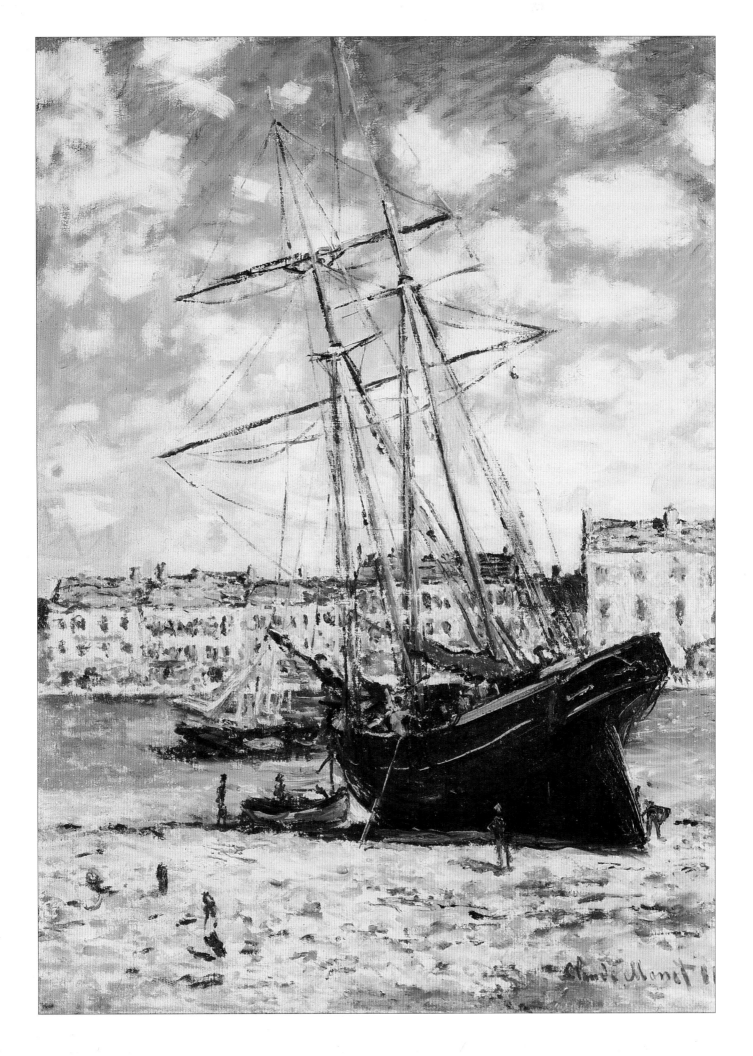

La Roche-Guyon in the centre of the sketch. In both these paintings there is a very high skyline near the top of the picture. In the castle sketch most of the drawing is in prussian blue with green, vert anglaise, chrome green in the meadows and gaps to reveal the ground, which is a pale cream. The cliffs have been 'whitened' and the rocks are ochre. The soil in the fields is *laque garance* (alarizon crimson). The sky has both the green and the crimson in sections to the right. Some of the brush-marks are in circles and some in spirals. The third sketch, 'Le Village de Vétheuil', W670 (page 130), is the view from the *bras de la Seine*, downstream from Monet's house. The colouring is identical to the others but in this case there is more alarizon crimson in the trees on either side of the *bras*.

Blanche Hoschedé-Monet, as she was called after her marriage in 1897, died in 1948. She left these three sketches to the French state, and in 1952 it was decided that they should go to the Musée des Beaux-Arts in Rouen. They were a wonderful inspiration to Blanche, who later on was

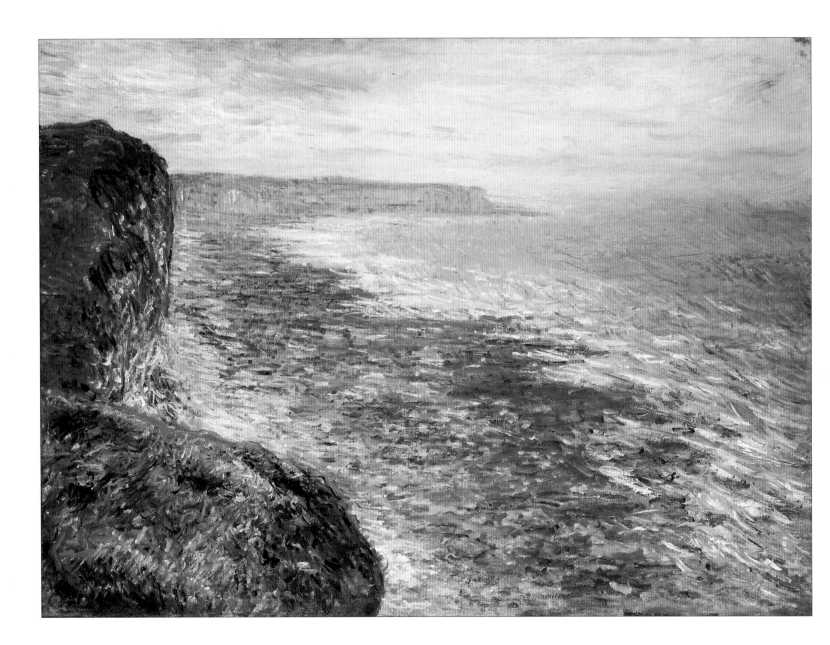

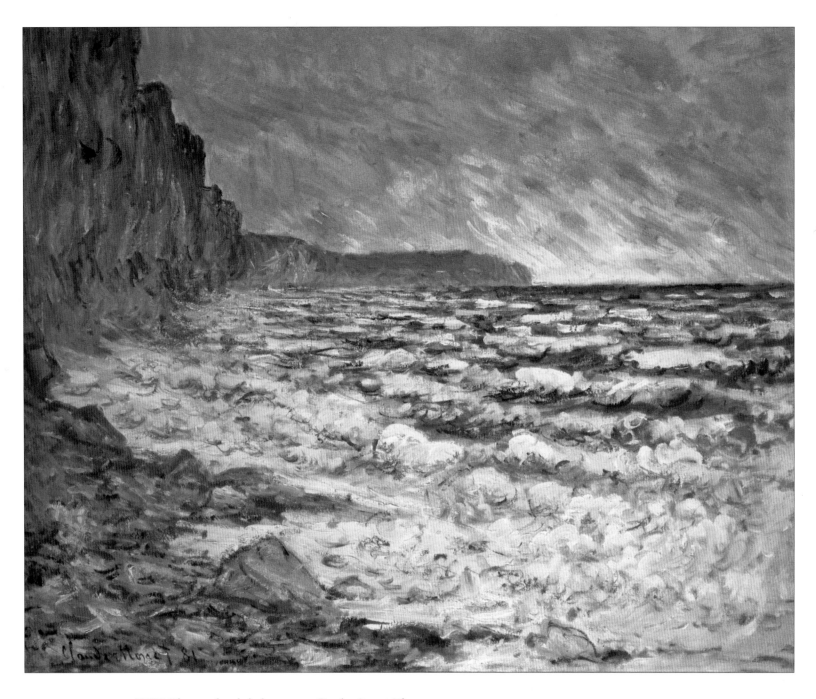

**W652 Fécamp, bord de la mer – By the Sea at Fécamp**

67cm x 80cm. 1881.    (Christie's Images Ltd.)

The same view as in W647, but this time from the bottom of the cliff, looking towards Yport. A strong westerly wind has whipped up the waves over the shallows.

**W647 Près de Fécamp, marine – Seascape near Fécamp**

60cm x 81cm. 1881.    (Christie's Images Ltd.)

This really was the beginning of Monet's successful cliff, beach and sea scenes. Here, from the clifftop, he has painted the sea and the shadows of the cliffs, looking towards Yport in the early evening at high tide.

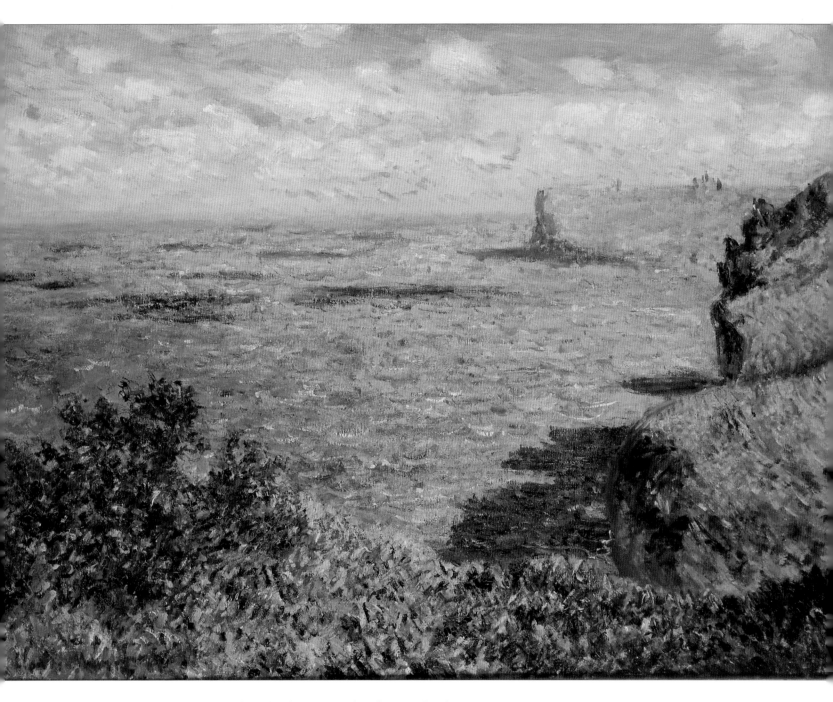

**W655 Vue prise à Grainval  –  View taken from Grainval**
61cm x 81cm. 1881.  (Photograph courtesy of Sotheby's, Inc. © 2002)

This view looks to the east towards Fécamp, with a background of Cape Fagnet.

**W662 Étude de mer  –  Sea Study**
50cm x 73cm. 1881.  (Sotheby's)

A good sea is running with fine waves pouring in. Monet is painting from high on the beach.

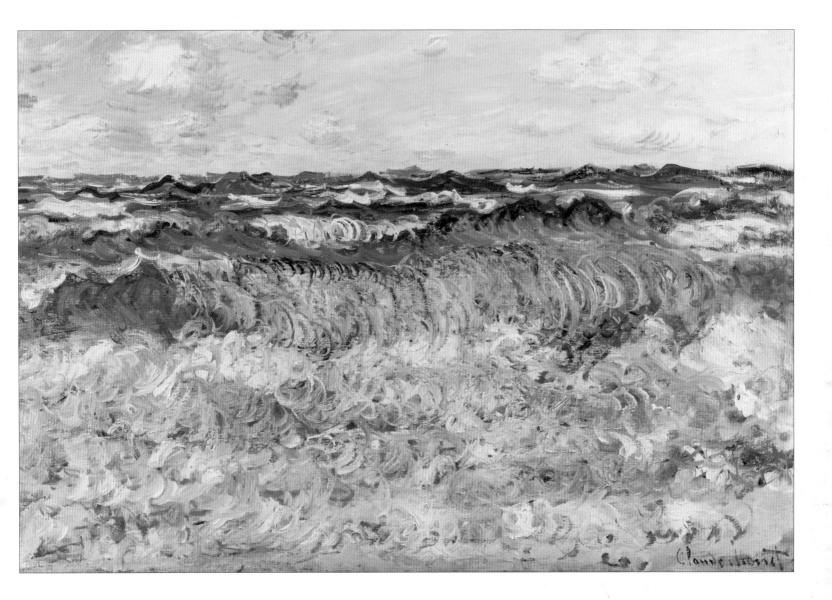

to paint regularly with Monet. After Alice's death in 1911 she continued to run his household and looked after him in his old age.

Monet made one full painting, 'Les Rochers de Chantemesle', W667 (page 138), from just below where the first sketch was made. In the giant cliffs on the left is cut a very large *colombier seigneurial*, a pigeon loft belonging to the Seigneur de La Roche-Guyon which provided pigeons for his table. In this picture the road and the *bras de la Seine* are developed to the right of the scene and the descending hill, not too steep here, has small trees and bushes against the background. One of the trees, a poplar, is a most curious shape as it towers up into the sky above the hills in the background. That seems to have been Monet's last visit to the hills above Chantemesle.

By now Monet had practically exhausted the possibilities of views of Notre Dame de Vétheuil but in W672, 'L'Eglise de Vétheuil', he tried a curious new aspect in which he looked at the church end-on from the west, into the sunset. He is on the same level as the choir, in a field which looks over the rooftops. The clock tower stands out against the faintly drawn hills behind. It is almost as if he were taking a last sad look, before leaving. Significantly, the painting remained with him, and did not leave his home until Michel Monet sold it, around 1965.

Monet returned to the Seine again, with two similar late summer paintings showing the *bras de*

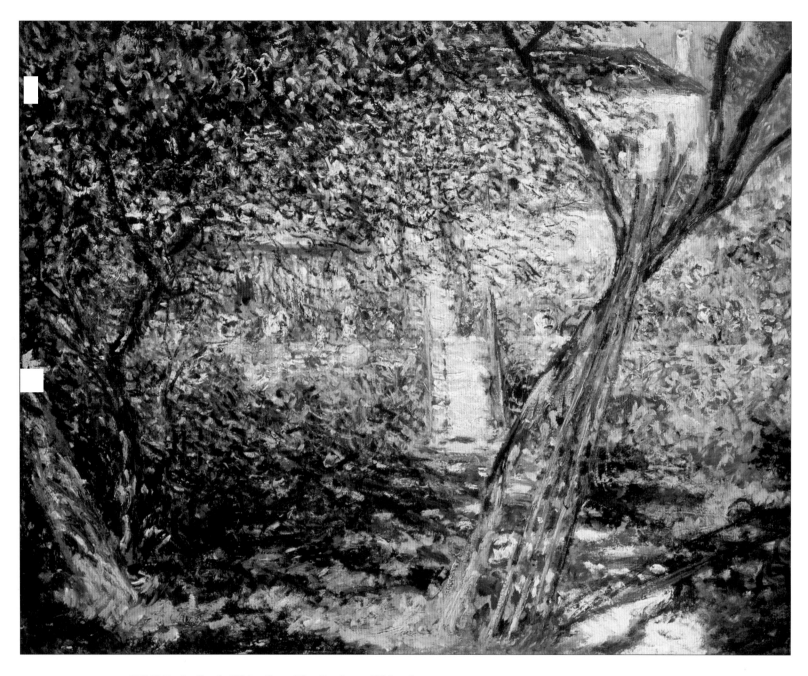

**W666 Le Jardin de Vétheuil  –  The Garden at Vétheuil**
60cm x 73cm. 1881.    (Christie's Images Ltd.)

Monet's neatly-tended garden, mid-year. The steps lead up to the road and across it to his house with a grey tiled roof and two skylights. Behind the painter, not thirty metres away, is the river Seine.

*la Seine* at the bottom of his garden. 'La Seine à Vétheuil', W673 (page 138), shows the hills of Chantemesle on the right, behind a great group of poplar trees with the Île de Bouche on the left. W675, 'Les Bords de la Seine près de Vétheuil', is a more distant scene from one of the islands, long since removed, downstream of Vétheuil. A grassy island with a willow bush, behind which is the great curve of the Seine round Lavacourt, with the hills of Chênay makes the background to the picture.

In 1881 he took his boat to Lavacourt again and painted two fine views of the plain, W676, 'Champ de blé' (page 133), shows a winding path through a wheatfield, with poplars beyond. W677, 'Champ de coquelicots' (page 138), is of an exceedingly attractive wild poppy-filled meadow, with a curiously bent poplar tree to the right, which was on the Plain at Lavacourt.

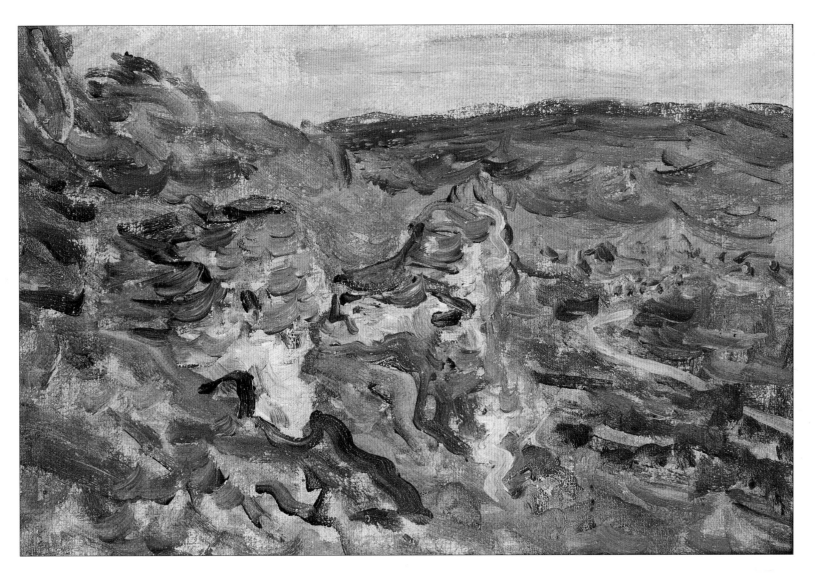

**W669 Les Coteaux près de Vétheuil – Hills near Vétheuil**
14.4cm x 22.1cm. 1881.    (© Musées de la Ville de Rouen) Photographie Catherine Lancien/Carole Loisel

The village can be seen where the road curves to the right.

The Île Saint-Martin, the island that runs up the Seine from Vétheuil to beyond the village of Saint Martin-la-Garenne, is over three kilometres long and up to 350 metres wide. River traffic passes to the west, en route to Paris and to the east en route to Rouen. The island is in the centre of a busy waterway today. Monet had already made paintings from it, including the two great 1880s views of Vétheuil.

He had to pass the Île Saint-Martin on his way back from Lavacourt and decided to make two more paintings, W678 and W679 (page 139), of that highly successful view from the island looking towards Vétheuil, but with considerable variation. In both these 1881 pictures the horizon line of the hills is moved higher, considerably higher in the first one, and there is a lot more foreground of ripening wheat and pathway in both, and of course less sky. In the second painting the trees are more dominant. Both were sold almost immediately to Durand-Ruel.

After these excursions in the boat Monet made six paintings in his garden. The first two, W680 (opposite) and W681, are of Alice Hoschedé sitting at a garden table reading; behind her is the spaced wooden fence and beyond, the Seine. These are charming compositions of Alice, in a summer dress on a summer afternoon. At this time she was thirty-seven years old, Monet was forty-one.

At the upper end of that garden are stone steps leading down from the road. In the afternoon sun, these steps were bordered by rows of great sunflowers, two rows on the right and three rows on the left. Monet had planted a mass of seeds and in the August sunshine was confronted with a sea of golden yellow faces. At the bottom of the steps were his six large Delft blue and white garden pots, planted up with gladioli, not quite in full bloom. Behind all this, and beyond the road, is the skyline of his house, on the right, with three open skylights and blue sky above. The first painting of this scene, W682, is relatively small at 80cm x 63cm. W683 is larger, 100cm x 81cm, and this time the easel has been moved back to reveal the pots and the puffy blue clouds that the thermals always push up in the afternoon in the Seine valley.

Greatly encouraged by what he has done and moving boldly, Monet now makes a similar sized picture, W684 (see page 134), but this time the two little boys have arrived in their sun hats, and are standing half way up and on either side of the steps, giving the effect of young explorers surprising the painter as he works.

His great masterpiece, W685, 'Le Jardin de Monet à Vétheuil' (see page 135), shows three children. The little girl on the top flight of steps on the left is probably Germaine, aged eight, then Michel on the right, and at the bottom in the garden is Jean-Pierre, with his toy wheelbarrow.

At this point the painter decided to take a rest from Vétheuil and visited both Trouville and Le Havre, whilst staying in Sainte-Adresse. At Trouville he took the cliff walk, where on his last visit in 1870 with Camille he had made nine paintings. The cliffs at Grand Beck on the Le Havre side of Trouville are only two kilometres from the town, and it is from here that he might have found the view in W686, 'La Cabane à Trouville, marée basse' (page 132), which shows a great bay with the coastline curving round to the horizon, and at least forty sailing fishing boats putting to sea and going down the English Channel in the distance. The clifftop runs across the left-hand corner of the painting only, and set just below the cliff is a small house with two chimneys. It is more substantial than a *cabane*, being at least a two-storey dwelling, with a magnificent view to the south-west across Le Rade de Caen. The city of Caen is the nearest large town and is but thirty-eight kilometres away.

It is very likely that Monet was taking a trip into the past at this time, revisiting places where he had been so happy with Camille in 1870. The first painting behind the clifftop, W687 (page 139), looking to seaward, is of a blackthorn tree, gnarled and old, leaning away from the prevailing south-westerly wind on the green sward well back from the cliff edge. In the distance animals are grazing.

'Coup de vent', W688, is a vertical canvas, larger at 94cm x 63cm, again on the clifftop looking out to sea, this time perhaps toward Cap de la Hève. On a friendly grass-covered slope is one single

**W680 Alice Hoschedé au jardin – Alice Hoschedé in the Garden**
81cm x 65cm. 1881. (Photograph courtesy of Sotheby's Inc. © 2002)

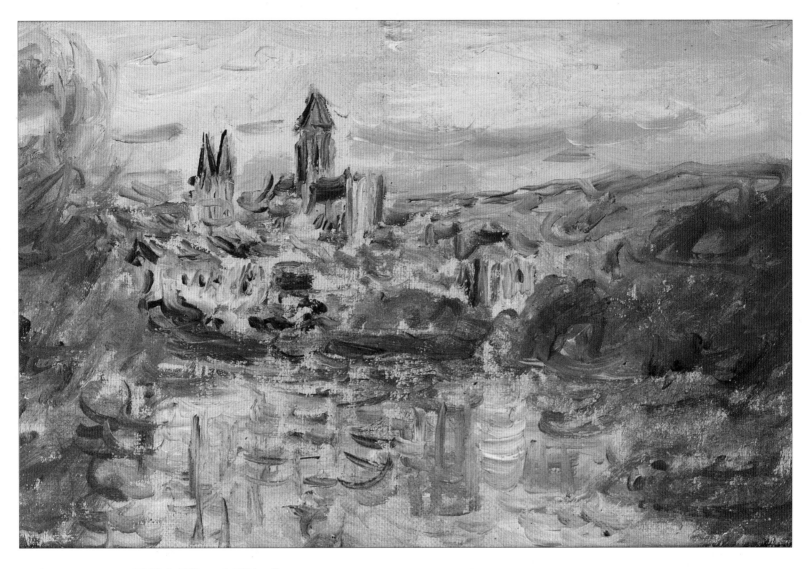

**W670 Le Village de Vétheuil**
14.4cm x 22.6cm. 1881.    (© Musées de la Ville de Rouen) Photographie Catherine Lancien/Carole Loisel
This swiftly executed sketch shows very dramatically the twin towers of 'Les Tourelles', dwarfed by the church.

tree, and behind it a ribbon of trees hiding the clifftop edge. There is bright sunlight, but a great blast of wind is crossing the picture from left to right.

Monet probably then went back to see his old home just beyond Le Havre. On a grey day he again painted 'Falaise de Sainte-Adresse', W689, in a sketchy, more Impressionist style than before. The tide is in and it is a spring tide too, right up to the shoreline and to the tops of the many breakwaters. A single figure is probably sea-fishing. A bit of wind blows from the south-west and a choppy sea is running.

After this excursion, the painter was back in Vétheuil by 13th September, where he could have been expected to put the finishing touches to his pictures. They were never varnished, by him anyway, so adjustments could be made at any time. Monet did not believe in varnishing paintings because his paint held sufficient oil in it to protect the surface.

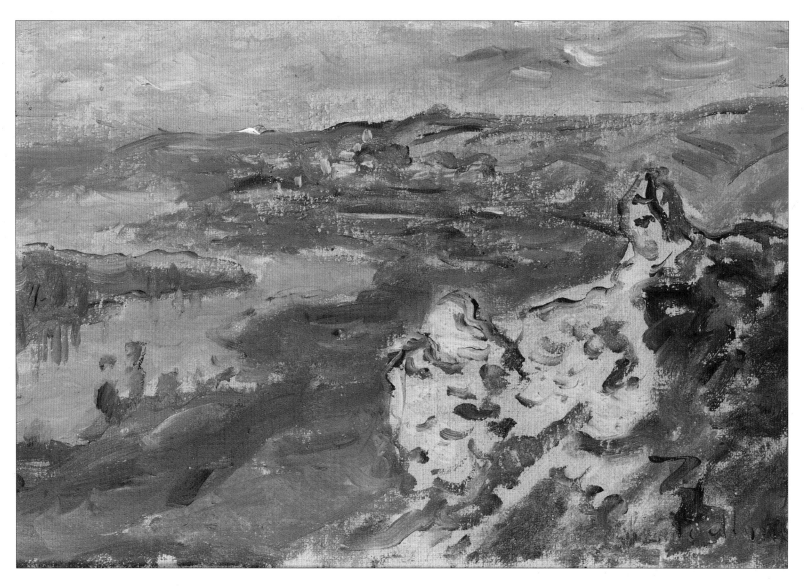

**W671 La Seine, vue des hauteurs de Chantemesle**
**The Seine seen from the Hills at Chantemesle**
14.4cm x 22.3cm. 1881.    (© Musées de la Ville de Rouen)
Photographie Catherine Lancien/Carole Loisel

These three sketches (W669-671) are unique. Monet has walked along the cliff path above the road, but below what is now the airfield, and set down these three views, probably on canvases which fitted into the lid of his paintbox. He gave the sketches to Blanche Hoschedé Monet.

With difficulty, in 2002 the author found the precise spot where Monet painted sketch W671. It was a misty day but nevertheless, the rocks are the same. It proved to be a dangerous rock climb, for the path no longer exists.

The gardens were still full of colour and he made two paintings of the garden gateway to the river. In one of them, W690, a little girl, probably Germaine, is leaning against the right-hand gate post. Two further canvases were painted in the garden with a foreground of massed wild flowers and the river beyond. W692 (page 137) looks straight across at Lavacourt, with a small island in between, the other looks up river towards Saint-Martin with the hills of Chênay behind (W693). The flowers have been identified as climbing nasturtiums.

The last two flower paintings made at Vétheuil (W694 and W695), were of gladioli in small vases. They are very large at 99cm x 41cm, probably life-sized. Whether they were commissioned for Durand-Ruel or not, he bought them in October 1881 soon after they were dry, and kept them until 1897.

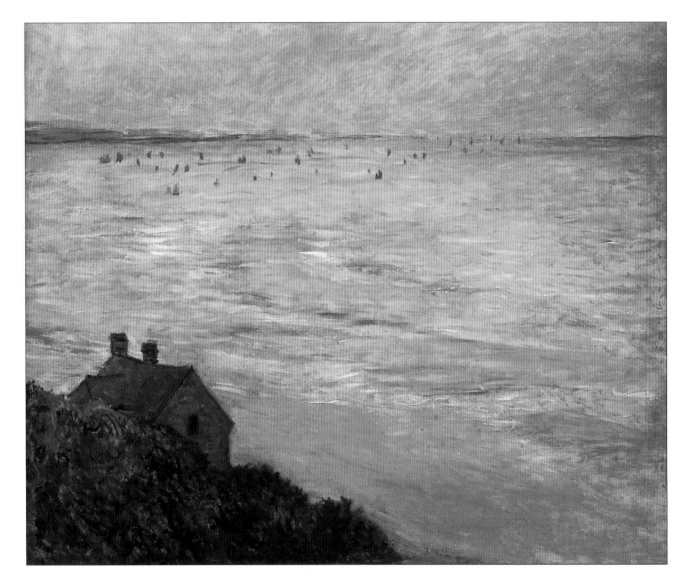

**W686 La Cabane à Trouville, marée basse – The Hut at Trouville, low tide**
60cm x 73.5cm. 1881.   (The Thyssen-Bornemisza Museum, Madrid)

Monet returned to his old haunts in Trouville during August/September 1881. This shows the fishing fleet at sunset working out of Ouistreham and the river Caen.

**W676 Champ de blé – Field of Wheat**
65.5cm x 81.5cm. 1881.   (Cleveland Museum of Art, Cleveland, Ohio)
This field of wheat is growing on the plain of Lavacourt on a glorious day with high cirrus clouds in the sky.

Of the last ten paintings made at Vétheuil, only five are signed by Monet. Those unsigned appear to be either sketches or unfinished. Perhaps he was too preoccupied with packing up, or finding the next house and schooling for the children at Poissy. Certainly, no one knew what was going to happen next in the triangle of Ernest Hoschedé, Alice and Monet. It seemed that the two families would end up by going their separate ways.

Starting with the signed paintings, all of which are to do with the Seine, 'Bords de la Seine, un

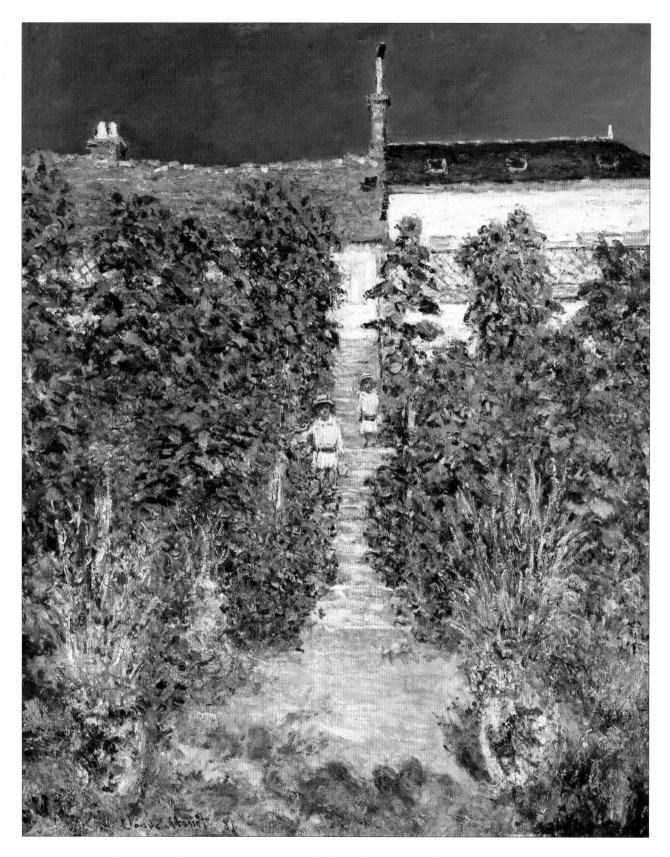

**W684 Le Jardin de l'artiste à Vétheuil  –  The Artist's Garden at Vétheuil**
100cm x 80cm. 1881.    (Christie's Images Ltd.)

Jean-Pierre Hoschedé stated that Michel is the boy on the right and that he is lower down on the steps, on the left.

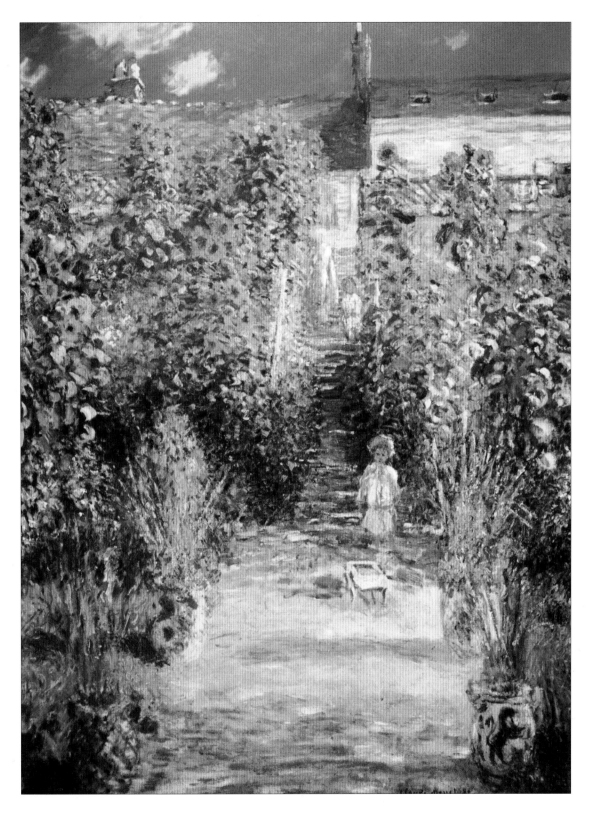

**W685 Le Jardin de Monet à Vétheuil – Monet's Garden at Vétheuil**

150cm x 120cm. 1881. (Ailsa Mellon Bruce Collection) Photo © 2002 Board of Trustees, National Gallery of Art, Washington, DC

These are the last two paintings in a series of four. Monet's house has the darker tiled roof, right background. On the steps of W684 are Jean-Pierre Hoschedé and Michel Monet. Here they are joined by Germaine Hoschedé with Jean-Pierre moving down to his toy wheelbarrow in the garden. Today the garden belongs to a more modern house, on the left, owned by Dr Tabernet and the street has been renamed rue Claude Monet. See detail, page 114, and photograph, page 37.

**W698 Bords de la Seine, un coin de berge – A spot on the Bank of the Seine**
81cm x 60cm.    (Photograph Courtesy of Sotheby's, Inc. © 2002)

coin de berge', W698 (above), is a vertical painting with a high horizon showing a mass of vegetation, grass and flowers, in front of the Seine with the plain of Lavacourt in the distance. Durand-Ruel bought it from Monet in October 1881.

A similar view, W699, is painted in a second edition but it is a landscaped picture with an even higher horizon. This was sold at the same time to Durand-Ruel.

A metre-wide canvas, W701, of the 'bras de la Seine' just downstream of Monet's house, which

**W692 Fleurs à Vétheuil – Flowers at Vétheuil**
60cm x 75cm.    (Christie's Images Ltd.)

The flowers are in Monet's garden, with the Seine beyond and Lavacourt behind the small island which has since been dredged away.

Monet had twice painted before (W673 and W674) includes more of the trees on Ile Musard, and has an evening sky. This has very little history and we know it was unsold in the Drouot sale in Paris on 19th February 1932, number 62. It appears now to be lost.

'Effet du soir sur la Seine', W702, must have been painted from the *bateau atelier*, moored amongst the willow trees, on a bank below Lavacourt. The view looks upstream and one of the houses of that village is seen through the screen of willows, which have been very rapidly painted in the evening light.

**W661 Mer agitée – Rough Sea**
60cm x 81cm. 1881.   (The Fine Arts Museums of San Francisco)

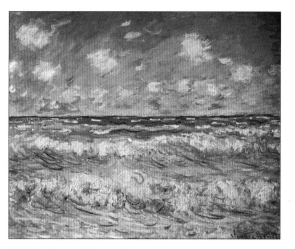

**W663 Mer agitée – Rough Sea**
60cm x 74cm. 1881.   (National Gallery of Canada, Ottawa)

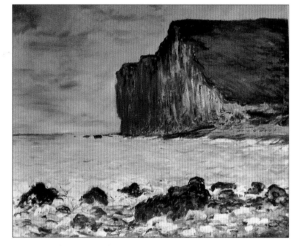

**W664 Falaise des Petites-Dalles –
Cliffs of Les Petites-Dalles**
60cm x 74cm. 1881.   (Private collection)

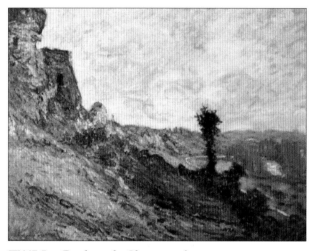

**W667 Les Rochers de Chantemesle –
The Rocks at Chantemesle**
59.5cm x 77cm. 1881.   (Private collection)

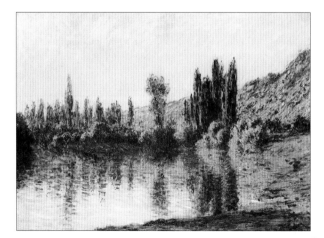

**W673 La Seine à Vétheuil – The Seine at Vétheuil**
73cm x 100cm. 1881.   (Private collection)

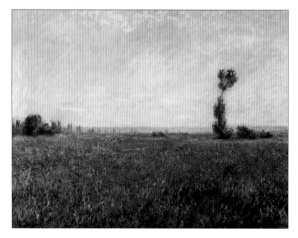

**W677 Champ de coquelicots – Poppy Field**
58cm x 79cm. 1881.   (Museum Boijmans Van Beuningen, Rotterdam)

**W687 Sur la Côte à Trouville  –  On the Coast at Trouville**
60cm x 81cm. 1881.   (Museum of Fine Arts, Boston)

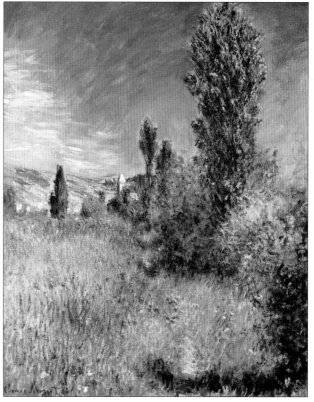

**W679 Paysage dans l'Île Saint-Martin  –**
**Landscape in Île Saint-Martin**
73cm x 60cm. 1881.   (Readers Digest collection, USA)

The last signed painting, W704, is of the loop of the Seine showing the hills of Chantemesle, looking upstream with the tip of the Île Musard on the right – a lovely sunlit scene of the Seine. This was also sold to his dealer in October 1881.

There followed three unsigned views of Notre Dame de Vétheuil and two sketches. 'Dans la Prairie (Vétheuil)' shows a figure standing to the left, possibly Alice, and her eldest daughter Marthe seated in the left foreground. It belonged to Germaine (later to be Mme. Salerou) until she died in 1968. The second sketch, entitled 'La Rivière', is of trees on the riverbank and in the left foreground a rowing boat. This remained with Michel Monet until around 1960 when it was sold.

So ends the list of 232 oil paintings that Monet is known to have made whilst living at Vétheuil. From August 1878 until November 1881 he averaged nearly sixty large paintings per year, relentlessly tracking down the views as he explored the surrounding countryside. A remarkable achievement, in all weathers, including two bitterly cold winters and over the long period of his wife's illness. This was a triumph over adversity by a man of very great determination and inner courage who has since been recognised as a great master of painting.

The Author is well aware that some of the paintings mentioned cannot be illustrated in colour. This is partly because some owners are reluctant to provide photographs for various reasons, including security. Some galleries too will not provide transparencies at realistic prices. However most paintings are shown in much smaller format in the Wildenstein four volume catalogue published by Taschen in 1996. Additionally some paintings have been destroyed by fire or in wars and at least two are stolen or missing.

# THE RELATIONSHIP BETWEEN MONET AND HOSCHEDÉS THE MOVE TO POISSY AND LATER EVENTS

Until they left Vétheuil Alice had been doing no more and no less than her duty. The Hoschedés and the Monets had decided to share a house and expenses after the disastrous failure of 'Au Gagne Petit', the grand store which had supported the Hoschedé empire, including the château at Montgeron. Ernest's spectacular bankruptcy had ruined any immediate chance of a financial recovery, so the poor man took a low paid job as a sub-editor on the Paris newspaper *Le Voltaire*, which meant that he had to live in Paris. At first he regularly visited his wife and children, then, as things became more difficult, he stayed in Paris, in a rented house provided for him by his mother.

Alice ran the household and nursed Camille, assisted by Monet and her elder daughters. After the sadness of Camille's death she continued to care for the eight children, whilst Monet earned his living making pictures throughout 1880 and 1881.

Prior to Camille's death Alice had insisted that she receive the last rites, and also that the church should finally sanction her civil marriage to Monet. This was accomplished on 31st August 1880 when the Abbé Amaury visited the house. Before leaving Vétheuil Alice also insisted on the baptism of Michel Monet, which was conducted by the Abbé, in the church of Notre Dame de Vétheuil on 18th November 1881. Monet, however, was not particular about these matters. Ten years earlier, it is believed, it was only on godfather Bazille's insistence that Jean Monet was baptised.

When Monet's lease at Vétheuil came to an end, as well as his credit, it was important to move on. Ernest Hoschedé wanted Alice to return with his children to Paris but clearly she did not want to take them back to the unhealthy city. Equally obviously, neither she nor Monet knew quite what to do. Monet could not go on painting expeditions without someone to look after his children and yet he knew that he had to work further afield than Vétheuil. So far his homes had moved progressively down the Seine from various addresses in Paris, then to Argenteuil, and after seven years there, to Vétheuil. As a landscapist he knew that he had to move further into the country, though he still wished to be near the River Seine. He also knew that he wanted to paint the sea and therefore visit the Normandy coast with which he was so familiar.

Schools had to be found, particularly for Jean Monet and Jacques Hoschedé who were already in their teens. The schooling of the girls was not a major consideration in those days. At Vétheuil all of

**W707 Dieppe (detail)**
60cm x 73cm. 1882.   (Christies Images Ltd.)

The main building is the gatehouse to the château precint. The Church of Saint-Jacques is to its left.

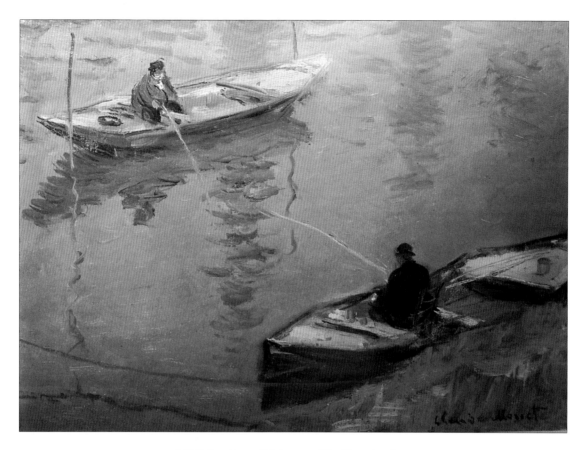

**W749 Les Deux Pêcheurs – The Two Anglers**
38cm x 52cm. 1882.   (Private collection, USA)

**D435 Pêcheurs à Poissy – Anglers at Poissy**

Monet only painted four canvases whilst at Poissy, a place which did not inspire him. His painting of these two fishermen conveys the peace, stillness and reflection. The drawing was made later, to illustrate an art magazine.

Memorial stone at Pourville on the site of Villa Juliette where Monet stayed in 1882. The Villa is in the centre of the spectacular beach where the British 4th Commando landed, as part of the Dieppe Raid, on 19 August 1942 and also at Vasterivel (Varengeville), where Major The Lord Lovat, commanding, destroyed the German Headquarters for the area. See Villa Juliette, page 145.

those eligible had attended the village schools, which were efficiently run by the Catholic Church. It was decided to move to Poissy, a halfway house to Paris which would please Ernest, but, more importantly, fulfil the educational requirements of the two eldest boys. Ernest would be able to visit his wife quite easily, for Poissy was on the main line from Paris. Vétheuil in contrast never had a railway connection. Monet, using the railways, could visit Paris to sell his pictures and go down to Rouen and on to Dieppe, Pourville and Trouville to paint. It seemed a sensible, middle-of-the-road solution.

To ensure that Ernest had freedom to be with Alice, Monet spent most of his time away from Poissy, but wrote to her very regularly. Thus, in mid-December 1881 the joined families were installed in a rented house, the Villa Saint Louis, at 10 cours de 14 Juillet, a large three-storey house with a view of the *bras de la Seine*. Poissy, then a town of 5,600 inhabitants, is twenty kilometres to the west of Paris. It had a *notaire*, two Bailiffs, three doctors of whom one, Dr. Labarrière, was to look after the family and schools for the children: for the boys the public school of the Institution Duplessier, and for the girls L'École Libre des Sœurs Saint-Paul, a convent school. By then the ages of the children were as follows: Marthe, seventeen, Blanche, sixteen, Jean Monet, fourteen, Suzanne, thirteen, Jacques, twelve, Germaine, eight, Jean-Pierre, four and Michel Monet, three.

The two small children, Jean-Pierre and Michel, demanded constant attention and the other six required regular schooling. Additionally the two older boys required a great deal more scholastic attention than was available in the agricultural village of Vétheuil. It was a period of great change in France, of technological advance after the first industrial revolution, iron and steam, and a sound education was a precursor to success. The second industrial revolution, the internal combustion engine, electricity generation and the telephone were just in their infancy in 1890, and it was therefore an excitement yet to come for the boys of this decade. At this time electricity had yet to

Monet's final stay at Vétheuil was in the painter Collignon's studio house at 3 Rue Pierre à Poisson, which is behind the Post Office. Photograph taken in 1998. Note the large studio window to his house.

be made available outside Paris; the first art galleries in Paris were not lit by electricity until 1882 (for the seventh Group Exhibition).

The Hoschedé family, which was bourgeois and proper, had accepted that the circumstances at Vétheuil had caused Alice to be living with Monet and the children there. Somehow they managed to square their consciences, but the new arrangement in Poissy was another matter. On Monet's side there was no-one to be upset about this, except perhaps his older brother Léon. But for Alice's family, the move to Poissy with the artist was a step too far, and she came in for criticism from her mother. However, Ernest had not been a very constant husband. He had seldom visited his wife and children in Vétheuil. It was an awkward day-long journey ending in a rough ride in the coach from Mantes to the village: any visit really meant at least three days away from his work. Apart from this, it must have always been in Alice's mind that Ernest had mismanaged his prosperous, inherited business, and not only had he lost that, but also her inheritance, a great deal

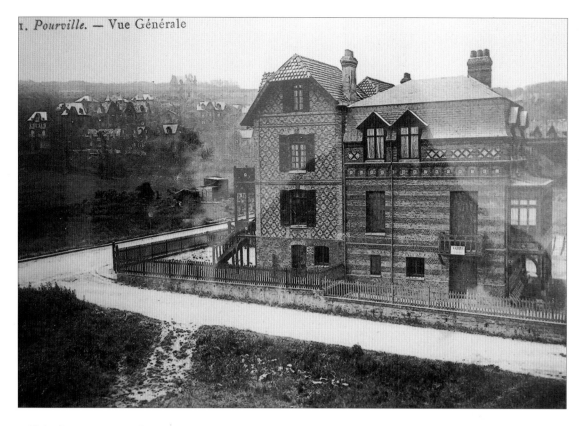

**Villa Juliette at Pourville.**

Monet took the eight children to Pourville for the long French *vacances* from June to September, 1882. The Villa Juliette was destroyed in the Second World War.

**W776 Marée basse à Pourville – Low Tide at Pourville**
65cm x 100cm. 1882. (Private collection)

The church at Giverny looking across the water meadows to the Seine. The Monet/Hoschedé tomb is at the left of the photograph beside the east end of the church.

of her own money and her château. Now he had virtually nothing to offer her. In any event, Ernest's behaviour to her and to the children was unsatisfactory.

On New Year's Day, 1883 Monet wrote a remarkably frank letter to Ernest Hoschedé – Letter number 306 in Wildenstein's numerical order in his great *Catalogue Raisonné*, translated as follows:

Hoschedé                                                                                          [Poissy] 1 January 1883

I would like to tell you of the sorrow that I suffer in thinking that my presence alone prevents you from being with your children today. I had hoped that in absenting myself for some days you would at least have consented and come to spend New Year's Day with them. You have refused to give them this joy. I am bitterly sorry, for you have not missed being here in the preceding years.

However if I am here amongst your family is it not by common agreement, and is it not with your consent that I have been able to rent our house in Poissy?

You know this quite well, but you have decided suddenly not to come here any more and have created a most difficult situation between us.

It will be no more agreeable to read this than for you to see me, but I cannot resist telling you of my deep sorrow.

Claude Monet

This does not sound at all like a letter from a man who has stolen another man's wife.

Absence, it is said, makes the heart grow fonder and both Monet and Hoschedé were absent. Monet was painting in January and February 1883 at Étretat, on the north Normandy coast.

**W707 Dieppe**
60cm x 73cm. 1882.    (Christies Images Ltd.)

Probably the first painting Monet made at Dieppe in February 1882. Painted from the heights to the west of the town showing the church of St. Jacques, left of centre, and to its left the tower of the church of Saint Remy (see detail, page 140).

Hoschedé was in Paris. Monet wrote to Alice every day and she replied to wherever he was staying. Most of his letters of this time are extant today but sadly all of hers were destroyed by Monet after her death at Giverny in 1911.

Thus we will never know the exact time of their decision to make their lives together. But at least from Monet's letters we can see the turning point. Perhaps they had had an affair long before, but of this there is no direct evidence. However, his letters to her up to and until the period at Poissy in

1882, always started 'Chère Madame'. Maybe this was deliberately done to mislead, but the contents of these earlier letters reveal nothing more than friendship and a desire to look after the joint families.

Later on, and in particular in a letter from Étretat dated 31st January 1883, Monet was to write for the first time 'toutes mes pensées, tout mon coeur', and then, on 8th February 1883, 'et prenez mes plus tendres caresses pour vous et dits vous – bien que je vous aime.'

So it might seem that five weeks after the new year, when for the first time in many years Hoschedé did not attend the holiday, that Monet, possibly for the first time, declared his love for Alice. Monet did not return to Poissy for some time, but when he learned that Ernest Hoschedé was to travel there to see his wife on 18th February 1883 he became most anxious. I quote Wildenstein here, with permission, for his descriptive text at this point cannot be bettered:

> 'Monet, apparently so anxious that husband and wife should meet, was suddenly tormented by the thought that he might lose Alice, with whom he had now been living for almost five years. One day when she was slow to return from a trip to Paris, he made half-serious, half-joking remarks that he had to apologise for by return of post, bidding her farewell and addressing her as a woman of loose morals. When Hoschedé and Alice finally met on Sunday, 18th February, and he knew that Hoschedé was actually at Poissy, he was in a state of anguish, could not put brush to canvas, and sent off a telegram asking for news. He wept over the four laconic lines that he received the next day: "Must I learn to live without you?" And, to cap it all, he had forgotten Alice's thirty-ninth birthday on 19 February. It was a trivial point compared to the decision facing Alice, but he was compelled to ask her forgiveness yet again: "You know I am not a man for dates."
>
> Hoschedé, no more anxious for a meeting than Monet, had presumably already left. If any decisions had been made, they did not change the status quo; Alice remained at Poissy, not unhappy to have obtained from Monet written declarations of love and commitment which she had, perhaps, long desired.'

When they left Poissy for Giverny on 29th April, only ten weeks later, Alice and all the children joined the painter for good.

Monet had found an ideal property in early April. It belonged to Louis George Singeot, a large landowner in Giverny, who agreed to rent his substantial 'Le Pressoir' (cider press), a house enclosed by a very large walled garden, and on 29th April Monet moved in with some of the children. Alice arrived the next day. It was the perfect home for them all at last, and seven years later Monet was to buy it outright.

Here it is timely to point out that Monet's principle concern was for his painting. This was more important to him than anything else. Camille knew this, and later on Alice was also to understand this fully. He depended on them both and they in turn on him, but he alone could forge his destiny. Both women encouraged him in his difficult pursuit of changing centuries-old ideas on painting, and both helped him in his great achievement.

Ernest Hoschedé had been a great friend to Monet and a firm supporter of all seven Impressionist painters. He bought their paintings, at more than fair prices, at the start of their great struggle to change the world of painting. Thus he played his part in the birth of Impressionism, and with a good eye he chose his collection well, in the face of some of the most hidebound critics, who were in a very strong position in 1874 when the Impressionists first challenged the establishment. It is recognised now that Ernest Hoschedé played a pivotal and vital part in the birth of this new movement. Monet finally prospered, having suffered great hardship and considerable vilification from the critics, all of whom look foolish today in the light of his quite brilliant success.

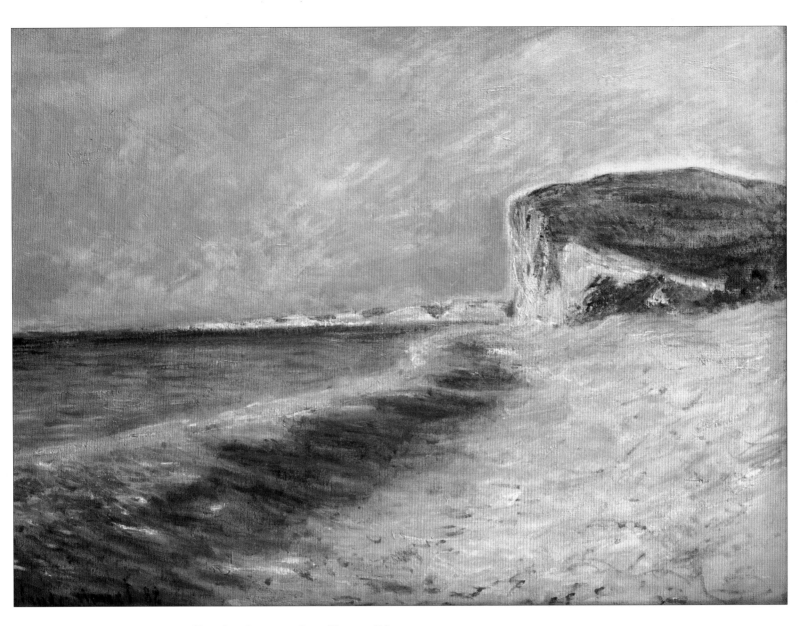

**W717 Pourville près Dieppe — Pourville near Dieppe**
60cm x 81cm. 1882.   (Christies Images Ltd.)

The beautiful beach is curved, which explains the symmetry of this breaking wave.

The joint families lived without visits from Hoschedé until his death in Paris, with Alice by his side, on 19th March 1891. He died, at the early age of fifty-three, of paralysis after a very bad attack of gout. Rather surprisingly he was buried at Giverny, the first member of the family to be placed in what is now the family tomb (page 145). Alice, Monet and most of their families were to be buried in the same place. The tomb is just to the east of the church of Giverny, in the principal position in the graveyard, looking down into the valley of the Seine.

The sequel to this story is that Monet married Alice in a civil ceremony at Giverny on 16th July 1892. Caillebotte, Helleu and Léon Monet were among the witnesses. They were both very anxious to be married so that Monet could take the late Ernest's place and give Suzanne in marriage, four days later, to Theodore Butler, the American Impressionist painter. Suzanne was the

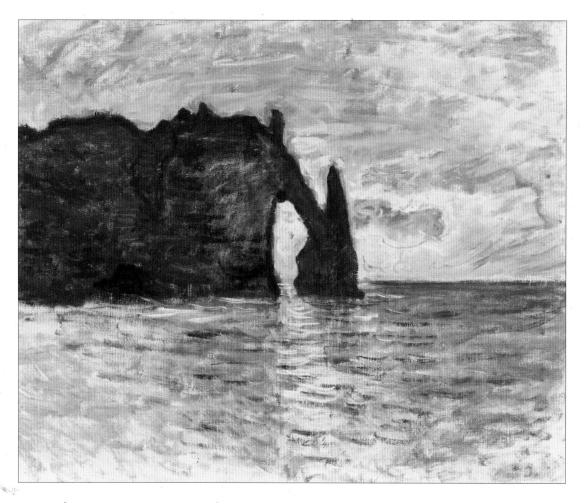

**W818A Étretat, coucher de soleil – Étretat, Sunset**
60cm x 73cm. 1883.    (Sotheby's Picture Library)

There are three paintings of this sunset scene from Monet's visit in January 1883. This is the most sketch-like and was not signed. It has the studio stamp but is quite the most interesting of the three.

first of the daughters to marry. She and Theodore were to have two children: James P. Butler, also to become a painter, and Alice (Lily), who married Roger Toulgouat and had one child, Jean-Marie Toulgouat (to whom this book is dedicated), a landscape painter who with his wife Claire Joyes, the Monet historian, lives today in Butler's house in Giverny.

Jean-Marie Toulgouat was born the year after Monet died, but he grew up at the Monet home, Le Pressoir, at Giverny and was taught to paint by Blanche Hoschedé Monet, who herself had been taught by Monet. Significantly, until 1966, this house held over four hundred of Monet's paintings, including his private collection, all of which were to have a huge influence on the young emerging painter.

In 1966, on the death of Michel, Monet's surviving son, the house and contents were gifted to L'Académie des Beaux-Arts and most of the paintings can now been seen in the Musée Marmottan in Paris. Daniel Wildenstein of Wildenstein Inc., New York, Paris and London, was appointed by the Académie to catalogue and receive the remaining paintings. He gained great fame through this and his very scholarly research for the *Catalogue Raisonné* of Monet's paintings, letters, life and work. The *Catalogue*, of course, can never be complete and has already taken over thirty years to compile.

Sadly, Daniel Wildenstein died in a Paris hospital on 23rd October 2001, having helped this

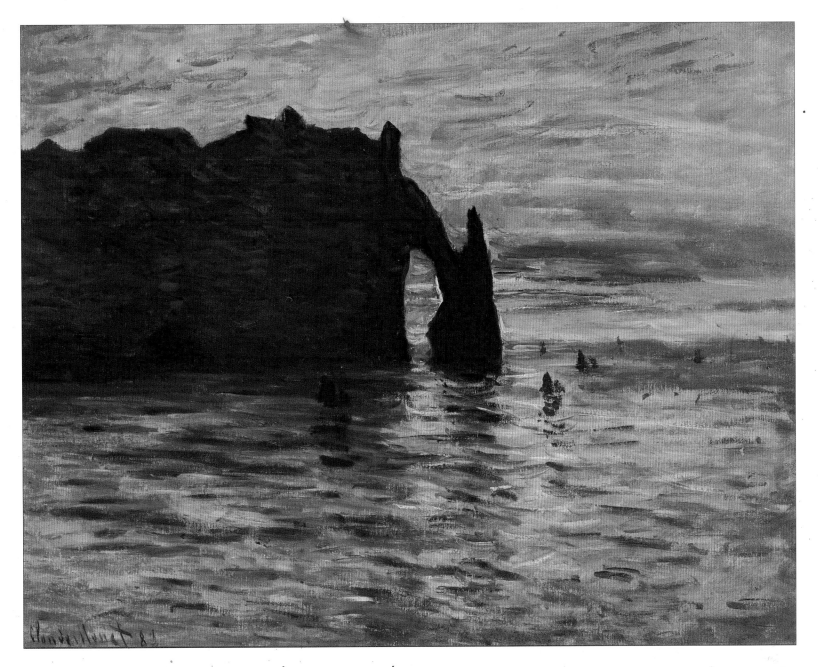

**W818 Coucher de Soleil à Étretat – Sunset at Étretat**
60cm x 73cm. 1883.  (Musée des Beaux-Arts, Nancy)

For comparison with W818A. This is a more finished painting and signed 1883. It shows the Falaise d'Amont (upstream/uptide) with the Étretat fleet going down channel in a light south-westerly breeze, for a night's fishing.

author in many ways with this book. His contribution to the Monet lore was immense, and all students of Monet owe a great debt of gratitude to him and to the Wildenstein Institute.

There are over nine hundred letters published in Wildenstein's *Catalogue Raisonné*, Volumes 1–5, with a supplement yet to come. In addition, there are Alice Hoschedé's diaries, some of which are held by J.M. Toulgouat, and also letters and diaries of Alice's mother, Madame Raingo, some of which have been seen at the Wildenstein Institute. These were first mentioned by the late Hélène Adhémar of the Musée d'Orsay, in *Hommage à Claude Monet* (Grand Palais) in 1980.

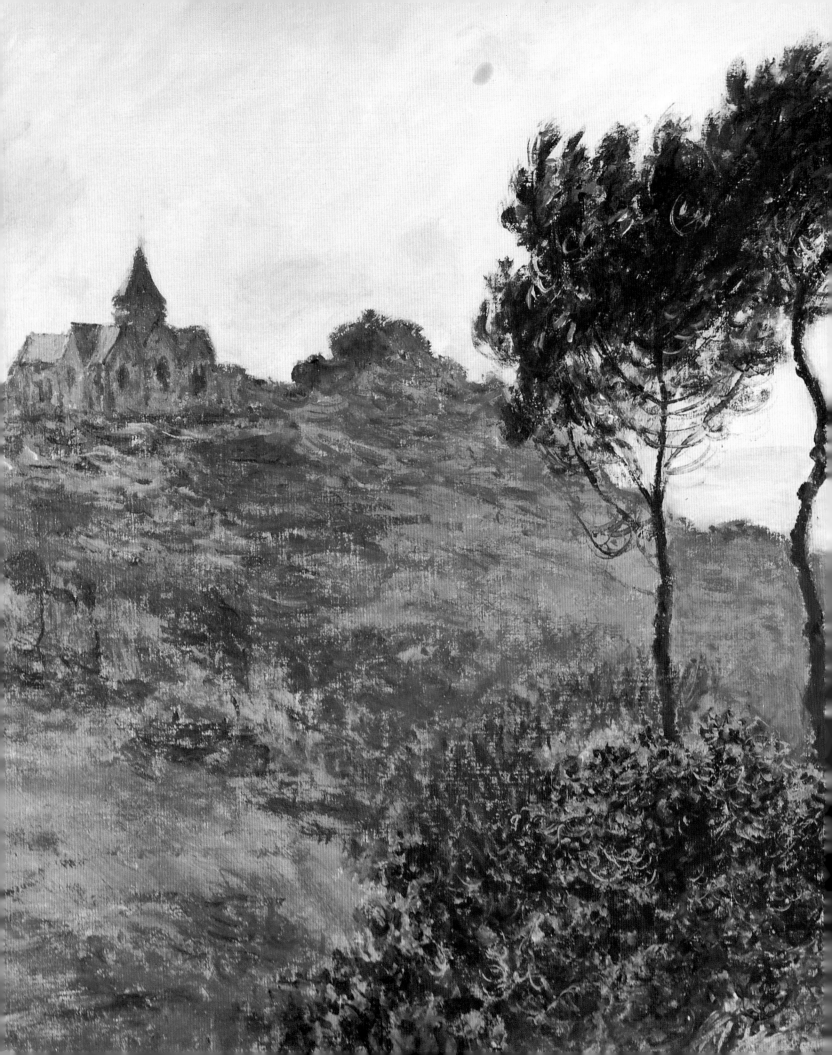

# MONET AT POISSY
# AND ON THE NORMAN COAST

The two families were greatly impoverished towards the end of their stay at Vétheuil, for only Monet was making any income and despite his herculean efforts this quite simply was not enough to support them. There had been no luxuries for three years. In consequence they were to default on payment of rent for the last half year. By this time their landlady, Mme. Elliott, had died and her two daughters, who had inherited her properties, quite rightly demanded the monies owing. When they were not forthcoming, the families were ordered to leave, in October 1881, owing large sums within the village for rent, provisions, laundry, and medicines. A kindly fellow painter owned a small house with a studio at No 3 rue Pierre à Poisson, behind the Post Office and they were allowed to move there temporarily until they could move on to the house they had found in Poissy in December, about seven weeks later.

So without Ernest, the families moved into their new abode, leaving Monet to pack up and follow, escaping their debts. This had happened before, but fortune was about to smile on him – from now on, though he did not know it, debts were to become a thing of the past. His painterly friend Collignon at Vétheuil enabled him to make a tactical withdrawal and a new start, despite, as it was to turn out, having to look after two families. It must have been very difficult to pack up his studio – easels, drawings, sketchbooks, paints, palettes, brushes, art materials, canvases, and stretchers, etc. All had to be loaded on to Papavoine's transport for carriage to Mantes and then on the train to Poissy. One wonders just how many unfinished works were destroyed and paintings given away in lieu of debts.

Monet started his second painting campaign on the Normandy coast, in the first week of 1882. There were to be several more, keeping him away from Poissy, where he only ever painted four pictures, two of fishermen on the Seine, page 142, another of the lime trees outside his villa and the last in the Saint-Germain forest, very near to his house, which he gave to his friend William Fuller of New York, much later on 9th July 1897.

Looking back, there were three periods in which he was away, for a total of seventy-five days during the first 150 days of the year, all spent on the north Normandy coast. Monet considered himself to be a Norman more than a Frenchman. This coastline really was his favourite painting area, for it was his home ground. Great cliffs and vast sea horizons, sometimes rough weather, good seas running with and against the channel tides, sometimes calm, the light on the waves and the sun and the fishing boats, that was what it was all about.

On 1st February Monet started out early but to his annoyance missed the train to Mantes, which

**W725 L'Église de Varengeville, temps gris – The Church at Varengeville, Grey Weather (detail)**
64.8cm x 81.3cm. 1882.   (The Speed Art Museum, Louisville, Kentucky) Bequest of Mrs Blakemore Wheeler, 1964.31.20

would have taken him on to Rouen. He caught the omnibus instead and from Rouen he took the train to Dieppe. Here he stayed at the Grand Hôtel du Nord et Victoria, at twenty francs per day. The letters he wrote almost daily to Alice are our main source of information. He searched high and low for good motives to paint and became depressed in his lonely room. However, a friendly painter lent him his studio and he made two sketchy pictures, one of the port and another overlooking the town (page 147).

Cliffs had always been part of Monet's life. From his family's summer home at Sainte-Adresse he had walked the shore beneath the cliffs, whilst his first visit to make paintings at Étretat was in 1864. There are small cliffs at Honfleur too, not far but on the other bank of the Seine from Le Havre. Perhaps north-facing cliffs, like those on the north Normandy coast, were those that he liked the best. The very tall cliffs from Étretat to Dieppe rise in several places to a height of over ninety metres (290 feet), and for painting purposes north-facing cliffs are much better than south, or east/west-facing cliffs. A north-facing cliff in Normandy will have the morning sun in the east, most of the day the sun will illuminate the sea, with the cliffs casting long shadows, and then the sunset in the west. This is the best way to see the clifftops, whilst walking along the shoreline, with the sun behind.

After his disappointing five days at Dieppe, Monet moved on to the hamlet of Pourville, having found an ideal hotel and restaurant, À la Renommée des Galettes, run by an elderly but gifted chef and his wife, Paul and Eugénie Graff, at six francs a day. Of course it was out of season, in February, which suited him admirably. On fine days he painted from the beaches or on the clifftops; when the weather was bad he painted indoors. He painted the portraits of Le Père Paul, see page 167, and La Mère Paul, and also a splendid still life of the chef's speciality, les Galettes (page 166).

Durand-Ruel played an even more vital role in supporting Monet over this period in spite of his bank, Union Général, being declared bankrupt on 1st February. Because of the need to repay his large loans, Durand-Ruel decided to hold the Seventh Exhibition of Independent Artists at a Palace at 251 rue Saint-Honoré on 1st March. This 'Palace' had been specially constructed to contain a huge Panorama of the Battle of Reichshoffen, yet another French defeat by the German invaders of 1870, and it had an equally large exhibition room on the floor above. It was a curious place for the Impressionists to show their work, and despite the critical press coverage this portrayal of a great patriotic defeat, with modern paintings in the great room above, attracted long lines of carriages to the rue Saint-Honoré, as high society took the opportunity to visit the two new exhibitions in the same building. The majority of the paintings for sale came from Durand-Ruel's stock and included all the major Impressionist painters, who wished to support their main dealer in every way possible. Initially, Monet refused to take part, agreeing only one week before it was due to start, after receiving a letter from Pissarro, saying that he had to participate, to help the beleaguered Durand-Ruel. Renoir had caved in too, even though Gauguin was invited, so Monet could hold out no longer. Even so, Monet no longer believed in large group shows. Caillebotte and Durand-Ruel assembled Monet's entry of thirty-five paintings, of which only a few came

**W714 Bateaux de pêche au large de Pourville  –  Fishing Boats off Pourville**
54cm x 65cm. 1882.   (Christies Images Ltd.)
Monet was captivated by the fishing boats. The caiques used brown sails for fishing and sometimes white sails for light winds.

**W715 Barques de pêche à Pourville  –  Fishing Boats at Pourville**
57cm x 71cm. 1882.   (Private collection)
This painting is one of several that Monet gave to his great friend, the painter Paul Helleu, a keen sailor.

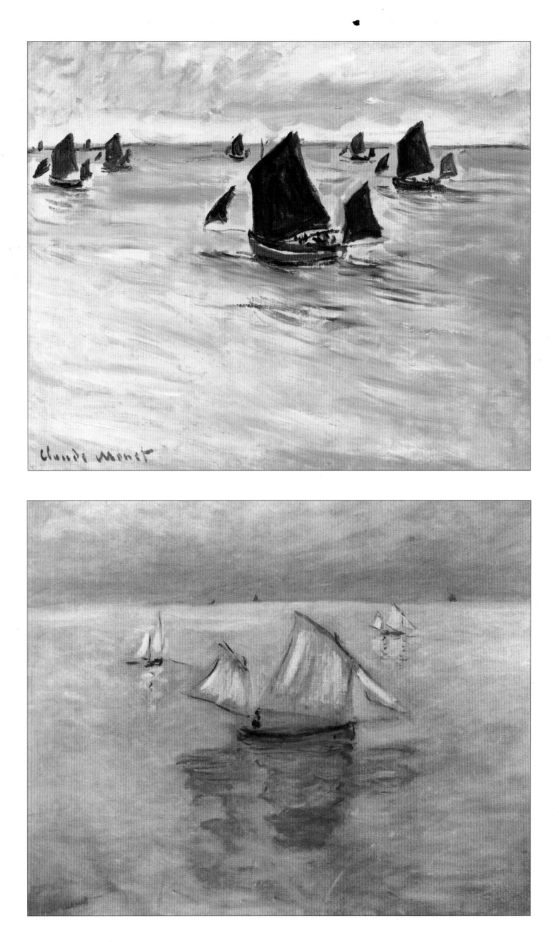

**W716 Marée basse devant Pourville – Low Tide at Pourville**

61cm x 81.2cm. 1882.   (© The Cleveland Museum of Art, 2002)  Gift of Mrs Henry White Cannon, 1947.197

Figures (maybe shore fishermen) are paddling amongst the rocks and pools on a lovely sunny day, with the Falaise d'Amont and the cliffs of Dieppe in the background.

from the Norman coast. The asking price for the best of the Monet paintings was between 2000 and 2500 francs. According to Wildenstein, Monet made a quick return to Paris to attend the opening of the show.

Wildenstein states in his magnificent *Catalogue Raisonné* that he had great difficulty in sorting out which painting of the cliffs was done when and in what sequence. I have every sympathy with him, but it is not too serious if a sequence is wrong. I doubt if even Monet himself could give the correct answer. At least the year of painting is correct. One of the great myths about Monet, and one he liked to encourage, is that he made and finished his pictures at one sitting. This is nonsense,

**W722 Marée basse devant Varengeville  –  Low Tide at Varengeville**
60cm x 81cm. 1882.    (Sotheby's Picture Library)

Monet has set his easel amongst the rocky pools below the Gorge des Moutiers as the tide flows in. The Gorge is below and to the east of the Church at Varengeville. The high cliffs are eroded every year and rock-falls result. Pourville is just round the corner of the first group of cliffs.

as every painter in oils will know. Some of his early works may have been made in one session, but even then I would guess that he adjusted the finish later.

From Paris, Monet returned to Pourville on 5th March, hoping to be back in Poissy by Easter, which was on 9th April, but he had to delay his return for a few days, writing to Alice that he was 'working like a madman', trying as always to finish his pictures. Hoschedé had still not visited his family and had only been able to send Alice 100 francs. The relationship was now very strained between them, although Alice still wrote to him as 'tu', but now she demanded a visit: he was to specify the hour of his arrival in order to avoid any meeting with Monet.

**W725 L'Église de Varengeville, temps gris – The Church at Varengeville, Grey Weather**
64.8cm x 81.3cm. 1882.    (The Speed Art Museum, Louisville, Kentucky)  Bequest of Mrs Blakemore Wheeler, 1964.31.20

The church, above the Gorge des Moutiers, is where Georges Braque (1882-1963) is buried. He designed three of the stained glass windows, but many years after Monet had immortalised the church in this painting of March 1882 (see detail, page 152).

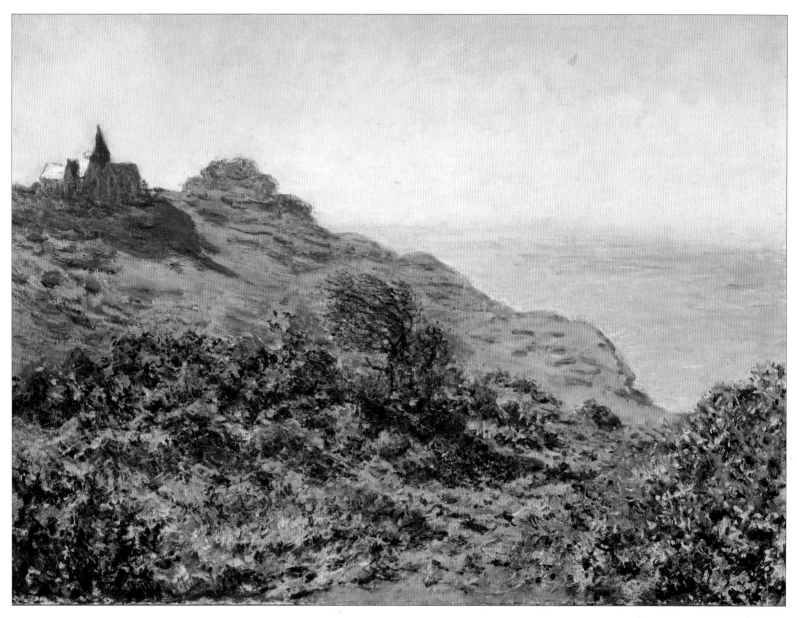

**W728 L'Église de Varengeville et la gorge des Moutiers – The Church at Varengeville and the Gorge of Les Moutiers**
59.69cm x 81.28cm. 1882.
(Columbus Museum of Art, Ohio)   Gift of Mr and Mrs Arthur J. Kobacker

This was painted along a dangerous ridge from a different position further to the right and thus the two pine trees in W725 are out of view.

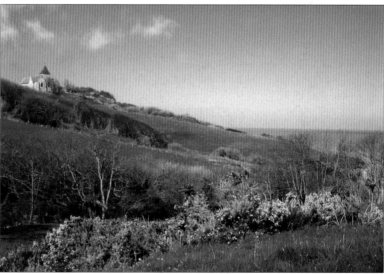

The church at Varengeville in April 2001. Each year it gets closer to the cliff edge, which is slowly eroding into the sea.

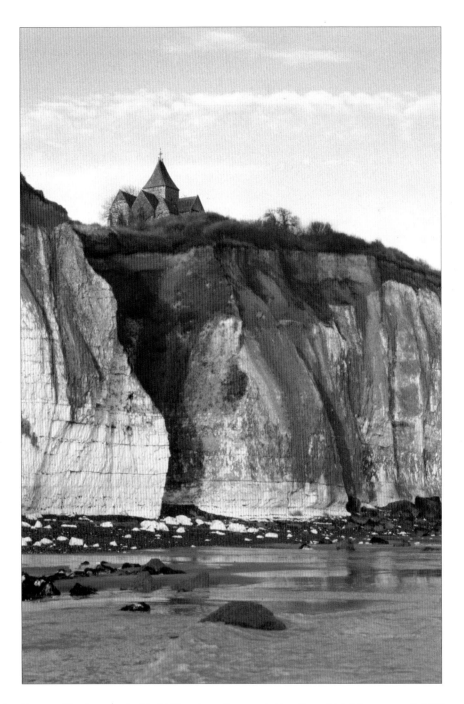

The church at Varengeville photographed in 2001 to show the remarkable effect which Monet recorded 119 years earlier (opposite). The cliffs continue to erode into the sea.   (Photographic adviser: Mike Parsons)

The latter had to vacate his studio/pied à terre at 20 rue de Vintimille, Paris by 15th April, when the rent which had been paid by Caillebotte expired. Durand-Ruel had to wait whilst this was done, receiving sixteen paintings on 22nd April and seven more three days later. He was very pleased indeed with this fresh work, and Monet's future now seemed secure at last. There could be no doubting his brilliant success in producing the most advanced and experimental art of the nineteenth century. The first sixteen pictures brought the painter a total of 6000 francs and the

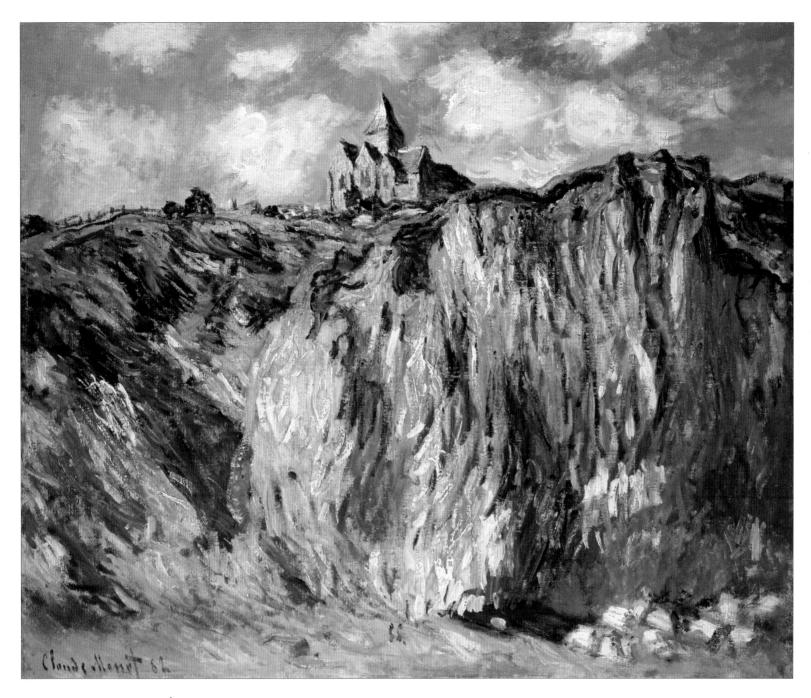

**W794 Église de Varengeville, effet du matin – The Church at Varengeville, morning effect**
60cm x 73cm. 1882.   (Christie's Images Ltd.)

following seven, 2800 francs. This repaid most of the advances made by Durand-Ruel; Monet's pictures were at last selling well and the risks taken by his dealer, against a hostile establishment, were now beginning to pay off.

Monet stayed in Poissy until early June and then returned to Pourville to rent the Villa Juliette for the long summer holidays. He took a further eight paintings to Durand-Ruel in Paris on 9th June and collected some much-needed cash. Georges Petit was visited, possibly for selling his

pictures at too low a price, and then, as the school holidays commenced, Monet returned to the Villa Juliette with Alice and the tribe of eight children.

He had always loved children, and was firm but fair with them, particularly over mealtimes. Anyone late was in disgrace! Here they were in new territory and the man they all called Monet was in charge of all the activities. He took them fishing, sailing, in the lifeboat and in return they helped him to carry canvases and his painting gear to all sorts of exciting places. Some of these were new and some were quite remote sites. No doubt they received strong warnings from him about the dangers of the cliffs, the sea currents and the danger of the rivers and the inland soft marshes. Monet was the key to their happiness for this long holiday, perhaps the best they had ever had.

Monet worked extremely hard, but the weather that July was uncharacteristically poor. The children were very happy and Alice delighted to be away from Poissy. Durand-Ruel visited twice, in July and again in August, staying in Dieppe, for he wished to see for himself the sites which Monet had chosen with such care and which now adorned his gallery.

The bills piled up and twice the bailiffs arrived, presumably a legacy of the Vétheuil days. Monet became despondent but Durand-Ruel sent, quite unsolicited for once, a further advance of 1500 francs together with a letter of encouragement. In late September Monet took the children to stay with his older brother Léon at Rouen. Alice's recent conversations with Ernest had been 'very

Sunrise at low tide, the Gorge des Moutiers in April 2002.

**W729 La Côte de Varengeville – The Coast at Varengeville**
65cm x 81cm. 1882.   (Christies Images Ltd.)

Looking down on the sea from the heights overlooking the Gorge des Moutiers just to the east of the church.

grim' and she asked him to put his 'plans for the future in black and white'. They all returned to Poissy on 5th October. The children went back to school, whilst Monet attended to his many unfinished paintings. By 20th October he had finished no less than a further twenty-six pictures from Pourville which were immediately bought by Durand-Ruel for 11100 francs.

In December, because of very heavy rainfall, the Seine flooded below Paris. Villa Saint Louis was

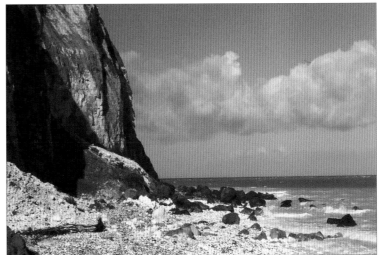

Pourville is seen beyond the cliffs at the Gorge des Moutiers as the tide comes in.   Mid-tide, looking to the west from Varengeville. Both photographed in April 2002.

surrounded by floodwater and the basement filled with dirty river water. After ten days it subsided, leaving Monet to clean up the mess, as his servants had deserted for fear of drowning. Despite this, the year ended successfully. Monet had received 24700 francs from Durand-Ruel against loans of 31241 francs. According to Wildenstein, the deficit was made up on 6th January 1883 by further paintings.

The family was not at all content at Poissy and Monet was on the lookout for a real home. His searches at the end of the year proved negative and Christmas was spent there.

After the resounding success of his Norman paintings, Monet decided on a further campaign based at Étretat, a place he knew well. Accordingly, after a short stay at his childhood home in Le Havre with his brother, where it rained incessantly, he arrived at the Hotel Blanquet on 3rd January. The weather must have improved, for filled with enthusiasm he wrote 'the cliffs here are like nowhere else'. Indeed they are spectacular, seventy-five metres (245 feet) tall, on either side of the sandy beach at Étretat, with all sorts of remarkable shapes where they have been worn by the action of the waves over the centuries.

The Hotel was at the western end of the town beach. There is no port and the fishing boats were hauled up the beach by manpower, using horizontal ships' capstans, an operation in which everyone helped, including the womenfolk. Monet was enchanted with his location and wrote, 'my subjects are at the door of the Hotel and there is even a superb view from my window'. Apart from the fishermen and their families, the place was deserted. He had painted at Étretat three times

**W730 La Gorge de Varengeville – The Gorge at Varengeville**
65cm x 81cm. 1882.

This small cottage was one of the watch houses used by customs officers, built during the continental blockade on the orders of Napoleon. They were then used by fishermen and later, Monet had a key to this one. It appears in 17 of his 1882 paintings and again in 1896 and 1897. The cottage became derelict and the roof fell in around 1942. The foundations eroded and it finally fell from the cliff on to the beach some 70 feet below in the 1950s.

**W736 Cabane des douaniers, effet du matin – The Customs House, Morning Effect**
54cm x 65cm. 1882.   (Christie's Images Ltd.)

Herring gulls are accurately portrayed searching the shore line and sailing on the updraught of the cliff winds.

before: first in 1864 (two), then in 1868 (four), and again in 1873 (one), all during short stays away from Le Havre. From his window on the first floor of the hotel he had a splendid view of the Porte d'Aval, the caiques on the beach and the rough seas. He was in his element for he could paint in some comfort from his room.

Durand-Ruel was to give Monet a one-man show starting on 1st March 1883. He knew therefore that he would have to return with the Étretat paintings by 20th February. Twenty days might have been enough, if the sun had shone every day. There was sun for the first few days and then it rained, to be followed by a storm so bad that the fishermen had to move their boats from the beach to 'winter quarters', behind the sea wall. A changing motif and fluctuating weather was the last thing that he wanted. But it did force a certain variety into his work, to his longterm benefit; a storm is much more difficult to paint than a measured calm. He returned to Poissy with twenty pictures, but not even one appeared in his one-man show. In the gallery Durand-Ruel assembled an exhibition with fifty-six titles catalogued. The Pourville-Varengeville paintings had pride of place.

This exhibition turned into a considerable success. For such an advanced painter, particularly in

**W744 Le Père Paul**

64cm x 51cm. 1882.    (Österreichische Galerie Belvedere, Vienna)

In March 1882 Monet stayed at the modest casino-hotel run by Paul Antoine Graff, a master pastry chef from Alsace. Monet also painted Paul's wife, 'La Mère Paul' and her portrait is now at Harvard. What an exchange for board and lodging!

**W746 Les Galettes**

65cm x 81cm. 1882.    (Private collection/Giraudon/Bridgeman Art Library)

One of Paul Graff's specialities. Large puff pastries laid out on osier racks at his restaurant, which was named 'À la Renommée des Galettes'.

Paris, one could not expect overnight success, though Monet may have done. The press reports were sound and the later ones excellent: one by Philip Burty attracted the gift of a small painting from Monet before publication of his long article in *La République Française* on 27th March. Monet had been impatient, but had a lot at stake.

## MONET and the Exhibitions of the Indépendants

Although this book is about the Vétheuil period and the short stay at Poissy, with three visits to the north Normandy coast, between 1878 and 1883, it is useful to follow Monet's ideas and actions on sales and exhibitions before he became famous.

As a schoolboy, and a not very attentive one at that, the youthful Monet had developed considerable expertise at drawing and making caricatures of his schoolmasters and leading citizens of the great port of Le Havre. These were sold quite openly by Monsieur Gravier's shop, which also sold Boudin's little masterpieces in oil. From his sales, Monet did well, banking the takings with his Aunt Lacadre, and this considerable sum of over 2000 francs was to enable him to live a more extravagant lifestyle than his fellow students in Gleyre's studio in Paris later on. At this stage, sales seemed all to easy, and this must have given him much encouragement.

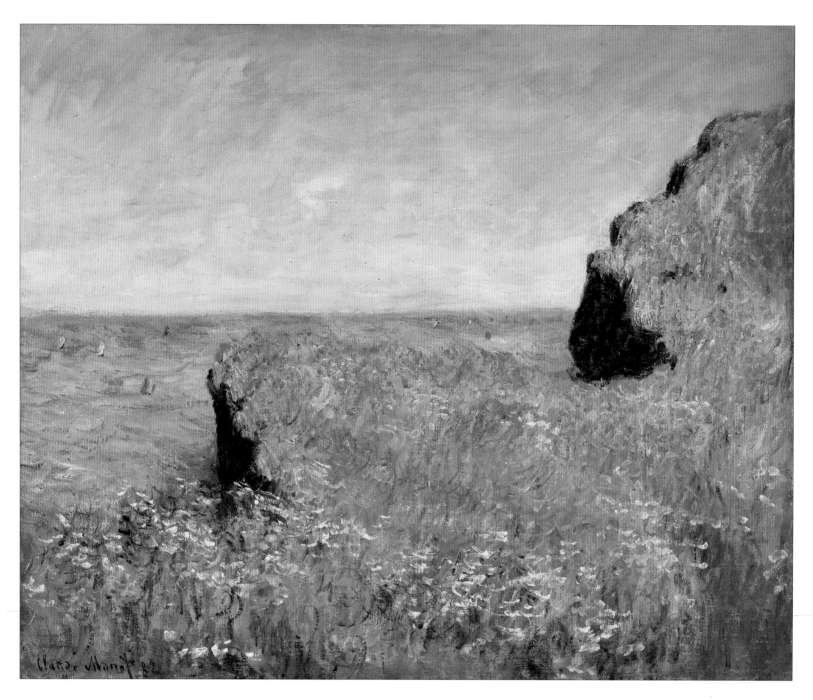

**W757 Bords de la falaise à Pourville  –  Edge of the Cliff at Pourville**
60cm x 73cm. 1882.    (Christie's Images Ltd.)

**W753 Chemin dans les blés à Pourville  –  Path in the Wheat Fields at Pourville**
58.2cm x 78cm. 1882.    (Christie's Images Ltd.)

This path led straight on to the beach at Pourville. Today it is no longer farmed but is a car park. We are looking here along the coast to Varengeville.

However, as time went on, he was to realise that life was not quite so simple in the world of finished paintings, more particularly when a revolutionary style of composing pictures and then painting them was undertaken. It was the convention in France that to become a successful painter you had to submit paintings to the Salon in Paris and if they were accepted you would do well, because commissions would follow. You had to be acceptable, however if you deviated from the norm you probably would not be shown. This had stultified French art for many years, which was hardly surprising. Therefore anyone who wished to change the system was deeply suspect.

When the Impressionists, as they were dubbed, emerged, it was obvious that they were going to have a desperate struggle to succeed. Their battle was just about to begin, and no-one of any importance was likely to back them in the unhealthy French art system which needed new blood, new ideas and fresh thinking.

Although the Salon did not realise it, these so-called Impressionists were about to change the world of art, to become the most popular painters of all time, and Monet was their champion and leader. He was well aware that he should adjust his finished work in order for it to be acceptable to the judges appointed to select the pictures to be hung in the annual exhibition, usually held in May. As a result he had two paintings each in the Salon in 1865 and 1866, one more in 1868, a marine painting, now lost, then finally in 1880 a riverscape of Lavacourt. That was all. He never sent another painting to the Salon. In London he was even less successful, for the prestigious Royal Academy rejected two fine oil paintings which he submitted to their annual show whilst he was

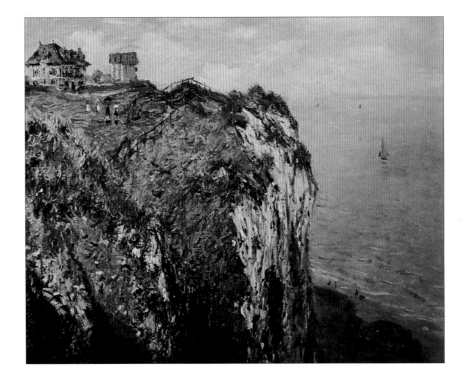

**W759 La Falaise à Dieppe  –  The Cliff at Dieppe**
65cm x 81cm. 1882.    (Kunsthaus, Zurich)

Bathers are on the beach below the tall cliffs to the west of Dieppe. Today these cliffs are totally built over but from this remarkable painting you can see the great height of the chalk cliffs.

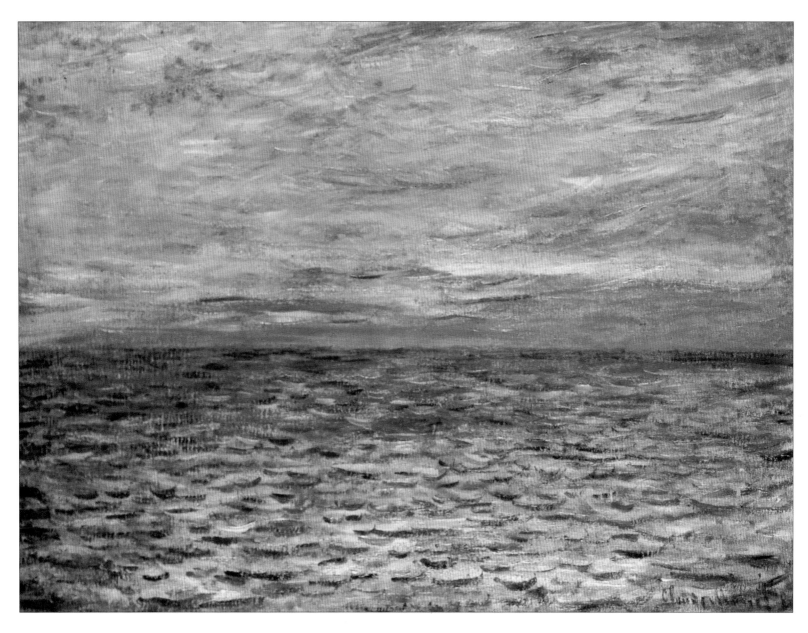

**W771 Coucher de soleil à Pourville, pleine mer — Sunset on the Sea, off Pourville**
54cm x 73cm. 1882.   (Christie's Images Ltd.)

The English Channel (La Manche) with the sun setting in the west.

living there with Camille in the spring of 1871. Monet was not alone in this lack of success which affected all of the Impressionists.

Because of this constant rejection, which is difficult for us to understand today, the Impressionists decided to hold their own exhibition independently of the Salon. There were, in all, eight of these from 1874, with the last in 1886. Monet did not exhibit in the fifth (1880), sixth (1881), and eighth (1886), and would not have taken part in two more, those of 1879 (the fourth) and 1882 (the seventh), had it not been for the persuasiveness of his great friend and benefactor the painter Caillebotte, who had a very substantial private income. For both these shows Caillebotte arranged

171

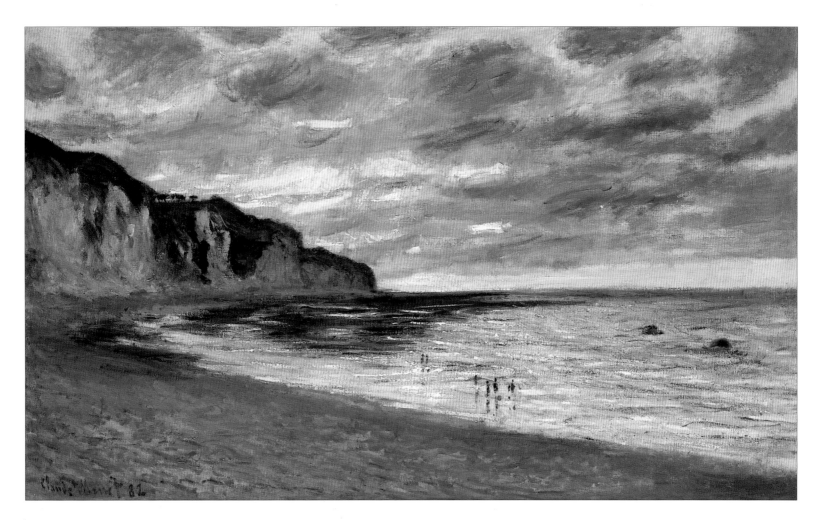

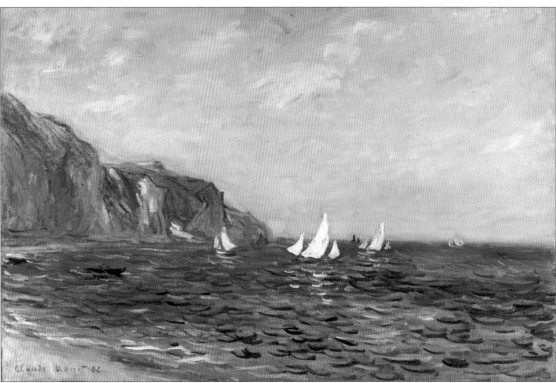

172

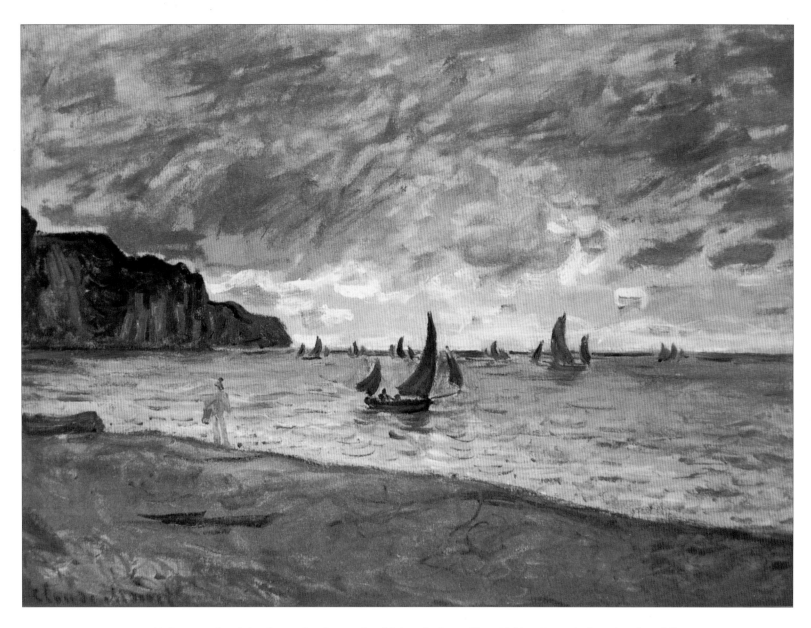

**W786 Barques de pêche devant la plage et les falaises de Pourville – Fishing Boats inshore by the Cliffs at Pourville**

60cm x 81cm. 1882.    (Christie's Images Ltd.)

There must be a shoal of fish inshore as the tide rises, or are they tacking inshore to keep out of the flood tide?

**W778 Pointe de l'Ailly, marée basse  –  The Pointe de l'Ailly, Low Tide**

60cm x 100cm. 1882.    (Christie's Images Ltd.)

Looking into the sunset.

**W785 Falaises et voiliers à Pourville – Boats by the Cliffs at Pourville**

60cm x 81cm. 1882.    (Christie's Images Ltd.)

Fishing boats inshore at high tide.

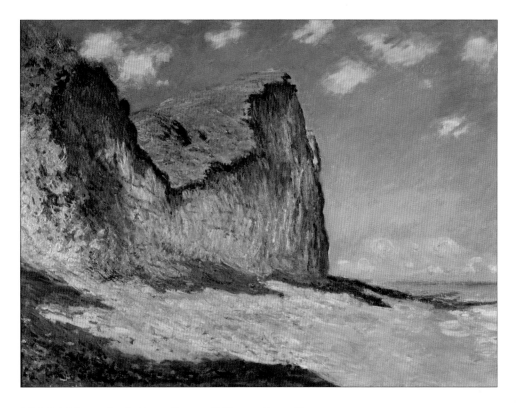

**W788 Falaises près de Pourville – Cliffs near Pourville**

60.4cm x 80.9cm. 1882.     (Collection Rijksmuseum Twenthe, Enschede, The Netherlands)  (photo: R. Klein Gotink)

Low tide and high cliffs in the morning sun. The cliffs are stained with strata of various ores.

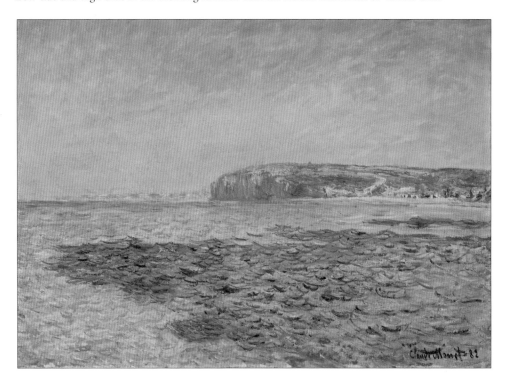

**W792 Ombres sur la mer à Pourville – Shadows on the Sea at Pourville**

57cm x 80cm. 1882.     (Ny Carlsberg Glyptotek, Copenhagen)  (photo: Ole Haupt)

Looking east, the morning sun illuminates a green sea with dark blue shadows from the cliffs near the Gorge du Petit Ailly, Varengeville. Pourville is the sandy beach on the right. Villa Juliette is one of the tall buildings.

**W807 La Plage de Pourville – The Beach at Pourville**
60cm x 73cm. 1882.   (Muzeum Narodowe, Poznan, Poland)

This painting was stolen in 2000 and so far has not been traced. Monet's hotel is one of the red-roofed buildings on the right and nearby is the Villa Juliette which he rented in 1882. He painted this lovely mid-morning scene from the cliff walk. Fishing nets are set on poles in the shallows on the left.

to borrow, repair, frame and transport Monet's paintings to the venue. He then arranged for all the Impressionist paintings to be hung correctly, and produced the catalogues. However, despite his prior refusal, Monet did attend the opening night on 1st March 1882. He had said that he would not attend either of these shows. For the fourth show, in 1879, he was at Vétheuil with Camille who was very ill, and by 1882 he said that he was wholly disenchanted with group exhibitions.

There was also one overriding rule for this Society of Independent Artists which should be mentioned: that if a painting was entered for the Salon on a particular year then the artist was automatically debarred from showing with the Indépendants. This happened to Dégas in 1882.

In this book we are only concerned with the Impressionists exhibitions of 1879 and 1882, shows which Monet did not attend, and where the indefatigable Caillebotte did the work for him. Gaston Vassy, a journalist, visited the Reichshoffen exhibition hall and was so struck by the extraordinary energy of Caillebotte that he wrote this charming piece: '…hat on the back of his head, hands in his pockets, M. Caillebotte came and went, giving orders, surveying the hanging of the canvases, and working like a porter, exactly as if he didn't have an income of fifty thousand francs. Alongside him M. Pissarro, seated on a large trunk, watched him with interest… and seemed tired just from being witness to so much activity.'

**W822 Bateaux de pêche et Porte d'Aval  –  Fishing Boats and the Porte d'Aval**
73cm x 100cm.    (Museen der Stadt, Köln, Wallraf-Richartz Museen)
Painted from the Hotel Blanquet, with a south-westerly gale and a heavy sea running, in February 1883.

This was to be one of their most successful exhibitions. They made very little, sold even less, but it was well attended, well reported for the most part and confirmed that the Impressionists could no longer be set apart from the mainstream of European art. Many of the paintings by Monet which were shown belonged to private collectors, to whom he had sold at low prices in his most frugal period following the death of Camille. Others had been lent by Durand-Ruel. Very few were actually sold from the exhibitions. But things were beginning to change in Monet's favour.

Monet's first break came with a small one-man show at the offices of the art magazine *La Vie Moderne*, granted him by George Charpentier who was a publisher and a client in 1880, when fourteen paintings were shown at their address in 7 Boulevard des Italiens. It was a sound start, a good address and was seen by many of the right people.

The Hotel Blanquet, Étretat, where Monet stayed from 3 January 1883. Was his bedroom studio on the first or second floor?   (Collection: Toulgouat)

**W827A Effet de vagues à Étretat  –  Effect of Waves at Étretat**
60cm x 73cm. 1883.   (Christie's Images Ltd.)

A full gale, a lumpy sea and a very high tide in this evocative sketch signed with the studio stamp after Monet's death.

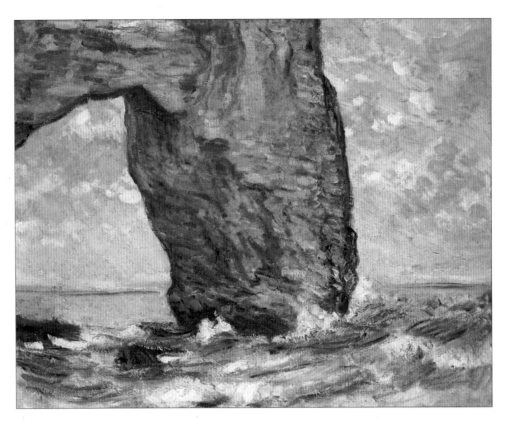

**W833 Le Manneporte vue en aval – The Manneporte seen from downstream.**
73cm x 92cm. 1883.  (Christie's Images Ltd.)

A sketch-like painting, neither signed nor dated, of this vast rock portal through which an Étretat caique could sail at high water.

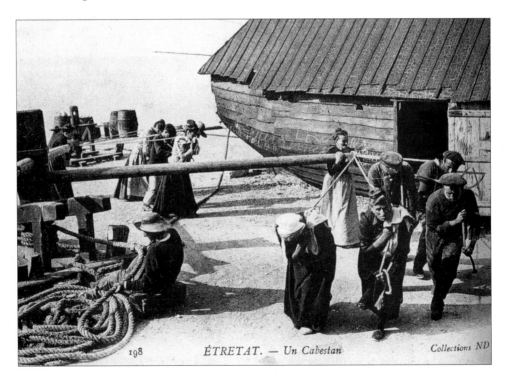

Men and women hauling on capstans at Étretat. Everyone helped to haul the fishing boats up the beach, men, women or children tall enough to reach the capstan bars or swifter ropes!  (Collection: Toulgouat)

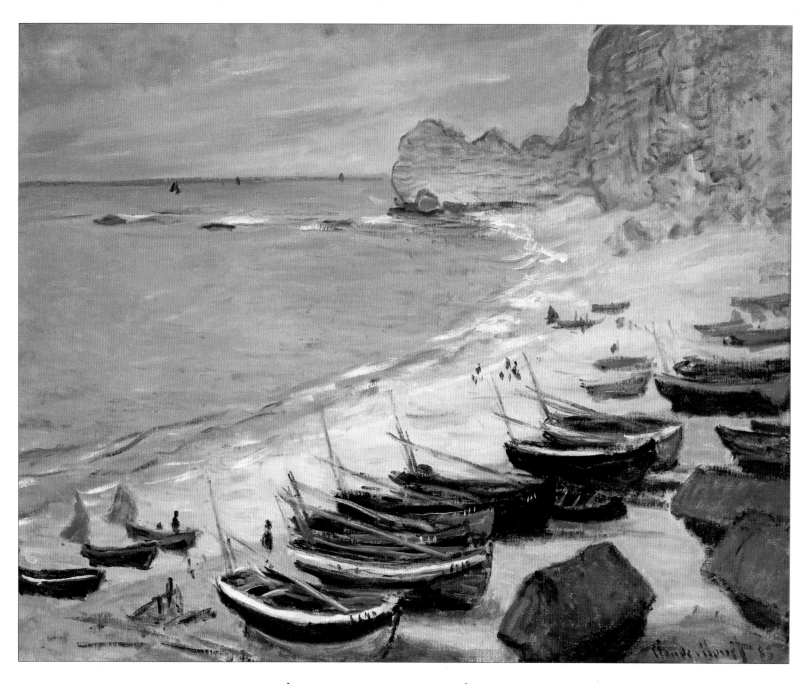

**W829 Bateaux sur la plage à Étretat – Boats on the Beach at Étretat**
65cm x 81cm. 1883.    (Christie's Images Ltd.)

The Étretat caiques, at least twelve of them, are shown hauled up on the beach at low tide in February 1883.

The next and most important exhibition was also a one-man show at Paul Durand-Ruel's new and expensively decorated gallery at Boulevard de la Madeleine from 1st-25th March 1883. Here about sixty fine paintings were shown and many sold, several from the period covered by this book, including the Norman coast scenes. After this Monet never looked back.

It is understandable that Monet felt that the later group exhibitions were no longer helpful to him. He had really had a very difficult time pleading and cajoling his friends and clients to buy his pictures

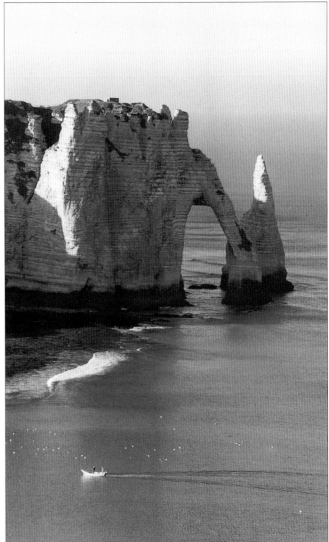

Fishing boats hauled up on the beach, in the year 2000. The ancient capstans are no longer serviceable. The Porte d'Amont is in the distance. *Amont* means 'upstream' and refers to the Channel tidal system.

Right: Late afternoon, taken from the fishermen's church, showing the Manneporte and a modern small fishing boat returning to the beach, surrounded by herring gulls.

### Caïque d'Étretat

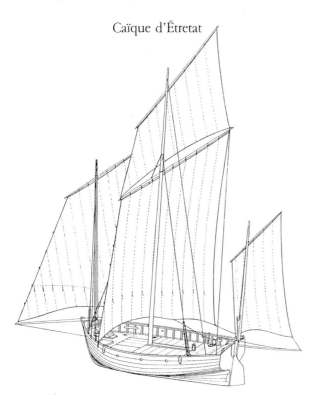

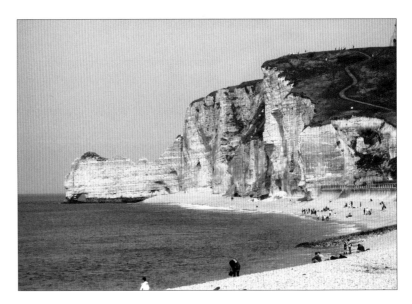

A model-maker's drawing of the unique Étretat caique.

Étretat in April, 2002. Nothing changes!

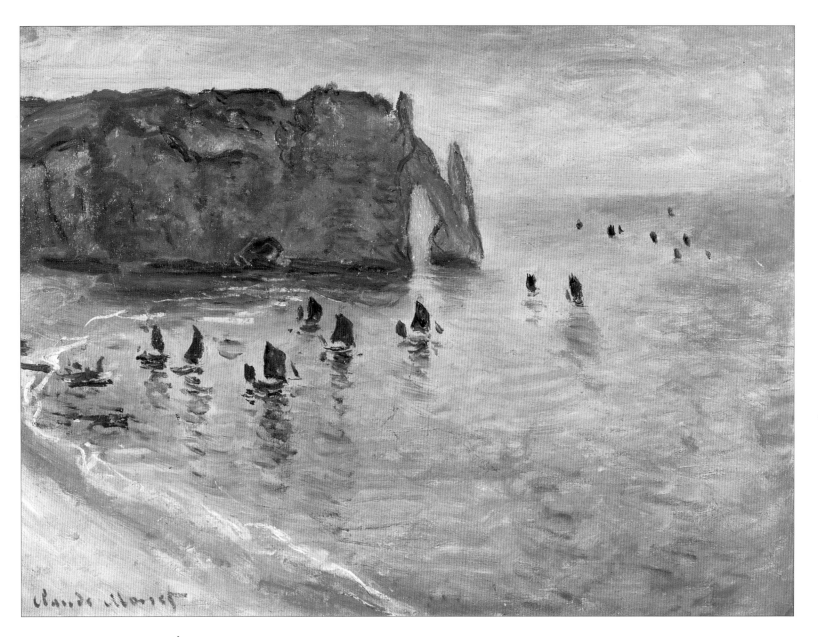

**W1047 Étretat – La Porte d'Aval**
60cm x 81cm. 1886.   (Musée des Beaux-Arts de Dijon)
A later painting of the fishing fleet leaving Étretat for a night's fishing.

before Impressionism was accepted and before he was well known. Once Durand-Ruel got going again, life became easier, especially when his dealer began to sell to the United States. Other dealers became interested, in particular Georges Petit, who was to give a great joint exhibition for Monet and Rodin in 1889; with a further one for Monet in 1896. Bernheim Jeune and Boussod et Valadon also sold his work towards the end of the nineteenth century, whilst many others joined in after 1900.

Monet moved to Giverny on 29th April 1883, just four weeks after his grand one-man exhibition with Durand-Ruel.

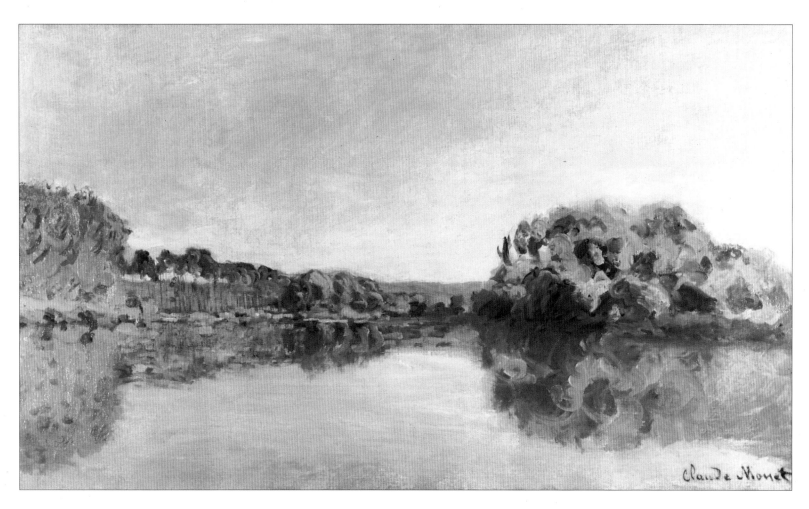

**Bords de la Seine à Argenteuil, vers 1873 – The banks of the Seine at Argenteuil**
43cm x 73.5cm. (Private collection)

A view of the Seine, in a complete calm, not a zephyr to disturb the water, looking downstream towards the hills behind Bougival, on a summer's day. Monet was painting at this time with Sisley, who was working from the left bank (page 191). Monet was in a boat, possibly his *bateau atelier*. There is still a bit of reed stuck in the paint.

This is the missing Monet painting from the collection of Mahmoud bey Khalil exhibited in the *Exposition Française en Caire* in 1927. Catalogue Number 74 (see pages 191-192).

# MONET'S PALETTE, TECHNIQUE AND MARKETING METHODS

Monet had a great natural talent. We can see how well he drew when still at school from the many caricature drawings he made of his schoolmasters and of the leading citizens of Le Havre. He found it all so easy, and made quite a lot of money by selling them. In reality he was self-taught. From the age of fifteen until he was eighteen he made a steady income from these drawings, which he sold for up to twenty francs each, giving the money to his aunt Marie-Jeanne Lecadre to bank for him. She encouraged him as an artist and by the time he set off for Paris, aged eighteen, she had over two thousand francs saved for his own use.

It was Boudin who had introduced a reluctant Monet to oil painting *en plein air*. He learned a great deal from this minor master. Later on Monet recalled: 'It was as if a veil suddenly lifted from my eyes and I knew that I could be a painter.' He went to Paris and enrolled in the Académie Suisse at 4 Quai des Orfèvres in order to improve his drawing. But there was no formal instruction to be had there, which suited him admirably! After a short period of military service spent with the African cavalry in Algeria, where normally the draft was for seven years, he was invalided home, with typhoid, after only eighteen months. His family then bought him a discharge and he was able to return to Paris to study. He chose to work under the history painter Charles Gleyre at the Gleyre Atelier. There he met

**D437 L'Église de Varengeville – Soleil Cochant**
**The Church at Varengeville – Sunset**
42cm x 30cm. Characoal drawing signed Claude Monet lower left
(Private collection)

Drawn for and published in *Gazette des Beaux-Arts* April 1883.

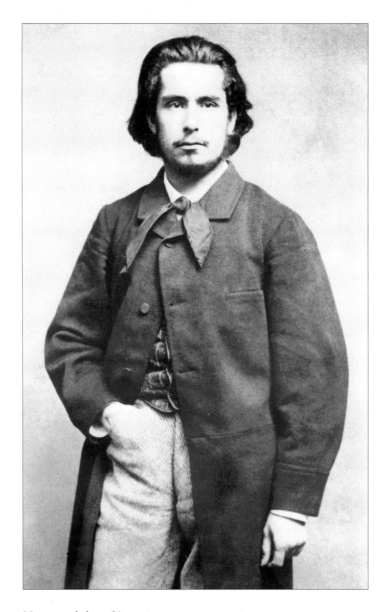

Monet aged about 20.    (Photo: Carjat. Courtesy Toulgouat)

other students including Renoir, Sisley and Bazille. He studied there on and off for two years and though he always said that he learned nothing from Gleyre, this may have been a young man's boast.

About this time Renoir recalled: 'back then, Monet amazed everyone with his virtuosity, but also with his ways. Jealous of his superb appearance when he arrived in the studio, the students nicknamed him "the dandy". He did not have a centime but wore shirts with ruffled cuffs.'

Monet himself recalled that Gleyre was accustomed to give a critique every so often. Two that he received were: 'that accursed colour will turn your head' and 'that's not bad but it is too like the model'. Both these statements were highly unacceptable to Monet. However, you cannot attend art classes in Paris without benefiting and it is certain that Monet was no exception. He drew there and he painted. He also met a lot of useful people in that café society, which centred on the Café Guerbois, where the avant-garde painters and writers regularly gathered.

At the same time, he was painting *en plein air* in company with other artists. In particular, he met Jongkind at Honfleur who had a very great influence on him. Monet said that Boudin, and then

184

Jongkind, were his masters. Boudin taught him to paint in the open air and to pay great regard to nature, particularly the sky. Jongkind taught him about colour and movement and focused his eye on what was important and what to ignore. Monet said 'Jongkind was my true teacher and I owe to him the final education of my eye.'

By the time Monet arrived in Vétheuil, sixteen years later, he was well known as an Impressionist painter and he was successful. He had exhibited several pictures in the official Salon but when several were later rejected he had to show pictures in the Salon de Refusée, the system of exhibitions whereby the Impressionists, despite and in spite of the official Salon, could show their own works. This story is too well known to go into again, but Monet, the strongest of all those painters was to become the leading Impressionist in his own right. Renoir was to say of him: 'without Monet, who gave us all courage, we would have given up'.

But it was a struggle, particularly in 1878 when Camille was ill, needing constant attention, and thus the painter was unable to pay full attention to his work. After her death he was able to redirect his efforts and slowly recovered from the lost time and an unusually low level of sales.

Monet did nothing to correct the view that was put about that he always finished his painting the same day, *en plein air* and that he did no repainting or retouching in a studio. In fact, he took great delight in saying that he had no studio. In truth he still kept one in Paris; but to be fair to him, it was more a place to store his paintings, and when possible to show and sell them to his collectors.

In the interview he gave to Emile Taboureux on 12th June 1880 for the art magazine *La Vie Moderne* the writer asked to see the studio at Vétheuil. 'Monet replied: "my studio. But I never had one" and then, with a gesture as expansive of the horizon encompassing the entire Seine, now flecked with the golds of the dying sun; the hills, bathed in cool shadows; and the whole of Vétheuil itself, which seemed to be dozing in the April sunlight that sires white lilacs, pink lilacs, primaveras and buttercups – "that's my studio".'

Johan Barthold Jongkind (1819-1891).     (Christie's Images Ltd.)
La Côte de Sainte-Adresse.
21.2cm x 42.5cm. 1862.

The art student who chooses Monet as his master can be seriously misled by Monet's statements. In fact most of his early paintings were retouched later on; like every other painter he needed a period of critical reflection before he put a final finish to a painting. Later on, Monet was to say that he became more and more dissatisfied with works completed at one sitting; he realised that many repaintings and retouchings were necessary to complete what he originally set out to do. For instance, the paintings he made in London of Waterloo and Charing Cross Bridges, mainly on foggy days, were not released until two years later and in that time he had worked extensively on all of them. Similarly, his Venetian paintings, with which he was thoroughly dissatisfied, were re-worked for a period of four years before he allowed them to be exhibited.

In the meantime, from the paintings of the Vétheuil period which may or may not be properly finished, Monet had moved on to make further detailed studies of light.

By the time he arrived at the 'Wheatstack' series he confided that he tried to paint the envelope of light around an object, rather than the object itself. Monet wrote 'what I am seeking is instanteity, especially the *enveloppe*, the same light spreading everywhere and more than ever I am dissatisfied with the easy things that come in one stroke'. The writer François Thiébault-Sisson, who had written several articles for his paper *Le Temps* about Monet, wrote a reminiscence on 8th January 1927 in which he remembers a conversation with the late artist. He recalls that Monet said: 'Inspiring motives could be chanced upon. A sky at its most elegant or most brutal, or a rare effect of the light, determined the course of my work. It is thus that, having stopped for a day at Vernon, I discovered the curious silhouette of a church, and I undertook to paint it. It was the beginning of summer, during a period that was still a bit brisk. Fresh foggy mornings were followed by sudden bursts of sunlight, whose hot rays could only slowly dissolve the mists surrounding every crevice of the edifice and covering the golden stones with an ideally vaporous envelope… I told myself that it would be interesting to study the same motive at different times of day and to discover the effects of light which changed the appearance and coloration of the building, from hour to hour, in such a subtle manner. At the time, I did not follow up the idea, but it germinated little by little in my brain. It was much later, ten or twelve years afterwards, that, having arrived in Giverny following a ten-year stay in Vétheuil and having noticed iridescent colours in the morning fog, pierced by the first luminous rays, I began my first series of Haystacks with the same sense of observation. The series of Cathedrals followed after a five or six year interval.'

Professor Paul Tucker believes the writer was mistaken and that it must have been the church at Vétheuil and not Vernon with the sun coming through the mist, for Vétheuil church was painted before the latter. In which case this is the painting, W518 (page 73), that Faure returned to Monet in exchange for another in 1879, saying it was 'too white' for him. Monet remarked to Lilla Cabot-Perry about this and said that when Faure returned the picture he said that 'he liked the picture himself, his friends laughed at him so much, that he could not keep it on his walls.' Monet had then and there made up his mind never to sell that picture and he never did, though often offered large sums for it. He goes on 'he told me that he had "la mort dans l'âme" when that picture was brought back and that he would sell the last shirt on his back before he would sell it'. La mort dans l'âme (the death of the soul) meant that he could not continue to paint like that and would have to do something else. So it was, and is, a key painting which on Michel Monet's death went to the Musée Marmottan. The Monets never parted with it!

To return to his technique in the Vétheuil period, it is apparent, particularly in the earlier paintings, that he would often outline what he was painting in blue and then mostly paint over this initial work, some blue remaining visible. Early critics suggested that there was too much blue in the paintings for normal vision and that perhaps Monet, and other Impressionists, had hyper-sensitive vision so far as ultraviolet light was concerned. Alfred Lostalot writes in the *Gazette des Beaux-Arts* in April 1983: 'Monsieur Monet's eyesight is highly unusual: he sees in a way that most human beings do not, and

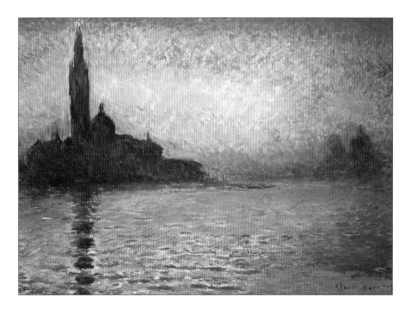

**W1768 Saint-Georges Majeur au crépuscule – San Giorgio Maggiore at Dusk**
65cm x 92cm. Ex. Bernheim Jeune Paris 1912. Bought by the Misses Davies and given in 1952 to the National Museum of Wales, Cardiff. Painted from near Via Garibaldi not far from Museo Storico Navale. Extensively reworked and not shown until four years after his visit to Venice.

because he is sincere, he attempts to reproduce what he sees. We know that the solar spectrum includes a range of rays that the cornea intercepts and that therefore, the retina does not receive. This range is called ultraviolet, because it extends beyond the violet range that everyone sees. It does play a significant part in nature, but its effects are not optical. Recent experiments by Monsieur Chardonnet [inventor of artificial silk 1839-1924] however, have proven positively that some people respond strongly to this invisible part of the spectrum. Without a doubt, Monsieur Monet belongs to this number; he and his friends see ultraviolet: the masses see something different. Hence the misunderstanding…'

'The public's eye rebels when Monsieur Monet pitches battle with the sun. The brilliance of the yellow rays stimulates the painter's nervous sensibility, then blinds him; at that point he undergoes a well known physiological phenomenon: the complimentary colour is evoked; he sees violet. Those who are

**W518 Vétheuil in the fog**. (See page 73)
A small detail of the church roof.

fond of this colour will be pleased; Monsieur Monet executes for them an exquisite symphony in violet. The motive is always well chosen – for instance, a mighty cliff, its twisted vegetation seared by the sea air; here and there the cliff reveals its vigorous ossature and contemplates the silhouette of its shadow in the blue waters. To one side stands a red roofed cottage, as if setting the pitch.' But the writer ends his article …'we felt it appropriate to inscribe this painter's name in a magazine that considers itself a conservative journal of art; that is we refuse to see in him an anarchist amongst painters.'

This phenomenon, called the 'violettomania' of the Impressionists, was examined in detail by Oscar Reutersward in the *Journal of Aesthetics and Art Criticism* in December 1950. He wrote: 'This explanation, however, is based on a double mistake. Yellow gives a violet after-image, but sunlight is white, with a black or grey after-image. Anyone who sees everything with a violet tinting does not paint in violet tints, for the colour in his box of paints will also seem violet tinted to him.'

Another criticism that was levelled at the Impressionists, of their discovery that shadows in nature were in fact always blue and violet, was also no longer valid after the 1882 exhibition. This is what the critics and others thought, but the ultraviolet accusations were not possible and must be set aside.

By 1879 Monet's palette was extremely simple. He had narrowed down the colours he used from fifteen in 1869 to no more than seven and he was never again to use more colours, as the table shows for 1926. (See Colour Table, page 195).

His brush technique evolved gradually from the time he met Boudin onwards. It was highly developed to show shape. He used wide brick-like strokes, particularly in the water to show reflections, and then *taches*, little comma-like strokes, to evoke the shapes and spirals in trees and undergrowth. He constantly used these methods to show the forms and his dexterity in turning the commas or the brick strokes to whatever position suited the subject was remarkable.

Monet gave advice which was written down by Lilla Cabot-Perry, an American painter living in Giverny, in an article in which she wrote: 'in spite of his intense nature and at times rather severe aspect, he was inexpressibly kind to many a struggling young painter. He never took any pupils but he would have made a most inspiring master if he had been willing to teach. I remember him saying to me: "When you go out to paint try to forget what objects you have before you, a tree, a house, a field or whatever. Merely think here is a little square of blue, here an oblong of pink, here a streak of yellow and paint it just as it looks to you. The exact colour and shape, until it gives you your own naive impression of the scene before you."

'He said he wished that he had been born blind and then had suddenly gained his sight so that he could have begun to paint in this way without knowing what the objects were that he saw before him. He held that the first real look at the motif was likely to be the truest and most unprejudiced one, and said that the first painting should cover as much of the canvas as possible, no matter how roughly, so as to determine at the outset the tonality of the whole and as an illustration of this he brought out a canvas on which he had painted once; it was covered with strokes about one inch apart and about a ¼" thick out to the very edge of the canvas. Then he took out another on which he had painted twice, the strokes were nearer together and the subject began to emerge more clearly.'

She went on 'Monet's philosophy of painting was to paint what you really see, not what you think you ought to see' and ended: 'This serious intense man had a most beautiful tenderness and love for children, birds and flowers and this warmth of nature showed in his wonderful, warm smile, a smile no friend of his can ever forget. His fondness for flowers amounted to a passion, and when he was not painting much of his time was spent working in the garden.'

Lilla Cabot-Perry was writing in the *American Magazine of Art* 'Reminiscences of Claude Monet from 1889-1909' published in March 1927.

A great deal of research has been undertaken by the Courtauld Institute's Technical Department

Brick strokes

Taches

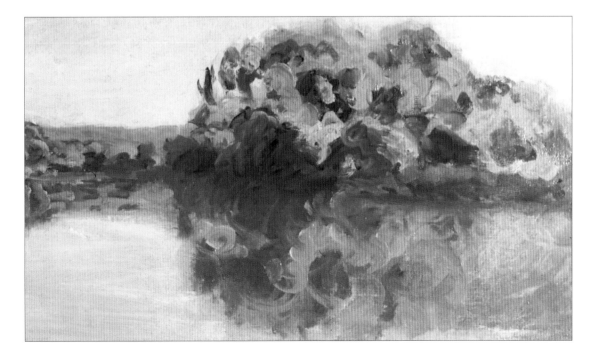

Spirals

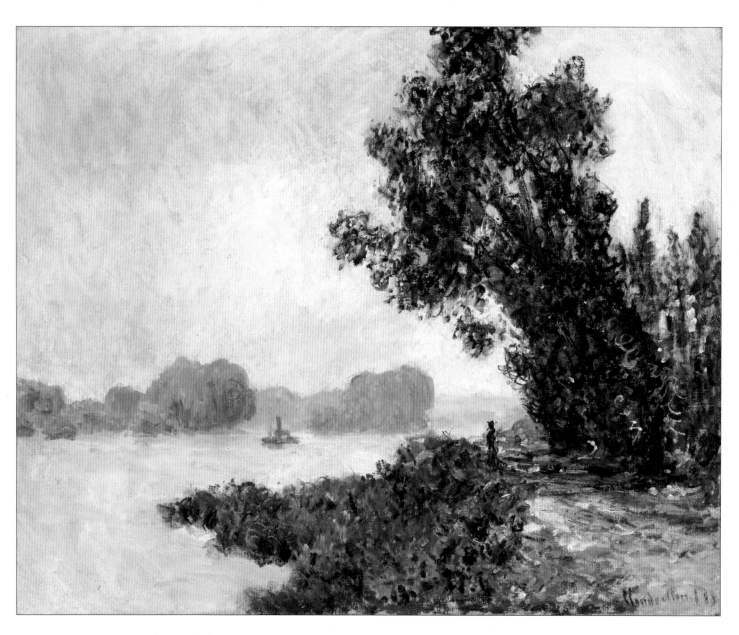

**W840 Le Chemin de halage à Granval – The Towpath at Granval**
65cm x 81cm. 1883. (Sotheby's)

This very blue painting shows the blue/violet underpainting which delineated the trees, giving rise to Alfred Lostalat's article in *Gazette des Beaux-Arts* in April 1883 and subsequent talk of 'Violettomania' of the Impressionists (pages 186-8).

and also by Dr Nicholas Eastaugh, on Monet's paintings and Table 2 shows the extent of the colours and media he used in seven separate periods. In 1872 he was using nine colours, in 1877, ten but by 1905 he was using only six.

The painting entitled 'Bords de la Seine à Argenteuil' (page 182) has been the object of more technical study than most. This is the painting which was given by Monet to Dr Porak. It has been fully examined by Professors John House (Courtauld), Paul Hayes Tucker (Boston), Ronald Pickvance (Glasgow), by Jean-Marie Toulgouat (the great grandson of Alice Hoschedé Monet, also a painter) and the author of this book. Daniel Wildenstein's only comment was: 'If it is a Monet, it is not a very good one.' But unfortunately he never saw it after extensive repainting had been removed from over a third of the surface of the canvas.

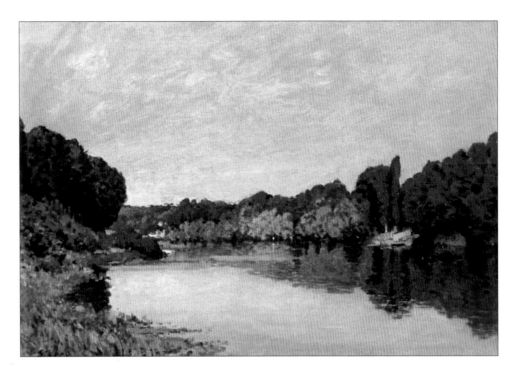

**Alfred Sisley (1839-1899). La Seine à Bougival**
46cm x 65cm. c.1872-73.   (Musée d'Orsay)

Sisley was working with Monet at this time and he made three similar paintings at Bougival to that which Monet made (page 182).

**Bords de la Seine à Argenteuil** (illustrated page 182, detail 189)
**Provenance**
Given by Monet in lieu of medical fees to Dr Charles Porak, circa 1880.
1919: Sold to Georges Petit, Paris.
1919: Bought by Mohammed Mahmoud bey Khalil, Paris and Cairo.
1953: Sold to Galerie André Maurice, rue de Prêcheurs, Paris.
       Sold to Arthur Tooth & Son (Dudley Tooth paid 2,200,000 francs).
1954: Sold to Sir Clifford and Lady Curzon.
1982: By descent to Fritz Curzon, Esq.
1993: Bought by present owner.

**Exhibited**
*Exposition Française en Caire, 1827-1927*, Collection of MM bey Khalil, Cairo, cat. no.74.
*Memorial Exhibition to Dudley Tooth*, London, November 1972, cat. no.7.
*Monet Retrospective* (arranged by Prof. Paul Hayes Tucker), Japan, 1994. Cat. no.26, travelled to Bridgestone Museum of Art Tokyo Feb.-April, Nagoya City Art Museum April-June, Hiroshima Museum of Art, June-July.
Crane Kalman Gallery, *Silence in Painting*, Oct.-Dec. 1999.

Geneviève Lacambre of the Musée d'Orsay, in her remarkable exhibition, *Les Oubliés du Caire*, realised that this painting was the missing one which had belonged to Mahmoud Khalil and was shown in the 1928 *Exposition Française en Caire*. Significantly, Wildenstein had no knowledge of this exhibition, which showed seven oil paintings by Monet, though he records six of the paintings in his *Catalogue Raisonné* (three for Khalil, one to Faure, two to Bernheim-Jeune). No.74, *Bords de*

A page from Claude Monet's address book written in his hand. The three additions for Sargeant, Mallarmé and Huysman are probably by Blanche Monet.

(Courtesy Toulgouat)

*la Seine à Argenteuil*, has the Petit number 5575 on the stretcher.

The late John Gimpel of Gimpel Fils suggested that Nicholas Eastaugh should examine the painting and analyse the pigments. He confirmed an exact similarity with the paints used by Monet for the Courtauld paintings of 1873/4. He also found that the signature was integral with the picture, i.e. wet into wet paint. With his electron microscope he was also able to read the writing, which is in pencil on the stretcher. For the first time we could read 'Dr Porak' and 'Villa St. Louis, Poissy'. Dr Porak was a noted consultant and contemporary of both Dr Gachet and Dr de Bellio and their patients were referred to him. He may even have advised on Camille Monet's problems. The medical journal *La Gynécologie*, in which Dr Porak's clinical research was published, was widely read in England (London and Cambridge). It has now been established that the painting was given to this very eminent doctor, either by Monet or Alice Hoschedé, in return for medical attention to the family in the Vétheuil period, 1878-83.

The painting is fully recorded in Arthur Tooth and Sons' ledger of purchases and sales in 1954. Specialists will know that Dudley Tooth bought and sold over forty pictures by Monet from 1936 onwards. It has escaped the cataloguing of the Wildenstein Institute for the year 1873/4 in Volume I, which went to print in 1974, before the details of the Cairo exhibition came to notice at the Musée d'Orsay, under the patronage of the two Presidents, Mitterand and Moubarak, in a joint venture by both nations in 1996.

Professor Pickvance believes that the painting was made in 1872/3, two years earlier than previously thought. At this time both Sisley and Monet were painting, often together, at Argenteuil. Monet, of course, had his *bateau atelier*. Sisley's painting, *La Seine à Bougival* (page 191) shows similarities but differences in technique.

Particular thanks are due to the Courtauld Institute and to Dr Nicholas Eastaugh for allowing me to use their research on this painting, and other Monets in the Courtauld Collection.

Jean-Marie Toulgouat, the only remaining painter in the Monet/Hoschedé family, photographed in 2002 in his studio in the house of his grandfather, Theodore Earl Butler, at Giverny. His personally signed photograph of Monet circa 1900 is also shown (left).

## MONET'S MARKETING METHODS

As every artist knows, picture-production is one thing which can be enjoyed, but selling the product is a much more difficult business. Every young artist, however good, must find a way to show his work for this is critical to survival and to success.

Initially, the Impressionists sought to have their paintings accepted in the official Salon exhibitions which were held annually in Paris in one of the Louvre Palaces. This was the accepted way to establish a reputation; and from that flowed sales. Like all large institutions of this type, the Salon became bogged down with traditional painters, using well-tried techniques. It became stultified and dull. The Impressionists, with their bright colours and natural pictures of everyday scenes, were enormously suspect. However, if they took the establishment line they stood a good chance of acceptance. Painting in their 'new' way they stood no chance with the selection Committee, who were traditionalists, and would not admit them.

The exhibitions were usually held in May. In 1863 the Committee refused so many paintings that the Emperor Napoleon III, in response to complaints, authorised an annex salon to exhibit the best of the works not accepted. This controversial arrangement did manage to show at least some of the more traditional work of the, by now, highly unpopular Impressionist painters.

Monet managed to get two of his paintings shown in the Salon of 1865. Both were large marine paintings of the Seine Estuary. They were sold for three hundred francs each. In 1866 both his entries were again in the main Salon. They were 'The Road to Chailly', W19, and 'Camille in a Green Dress', W65. His entries for 1867 were both refused. In 1868 only one of his two entries was accepted. In 1869 and 1870 both his entries were refused and from then on he did not enter for a further ten years. The English were just as hide-bound as the French – Monet's entries to the 1871 Royal Academy in London were refused as well!

By then, most of the Impressionists had gathered together in revolt against the establishment, but it was not until 1874 that they held the first of their own Impressionists Exhibitions. Eight

Details of Monet's Studios and Homes including rents paid

| 1870 | 1871 | 1872 | 1873 | 1874 | 1875 | 1876 | 1877 | 1878 | 1879 | 1880 | 1881 | 1882 | 1883 | 1884 | 1885 | 1886 |
|------|------|------|------|------|------|------|------|------|------|------|------|------|------|------|------|------|
| **IN PARIS** | | | | | | | | | | | | | | | | |
| Nov ← | | **Studio** → | | | --------- | | Jan **Studio** July → | Oct | **Studio** → | | April ← | April **Studio** → | | | | |
| | 8 Rue St. Isly (5th Floor) (Near Gare St. Lazare) | | | | | | 17 Rue Moncey | | 20 Rue de Ventimille | | | 20 Rue de Ventimille (another studio) | | | | |
| **RENTAL** 450 francs per annum | | | | | | | 700F per annum paid by Caillebotte | Jan Sept ← → | 700F per annum paid by Caillebotte | | | | | | | |
| | | | | | | | | Apartment - 26 Rue d'Edimbourg Rent 1360F per annum (Michel Monet born here) | | | | | | | | |
| **OUTSIDE PARIS** | | | | | | | | | | | | | | | | |
| | 21 Dec | ARGENTEUIL → | | 1 Oct | ARGENTEUIL → | | | Jan Aug Sept ← → Rue de Mantes VETHEUIL → | | | POISSY Dec ← → | Villa Saint Louis 15 April 10 Cours de 14 Juillet | | | | |
| | | Near Hospice, Porte St. Denis 2 Rue Pierre Guienne | | | 2 Blvd Saint Denis facing railway station | | | Oct Rue de Roche Guyon Oct | | | | | GIVERNY → | le Pressoir | | → |
| **RENTAL** | | Property of L.E. Autry (friend of Manet) 1000F per annum | | | Property of a joiner Mons A Flament 1400F per annum | | | Property of Mme Elliott owner of Les Tourelles 600F per annum | | | | 29 April | Monet bought his Giverny estate in 1890 for 22000 francs | | | |
| | | | | | | | | | | | | POURVILLE June Sept ← → Villa Juliette | | | | |
| 1870 | 1871 | 1872 | 1873 | 1874 | 1875 | 1876 | 1877 | 1878 | 1879 | 1880 | 1881 | 1882 | 1883 | 1884 | 1885 | 1886 |

followed in 1874, 1876, 1877, 1878 (the International Exhibition in Paris), 1879, 1880, 1881, 1882 and finally in 1886.

Monet exhibited as follows only:

| | | |
|---|---|---|
| 1st Impressionists Exhibition | 1874 | 5 oil 7 pastel |
| 2nd Impressionists Exhibition | 1876 | 18 oil |
| 3rd Impressionists Exhibition | 1877 | 30 oil |
| 4th Impressionists Exhibition | 1879 | 29 oil |
| 7th Impressionists Exhibition | 1882 | 35 oil |

He entered the Salon, again, in 1880 when one painting, of Lavacourt, W578, was accepted. Never again did he go near the place!

All of this was unsatisfactory, so like other artists, he had to rely on private sales and later, on dealers. Times were hard for painters anyway and particularly hard for the Impressionists, for at this time their paintings were neither liked nor understood. Today they are the most admired and discussed, and as valuable as the most precious paintings ever made.

Luckily for Monet, whose chosen subject was landscape, there were some discerning collectors who bought his work; there were some investors too, who were hoping to profit from the new movement in art. At first dealers had to be cautious with the new work, but they always had their steady trade to rely upon. Some were traditional artists' colourmen as well.

Monet's first dealer seems to have been Louis Latouche, who also supplied canvas and paints. His first purchase was in 1867 but he only bought about eight of Monet's pictures although there may be some unrecorded. His most important dealer was Paul Durand-Ruel whom he had first met in London in December 1870. Following this meeting the dealer put Monet in touch with Pissarro, who unknown to him was also a refugee in London. In 1872 and 1873 Durand-Ruel purchased over sixty-five Monets, but in December 1873 there was a very severe recession which resulted in

| MEDIUM OR COLOUR | 1869 La Grenouillère | 1870 Plage à Trouville | 1872 Petit-Bras Argenteuil | 1877 June Gare Saint-Lazare | 1879 Lavacourt, neige | 1905 Monet to Durand-Ruel | Gimpel notes 1926 | FRENCH NAMES |
|---|---|---|---|---|---|---|---|---|
| Linseed<br>Poppy<br>Walnut<br>Pine Resin<br>Beeswax<br>Castor Oil<br>Gum (gouache) | Linseed Oil<br>Poppy Oil | Linseed Oil<br>Poppy Oil | Linseed Oil<br>Prepolymerised Linseed Oil<br>Poppy Oil<br>Prepolymerised Poppy Oil | Linseed Oil<br>Linseed Oil &<br>Poppy Oil mixture<br>Poppy Oil | Walnut Oil<br>Poppy Oil<br>Poppy Oil & a little Pine Resin | – | – | Linseed - huile grasse<br>Poppy - huile d'oeillette<br>Walnut - huile de noix<br>With resin - huile copal |
| **ENGLISH** | | | | | | | | **FRENCH** |
| LEAD WHITE | √ | √ | √ | √ | √ | √ | √ | Blanc de Plomb |
| PRUSSIAN BLUE | √ | | | | | | | Bleu de Prusse |
| COBALT BLUE | √ | √ | | √ | √ | √ | √ | Bleu de Cobalt |
| FRENCH ULTRA | √ | | √ | √ | √ | | √ | Ultramarine |
| CERULEAN BLUE | | | | √ | | | | Bleu Céruléan |
| EMERALD GREEN | √ | | | √ | √ | | | Vert Veronèse |
| VIRIDIAN | √ | √ | √ | √ | √ | √ | √ | Vert Emerande |
| CHROME GREEN | √ | | √ | | | | | Vert Anglais |
| CHROME YELLOW | √ | | √ | √ | | | | Jaune de Chrome |
| LEMON YELLOW | √ | | | | | | | Jaune de Cadmium Citron |
| YELLOW OCHRE | √ | √ | √ | | | | √ | Ocre Jaune |
| ORGANIC YELLOW | √ | | | | √ CAD YELLOW | | | Jaune de Cadmium |
| VERMILLION | √ | √ | √ | √ | √ | √ | √ | Vermilloné |
| RED OCHRE | √ | | √ | | | | | Ocre Rouge |
| RED/BROWN OCHRE | | √ | | | | | | |
| RED LAKE (al/sn) | | | | √ | | | | |
| RED LAKE (ca) | √ | | | | √ | | | Rouge de Cadmium Foncé |
| CARMINE MADDER | | | | | | √ | | Carmine de Garance |
| COBALT VIOLET | √ | | | | | | √ | Violet Cobalt |
| IVORY BLACK | √ | √ | √ | √ Trace only | | | | |

his inability to purchase any more Impressionist paintings until 1881. This was a severe blow to them all and to Monet in particular. Just as he seemed to become successful his main sales outlet collapsed. As a result he lost confidence and henceforth he always had several dealers and was to play one off against another on many occasions. In the end this boosted his sales and then his prices. He was very crafty in setting about this. However, for the next few critical years he had to sell privately and no man ever tried harder, particularly when Camille was in her final decline.

His next most important dealer was Georges Petit, whom he met first in 1878, at the second Hoschedé Sale. Petit was to buy steadily from Monet and eleven years later held the Monet-Rodin Exhibition of 145 paintings and thirty-six sculptures, but that is outside the scope of this book. In the early 1880s Georges Petit was the first to tell Monet to increase his prices, and after that he did not look back.

Monet simplified his palette as time went on.

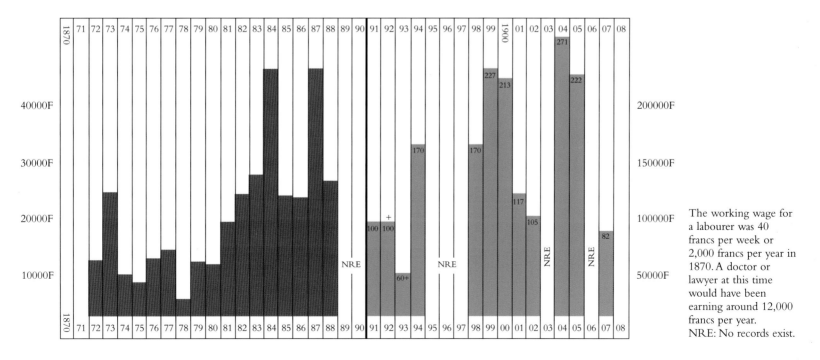

The working wage for a labourer was 40 francs per week or 2,000 francs per year in 1870. A doctor or lawyer at this time would have been earning around 12,000 francs per year.
NRE: No records exist.

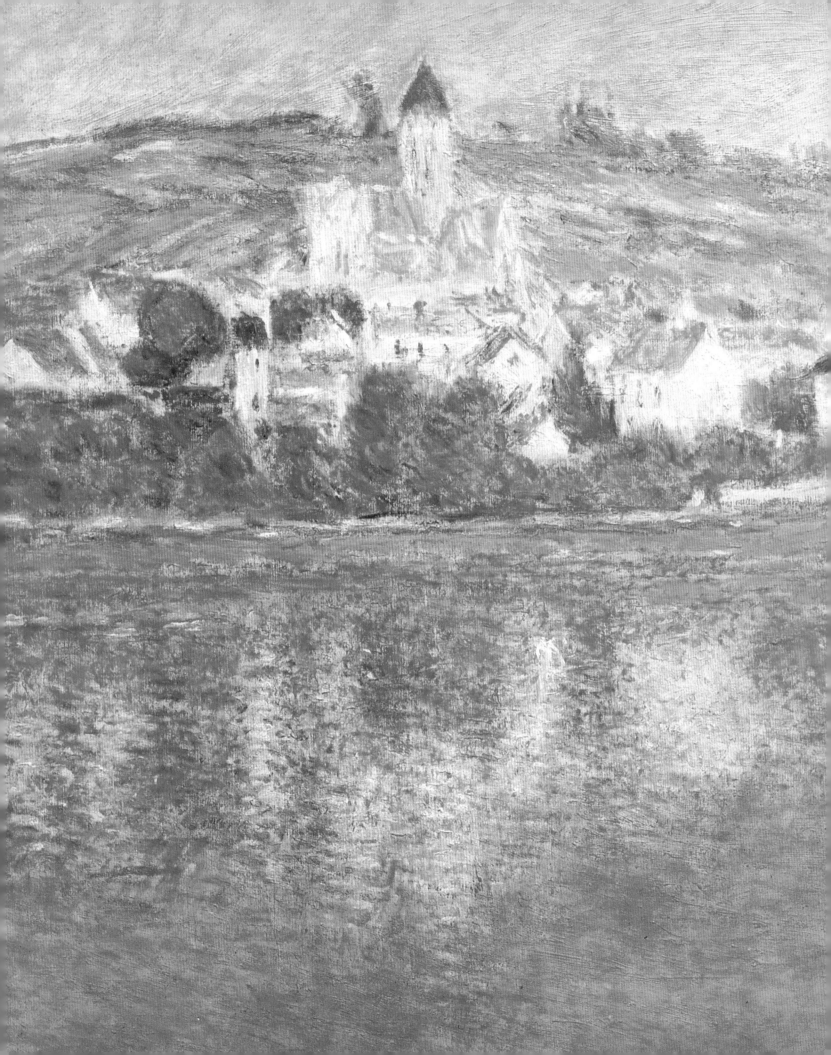

# A RETURN VISIT TO PAINT VÉTHEUIL IN 1901

Monet obviously passed by or visited Vétheuil from Giverny, but he did not stop to paint there. He had painted every view that interested him and moved on to other scenes.

However, he decided to order a motor car in 1901, a Panhard-Levassor, registration number 937 VZ, which arrived whilst he was finishing his Thames series of paintings in London. The younger members of the family were intrigued and the young men in particular were very excited. Jean Monet and Jacques Hoschedé were then in their thirties, Michel and Jean-Pierre Hoschedé in their early twenties. Suzanne had recently died, leaving Alice inconsolable but she soon discovered that she loved motoring and speed. Here was the opportunity to drive around at leisure, helping her to come to terms with her loss.

On his return to Giverny and his gardens, Monet went on a drive to Lavacourt and decided that he would do a series of paintings there. Fortuitously, on their second visit, they were able to rent a small chalet, from July for six months, at a rent of 120 francs. It had a wonderful view across the river to Vétheuil and its Church of Notre Dame, now so famous from his earlier paintings.

Monet never learned to drive but preferred to employ a chauffeur. The first was Fouillard, who was also the butler. Daily, during that lovely hot summer, Monet and family were driven to Lavacourt, to their chalet, which by now had been furnished and made comfortable. In the late afternoon they drove home, sometimes using the bridge at La Roche. It was a short journey of around twelve kilometres.

The painter made a series of fifteen paintings – either square about 89cm x 92cm, or nearly square 81cm x 92cm, all painted from precisely the same viewpoint in a pavilion he had rented from Mme de Chambry. Some are morning paintings, others of the afternoon. There is little foreground, some have a few tufts of reeds, all have a large area of the Seine below the church and village, with the hills behind. The Seine in every case occupies more than half the picture. Sometimes it is flat calm with full reflections, others record a breeze over the river and a mass of broken water. Only one has the after section of a barge moving out of the right of the picture. Here the bargee has his hand on a large curved tiller, as he steers to starboard of the Île Saint-Martin.

Significantly, in three of the pictures, Monet has painted a single skiff with figures rowing; the younger members of the combined families at play. In one painting there are two skiffs; no doubt they demanded that Monet put them both in the painting.

These pictures, as one might expect after twenty years, are quite different to those made before. They are much freer, less detailed and are in keeping with his paintings of the period. The motif is there, but the painter is definitely more interested in the envelope of light surrounding it.

This series numbers from W1635 to W1649. All except W1647, the one with the barge and two

**W1643 Vétheuil, effet rose – Afternoon Light, Vétheuil (detail)**
90cm x 93cm. 1901.    (The Art Institute of Chicago, All Rights Reserved). Mr and Mrs Lewis Larned Coburn Memorial Collection

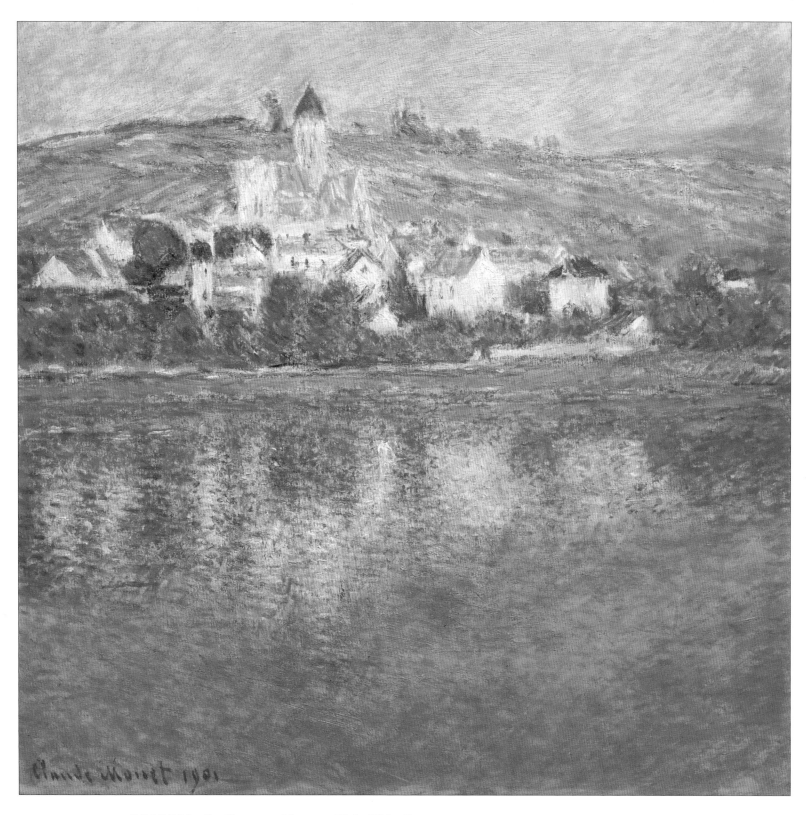

**W1643 Vétheuil, effet rose – Afternoon Light, Vétheuil**

90cm x 93cm. 1901.    (The Art Institute of Chicago, All Rights Reserved)  Mr and Mrs Lewis Larned Coburn Memorial Collection

Two of the paintings Monet made from Lavacourt are shown here, so they can be compared with the earlier pictures of the 1878 period. His style has changed and so have his colours, and so too have the compositions.

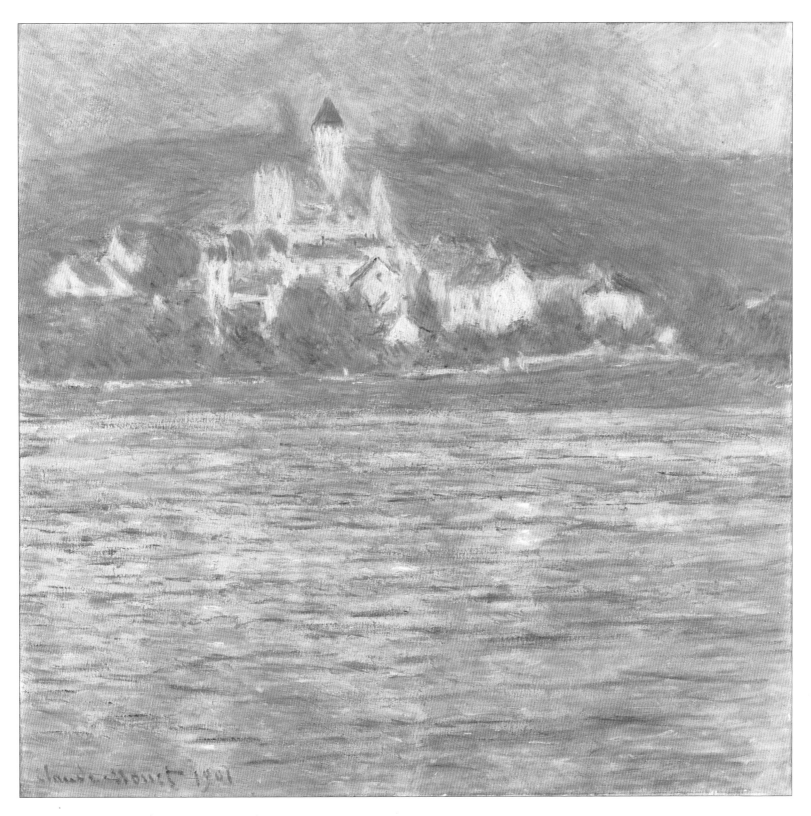

**W1646 Vétheuil, effet gris – Grey effect**

90cm x 93cm. 1901.   (Musée des Beaux-Arts, Lille)

It does look overcast in the sky and some wind across the water disturbs the reflections.

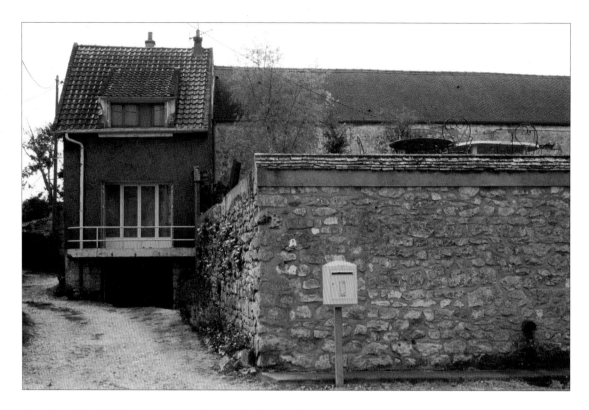

Monet's studio of 1901 at Lavacourt. Photographed in April, 2002.

skiffs, are signed. Most are dated 1901, but W1648 is dated 1902 and that is probably correct for it is more of a sketch.

Those in major Galleries are as follows:

| | |
|---|---|
| W1635 | Pushkin, Moscow |
| W1637 | Schweinfurt, Germany |
| W1641 | Heydt, Wuppertal, Germany |
| W1643 | Art Institute, Chicago |
| W1644 | Musée d'Orsay, Paris |
| W1645 | Art Institute, Chicago. |
| W1646 | Musée des Beaux Arts, Lille |
| W1648 | Musée Nationale d'Art Occidental, Tokyo |
| W1638 | has not been seen since 1902! |

These were to be the painter's last pictures painted either at Lavacourt or at Vétheuil; a perfect ending to his series of paintings of Notre Dame de Vétheuil.

However, Monet apparently was not satisfied with them. Alice relates that during the course of packing the paintings up to send to Bernheim's late in January 1902, Monet 'would utter terrible curses', adding 'he was ashamed to send such things'. They were exhibited from 20-28th February, together with some recent works by Pissarro.

We are indebted to Philippe Piguet, a Monet historian and grandson of Germaine Hoschedé (Salerou) for this information. Piguet is also an authority on Monet's paintings of Venice in 1908. He published his book entitled *Monet et Venise* in 1986.

# FAMILY MONET

Camille Doncieux
(1847-1879)     m. (1870)     Claude Monet
(1840-1926)

Jean
(1867-1914)

Michel
(1878-1966)

# FAMILY HOSCHEDÉ

Alice Raingo
(1844-1911)     m. (1863)     Ernest Hoschedé
(1838-1891)

| Marthe | Blanche | Suzanne | Jacques | Germaine | Jean-Pierre |
|--------|---------|---------|---------|----------|-------------|
| (1864-1925) | (1865-1947) | (1868-1899) | (1869-1941) | (1873-1968) | (1877-1961) |

# FAMILY HOSCHEDÉ-MONET

Alice Hoschedé
(1844-1911)     m. (1892)     Claude Monet
(1840-1926)

Marthe Hoschedé
(1864-1925)
m. (1900)
Theodore Butler
(1861-1936)

Blanche Hoschedé
(1865-1947)
m. (1897)
Jean Monet

Jacques Hoschedé
(1869-1941)
m. (1895)
Inga Jorgensoen
(1862-1944)

Jean Monet
(1867-1914)
m. (1897)
Blanche Hoschedé

Michel Monet
(1878-1966)
m. (1931)
Gabrielle Bonaventure
(1890-1964)

Suzanne Hoschedé
(1868-1899)
m. (1892)
Theodore Butler
(1861-1936)

Jean-Pierre Hoschedé
(1877-1961)
m. (1903)
Geneviève Costadau
(1874-1957)

Germaine Hoschedé
(1873-1968)
m. (1902)
Albert Salerou
(1873-1954)

James (Jimmy) Butler
(1893-1976)
m.
Margot Montcleuse

Alice (Lily) Butler
(1894-1949)
m.
Roger Toulgouat
(1897-1945)

Simone Salerou
(1903-1986)
m. (1926)
Robert Piguet
(b.1902)

Nitia Salerou
(1909-1964)

Jean-Marie Toulgouat
(b.1927)
m. (1964)
Claire Joyes
(b.1940)

12 Children
including
Philip Piguet
(b.1946)

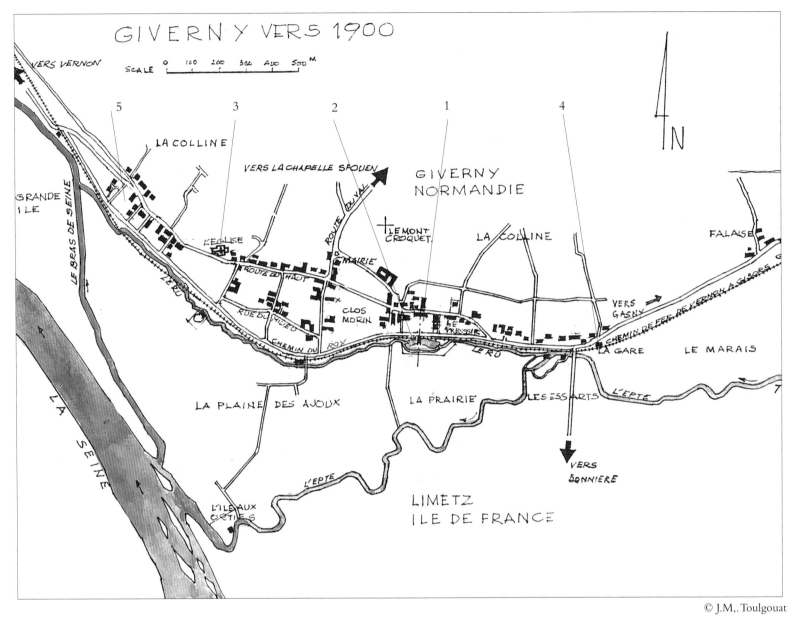

Giverny in 1900

1. Monet's House, Garden & Studios
2. Waterlily pond
3. L'Eglise (Church)
4. La Gare (Railway Station)
5. Monet's Kitchen Garden

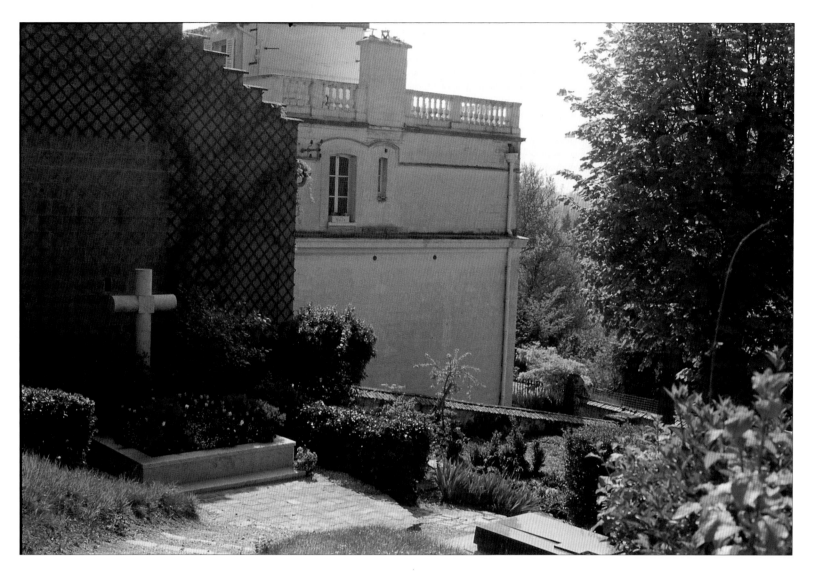

The Monet/Hoschedé tomb at Giverny:

1. Ernest Hoschedé 1891
   Suzanne Butler 1899
   Alice Hoschedé Monet 1911
   Jean Monet 1914
   Claude Monet 1926
   Blanche Hoschedé Monet 1947
   Gabrielle Monet 1964
   Michel Monet 1966

   NB Jacques Hoschedé died in 1941 and Jean-Pierre Hoschedé 1961

2. The Butler family tomb at Giverny:

   Theodore Earl Butler 1936
   Marthe Hoschedé Butler 1925
   Jim Butler 1976
   Alice (Lily) Butler 1949

3. The Mazarin-Salerou tomb:

   Albert Salerou 1954
   Germaine Hoschedé Salerou 1968

L'Église de Giverny - Approximate position

# PEOPLE, STUDIOS AND GALLERIES
## MENTIONED IN THE TEXT

There follow some short descriptions of persons and places mentioned in the main text which may help those who are unfamiliar with the names or dates.

### ACADÉMIE SUISSE
Located at 4 Quai des Orfèvres, Paris. Monet probably first met Pissarro at life drawing classes here before he joined the French army in 1861.

### BAZILLE, Frédéric (Montpellier 1841-1870 Beaune-la-Rolande)
Pioneer of Impressionism who did not live long enough to fulfil expectations, for he was killed in battle serving with a Zoave regiment in the Franco-Prussian War. A firm friend of Monet's since their days in Gleyre's studio, they often painted together, experimenting successfully in painting groups of people *en plein air*, putting light and sunshine into their pictures. Bazille was of independent means and often helped Monet with money. He bought Monet's 'Women in the Garden' from him in 1867 for 2500 francs. His untimely death removed one of Monet's strongest supporters.

### BELLIO, Dr Georges de (1828-1894)
A wealthy Romanian who became a champion of the Impressionists. He studied medicine in Paris and once qualified became a homoeopathic doctor. He was a member of the old aristocracy from Macedonia and an avid collector of paintings, buying his first Monet at the 'Hoschedé Sale' at the Hotel Druoat on 14 January 1874. Later he and Monet were to become firm friends. His daughter, Victorine, became Mme Donop de Monchy and inherited much of the doctor's collection of paintings which formed the basis of her donation to the Musée Marmottan. This greatly influenced Michel Monet, who in his will donated all of his remaining collection, plus Monet's house, to the Académie des Beaux-Arts in Paris, which wisely added most of the paintings to those already in the Marmottan.

De Bellio was a key figure for the Impressionists, strongly supporting them during the difficult time at the commencement of the movement, both by buying their paintings and, particularly in Monet's case, by giving not only money but medical advice, free of charge. At one time he owned over 35 paintings by Monet. See also Dr Porak and Dr Gachet.

### BERNHEIM-JEUNE
One of the earliest art galleries in France was founded in Besançon by Joseph Bernheim. His son Alexandre moved to Paris and established a *galerie* at 8 rue Lafitte in 1863. This *galerie* came comparatively late to the Impressionists market and became active in selling Monet's paintings from 1901 onwards. Since 1903 they have become one of the main dealers in Claude Monet's paintings, listing sales of over 250 pictures. See Prince de Wagram.

## BOUSSOD & VALADON

The connection of this gallery with Impressionism first came through their employment of a young Dutchman, Theo van Gogh, who was able to sell a Pissarro in 1884, and one each of Sisley, Monet and Renoir in 1885. They became one of Monet's dealers with whom he signed a contract in 1887, later to be broken when Durand-Ruel came back upon the scene. When Theo died in 1891, M. Boussod said that he had 'accumulated appalling things by modern painters which brought the firm to discredit' – works by Dégas, Gauguin, Pissarro, Lautrec and Monet! They were able to sell over 100 pictures by the last named as the years went by.

## BOUDIN, Eugène (Honfleur 1824-1989 Deauville)

He started working in pastel and watercolour in 1848, invariably painting out of doors. He later made oil paintings from these sketches, progressing to painting small oil paintings *en plein air*. Monet reluctantly became his principal pupil and was later to acknowledge that Boudin was his first master. Boudin had a profound effect on the Impressionists and his paintings are very highly regarded.

## BRACQUEMOND, Félix (1833-1914)

An etcher/engraver and friend of Dégas and Fantin-Latour. He was also a portraitist, well known to all the Impressionists, and exhibited together with his wife in several of their exhibitions.

## BUTLER, Theodore Earl (Colombus, Ohio 1860-1936 Giverny)

American Impressionist painter who studied in New York City and Académie Julian in Paris. He was introduced to Monet and Giverny by Theodore Robinson. He married first Suzanne Hoschedé in 1892 and they had two children, James and Alice (Lilly). Suzanne died of paralysis in 1899 and in 1900 Butler married her eldest sister Marthe Hoschedé – with no issue. Lilly had one son, Jean-Marie Toulgouat (b.1927), an artist now living in Giverny. Butler had one-man exhibitions at Vollards 1898, Durand-Ruel 1900, Moline 1901, Thomas 1904, Schulter (Berlin) 1906, Bernheim-Jeune 1909 and 1912, Kraushaar (New York) 1917, Swartz (New York) 1921.

## CAILLEBOTTE, Gustave (Paris 1848-1894 Paris)

Studied at École des Beaux-Arts, Paris. He took part in the first seven Impressionists Exhibitions, missing only the sixth after differences with Dégas. He was of a wealthy family and assisted the Impressionists, particularly Monet, both financially and in kind. His early death deprived him of the fame his painting deserved. He was a keen yachtsman and yacht designer and at one time was the Vice President of the 'Cercle de la Voile de Paris', racing at Argenteuil, Le Havre, Trouville and Villers.

## CAMONDO, Count Isaac de (1851-1911)

He was a rich banker and collector of Impressionist paintings. He bought his first Monet in 1894 and when he died his paintings were given to the Louvre. Amongst them were 14 by Monet, 10 by Manet and works by Corot, Boudin, Dégas, Cézanne, Pissarro, Sisley, Van Gogh and Toulouse-Lautrec.

## CÉZANNE, Paul (Aix-en-Provence 1839-1906 Aix-en-Provence)

He studied drawing at Aix and went to Paris in 1861 to the Académie Suisse. His boyhood friend was Zola. An intensely shy man, he probably first met Monet at the Café Guerbois, after being introduced by Pissarro. Monet collected his works from 1870 and owned at least a dozen of them

by 1926. His declared ambition, 'I wanted to make something solid and permanent out of Impressionism, like Art in Museums', certainly succeeded. The story of his visit to Monet at Giverny is well known. Monet had the greatest respect for him and his painting.

CHABRIER, Emmanuel (1841-1894)
French composer born in Ambert. Operas: Gwendoline (1886), Le Roi malgré lui (1887). The piece most performed today is the orchestral rhapsody 'Espagne'. He was a friend of Manet who introduced him to Monet, whose works he was to collect. He is shown in Manet's painting 'Le Bal masqué à l'Opéra'.

CHARPENTIER, Georges (1846-1905)
Editor of *La Vie Moderne*, which he started in 1879. He had inherited the publishing firm of Charpentier from his father in 1871. It had a high reputation with many well known authors including Victor Hugo, Dumas, Balzac, Zola and Daudet. In July 1880 Monet had his first one-man exhibition at the Gallery of *La Vie Moderne* with 18 works shown. Mme. Charpentier bought the painting 'Floating Ice' W568 from the exhibition as a present to her husband. Today it is at the Shelburne Museum, Vermont.

CHOCQUET, Victor (Paris 1821-1891 Paris)
He was a Customs official, a dedicated art collector and a defender of Impressionism. Renoir said 'he starved himself to buy pictures he liked', collecting over 50 Impressionist paintings at the critical time when the painters were very poor.

CLEMENCEAU, Georges (1841-1929)
French statesman. He became a physician in Paris and was elected to the National Assembly in 1871. He was Premier 1906-09 and 1917-20. The 'Tiger of France', he was an outstanding journalist who founded and edited *L'Aurore*. He was a lifelong friend of Monet whom he first met in 1864 as a medical student. Later on Clemenceau came to have great influence on Monet, which resulted in the great gift of 'Nympheas' to the Orangerie, Paris.

CORBET, Gustave (Ornans 1819-1877 La Tour de Peilz)
The leader of the Realist School and an outdoor painter who befriended Monet early on at Fécamp, and at Étretat in 1867. He was disgraced during the Commune as a result of the toppling of the Vendôme Column, for which he was blamed by the state, quite unfairly and ordered to pay a gigantic sum for its replacement. He was 'The Master of Ornans'. Wildenstein produced a *Catalogue Raisonné* of his works in 1978.

COROT, Camille (Paris 1796-1875 Paris)
The forerunner of modern landscape painting and perhaps the first to paint before the motif. His work was much admired by the Impressionists. Monet met him in 1867 and later Corot was to resign as a jurist for the Salon in protest at the refusal of two of Monet's paintings. He was very generous to less successful painters.

DAUBIGNY, Charles (Paris 1817-1878 Auvers)
He was, more than any other painter, the forerunner of Impressionism. Of the Barbizon School, he had a great influence on the Impressionists and Monet in particular. Monet's aunt Lacadre gave

him one of her paintings by Daubigny, which he much admired, but which he was forced to sell later on to raise money. Daubigny as a Salon jurist strongly supported Monet in 1868. In 1870, when Monet's paintings were turned down, both he and Corot resigned in protest. Daubigny painted riverscapes from his *bateau atelier* as early as 1857 and Monet was to emulate him, in a similar boat, in 1873.

## DONOP de MONCHY, Victorine (Paris 1863-1957 Paris)

She was the only child of Dr George de Bellio. She inherited de Bellio's collection of paintings and donated many to the Musée Marmottan. This was to have a profound effect later on Michel Monet who donated the residue of Monet's paintings at Giverny to the same museum in 1967.

## DURAND-RUEL, Paul (Paris 1831-1922 Paris)

The greatest, kindest, most supportive, most responsible and sympathetic dealer that seems ever to have existed. A gentleman amongst the dealers, who persevered through extraordinarily difficult times to champion our favourite artists of today. Without his giant effort in support it is possible that Impressionism would have failed. Of this there can be little doubt, for their movement arose at a critical time in the history of the Republic of France, and it could have failed without him and his bankers, Union General, which unfortunately for the Impressionists and many others was declared insolvent in 1873. By February 1881 the bank and business were reinstated and Durand-Ruel started to buy paintings from Monet and the others once more. But this time Monet insisted on having several dealers and did so for the rest of his life. Paul had three sons in the business, Joseph (1862-1928), Charles (1865-1892) and Georges (1866-1931). Only Joseph had issue with two sons, Pierre (1899-1961) and Charles (1905-1985). The gallery today is directed by the second Charles' daughter Mme Caroline Durand-Ruel Godfroy. The gallery has maintained full records of the Impressionist period, including a massive correspondence with Monet and details of his paintings. These have been made available to scholars, including Daniel Wildenstein, enabling him to write the detailed *Catalogue Raisonné*.

## DURET, Théodore (1838-1927)

A writer and art critic and a confidant of Monet and the Impressionists. He championed them and Monet in particular. After travelling around the world, including Japan in his itinerary, he realised the similarity of the construction of the Impressionist paintings with those of old Japan. But their results were separately achieved, even though both groups of art collectors were aware of the others work. He wrote well and simply of the Impressionists and was to produce the first book on them. He was also at one time a minor political figure.

## FAURE, Jean Baptiste (1830-1914)

He was an important baritone singer, much in demand for operatic roles over a long period. He had a sound belief in the new Impressionism and was an early collector of their paintings, particularly those of Monet whom he helped with significant purchases, albeit at a low price, in his time of need. He also lent him his house at Étretat in September-October 1885.

## GACHET, Dr Paul (1828-1909)

He was of unique service to the Impressionists. Quite apart from being a successful Parisian doctor and a homoeopathic doctor at that, he was an enthusiastic art lover, a painter and an expert etcher. He assisted all the Impressionists who regarded him as a friend, a collector and a medical adviser in times of ill health. In particular his support of Cézanne and later Van Gogh are extremely

important. He lived at Auvers-sur-Oise, north-west of Paris, where he treated the poor for no fee, for he also had a successful practice in the heart of Paris. He had a magnificent collection of Impressionist paintings, purchased in their dark days in order to support them, which he did throughout his long life. See also Dr Porak and Dr de Bellio.

GAUDIBERT, Marguerite-Eugénie-Mathilde (1846-1877) wife of Louis Gaudibert (1838-1870) From a wealthy ship-owning family in Le Havre. Monet painted her now famous portrait in 1868. It went to the Louvre in 1951 and is in the Musée d'Orsay today. The portrait of Marguerite was probably painted in the Château des Ardennes-Saint-Louis near Le Havre. Monet also painted Louis and their young son. Louis gave Monet a lot of support at this time and bought some of his paintings which had been confiscated after debts Monet had incurred in Le Havre. 'Marguerite Gaudibert' is rightly now considered as one of the greatest portraits of the period.

GEFFROY, Gustave (1855-1926) Writer and art critic who first wrote about Monet in Clemenceau's *La Justice* in 1883, at the time of the painter's second 'one artist' exhibition at Durand-Ruel's gallery. They met for the first time at Belle Isle where Monet was painting and Geffroy was a tourist. The two men remained friends for the next 40 years. Geffroy became Monet's official biographer in 1921 and the biography was published the following year. Unfortunately Geffroy did not use this unrivalled opportunity to ask deeper questions of the artist about his life and thoughts.

GIMPEL, René (1881-1945) A Parisian art dealer of international repute who, in his published *Diary of an Art Dealer* records several visits to Giverny to buy paintings direct from Monet. His diary covers 1918 to 1939, is well written and contains a great deal of anecdotal information on the artists he met over this period. The diary was first published in France in 1963. His gallery, Gimpel Fils, is still in London at 30 Davies Street, managed by his descendants.

GOUPIL, Alphonse (1806-1893) The founder of Goupil's which became a very successful business, with two galleries in Paris and branches in The Hague, Brussels, Berlin and London. Vincent Van Gogh worked for four years in The Hague and was promoted to the London branch, where he worked for a year and was then moved to Paris. He left Goupil's in 1874. Etienne Boussod became Goupil's son-in-law and Theo Van Gogh was to work for him later on. The name of the firm became Boussod & Valadon in 1887, at 19 Boulevard Montmartre, by which time Theo was the manager in Paris. He sold two Monets that year and more later but could not sell Vincent's paintings. (See Boussod & Valadon.)

GLEYRE, Charles (1806-1874) He was an academic painter, of Swiss origin, who settled in Paris in 1838 where he first taught at the École des Beaux-Arts. Later he opened his own studio for instruction and in 1862, amongst his many pupils, were Monet, Sisley, Renoir and Bazille. He taught drawing and painting and exhibited at the Salon.

GRANOFF, Katia (1895-1989) This unusual lady from middle Europe started to invest in Monet's work just after the Second World War. She was fortunate enough to interest Michel Monet and from that moment her gallery

achieved more success, with the later water-garden paintings, than any other. She carefully cultivated Michel on her journeys to and from Paris and Honfleur where she had a second house and gallery, usually calling on him at his house in Sorel Moussel about 40km south-west of Giverny. The Monets were elderly and she brought them simple gifts. Michel sold no less than 76 waterlily and related paintings to her between 1953 and his death in 1966. She sold to all the great museums in the USA, London and Switzerland. Her descendant Pierre Larock inherited Michel's house which she had bought from him. In old age she was more interested in publishing her poems than in the gallery.

HAUSSMANN, Baron Georges Eugène (1809-1891)
He entered the public service and was so successful that Napoleon III made him Préfect of the Seine in 1853. He then began the huge task of improving the city of Paris, demolishing the old narrow-streeted areas and building wide boulevards with modern housing and offices in their place. He forced the building of efficient sewers, water supplies, bridges, street-washing facilities and the laying-out of parks and recreational areas. This added greatly to the magnificence of Paris, but imposed a heavy tax burden on the ungrateful Parisians. He was dismissed in 1870 but, more than any other, is responsible for the layout of the great city of today. The debts incurred were as nothing to the results achieved, but of course the French do not enthuse about paying taxes!

HELLEU, Paul Cézar (1859-1927 Paris)
He and Alice, his wife, whom he married in 1886, were great personal friends of the Monets whom he had first met ten years earlier. He was a pupil in the Paris Atelier of Gérôme and despite the latter's violent criticism of the Impressionists, Helleu embraced their concepts, becoming friendly with them all, particularly with Monet. His closest friend was John Singer Sargent. He was a keen yachtsman, often crossing the Channel to Cowes and became a great anglophile. He often met King Edward VII, both as King and Prince of Wales and engraved a portrait of Queen Alexandra. He was a highly competent portrait painter and his pictures are much sought-after today.

HOSCHEDÉ, Jean-Pierre (1877-1961)
The youngest Hoschedé child, frequently mentioned in the text. His lifetime interest in the motor car was firmly established in his youth. He became the agent for Hotchkiss and Renault cars at his garage in Vernon. He lived in rue de Colombier, Giverny, where the garden of his home adjoined that of Theodore Butler. In 1903 he married Genevieve Castadau, who died in 1957. They had no children and he therefore took a great interest in his great-nephew, Jean-Marie Toulgouat, who inherited the Butler house and lives there today. Jean-Pierre was a tall man and bearded, and looked like his father Ernest. However he did play tricks on people and pretended to be Monet's third son when he was in his old age. Because of his beard, resembling Monet's, some people were misled, according to Wildenstein.

JONGKIND, Johan Barthold (Lattrop, Netherlands 1819-1891 La Côte Saint-André)
A key figure in Monet's studies in painting. Boudin had been his first master and showed him how to observe *en plein air* and how to paint, but Monet stated that it was Jongkind who was 'to educate his eye'. A Dutchman steeped in the painting of the Netherlands, he had simplified the techniques of their inherited system. He painted particularly in watercolour, in simplified colour and form. No easy matter, but this is precisely what his pupil Monet had sought to find and Jongkind showed him the way. It was a matter of concern to Monet's family that he was a half-crazed and at times drunken companion – but perhaps *in vino veritas*, Jongkind helped to point the way to

Impressionism. Jongkind's story is just as weird as that of Van Gogh, but not so extreme. He painted and drew with great clarity and with simplicity, but often lapsed into spells of alcoholism and was only saved by his companion, to die at the ripe old age of 72. Edouard Manet called him 'The Father of Modern Landscape'.

KHALIL, Mohammed Mahmoud bey (Cairo 1877-1953 Paris)
A very rich Egyptian of Turkish extraction who became President of the Egyptian Senate. Educated in Cairo and Paris, he took as his second wife Emilienne Luce, a French lady educated at the Paris Conservatory. His abiding love of French art and his deep interest in this subject resulted in his collection and Palace being given to the Egyptian State as a major museum in Cairo. It houses a fine collection of French sculpture and painting, including over 30 Impressionist paintings (four Monets). He bought mainly from Georges Petit, Bernheim-Jeune and Durand-Ruel. He took his favourite Monet 'Bords de la Seine à Argenteuil' to Paris and after his death Mme. Khalil sold it to Galerie André Maurice who sold it on to Dudley Tooth. Much of the Khalil collection was shown in Paris at Musée d'Orsay October 1994 – January 1995. His five Monets were previously exhibited at l'Exposition d'Art Français in Cairo in 1928. He was elected a member of the Institut de France in 1949.

LABARRIERE, Dr (fl.1850-90)
One of four doctors in the town of Poissy, who was to advise the Hochedé/Monet family when they were resident at Villa Saint Louis. One or other of the eight children was usually ill and Doctors Labarriere and Love, both qualified doctors and homoeopaths, were to advise, using Dr Porak, the paediatrician, as consultant.

LATOUCHE, Louis (1829-1884)
Artists' colourman and picture dealer. Unusually he was himself a painter and was to exhibit in the first Impressionists Exhibition. He supplied canvas and materials to Monet and was the first to show Monet's paintings in Paris in 1867, in his gallery window, at 34 rue de Lafayette. This almost caused a riot in the street.

LECADRE, Marie-Jeanne (1790-1870)
Wife of Jacques Lecadre (1795-1858), who ran the ship chandlery business at Le Havre, that Monet's father was to take over. Called Aunt Lecadre, she was a formidable lady who, a minor artist herself, championed Monet as a painter against his father's wishes.

LOVE, Dr (fl.1840-90)
A fully qualified doctor and homoeopath in whom Alice Hoschedé placed great trust, both when living at Montgeron and later on in Poissy. He was the most frequently consulted doctor for the Hoschedé family over those periods and knew Dr Charles Porak, the paediatrician.

LUQUET, Jules (1824- after 1878)
Dealer in landscapes, who bought from Monet in his disastrous year of 1878, in which the painter sold only 4,000 francs worth of paintings (numbers W84, Saint-Germain-l'Auxerrois Church in Paris, now in the National Gallery in Berlin and later in 1880, W508 Route de Vétheuil, now in St Petersburg Museum in Florida and W580, also in 1880, Vétheuil au Soleil).

MANET, Edouard (Paris 1832-1883 Paris)

After an initial confusion between his name and Monet's in the Salon of 1865, the two men became firm friends. Manet was a well established painter at this time and came from a prosperous middle class background. His painting was avant-garde, free and brilliant, most colourful and yet harmonious. He was much admired by all the Impressionists whom he championed. They all met often at the Café Guerbois. Later, at Monet's instigation, he painted *en plein air*, but he was never considered an Impressionist and did not exhibit at their exhibitions. He was a staunch supporter of Monet, both financially and with advice, in his difficult times. He died on the day that Monet arrived in Giverny. Monet was one of his pall-bearers and later raised subscriptions to purchase Manet's great masterpiece 'Olympia', painted in 1863. After a great deal of official difficulty it was accepted and hung by the state in the Luxembourg in 1890. 'Olympia' has been transferred now to the Musée d'Orsay.

MONET, Claude Adolph (Paris 1800-1871 Le Havre)

Monet's father became a widower in 1857. He disapproved of his son's desire to become a painter, but relented when his sister-in-law, Monet's Aunt Lacadre, persuaded him to support his son with an allowance. This was stopped when he discovered that Claude was living with Camille. Before the old man died he married his long-time mistress, thus legitimising his daughter Marie (1860-1891) who became Monet and Léon's half sister.

MONET, Léon (Paris 1836-1917 Rouen)

Monet's elder brother lived at Rouen where he had a small chemical business. He also had a summer home at Les Petites-Dalles. Monet stayed at both houses from time to time; Léon strongly disapproved of Monet living with another man's wife and family, but relented once he remarried. Monet's eldest son Jean was to work for Léon in 1891. Léon had a daughter Louise who married a Docteur Lefebvre. According to Wildenstein they owned the *droit morale* to Monet's works after Michel Monet's death in 1966.

MORISOT, Berthe (Bourges 1841-1895 Paris)

The leading female Impressionist painter and a beautiful lady too, as various portraits bear witness (by Manet and Renoir). She was one of the daughters of a high-ranking civil servant, and at the start of her career came under the teaching of Corot and studied in the Louvre. She met Edouard Manet in 1868, and under his influence began figure and portrait painting. She married his brother Eugène in 1874. She became a friend of all the major Impressionists and exhibited with them. She painted with Renoir near Meulan in 1880 and his influence was strongly felt. Her daughter Julie (1879-1869) often sat for her and wrote her biography, published in 1952.

MURER, Eugène (1841-1906)

This pastry cook, baker and restaurateur at 95 boulevard Voltaire, had a great interest in painting. Most of the Impressionist painters were amongst his regular customers and sometimes paid him for their dinners in exchange for a picture. He also bought their paintings and accumulated a remarkable collection, including 10 Monets, eight Cézannes, 25 Pissarros, 28 Sisleys and 16 Renoirs. He commissioned the latter to paint portraits of himself, his son and sister. Around 1883 he left Paris for Rouen where he opened an hotel. He then became a painter and writer, exhibiting at Vollard's in 1898. His collection was dispersed after his death.

NADAR, Félix (1820-1910)

At 35 boulevard des Capucines, Paris was the studio of Nadar, the leading early Parisian

photographer, in which the first Impressionist exhibition was held in 1874. His work was well known to them for he was an early enthusiast and pioneer; obviously this new method of recording landscapes and people was important to them. They all knew one another well from their meetings in the Café Guerbois: Nadar was very generous to them during and after the first exhibition.

## NAPOLEON III (1808-1873)

Emperor of the French, after a *coup d'état* on 2 December 1851 he headed the Second Empire. He was the son of Louis-Napoléon, brother of Bonaparte. In his reign Paris was re-modelled. His foreign policy was adventurous – the Crimean War, intervention in Mexico, war against Austria and Italy. All dictators fail, and having been manoeuvred into the Franco-Prussian War by Bismarck he was defeated at Sedan. He lost his throne and 'retired' to England where he died. His uncle Bonaparte had surrendered to the English and was imprisoned at St. Helena where he died of arsenic poisoning by one of his personal staff at the behest of the French Government of the time. This is still not recognised in France.

## PERRY, Lilla Cabot- (Boston 1848-1933 Boston)

An American painter who first came to Giverny in June 1889, staying with her family at the Hotel Baudy, where one of her party had an introduction to Monet. The Perrys were to stay at Giverny for eight more summers over the next 20 years, at one time renting a house next door to Monet. Lilla spent some time with Monet and he explained to her his method of painting. Luckily she wrote this down for posterity. The article, entitled 'Reminiscences of Claude Monet from 1889-1909', was published in the *American Magazine of Art* in March 1927, just after Monet's death.

## PETIT, Georges (1835-1900)

The Petit Gallery became a serious rival to Durand-Ruel from 1878 and was to host the great Monet/Rodin exhibition of 1889 in consequence. Georges Petit inherited a successful gallery from his father, which was renowned for its size and extravagant decor. It was he who first advised Monet to raise his prices. An extraordinary man who tracked down one of Corot's paintings in the Fontainebleau area where it had been given to settle a grocer's bill. No doubt he did the same for other painters too. He was extremely successful in marketing the Impressionists and sold over 100 Monets at good and later on high prices. Described by René Gimpel as looking 'like a large and ensyphellitic cat' he appears to have been quite a character and a very efficient dealer. His gallery continued to operate until the 1930s. All records from his Gallery are missing, presumed lost for ever.

## PISSARRO, Camille (St. Thomas, West Indies 1830-1903 Paris)

A leading Impressionist, and the oldest, whose fatherly figure and long white beard made him a suitable patriarch. Born on the Caribbean Island of St. Thomas (Danish), of Jewish parents of Portuguese origin, he came to France in 1841 and studied later with Corot. He met Monet first at the Académie Suisse in 1861; they were probably near Saint Marie des Batignolles in Paris VIII, for Pissarro's mistress Julie Vellay was named godmother at Jean Monet's baptism, with Bazille as godfather. So Pissarro must have been a good friend by 1867. He was the only Impressionist to take part in every one of their eight exhibitions from 1874 to 1886. He joined the pointillist school of Seurat and Signac, practising for five years from 1885, but came back to Impressionism. He was a lifelong socialist and had a large family, of which five of the boys became successful painters – though none as great as their father. Monet lent Pissarro 15,000 francs in July 1892 so that he could buy his house in Eragny. This was repaid, plus the gift of a painting, in 1896.

**PORAK, Dr Charles Auguste (Paris 1845-1921 Paris)**
Professeur at the École de Maternité de Paris, Member of the Académie de Medecine, *accoucheur*, gynaecologist and paediatrician. Chevalier de la Légion d'honneur 1892 and Officier de la Légion d'honneur 1918. He wrote many papers including 'Jaundice amongst the newly born', 'Diseases of the womb', 'Treatment of Syphilis' etc. Colleague of Dr Gachet and Dr de Bellio, who both referred patients to him at the Maternité. Friend of writers and artists. It was probably he who was consulted about Camille Monet's illness in 1876 and later he must have assisted the Monet/Hoschedé family with their eight children, in Poissy, 1881-83, for Monet gave him a painting, 'Bords de la Seine à Argenteuil'. The painting has 'Villa St Louis, Poissy' and 'docteur Porak' written in pencil in Monet's hand on the reverse of the stretcher.

**POLIGNAC, Prince Edmond de (d.1901)**
An aristocrat of the old school who married the American heiress Winnaretta Singer (1865-1943) as her second husband in 1893. The family owned seven Monets. His Princess was to live on and finally died in London, 41 years after being widowed.

**RENOIR, Pierre-Auguste (Limoges 1841-1919 Cagnes)**
He started as a porcelain painter at the Limoges factory and this experience was a valuable part of his training. He met Monet at Gleyre's studio, and they became great friends, painting together often, particularly on the Seine and when Monet lived at Argenteuil. Later, Monet preferred to paint alone. They shared many Impressionist exhibitions and met in Paris often as their reputations were established. Around 1883 he went back to study and experiment, moving away from Impressionism and producing more linear work. Suffering badly from rheumatism, he moved to the hot sun of the South of France at Cagnes in 1903 where he lived and painted until the last day of his life. His house and garden are open to the public today. Monet did not see him again after his visit to Venice in 1908 when on his return journey he visited the Salerous and Renoirs in Cagnes, but they always kept in touch.

**RODIN, Auguste (1840-1917)**
The principal sculptor of his era who brought the same freshness and technique to his work as did the Impressionists. Monet was a great admirer and together they shared a very successful exhibition at Georges Petit's gallery in 1889. Monet wrote in 1911 to Rodin's close friend and biographer Judith Claudel, adding his approval to the projected Rodin Museum, at his studio in the Hotel Biron, Paris.

**ROMMEL, Erwin Johannes Eugen (Neidenheim 1891-1944)**
Field Marshal. During the Second World War Monet's house at Giverny was placed out of bounds to the German occupying troops, however Rommel asked Blanche for permission to visit in 1944, arriving at the main entrance and walking with his staff up the Grande Allée. Here he was met by Blanche and Jean-Marie Toulgouat (aged 16). He was very courteous and much appreciated Monet's work. Deliberately, but not unkindly, they did not shake hands with him. To have done so at this time would have been quite improper.

**SALEROU, Germaine (Montgeron 1873-1968 Cagnes)**
She was the youngest of the four Hoschedé sisters, all of whom were devoted to their step-father. She met Albert Salerou, a young lawyer in Cagnes, and they married at Giverny on 12 November 1902. Albert (1873-1954) and Germaine had two daughters, Simone (1903-1986) and Nitia

(1909-1964), only Simone had issue. She married Robert Piguet in 1928 and they had twelve children. Many of the early photographs of Monet come from the Piguet collection, whilst Philippe Piguet (b.1946) wrote the definitive book *Monet et Venise* published in 1986.

SIGNAC, Paul (Paris 1863-1935 Paris)
He began painting in 1882 in Paris under the influence of the Impressionists, particularly Monet. He became a brilliant draughtsman and watercolourist and painted all over France, and Europe. He was a Neo-Impressionist and in 1884 became a founder member of the Society of Independent Artists, where he met Seurat. He showed some pointillist paintings in the final (8th) Impressionists Exhibition. Monet was a friend and collector of his paintings. Signac was particularly an admirer of Monet's Venice paintings, first exhibited in 1912. At his death Mme. Ginette Signac was still in possession of many of his exquisite watercolours.

SISLEY, Alfred (Paris 1839-1899 Moret-sur-Loing)
He was born in Paris, of English parents, where his father was a successful silk merchant. He was sent to London to train as a merchant, which did not appeal to him, and he returned to France determined to be a painter. His parents acquiesced and he went to Gleyre's School where he met Monet, Renoir and Bazille. Sisley was supported by his father and had no worries until the Franco-Prussian War of 1870 which caused his father's bankruptcy. By then he was an established Impressionist painter more in the mould of pure landscape, like Monet, than the others. By this time he was married and from 1872 he had to earn his living. He lacked the drive of Monet and never rose above penury. He took part in all the Impressionist exhibitions but despite this his beautiful paintings were not recognised in his lifetime. His wife, Marie-Eugènie, died of cancer in 1898 and he of cancer of the throat in 1899. Claude Monet came to his bedside before he died. From the day he died his superb paintings became highly sought-after but all too late for him and his devoted wife. Monet arranged the sale of Sisley's paintings for the children, Pierre and Jeanne in 1899. Sisley and Monet had painted together at Argenteuil and Bougival in 1872 and 1873, see *Sisley Catalogue Raisonné* by Francoise Daulte, 1959. (D269, D86 & D87.)

TICHY, Dr (fl.1875-85 at La Roche-Guyon)
The nearest doctor to attend the dying Camille at Vétheuil. So far no documentation has been found, but it is believed that he prescribed drugs for her, and probably consulted Dr Porak.

TOOTH, Arthur & Sons Limited
This leading London art gallery was founded by Arthur Tooth senior in 1842 in the Haymarket, where they published and sold prints. By 1870 they were dealing in English portraits and Dutch paintings and at this time Arthur Tooth junior joined the business. His son, Dudley Tooth, joined after the 1914-1918 War and staged the first Boudin exhibition in London in 1924. From then on he was to champion the Impressionists, selling over 40 oils by Monet in the following years until his death in 1972. The firm continues in Bruton Street today. It was selling Monet's work in London long before Wildenstein and the Granoff Galleries in Paris.

TOULGOUAT, Jean-Marie (b.1927)
The only child of Roger and Lilly Toulgouat. An architect-turned painter, who lives and works at Giverny. He exhibits regularly in London, New York and Columbus, Ohio, where his grandfather Theodore Butler lived when in the USA. He inherited the Butler home in Giverny, with all its records and memorabilia of Monet and his times. These records are invaluable to Monet scholars and Toulgouat

is generous in their use. His wife, Claire Joyes, is an art historian and leading Monet scholar. Together they wrote *Monet at Giverny*, 1975, *Life at Giverny*, 1985, and *Monet's Cookbook*, 1989 and have been gracious in assisting with this book. Without them it could not have been written. He was brought up in Monet's house at Giverny and taught to paint by Blanche Monet, Monet's only student. At that time the house contained about 400 Monet paintings for him to look at, and these have greatly influenced him.

## TOULGOUAT, Roger (1897-1945)
He married Suzanne and Theodore Butler's only daughter Lilly (Alice) (1894-1949) on 14 June 1926 at Giverny, some five months before Monet died. Lilly had always been a great favourite of Monet, as photographs show. He was a graphic artist and was wounded in tanks and gassed in the First World War.

## VAN GOGH, Theo (Zundert, Netherlands 1857-1891 Utrecht)
Vincent's younger brother. Theo was devoted to Vincent throughout his life. He became a successful art dealer, working his way up to be manager of the Paris Gallery of Boussod & Valladon, previously Goupil's. He sold his first Impressionist painting, a Pissarro, in 1884, and thereafter sold paintings by all of them. His support was pivotal to the painters; he also supported his brother, but only managed to sell one of his paintings. Gustave Kahan wrote that Theo '...was pale, fair haired and melancholy. There was nothing loud in his ways, but this dealer was an excellent critic and as an art expert would join in discussions with painters and writers'. Pissarro told Theo of Dr Gachet's interest and expertise with patients such as Vincent, and Theo arranged for his mentally sick brother to stay in Auvers under Dr Gachet's supervision. Theo died within one year of Vincent's death; they are buried beside one another in the cemetery at Auvers-sur-Oise.

## VAN GOGH, Vincent (Zundert, Netherlands 1853-1890 Auvers-sur-Oise)
Son of a Dutch Pastor who practised in Holland. From the age of 20 he worked as an assistant in the Goupil Galleries, first in The Hague and then in Brussels, followed by London and then Paris. He gained an excellent knowledge of paintings of the day, particularly the modern movement of Impressionism. Suddenly he left to become an evangelist and missionary amongst the poor miners in Belgium. He started to draw and paint in 1878-79 and within 11 years he was dead. When in Paris from 1886-88 he said 'it is as necessary now to spend time regularly with the Impressionists, as it used to be to study in a Paris studio'. His brother Theo introduced him to all the Impressionists and he made friends with Camille and Lucien Pissarro. Toulouse-Lautrec, Signac, Seurat and Gauguin. Later he stayed with Dr Gachet at Auvers, where he was to shoot himself and die. He sold just one of his 2,125 paintings in his lifetime!

## VOISINOT (fl.1860-80)
'Marchand de couleurs', which by this date meant that he had a shop and probably sold paints, canvas and associated art materials. Earlier in the century it meant that he ground up and sold colours. Monet ran up a large bill of 1,300 francs with him between 1873 and 1877. He paid Voisinot with 16 paintings on canvas and received back 50 francs in cash. So he received an average of 80 francs per canvas in 1877.

## VOLLARD, Ambroise (Réunion 1866-1939 Paris)
A very successful gallery owner who wrote *Recollections of a Picture Dealer*, first published in English in 1936 in Boston, Mass. It covers the period 1889 to about 1920. He first met Monet when the artist walked into his gallery and bought three oils by Cézanne outright; later on he was to visit

Giverny and write about it. He was from the Island of Réunion, and studied law in Paris before opening his gallery in rue Lafitte. He was the principal dealer for Cézanne from 1893 and for Gauguin from 1896, later for Picasso from 1901, Matisse in 1904, for Derain 1905 and Vlaminck in 1906. He had an exhibition of Theodore Butler's work in 1898.

WAGRAM, Prince de (killed in First World War)
Descendant of the Napoleonic 'victory prince' Marechal Bertier, created by the Emperor in 1809. This Prince died in battle in 1918 without heir and the title became extinct. His huge collection of no less than 210 Impressionist paintings, mostly acquired from the Bernheim brothers, included over 50 by Monet. The Prince's sister Mme. de Gramont inherited the paintings and sold them in the 1930s for perhaps twenty-five times their cost, according to René Gimpel's diary entry for 30 August 1930. He says that she sold them to the Knoedler Gallery.

WILDENSTEIN, Daniel Leopold (Verrieres-le-Buisson 1917-2001 Paris)
Art historian and President of Wildenstein Foundation Inc. from 1964. Chairman of Wildenstein and Co., New York from 1968. Grandson of Nathan Wildenstein (1852-1934), founder of the firm, who started by selling ties in Strasbourg, then antiques in Vitry-le-François, before moving to Cité de Retiro in Paris, thence to 56 rue Lafitte and 9 rue La Fayette, where in many deals his partners were Gimpel and Duveen. By 1902 he was extremely successful and was able to open also in New York. The partnership with René Gimpel ended in 1919. He handed over to his son, Georges Wildenstein in Paris, dealing mainly in French and Old Master paintings, opened the London gallery in 1933, and Buenos Aires in 1940. Daniel, the grandson of the founder, was sent to the New York firm in the Second World War, becoming Vice President there in 1943 and President from 1959 onwards, by which time it had become the principal gallery trading in Impressionist paintings. In his turn he opened the Tokyo gallery in 1972, and undoubtedly it has become the richest and best known gallery in the world. The Wildenstein Institute is in rue la Boétie, Paris. Here Daniel Wildenstein was the principal Monet, Manet and Corbet scholar and produced the *Catalogue Raisonné* of their works. On the death of Monet's sole surviving son Michel in 1966, Wildenstein, by then a member of the French Académie des Beaux-Arts, unusually for a dealer, was asked to collate Michel Monet's legacy to the Académie, which he did in 1967. He thus had unrivalled access to Monet's estate and produced a magnificent *Catalogue Raisonné* in five volumes, the last published in 1991. However, he tried to make himself the sole authority on Monet's work, which some might consider a mistake for there are several outstanding Monet scholars, who are independent of the art trade. It is always risky for a chronicler of an artist's life and work to assume the mantle of sole judge of his works. In consequence there are a number of works by Monet not yet admitted to his œuvre and there will be more to come, probably at a later date, when other scholars will have to decide their authenticity. Monet's work is unique and serious scholars have little difficulty in identifying it. There have been some attempts at forgery, but they are easily detected according to Wildenstein. Georges Wildenstein (1892-1963) produced a *Catalogue Raisonné* for Paul Gauguin published in 1964. The Fondation Wildenstein is working on further Catalogues for Odilon Redon, Albert Marquet and Maurice de Vlaminck. It is understood that new catalogues are being prepared for Camille Pissarro and Paul Gauguin, replacing those of 1939 and 1964 respectively. Daniel Wildenstein's sons Alec (b.1941) and Guy (b.1946) worked with him on many of these projects and they live in New York and Paris.

# KEY DATES IN MONET'S LIFE

| | |
|---|---|
| 1840 | 14 November. Birth of Claude Monet at 45, rue Lafitte, Paris. |
| 1845 | Father moves to ship chandler business, Le Havre. |
| 1857 | Death of his mother. Meets Boudin. |
| 1859 | Returns to Paris as art student. Meets Pissarro. |
| 1861-2 | Military service with French Zouave cavalry in Algeria. Invalided with typhoid. |
| 1862 | Convalescence at Le Havre. Meets Jongkind at Gleyre studio, Paris. Meets Bazille, Renoir and Sisley. |
| 1866 | Meets Camille Doncieux who becomes his model. |
| 1867 | Birth of Jean Monet (8 August), Paris. |
| 1868 | Winter at Étretat with Camille and Jean. |
| 1869 | At Bougival. |
| 1870 | Marries Camille. Moves to London to avoid Franco-Prussian War. Meets Durand-Ruel. |
| 1871 | Moves to Holland with Camille and Jean to paint at Zaandam all summer. |
| 1872 | Settles in Argenteuil. Painting with Sisley. |
| 1874 | First Impressionist Exhibition. |
| 1876 | Second Impressionist Exhibition. Stays at Château Montgeron as guest of Hoschedé. |
| 1877 | Paints Gare Saint-Lazare pictures. Third Impressionist Exhibition. |
| 1878. | Leaves Argenteuil. Birth of Michel Monet (17 March), Paris. In August the family moves to Vétheuil to be joined by Hoschedé family. |
| 1879 | 5 September. Death of Camille. A cold winter follows. |
| 1880 | The Seine freezes over. Lowest temperature -40°C. *La Débâcle* – break-up of the ice floes. |
| 1881 | *L'inondation*. The Seine floods. Monet visits Fécamp and Grainval and returns to pack up at Vétheuil. The families move to Poissy (December). |
| 1882 | Visits Dieppe, Pourville and Varangeville. |
| 1883 | To Étretat and back to Poissy. 29 April: the final move to Giverny. |
| 1884 | South of France paintings. |
| 1885 | Return to Étretat. |

| | |
|---|---|
| 1886 | Short stay in Holland. Autumn in Belle Île. |
| 1888 | Antibes. |
| 1889 | Creuse Valley (Fresselmes). Exhibits with Rodin. |
| 1890 | Wheatricks or Grainstacks (Haystacks) series. |
| 1891 | Poplar series. 19 March: Ernest Hoschedé dies in Paris. |
| 1892 | Rouen Cathedral series. 16 July: Monet marries Alice Hoschedé at Giverny. |
| 1893 | More Cathedrals finished. |
| 1895 | Norway, at Sandviken. |
| 1896 | Pourville again. |
| 1899 | Début of Nymphéas and Pont Japonaise. |
| 1900–01 | Visits London. |
| 1900–04 | Exhibits views of fogs on the Thames, the Bridges and Parliament. |
| 1908 | Venice. |
| 1911 | 19 May: Death of Alice. |
| 1914 | Grands Décorations des Nymphéas. |
| 1923 | Cataract operations. |
| 1926 | 5 December: Death of Claude Monet at Giverny. |

# SHORT MODERN BIBLIOGRAPHY

Adhémar, Hélène, *Hommage à Claude Monet*, Exhibition Grand Palais, 1980.

Champion, Pierre, *Vétheuil: un village et son église*, Editions du Valhermeil, 1995.

Dixon, Annette, McNamara, Carole and Stuckey, Charles, *Monet at Vétheuil*, Exhibition University of Michigan, 1998.

Geffroy, Gustave, *Claude Monet: sa vie, son temps, son œuvre*, Paris, 1922.

Gordon, Robert and Forge, Andrew, *Monet*, Abrams, New York, 1983.

Herbert, Robert, *Monet on the Normandy Coast, 1867-1886*, Yale University Press, 1994.

Hoschedé, Jean-Pierre, *Claude Monet ce mal connu*, Cailler, Geneva, 1960.

House, John, *Monet. Nature into Art*, Yale University Press, 1986.

Isaacson, Joel, *Monet. Observation and Reflection*, Phaidon, 1978.

Joyes, Claire, *Monet at Giverny*, Matthews Miller Dunbar, London, 1975; *Claude Monet, Life at Giverny*, Thames & Hudson, 1985.

Kendall, Richard, *Monet by himself*, Macdonald & Co., 1989.

Lacambre, Geneviève, *Les Oubliés du Caire*, Musée d'Orsay, 1994.

Levine, Steven, *Monet, Narcissus and Self-Reflection*, Chicago, 1994.

Moffett, Charles, *The New Painting. Impressionism 1874-86*, Geneva, 1986.

Pickvance, Ronald, *Monet and Renoir in the mid-1970s*, Chisaburo, 1980; *Alfred Sisley (1839-1899) Impressionist Landscapes*, Nottingham University, 1971.

Pissarro, Joachim, *Monet's Cathedrals*, Pavilion Books Ltd., 1990; *Monet and the Mediterranean*, Rizzoli International Publications Inc., New York, 1997.

Pouchain, Gérard, *Promenades en Normandie*, Corlet, 1992.

Rachman, Carla, *Monet*, Phaidon Press Ltd., 1997.

Rewald, John, *Aspects of Monet. A Symposium*, Abrams, 1984.

Sagner-Duchting, Karin, *Claude Monet. Feast for the Eyes*, Taschen, 1990.

Seitz, William, *Claude Monet, Seasons and Moments*, Museum of Modern Art, New York, 1960.

Skeggs, Douglas, *River of Light. Monet's Impressions of the Seine*, Victor Gollancz Ltd., 1987.

Spate, Virginia, *The Colour of Time: Claude Monet*, Thames & Hudson, 1992.

Stevens, Mary Anne, *Alfred Sisley*, Exhibition, Royal Academy of Art, London, 1992.

Stuckey, Charles, *Monet. A Retrospective*, Lauter Levin, New York, 1985.

Thomas, Jean-Pierre, *Étretat. Autour des années 1900*, Bertout, 2000.

Toulgouat/Piguet, *Blanche Monet. Notes sur Claude Monet*; *Alice Monet, Journal 1863-1910*.

Tucker, Paul Hayes, *Monet at Argenteuil*, Yale University Press, 1982; *Claude Monet. Life and Art*, Yale University Press, 1995.

Wildenstein, Daniel, *Claude Monet. Biographie et catalogue raisonnée*, 5 Vols., Bibliothèque des Arts, Lausanne-Paris, 1974-1991; *Monet or the Triumph of Impressonism*, 4 Vols., Taschen-Wildenstein Institute, 1996.

# INDEX

Page references in bold type refer to illustrations

# THE ANTIQUE COLLECTORS' CLUB

The Antique Collectors' Club was formed in 1966 and quickly grew to a five figure membership spread throughout the world. It publishes the only independently run monthly antiques magazine, *Antique Collecting*, which caters for those collectors who are interested in widening their knowledge of antiques, both by greater awareness of quality and by discussion of the factors which influence the price that is likely to be asked. The Antique Collectors' Club pioneered the provision of information on prices for collectors and the magazine still leads in the provision of detailed articles on a variety of subjects.

It was in response to the enormous demand for information on 'what to pay' that the price guide series was introduced in 1968 with the first edition of *The Price Guide to Antique Furniture* (completely revised 1978 and 1989), a book which broke new ground by illustrating the more common types of antique furniture, the sort that collectors could buy in shops and at auctions rather than the rare museum pieces which had previously been used (and still to a large extent are used) to make up the limited amount of illustrations in books published by commercial publishers. Many other price guides have followed, all copiously illustrated, and greatly appreciated by collectors for the valuable information they contain, quite apart from prices. The Price Guide Series heralded the publication of many standard works of reference on art and antiques. *The Dictionary of British Art* (now in six volumes), *The Pictorial Dictionary of British 19th Century Furniture Design, Oak Furniture* and *Early English Clocks* were followed by many deeply researched reference works such as *The Directory of Gold and Silversmiths,* providing new information. Many of these books are now accepted as the standard work of reference on their subject.

The Antique Collectors' Club has widened its list to include books on gardens and architecture. All the Club's publications are available through bookshops world wide and a full catalogue of all these titles is available free of charge from the addresses below.

Club membership, open to all collectors, costs little. Members receive free of charge *Antique Collecting*, the Club's magazine (published ten times a year), which contains well-illustrated articles dealing with the practical aspects of collecting not normally dealt with by magazines. Prices, features of value, investment potential, fakes and forgeries are all given prominence in the magazine.

Among other facilities available to members are private buying and selling facilities and the opportunity to meet other collectors at their local antique collectors' clubs. There are over eighty in Britain and more than a dozen overseas. Members may also buy the Club's publications at special pre-publication prices.

As its motto implies, the Club is an organisation designed to help collectors get the most out of their hobby: it is informal and friendly and gives enormous enjoyment to all concerned.

*For Collectors — By Collectors — About Collecting*

ANTIQUE COLLECTORS' CLUB
Sandy Lane, Old Martlesham, Woodbridge, Suffolk IP12 4SD, UK
Tel: 01394 389950  Fax: 01394 389999
Email: sales@antique-acc.com Website: www.antique-acc.com
or
Market Street Industrial Park, Wappingers' Falls, NY 12590, USA
Tel: 845 297 0003  Fax: 845 297 0068
Email: info@antiquecc.com Website: www.antiquecc.com